Design, Philosophy and Making Things Happen

Drawing from the work of Dewey, Wittgenstein and Heidegger, this book aims to relate a series of philosophic insights to the practice of engaging in design research for change.

These insights are explored and presented as a set of potential strategies for grounding transformative design research within an intellectual context which both embraces and celebrates experience, process and uncertainty. Chapter by chapter, through theory, practical examples and case studies, an accessible narrative opens up around the coupled themes of existence and experience, language and meaning and knowing and truth. The outcome is a rich and detailed perspective on the ways in which philosophy may afford design research for change a means to both explain, as well as understand, not only what it is and what it does, but also what it could be.

The book will be of interest to scholars working in design studies, design theory and design research.

Brian S. Dixon is Head of Belfast School of Art, Ulster University, Belfast.

Design Research for Change
Series Editor: Paul A. Rodgers
University of Strathclyde

Design Research for Change includes books that highlight the wide-ranging social, cultural, economic, and environmental impacts of emerging design research on industry, governments, and the wider public. The series will reach across disciplinary, methodological, and conceptual boundaries and will include scholars from around the globe. The series will be of interest to scholars working in the fields of social design, design history, design research, design culture studies, and design studies.

Design for People Living with Dementia
Edited by Paul A. Rodgers

Metadesigning Designing in the Anthropocene
Edited by John Wood

Designing Interventions to Address Complex Societal Issues
Edited by Sarah Morton

Design, Philosophy and Making Things Happen
By Brian S. Dixon

For more information about this series, please visit: www.routledge.com/Design-Research-for-Change/book-series/DRC

Design, Philosophy and Making Things Happen

Brian S. Dixon

NEW YORK AND LONDON

Designed cover image: Michael Pierre Johnson

First published 2023
by Routledge
605 Third Avenue, New York, NY 10158

and by Routledge
4 Park Square, Milton Park, Abingdon, Oxon, OX14 4RN

Routledge is an imprint of the Taylor & Francis Group, an informa business

© 2023 Brian S. Dixon

The right of Brian S. Dixon to be identified as author of this work has been
asserted in accordance with sections 77 and 78 of the Copyright, Designs and
Patents Act 1988.

All rights reserved. No part of this book may be reprinted or reproduced or
utilised in any form or by any electronic, mechanical, or other means, now
known or hereafter invented, including photocopying and recording, or in any
information storage or retrieval system, without permission in writing from the
publishers.

Trademark notice: Product or corporate names may be trademarks or registered
trademarks, and are used only for identification and explanation without intent
to infringe.

ISBN: 978-1-032-03957-2 (hbk)
ISBN: 978-1-032-04696-9 (pbk)
ISBN: 978-1-003-19430-9 (ebk)

DOI: 10.4324/9781003194309

Typeset in Sabon
by Apex CoVantage, LLC

To Ciara, for all the thinking and listening time.

Contents

Acknowledgements ... x

Prologue: The Entwining of Design and Dynamic Knowledge Production ... 1
Philosophy, Epistemology and Developing an Epistemological Narrative for Design Research Involving Practice? 3
This is a 'Pragmatist' Book 6
Yes, but Really, Why Just Focus on Dewey-Wittgenstein-Heidegger? 8
Two Additional Points on Privilege, the Dewey-Wittgenstein-Heidegger Baseline and Myself as Author 9

Introduction: Design Research, Philosophy and Some Radical Philosophers ... 14
A Brief Sketch of Design in the Present 14
A Brief Sketch of Design Research in the Past and the Present 18
A Brief Sketch of the History of Western Philosophy (and Epistemology) 22
A Brief Note on the Concept of the Radical in Philosophy 28
Where do Dewey, Wittgenstein and Heidegger fit into Philosophy? How are They Radical? 29
The Present Relationship between Design and Philosophy 31
The Philosophy of Design 33
Polanyi, Schön and Ingold: Theory at the Edge of Philosophy 34
The Design-Philosophy Nexus as a Whole 35
Dewey, Wittgenstein and Heidegger: Their Backgrounds and Some Quick Intersections 36
Why Dewey, Wittgenstein and Heidegger Over Anyone Else? 38
Pathway 0.1 An Historical Pathway: The Marxist Influence 42
The Dewey-Wittgenstein-Heidegger Baseline as a Means of Carrying Things Forwards 43
The Structure of this Book 44

viii *Contents*

1 Positioning: Working with Context in Experience 56

Motivations in Design Research 56
Objectivity in Research: The Position of the Researcher and the
Designer-Researcher 58
Moblising Dewey-Wittgenstein-Heidegger 63
Dewey's Interlinking of Experience-Existence 64
Wittgenstein's Forms of Life and Ways of 'Seeing' 65
Heidegger's Dasein, Care and b/Being 67
 Pathway 1.1 Two Established Pathways: Heidegger on Things and
 Technology 70
Positioning via Dewey-Wittgenstein-Heidegger: Design Research
 and Organism-Environment Relations; Being-in-World; and Forms
 of Life 72
 Pathway 1.2 A Pathway to Consider: A Marxist Positioning on
 Creativity 73
 Pathway 1.3 Pathways Which Have Opened up a Series of Key
 Horizons: Quick Notes on the Decolonial; Feminism; the
 Ecological; and Buddhism 75
 Design Research Projects 1.1 Transition Design 80
 Design Research Projects 1.2 Decolonising Design 82

2 Processing: Making a World Together through Meaningful Inquiry 93

The Intersecting of the Design (Research) Process and the
 Methodological 94
Processing and Dewey-Wittgenstein-Heidegger: Linking Action and
 Meaning in Coming to Know, See and Discover 97
Dewey's Theories of Inquiry and Communication 98
 Pathway 2.1 An Established Pathway: Semiotics 100
 Design Research Projects 2.1 Design Tools: A Means of Meaning
 Making 102
Wittgenstein's Language Games 104
 Design Research Projects 2.2 The Women's Design + Research
 Unit 106
Heidegger's Discovery and Poetic Thinking 108
 Pathway 2.2 A Potential Pathway in Formation: Design and
 Buddhism 111
Ways of Processing via Dewey-Wittgenstein-Heidegger: Knowing,
 Understanding, Discovering 112
 Pathway 2.3 Some Additional Potential Linguistic Pathways:
 Austin, Foucault and Butler 115

3 Producing: Knowing Value 124

Designing and Knowing in the Contemporary Field: Designerly
 Endpoints and Outcomes 125

Contents ix

Producing and Dewey-Wittgenstein-Heidegger 131
Dewey's Escape from Knowledge and Belief: Warranted
 Assertability 131
Wittgenstein's Grounding of Knowledge, Certainty, Judgement and
 Doubt 133
Heidegger's Unconcealment: Truth as Discoveredness 136
 Design Research Projects 3.1 The 'Reorientation' of the Designing
 Quality in Interaction Group at TU Delft 138
Producing and Dewey-Wittgenstein-Heidegger: Asserting, Defending,
 Unconcealing 139
 Pathway 3.1 An Establishing Pathway: Latourian Actor Network
 Theory and Design via Latour 143
 Pathway 3.2 A Pathway in Formation: Postphenomenology 144

Conclusion – Understanding the Boundaries, A Justificatory
Narrative and What Next? 154
Positioning, Processing and Producing in the Round: The Baseline
 and Design Research Involving Practice 155
A Brief Note on the Pathways 158
Mapping the Baseline Philosophers and Some Pathways: A First
 'Sketch' 158
An Early Epistemological Justificatory Narrative for Design Research
 Involving Practice via the Baseline 159
 Pathway C.1 A Pathway to be Considered Further: A Quick
 Outline of the Potential of Critical Theory's Commitment to
 Transformation 164
 Pathway C.2 A Pathway that is Appealing but Challenging:
 A Quick Note on the Potential of Deleuze-Guattari for the
 Development of an Epistemology of Design Research Involving
 Practice 166
 Pathway C.3 A Final Pathway, not yet Fully Formed but Needing
 to be Explored: Process Philosophy, Whitehead and the
 Potential for a Metaphysics for Design 168
 Design Research Projects C.1 Philosophy in Action at the
 Everyday Design Studio, at Simon Fraser University 170
 Design Research Projects C.2 Antidisciplinarity 172
Why Does This Matter? 173
How Might Philosophy Benefit from a Designerly Perspective? Or,
 Towards a Designer-Philosopher 174

Index 184

Acknowledgements

Texts such as this emerge not off the back of one or two interactions, but many, and over many years. You have conversations, you enter into intense exchanges. You go to a talk or a workshop. You hear something said, you see something. It all builds up. These interactions may seem important or they may not. Nonetheless they all leave a mark and ultimately feed into what is eventually created. As such, an initial, general thanks must be first offered for all the tangible and intangible opportunities I have had to encounter and engage with a multitude of powerful perspectives in and around the subjects of design, design research and, of course, philosophy. The last decade especially has been wonderfully rich. This is largely the result of my privileged position as an academic and I want to acknowledge and express gratitude for this privilege here above all else. Thank you.

Beyond the general, there are of course groups and individuals who are especially deserving of direct thanks. The first group involves the long list of inspiring colleagues I have had the joy of working with over the last ten years. It was at the Institute of Design Innovation (later the Innovation School) at the Glasgow School of Art that I had my first opportunity to really think through the themes of the present text. Here, I was incredibly lucky to be involved in prolonged earnest conversations and debates around what constituted knowledge in design and these inevitably informed the early outline of what has emerged here. To Donald, to Lynn, to Gordon, to Elio, to Cara, to Michael, to Marianne, to Irene, to Katherine, to Paul, to Fergus and to Joe: thank you. Those were intense years but worth it.

Thanks also to colleagues at the Belfast School of Art. What a journey it's been. To Justin, to Louise, to Ian and the many others whose support allowed this work to happen, I am grateful. Thank you!

In terms of individuals, I turn first to Prof Janet McDonnell and Tricia Austin. Janet, in particular, will likely always be my academic hero. If there is any rigour or clarity underlying the proposals of this text it is off the back of the many hours she put into supervision – sometimes pleased, sometimes not but always honest. Along with the support of Tricia, this guidance has led me to where I am. Thank you Janet and thank you Tricia.

Prof Ilpo Koskinen and Prof John McCarthy come next. They both offered support to this and my previous book on Dewey. They have, through example and direct advice, come to shape who I am as a researcher, a theorist and an author. I hope what has resulted here measures up, even partially, to what they initially helped trace out. Thank you.

Acknowledgements xi

Thank you to Dr Anna Rylander Eklund and Frithjof Wegener. You have both enriched and extended my philosophic understanding in the context of design. I hope I have offered some insights in return.

Thank you also to Prof Terry Irwin, Dr Lesley-Ann Noel, Dr William Odom, Prof Liz Sanders, Prof Teal Triggs and Prof Ron Wakkary. You were each very generous in allowing your images to be reproduced here and in responding to my requests to gain additional insights in relation to your specific perspectives. I hope the conversations continue!

Finally, that essential, deep and heartful thanks goes to family. To Ciara, Samúéil, Conall and my parents, thank you. It simply wouldn't have been possible to produce this work without your support and presence. One forgets in the midst of all of this that words on a page really don't matter. It's the meaning they lead to that matters and, from this, the good, such as it is, that may (or indeed may not) result. I do this in the hope that good can result and, so, I do this for you.

Prologue

The Entwining of Design and Dynamic Knowledge Production

The last two decades have seen design enter the knowledge production process (Koskinen et al. 2011; Vaughan 2017). One of the most common labels applied to this emergent approach is research *through* design (Frayling 1993). The term – now often shortened to RtD in the literature – is self-descriptive, pointing to a form of research which centres upon foregrounding the design process as *the* key method of inquiry. Over the years, other terms and labels have followed including: practice-based and practice-led research (see, e.g., Rust et al. 2007; Candy 2006), constructive research (Koskinen et al. 2011) and 'design research involving practice' (Dixon 2020). Recently, the apt term 'design research for change' has also entered the scene (Design Research for Change 2020).[1]

Regardless of which term/label is applied, it is possible to highlight a number of common features evident in such research. Most immediately, projects will often engage with problematic or emergent real-world contexts, e.g., organisations and communities with immediate needs and concerns that stand to benefit from creative support (Halse et al. 2010). Linking directly to this, as is clear in the 'design research for change' label, there is also a general focus on seeking to bring about positive *transformation* within such contexts, i.e., addressing and responding to that which is deemed problematic/emergent (Design Research for Change 2020). Drawing these aspects together, a working definition of what will here be termed 'design research involving practice' might read as follows: a form of research which aims to achieve positive transformation through the application of design in problematic/emergent real-world contexts.

Such a definition gets us some of the way there but does not give us any sense of the underlying nuances or subtleties that surface when the design process is enfolded within research. I would suggest that two features in particular are missed. The first points to a potentially profound issue. Here, I believe it is arguable that the approach (i.e., design research involving practice) implicitly overturns traditional Western epistemological convention – that is, the norms associated with knowledge production in the West. In taking this view, I claim that, in principle, the enfolding of design in research has tended to result in a rejection of theoretical explanation/description in favour of practical and conceptual *transformation* (Gaver 2012) – and alongside this, a trade-off between methodological objectivity/impartiality and the researchers' deep immersion and participation in the context of the research (Dixon 2021; Cross 2007). All of this points to conditions of *un*certainty rather than certainty; one cannot know a likely outcome in advance nor the extent to which it will generalisable.[2] As such, when set against other more established disciplines/methodologies, which seek to objectively

DOI: 10.4324/9781003194309-1

2 Prologue

describe and explain such that *certain*, generalisable knowledge can be gained (e.g., the natural sciences), the approach may be considered *radical*.[3]

The second key feature overlooked in the latter definition is the sheer diversity of methods underpinning design research involving practice.[4] Though the above labels (i.e., RtD, practice-based/led, constructive research, design research for change) often appear to suggest the existence of single, universal approaches or sets of techniques, no such approach/set of techniques exists (Boon et al. 2020). Insofar as one can identify methodological unity, it is perhaps to be found in an often-implicit commitment to experimental action, coupled with a series of more general commitments such as an attentiveness to context alluded to above and, for some, the expectation of artefactual outcomes (e.g., Candy 2006).

Beyond these, what happens, when and how, is by no means prescribed. Many possibilities arise, whether at the beginning, middle or end. Working contextually, in dialogue with organisations and/or communities, it is for the researchers to decide. A project might link to the traditions of the sciences (social or natural) or the arts or humanities, as Ilpo Koskinen and colleagues have suggested (Koskinen et al. 2011; Krogh and Koskinen 2020). Its outcomes might be generalisable at scale or, equally, highly particular to a specific time, location and group. On this view, design research involving practice becomes a method without a procedure – a way of going about things that has an anticipated outcome (i.e., some form of change) but not necessarily a predefined, prescribed process.

Seeking to gather the above together and build on our above (incomplete) definition we might say the following. Design research involving practice is an *epistemologically radical* (i.e., not of the descriptive-explanatory-objective tradition), non-prescriptive form of research (i.e., it lacks a predefined procedure), which aims to achieve positive transformation through the open-ended application of design (processes) in problematic/emergent real-world contexts.

This book focuses in particular on the epistemological character of the approach, seeking to unpick its radicality at the same time as sketch a framework which gives this grounding. It does so by moving through accounts of methodological and process-based concerns, offering outlines so far as is possible and linking these to the subject of philosophy or to be more precise to the work of particular *philosophers*.

This brings us to key point. This is a book about design in research, yes, but most importantly it is also a book about design *and* philosophy.

Design and philosophy are not often drawn into close relations with one another.[5] It is arguable that they are too far apart for any meaningful alignments to be considered (Koskinen et al. 2011, pp. 119–121). Nonetheless, when it comes to design research involving practice, I believe that the two disciplines must be brought into closer contact than currently occurs. Indeed, so close as to almost touch – for, as will gradually become apparent, methodological questions carry epistemological questions and epistemological questions, if pursued to their endpoint, eventually lead to philosophical questions.

It is acknowledged that such a proposal may jar. Philosophical questions are often understood as wholly intellectual and impractical, 'merely' theoretical as it were. However, exploring how design research might draw on certain perspectives in order to *shore up* its epistemological grounding can only strengthen the field, allowing new relationships to be drawn with other disciplines and, in this, open up the potential for the development of a renewed understanding of the field itself (see, e.g., Vermass and

Prologue 3

Vial 2018). The proposal put forward here is that this can be enabled through what I term an 'epistemological justificatory narrative' (Dixon 2021) – in other words, a story about how, in this discipline (i.e., design), using this methodology (i.e., design research involving practice), knowledge is produced.

The logic here is simple. If we don't have a story or at least a rationale, we don't have a means of sharing our position and vision. Without a means of sharing, we cannot forge new relationships or work to renew our own self-understanding such that we can progress and build on what has been achieved.

While developing such a narrative is by no means a straightforward task, this text will endeavour to take a series of tentative, early steps in its direction.

To start things off, the present prologue will do some of the necessary, initial work. First, I ask how philosophy might be drawn upon in the process of constructing an epistemological narrative. I will thereafter discuss the philosophic perspective driving the arrangement of the present book (i.e., pragmatism), provide a brief rationale for the selection of its three key philosophic voices as core references (i.e., John Dewey, Ludwig Wittgenstein and Martin Heidegger) and, finally, finish up with a brief positioning statement, thus setting the rest of the text in motion.

Let us start then by turning to consider the question of how we might develop an epistemological narrative.

Philosophy, Epistemology and Developing an Epistemological Narrative for Design Research Involving Practice?

Philosophy refers, literally, to a 'love of wisdom', with philosophers notionally acting as those who 'practice' or progress wisdom. Though some might maintain that wisdom remains the discipline's principal ideal, in a straightforward sense this is longer the case and has not been for some time. Today it is *epistemology* – the quest to provide a clear and precise theory of knowledge (noted above) – which sits at the heart of the philosophic enterprise. Indeed, it has been argued that, such is the emphasis placed on epistemology, a more appropriate label for philosophy today might be 'philepistemy', meaning a 'love of knowledge' (see Alexander 2013, p. 73).

Tracing back over time, it is arguable that theorising knowledge has been philosophy's key function since at least the sixteenth century.[6] From this time onwards, the gradual advance of empirical science (i.e., science based on the results of live experiments) meant that, one by one, discipline after discipline – whether chemistry, physics, biology, psychology, or sociology – peeled away to become standalone fields (see, e.g., Grayling 2019, pp. 279–280). Freed from the responsibility of direct investigation in these areas, philosophy's role became one of abstract regulation in the form of defining knowledge and, from this, pointing to potentially appropriate methodological procedures (e.g., experimentation based on the quantification of results).

However, this did not happen in the case of design. As a whole, the field lacks a single regulative theory of knowledge and while design research involving practice has progressed methodologically over the last 20 years, it continues to lack epistemological grounding (Dixon and French 2020). Thus, in seeking to develop a justificatory narrative for the approach, here my efforts can only be seen as *prototypic*.

At this point, it is very important to make clear that I would not intend that any narrative be 'final' or 'definite'. Indeed, the possibility of a final or definite narrative seems highly unlikely (and, as I will later note, possibly even undesirable too). Rather,

4 *Prologue*

my aim is far humbler. Ultimately, I hope that, in this text, it might be possible to develop what I will term a 'sketch map' of these two interweaving terrains. Some parts of this map will highlight specific (relevant) aspects of philosophy pertaining to the epistemological concerns of design research involving practice, while the whole will be structured according to the general sequence of the activities underpinning the approach, i.e., *what* notionally happens *when* in design research involving practice.

The *idea* of a map appeals deeply. Firstly, maps *reveal*. What would otherwise be hidden is rendered available and apparent. Further, such an outcome can be achieved without too great an effort (at least insofar as for it not to be overwhelming). The key here is that maps allow for varying degrees of *accuracy* and *precision*, depending on content and scale. Through this economy of representation, efficient communication becomes possible. Some aspects of what is being shown will be rendered in full clarity, while others may be merely suggested.

When it comes to any attempt to consider epistemology in the context of design research involving practice, this is an invaluable feature. There is simply too much terrain to navigate across the totality of personalities, voices, centuries, movements and cultures that might be drawn upon. And within this there are too many subtleties, too many fractious divides to note and attend to in the depth that would be required. Additionally, in relating the two, the sheer breadth of possible connections – whether to insights relating to concerns regarding knowledge, or something else – is simply so vast that it is potentially overwhelming. As such, a fully accurate representation would be impossible and it is necessary to accede that a total overview of the potential interweaving of epistemology and design cannot be achieved in a single text.

At this stage, I believe that the aforementioned 'sketch map', the one this book will offer, is our best option. Though limited, it will still hold value, opening up the possibility of further surveys and further mappings and, from this, greater detail and greater clarity. More can come from it.

So how to begin?

Even if loose and imprecise, a sketch map will, nonetheless, require structure. To set about the task of beginning to form that structure here, I have devised what might be termed a rough framework. My starting point is found in the idea, noted above, that design research involving practice overturns (and, to a degree, works against) Western epistemological convention. Accordingly, I turn to three philosophic voices who, in keeping with this outlook, can be found to have done the same, or at least attempted to do so. Their names are John Dewey, Ludwig Wittgenstein and Martin Heidegger. I select them as a *baseline* for the narrative and the sketch map.

Why these three in particular?

While a more specific outline of what these three offer in direct terms is set out in the next chapter, I would like to foreground, preface if you will, three key reasons.

In the first instance, in Dewey, Wittgenstein and Heidegger, we have three voices which have already been *mapped* in design research, i.e., other theorists have, for many years, been noting and exploring potential relatability of their work (whether practice, theory or research), highlighting specific links and possible connections.[7] These links and connections will be noted as we proceed through the text, either generally (i.e., as we explore design's points of intersection with philosophy) or, specifically, when noting immediate connections that have been drawn to the work of either Dewey, Wittgenstein, or Heidegger.

Prologue 5

Of course, in noting that Dewey's, Wittgenstein's and Heidegger's works have already been mapped to design, it is also important to point out that these are not the *only* philosophers whose work has received such attention. As will be discussed in the next chapter, both historically and in recent years some effort has gone into mapping particular philosophers' work to concerns within the field of design (e.g., Vermass et al. 2008; Vermass and Vial 2018; Marenko and Brassett 2015). I do not deny the value of these efforts. Each makes a special contribution. However, when it comes to the question of knowledge, for reasons that will be revealed as we advance, I believe that it is *these* philosophers who offer design the most immediate clarity.

The second key benefit to their selection as a baseline for the development of an epistemological narrative relates to the way in which their work opens up clear pathways (to continue the mapping metaphor) towards interrelating design with pressing contemporary social/cultural/political concerns in philosophy/epistemology. As will be covered, these concerns include what is termed 'decoloniality'; feminism; developing more holistic ecological understandings; and, finally, aspects of Buddhism. Of course, all of these horizons are, to a greater or lesser extent, being addressed within contemporary design research discourse. Each has its representatives and each is gradually gaining traction, with philosophy being drawn a variety of ways. I contend that working through the epistemological insights of Dewey-Wittgenstein-Heidegger may aid the progression of such viewpoints within design discourse – offering theorists/activists further tools (beyond any existing philosophic references) by which they may extend their questioning and interrogation of the structuring of their field, as well as its embedded systems of power and discrimination. This adds a further dimension to our epistemological agenda. Not only are we looking at how to accommodate the transformation, participation and uncertainty, noted earlier, but also difference and diversity.

The third and final key reason for selecting these three individuals comes from the field of philosophy itself. Here, this trio has on a number of occasions been upheld – whether as a grouping, as pairs or independently – as key, early reforming figures within the last hundred years of philosophy (see, e.g., Rorty 2009/1979; Toulmin 1984; Bernstein 2010; Volbers 2012; Braver 2012; Sleeper 1986). Many note the continued significance of their contributions for the contemporary field today. Indeed, if anything, interest in their work is increasing, with the last decades having seen a vast catalogue of new publications setting out to explore potential, novel threads that might be drawn upon.[8]

As is covered below, the general claim put forward by authors here is that the epistemological contributions of Dewey, Wittgenstein and Heidegger may provide a set of valuable insights that can help us to both clarify and apprehend just what is at stake when it comes to our contemporary understanding(s) of knowledge. As a trio, Dewey-Wittgenstein-Heidegger open up a unique horizon that allows us to begin to consider notions of change/transformation/uncertainty in the process of knowledge production.

In doing so, they also permit (indeed encourage) the positive conceptual enfolding of ideas relating to the participation of individuals/groups within the process and, importantly, alongside this, of personal meanings and creativity. Though they make little or no explicit reference to design,[9] following others (e.g., McCarthy and Wright 2004; Krippendorff 2006; Mazé 2007), I will argue their orientation can, in many

6 Prologue

ways, be seen as *designerly* – they would likely recognise the meaning and value of design research involving practice and what it stands for.

This isn't it however. There is yet another dimension to the rationale for their selection, a larger one than those set out above – when it comes to knowledge and knowledge production, I see them as all sharing a *pragmatist* outlook, without necessarily being pragmatists themselves.

This is a 'Pragmatist' Book

Those who know the work of Dewey, Wittgenstein and Heidegger will know that each is aligned with a different philosophical tradition or 'school' – pragmatism for Dewey; the analytic for Wittgenstein; and the phenomenological for Heidegger.[10] It must be acknowledged at the outset that these traditions/school do not readily 'fit' together as a grouping. On top of this, it must also be acknowledged that each of these philosopher's *individual* positions is very different from that of the others, i.e., they diverge in one way or another from *each other*. This is further complicated by the fact that over their lifetimes all three underwent a *change* in position, shifting in one way or another such that their early work contrasts slightly with that which came later.

The reality is that, ultimately, any effort to relate their positions requires more than a little 'smoothening' out of key differences and disagreements.[11] A philosophical purist would be right to object to such smoothening if not properly contextualised. This is acknowledged and accepted. As a result, I will, throughout, endeavour to contextualise the differences as carefully as possible.

Nonetheless, it may also be noted that I am not alone in arguing in favour of bringing these voices together. Over the last decades, several others have noted similarities and *relatable* characteristics in their work, either as a trio (e.g., Rorty 2009/1979; Toulmin 1984; Bernstein 2010) or in pairs (e.g., Volbers 2012; Braver 2012; Rorty 1976).[12] In the latter case (i.e., those who link the trio), contributors have put forward the argument that, from an epistemological perspective (i.e., a knowledge-based perspective), there is much that overlaps and compliments in the Deweyan, the Wittgensteinian and the Heideggerian bodies of work.

Richard Rorty was among the first and, possibly, the most famous to put forward such a proposal. In the opening to his groundbreaking *Philosophy and the Mirror of Nature*, he described these three individuals as *the* most important philosophers of the twentieth century (2009/1979, p. 5). In his view, they had brought about a ' "revolutionary" period of philosophy', introducing 'new maps of the terrain'. Their joint ultimate aim, he insists, was 'to help their readers, or society as a whole, to break free from outworn vocabularies and attitudes' (p. 12). In this, knowledge was no longer to be understood as a matter of 'accurate representation' supported by 'special mental processes' (p. 6) but, rather, in new, dynamic ways, with each offering their own novel viewpoint.

Similarly, in an introduction to one of Dewey's *Later Collected Works*, Stephen Toulmin argued that Dewey's critique of traditional epistemology can be seen to parallel that of both Wittgenstein and Heidegger. They all share, he posits, the belief that the 'the traditional image of the human thinker or "knower" as removed from the processes he observes has to be set aside' (Toulmin 1984/1929, p. xvii).

Robert Brandom, a former PhD student of Rorty, sees Dewey, (the later) Wittgenstein and (the early) Heidegger as together rejecting theories of meaning based on

Prologue 7

'representation', what he refers to as the *representational* semantic paradigm. Each, he argues, independently developed a *grounded, social* vision of how concepts (i.e., particular ideas, understandings) are engaged with, judged and acted upon (Brandom 2000, p. 34).

Richard Bernstein aligns Rorty's essential 'bringing together' of the three, noting 'deep similarities' (2010, p. 17).[13] However, he recognises that some will feel unease in relation to the idea that their offerings are fully relatable, acknowledging that their 'philosophical styles and idioms are strikingly different'. Accordingly, he moves to offer another perspective on grouping and, here, looks beyond Dewey towards the wider grouping of American pragmatists (i.e., Charles Sanders Peirce, William James). American pragmatism, Wittgenstein and Heidegger, he believes, were all, from the outset, motivated by a 'similar problematic' regarding traditional epistemology and may be seen to be seeking out 'a more adequate way of understanding our forms of life and being-in-the-world' (ibid, p. 19).

While such efforts have been well received in some quarters, inevitable objections have arisen. Given the high profile of Rorty's work, it is his views which have perhaps drawn the harshest criticism, with many arguing that he has misunderstood the intent and contribution of the three philosophers, whether Dewey (see, e.g., Campbell 1984), Wittgenstein (see Crary 2000), or Heidegger (e.g., Caputo 1983).

As a result, the question arises, if the combination of Dewey, Wittgenstein and Heidegger (along with other disparate voices) remains controversial in philosophy, how can they be justified here?

The answer is that, as per the orientation of most of the list of authors cited above (Rorty, Brandom, Bernstein), I present myself and this book as *pragmatist*.[14] Pragmatism, as has been noted, was Dewey's philosophy and it is one from which I believe design has much to gain intellectually (see Dixon 2020; also see Melles 2008). While the pragmatist perspective – or, to be more precise, the 'classical' pragmatist perspective – is difficult to define in concise terms, it is possible to say that its adherents seek to focus on exploring what the practical consequences of a given thought or proposal might be as opposed to any form of abstract theorising that will *not* have practical consequences.[15] The practical consequences of bringing Dewey, Wittgenstein and Heidegger together around the question of knowledge in the context of design research, allows us to ask questions and make comparisons that may result in the noting of linkages and, as such, open up further potentially productive lines of communication between design and philosophy, philosophy and design, as well as design and other disciplines.

It might be claimed that positioning myself and this book as pragmatist is a convenience, allowing me a licence to run roughshod over what are deeply ingrained differences and discontinuities. It is bad philosophy, one might argue, or, worse, bad scholarship.

My response is twofold. First, I accept there are differences and discontinuities in Dewey, Wittgenstein and Heidegger. As result, I endeavour to highlight key differences/discontinuities where, when and *if* appropriate. Nonetheless, this is a book about what they offer design in the context of their individual but (as I see it) complimentary critiques of Western epistemology. The point being made is a *positive* one. They give us alternative but relatable starting positions that both converge and diverge. *Both* differences and similarities will be useful here, depending on the aims of a given designer-researcher or the agenda of a given design research programme (e.g., does it

8 *Prologue*

wish to position itself as phenomenological or pragmatist?). What matters here more than difference/discontinuity is that, given their existing mapping to design and design research noted above, their near (but not quite) contemporaneous critiques be made available and accessible in design.

Second, in accepting differences and discontinuities, I also believe in there being similarities, which include but *also* extend beyond epistemological critiques. Here, many scholars have noted what may be termed 'pragmatist themes' at play within both Wittgenstein's and Heidegger's work (e.g., Philström 2015; Okrent 1988; Putnam 1995; Thayer 1968). Brandom goes so far as to group all three under the label 'semantic pragmatists', due to what he sees to be a focus on meaning (e.g., Brandom 2000, p. 23). In taking up a pragmatist positioning, it is these pragmatist themes, in particular those relating to knowledge production, that I wish to surface.

To be clear, I am *not* claiming Wittgenstein and Heidegger were pragmatists – quite simply, *they* were not. Rather, I am noting, along with the others already referenced, that they may be seen to offer *insights* that link to and align with pragmatism. These, in turn, may offer potential value to design.

Yes, but Really, Why *Just* Focus on Dewey-Wittgenstein-Heidegger?

If one were to object to the above rationale for selecting Dewey-Wittgenstein-Heidegger – i.e., their already being mapped to design, their potential for the opening up and connecting of horizons, their reformist credentials, their latent pragmatism – one might point to the work of other major philosophers. For example, why would you not include Karl Marx? Or if you're not considering historical giants, why not reference Michel Foucault or Gilles Deleuze and Felix Guattari instead? Or even Bruno Latour, in our own time? If your pragmatism is so generous, might they too be seen as pragmatist, in some way, shape, or form?

Another line of attack might be that there are many philosophers who were revolutionary in their time but are now simply footnotes in history.[16] What makes Dewey, Wittgenstein and Heidegger special?

In response, it is very important to state that I recognise and acknowledge that Dewey-Wittgenstein-Heidegger are not the *only* epistemological agitators worthy of consideration in design. Indeed, it is my hope that this is and will remain clear throughout.

Thus, as the text progresses, additional, well-known and not-so-well-known voices/perspectives will be located next to theirs.[17] For example, I believe two further traditions deserve a special airing: namely the 'method' of critical theory and the grouping of philosophers commonly referred under the umbrella of 'process philosophy'[18] – including Alfred North Whitehead, a contemporary of Dewey-Wittgenstein-Heidegger and also deserving of attention. None (for reasons to be covered as we progress) are central to this presentation. However, I find that these voices/perspectives, along with others, do exhibit highly compelling and, indeed, complimentary thinking to the special offering found in Dewey-Wittgenstein-Heidegger.

Thus, as a means of handling this strategy of drawing in others' work, through the course of each advancing chapter I will aim to introduce and highlight these additional voices/perspectives in dedicated sections (focusing on, for example, Marx), called 'philosophical pathways'. The term 'pathway' is a deliberate choice here. Again, it holds connection to the mapping metaphor, connoting the possibility of inscribing

Prologue 9

further openings worthy of exploration, which, ultimately, extend beyond the bounds of the present text.

Leading on from the above, there are two further important and interconnecting points, which I wish to raise before closing.

Two Additional Points on Privilege, the Dewey-Wittgenstein-Heidegger Baseline and Myself as Author

In terms of additional points, first, I wish to acknowledge (upfront as it were) that Dewey, Wittgenstein and Heidegger are, of course, all white, Western and male. As such, their perspective is necessarily privileged and particular. Given that they were writing in the early twentieth century, it is also true that theirs is, again, necessarily, an *historical* perspective. With an eye on diversity and currency, this is, undeniably, problematic. Nonetheless, it is my view that all of this can be counterbalanced by drawing out the links between their then-revolutionary epistemological ideas to the contemporary epistemological concerns just noted (e.g., regarding ethnicity, colonialism, gender and the environment/biosphere). Here, on the one hand, affinities may be demonstrated and, on the other, the potential for profitable exchange may be explored. Thus, there is the possibility of opening up a rich and valuable horizon connecting old arguments to new. Such links can only be of benefit to design, given that Dewey-Wittgenstein-Heidegger are already here.

Leading directly on from this, a related issue arises with regards to my position as author. In keeping with the political currents of the times and, indeed, for the sake of transparency alone, it is important that I be explicit about the fact that, like many people who write books such as this, I come from a relatively (in global terms) privileged background. Like Wittgenstein, Dewey and Heidegger, I am white and male. I am from a secure (now wealthy) western European nation in the Global North (Ireland). I am educated to the PhD level.

Such a profile is, of course, all too common in the design and academic discourse generally. The simple fact is however that I cannot change my background. If it is accepted that this contribution holds value in and of itself (regardless of my white, male European authorship), then it becomes my responsibility to work (in whatever ways possible) to reconcile my privilege against the injustices wrought upon and by the present-day society and culture of which I am a part.

In seeking to do so, I do not (and cannot for that matter) claim any special access to others' perceptions, their understanding of the world or their value systems. In the context of this text, what I can do – as noted in the baseline discussion – is work out a position which clarifies the ways in which the epistemological insights of Dewey-Wittgenstein-Heidegger allow for and, indeed, celebrate *difference* and *diversity*. As a privileged white, European male, it is my hope that these insights may be of some use to those who are different to myself and/or those who wish to explore and express difference through their work. If they are not, then at least we have started a conversation.

Notes

1. This specific term can be traced back to the mid-to-late 2010s in the UK, where, under this banner, the Arts and Humanities Research Council (AHRC) launched a vigorous programme of activities centred upon design research. Overseen by the AHRC's Design

10 *Prologue*

Leadership Fellow, Prof Paul Rodgers, key highlights of the programme have, to date, included: the Design Research for Change Showcase at London's Design Week in September 2018; the 'Does Design Care?' workshops, held at both Lancaster University in the UK and Chiba University in Tokyo, Japan; and, recently, the Design Research for Change Symposium, which took place in London in December 2019 (see Design Research for Change 2020). This latter event can be seen to have gathered a truly global community together, extending the reach of the design research for change label beyond the bounds of the UK alone.

2. By generalisable I mean knowledge which can be readily reapplied and produce the same results.

3. The exploration of this specific aspect will hold our focus through the remainder of this book as we endeavour to draw out the philosophical complications/implications.

4. Subtle though definite differences may be made when distinguishing between these terms/labels. For example, it has been argued that to properly qualify as 'practice-based' research a project must result in a made-artefact, i.e., a physical or digital 'thing' that can stand as a practical exemplar of the research outcome; while, following the same view, a proper 'practice-led' project would result in insights which hold 'operational' significance for practice (see Candy 2006, p. 3).

5. As will be discussed later, there is a growing design philosophy discourse within the field (Galle 2002; Vermass and Vial 2018). This however does not tackle, head on as it were, the question of the epistemology in design research involving practice.

6. Arising off the back of the work of Rene Descartes (to be discussed in the next chapter).

7. The next chapter will see an exploration of these and further references will be drawn through the remainder of the text. In terms of key linkages that might be highlighted here, the following may be noted. Links between Dewey and design have been drawn by Schön (e.g, 1995, 1983), McCarthy and Wright (2004; also see Wright and McCarthy 2010); Bjögvinsson et al. (2012); as well as Dixon (2020). Wittgenstein's work has been linked by Krippendorff (e.g., 2006). Heidegger's has been linked by Winograd and Flores (1986); Fry (e.g., 2011) and Dourish (2001).

8. For Dewey see e.g., Alexander (2013), Campbell (1995) and Sleeper (1986). For Wittgenstein see e.g., Wuppuluri and da Costa (2019), Crary and Read (2000) and Genova (1995). For Heidegger see e.g., Dreyfus (1990).

9. Wittgenstein was, for a brief time, an architect, designing his sister's house in Vienna. He famously found it a more difficult and challenging profession/pursuit than philosophy (see Monk 1991).

10. Another reason for selecting Dewey, Wittgenstein and Heidegger might be that when it comes to the recent history of Western philosophy, the work of these three individuals can be usefully positioned as representative pillars for three of what are among the more compelling (in the context design research) of philosophy's contemporary/historical perspectives; namely, analytic philosophy, pragmatism and phenomenology respectively. This allows for the drawing lines of connection to other voices located within the same tradition (e.g., William James's work, like Dewey's, sits within pragmatism), as well as more contemporary philosophic threads that can be linked back to these 'historical' figureheads (e.g., the work of poststructuralists such as Derrida via Heidegger).

11. The relationships, or lack thereof, between Dewey, Wittgenstein and Heidegger will be discussed later. For now, we may note that although there is evidence that some had awareness of others, not all of them knew of each other.

12. Some have noted what they might learn from each other, such as Dewey and Heidegger (Blattner 2008).

13. It must be noted the Bernstein, does not believe it fair to claim to see pragmatism underlying the work of all the philosophers that Brandom links in his pragmatist family portrait, calling the effort 'inflationary' (Bernstein 2010, p. 16).

14. I must be clear that in presenting myself and this book as pragmatist, I am not claiming to be a philosopher. My training has been in design and research. Here, I see myself acting as a design theorist.

15. For a popular outline of classic pragmatism's purported early agenda, see James (1975/1907).

16. We will consider some of these in due course.
17. The idea of radical philosophy and the radical nature of their contribution to epistemology is also considered in the next chapter.
18. This grouping ironically includes Dewey, as well as fellow pragmatists Charles Sanders Peirce and William James.

References

Alexander, T., 2013. *The Human Eros: Eco-Ontology and the Aesthetics of Existence.* New York: Fordham University Press.

Bernstein, R., 2010. *The Pragmatic Turn.* London: Polity Press.

Bjögvinsson, E., Ehn, P., and Hillgren, P. A., 2012. 'Design things and design thinking: Contemporary participatory design challenges'. *Design Issues*, 28(3), pp. 101–116.

Blattner, W., 2008. 'What Heidegger and Dewey could learn from each other'. *Philosophical Topics*, 36(1), pp. 57–77.

Boon, B., Baha, E., Singh, A., Wegener, F. E., Rozendaal, M. C., and Stappers, P. J., 2020. 'Grappling with diversity in research through design'. In S. Boess, S. Cheung, and S. Cain (Eds.), *Synergy – DRS International Conference 2020, Vol. 5: Situations*, pp. 139–151. London: The Design Research Society.

Brandom, R., 2000. *Articulating Reasons.* Cambridge, MA: Harvard University Press.

Braver, L., 2012. *Groundless Grounds: A Study of Wittgenstein and Heidegger.* Cambridge, MA: The MIT Press.

Campbell, J., 1984. 'Rorty's use of Dewey'. *The Southern Journal of Philosophy*, 22(2), pp. 175–187.

Campbell, J., 1995. Understanding John Dewey. Chicago, IL: Open Court Press.

Candy, L., 2006. *Practice-Based Research: A Guide.* A report from Creativity and Cognition Studios. Sydney: Sydney University of Technology.

Caputo, J. D., 1983. 'The thought of being and the conversation of mankind: The case of Heidegger and Rorty'. *The Review of Metaphysics*, pp. 661–685.

Crary, A., 2000. 'Wittgenstein's philosophy in relation to political thought'. In A. Crary and R. J. Read (Eds.), *The New Wittgenstein*, pp. 118–145. London: Routledge.

Crary, A., and Read, R. J. (Eds.), 2000. *The New Wittgenstein.* London: Routledge.

Cross, N., 2007. *Designerly Ways of Knowing.* Basel: Birkhäuser.

Design Research for Change, 2020. 'Design research for change'. [Online]. Available at: www.designresearchforchange.co.uk/ [Accessed: 30 September 2020].

Dixon, B., 2020. *Dewey and Design: A Pragmatist Perspective for Design Research.* Cham: Springer.

Dixon, B., 2021. 'Scoping a justificatory narrative for design practice in research: Some epistemological intersections in Dewey, Wittgenstein and Heidegger'. *Design Issues*, 37(2), pp. 77–88.

Dixon, B., and French, T., 2020. 'Processing the method: Linking Deweyan logic and design-in-research'. *Design Studies*, 70, p. 100962.

Dourish, P., 2001. *Where the Action Is.* Cambridge, MA: The MIT Press.

Dreyfus, H. L., 1990. *Being-in-the-World: A Commentary on Heidegger's Being and Time, Division 1.* Cambridge, MA: The MIT Press.

Frayling, C., 1993. 'Research in art and design'. *Royal College of Art Research Papers*, 1(1), pp. 1–5.

Fry, T., 2011. *Design as Politics.* London: Berg.

Galle, P., 2002. 'Philosophy of design: An editorial introduction'. *Design Studies*, 23(3), pp. 211–218.

Gaver, W., 2012. 'What should we expect from research through design?'. In *Proceedings of the SIGCHI Conference on Human Factors in Computing Systems*, pp. 937–946. New York: ACM.

12 Prologue

Genova, J., 1995. *Wittgenstein: A Way of Seeing*. Abingdon: Routledge.

Grayling, A. C., 2019. *The History of Philosophy: Three Millennia of Thought Form the West and Beyond*. London: Penguin.

Halse, J., Brandt, E., Clark, B., and Binder, T. (Eds.), 2010. *Rehearsing the Future*. Copenhagen: The Danish Design School Press.

James, W., 1975 [1907]. *The Collected Works of William James: Pragmatism: A New Name for an Old Way of Thinking*. Edited F. H. Burkhardt, F. Bowers, and I. K. Skrupkelis. Cambridge, MA: Harvard University Press.

Koskinen, I., Zimmerman, J., Binder, T., Redström, J., and Wensveen, S., 2011. *Design Research Through Practice: From the Lab, Field, and Showroom*. Amsterdam: Elsevier.

Krippendorff, K., 2006. *The Semantic Turn: A New Foundation for Design*. Boca Raton, FL: The CRC Press.

Krogh, P. G., and Koskinen, I., 2020. *Drifting by Intention: Four Epistemic Traditions from with Constructive Design Research*. Cham: Springer.

Marenko, B., and Brassett, J. (Eds.), 2015. *Deleuze and Design*. Edinburgh: Edinburgh University Press.

Mazé, R., 2007. *Occupying Time: Design, Technology, and the Form of Interaction*. Ph.D. Dissertation. Malmö: Malmö University, Blekinge Institute of Technology.

McCarthy, J., and Wright, P., 2004. *Technology as Experience*. Cambridge, MA: The MIT Press.

Melles, G., 2008. 'An enlarged pragmatist inquiry paradigm for methodological pluralism in academic design research'. *Artifact*, 2(1), pp. 3–11.

Monk, R., 1991. *Wittgenstein: The Duty of Genius*. London: Vintage.

Okrent, M., 1988. *Heidegger's Pragmatism: Understanding, Being, and the Critique of Metaphysics*. Ithaca, NY: Cornell University Press.

Philström, S., 2015. *The Bloomsbury Companion to Pragmatism*. London: Bloomsbury.

Putnam, H., 1995. *Renewing Philosophy*. Cambridge, MA: Harvard University Press.

Rorty, R., 1976. 'Overcoming the tradition: Heidegger and Dewey'. *The Review of Metaphysics*, 30(2), pp. 280–305.

Rorty, R., 2009 [1979]. *Philosophy and the Mirror of Nature*, 30th anniversary edition. Princeton: Princeton University Press.

Rust, C., Mottram, J., and Till, J., 2007. *Review of Practice-Led Research in Art, Design & Architecture*. Bristol: Arts and Humanities Research Council.

Schön, D. A., 1983. *The Reflective Practitioner: How Professionals Think in Action*. New York: Basic Books.

Schön, D. A., 1995. 'Knowing-in-action: The new scholarship requires a new epistemology'. *Change: The Magazine of Higher Learning*, 27(6), pp. 27–34.

Sleeper, R. W., 1986. *The Necessity of Pragmatism: John Dewey's Conception of Pragmatism*. New Haven, CT: Yale University Press.

Thayer, H. S., 1968. *Meaning and Action: A Critical History of Pragmatism*. Indianapolis, IN: Bobbs-Merril Company.

Toulmin, S., 1984. 'Introduction'. In J. Dewey and J. A. Boydston (Eds.), *The Collected Works of John Dewey: The Later Works, 1925–1953, vol. 4, the Quest for Certainty*, pp. i–xxii. Carbondale, IL: Southern Illinois University Press.

Vaughan, L. (Ed.), 2017. *Practice-Based Design Research*. London: Bloomsbury.

Vermass, P., Kroes, P. A., Light, A., and Moore, S. (Eds.), 2008. *Philosophy and Design: From Engineering to Architecture*. Dordrecht: Springer.

Vermass, P., and Vial, S. (Eds.), 2018. *Advancements in the Philosophy of Design*. Cham: Springer.

Volbers, J., 2012. 'Wittgenstein, Dewey, and the practical foundation of knowledge'. *European Journal of Pragmatism and American Philosophy*, 4(IV–2).

Winograd, T., and Flores, F., 1986. *Understanding Computers and Cognition*. Norwood, NJ: Albex.

Wright, P., and McCarthy, J., 2010. 'Experience-centered design: Designers, users, and communities in dialogue'. *Synthesis Lectures on Human-Centered Informatics*, 3(1), pp. 1–123.

Wuppuluri, S., and da Costa, N., 2019. *Wittgensteinian (adj.): Looking at the World from the Perspective of Wittgenstein's Philosophy*. Cham: Springer.

Introduction
Design Research, Philosophy and Some Radical Philosophers

This book has a single underlying premise: namely, that in the context of the rising popularity of a particular approach to design research – one which applies design practice within the research process and aims to achieve positive transformation – there is a clear need to draw philosophy and design into greater proximity in relation to the questions of what knowledge is and how it is to be attained.

The work is guided by two related aims. In the first instance, there is the aim to develop an epistemological narrative, which clarifies those aspects of design research involving practice which diverge from conventional understandings of research (and knowledge). From this and our exploration of design research involving practice, the second aim is, conversely, to take an initial, brief step towards reflecting on whether or not there might be ways in which philosophy itself could benefit from a more designerly perspective (though what form this might take remains, as yet, unclear).

This chapter, then, is about beginning to respond to such an agenda. In setting out, there are of course a number of threads to pick up on. First, building on the prologue's brief introduction to the areas of design research involving practice and philosophy, we must continue to explore and detail these subject matters, working to gradually build up an understanding of their history, present form and links. To this end, the chapter opens with a series of sections that aims to further detail the background, growth and development of both design research and philosophy and, next to this, look at the role that philosophy has played in the field of design, up to the present. Here, the work of some of design's key philosophic voices are highlighted, which leads us to consider the work of John Dewey, Ludwig Wittgenstein and Martin Heidegger – the three philosophers making up the baseline for the proposed epistemological narrative for design research involving practice and the subsequent sketch map representing this. The chapter draws to a close with an initial framing for this baseline, taking a brief look both at what these philosophers can offer when drawn together and where they might take us.

We begin, then, by turning to sketch out a portrait of design in the present.

A Brief Sketch of Design in the Present

The design professions – whether industrial design, product design, graphic design, fashion design, interaction design and so on – did not simply 'appear' as the disciplines we know today – 'ready-made' with their own distinct subject matters and specialised focus. Rather, each can be seen to have evolved little by little over time, gradually taking on their present, mature forms. For example, graphic design emerged out of what

DOI: 10.4324/9781003194309-2

was referred to as 'commercial art', with practitioners gradually gaining their identity over time (Hollis 1994).

In some ways, this latter example points to a wider historic trend. Design itself had little if any standalone identity at the beginning of the twentieth century, being seen as a concern which fell under the wider remit of art and aesthetics. Over the twentieth century, the expansion of industry, coupled with the proliferation of reproduction processes and material products, has meant that wholly new areas of design practice became possible and eventually, given the demand placed upon them, necessary. Two of the most recent examples of this developmental path are the areas of interaction design and service design, both of which emerged tentatively (little by little) from under the wings of HCI and product design respectively (see, e.g., Moggridge 2006; Rodgers 2012; Kimbell 2011).

Interaction design was established in response to the rise of digital interfaces and an increasing need to frame a practice around their *design* (Moggridge 2006). Service design developed as a consequence of the increasing emphasis being placed on organisations' systems-level delivery of products and the complex interactions such as delivery entails (e.g., Stickhorn and Schneider 2012 for an outline of the field).

Design continues to change apace. Indeed, with the digital revolution, alongside other pressing social and political changes – e.g., the financial crisis of the late 2000s and 2010s, the rise of the service and experience economy – many believe that, in the present period, it is undergoing a particularly profound reorganisation (e.g., Bremner and Rodgers 2013; Oxman 2006; Dearden 2006; Press and Cooper 2003). Perhaps the most obvious shift is to be found in the relative decline of what might be referred to as the traditional, craft-based approaches to design. Today, as a practice, design is approached and presented less and less as a matter of individualistic expression and more as a force for collaborative problem solving, where multidisciplinary, or interdisciplinary, groups come together to tackle large-scale projects involving multiple actors and many (often competing) interests. Work of this type is underway in the domains of healthcare (e.g., Tsekleves and Cooper 2017; Jones 2013), policy and government (e.g., Kimbell and Bailey 2017; Bason 2016) and the financial services (e.g., Varga 2017).

As a specific example, here we might refer to the health and care work of the Helix Centre – an innovation lab jointly operated by the Royal College of Art and Imperial College London. Their portfolio includes projects which aim to explore issues relating to, for example: diagnostic technology, clinical task management, care planning and children's hospices. In managing this work, Helix draws together a team of 'designers, technologists, clinicians and researchers', who, in applying a human-centred design approach, work to 'rapidly dissect problems, identify opportunities and develop clinically-evaluated digital solutions' (Helix Centre 2020).

In contexts such as these, regardless of whether or not one identifies directly as a designer, it is becoming less and less appropriate to think exclusively in terms of siloed design disciplines – e.g., huddled groups of service designers, interaction designers, or visual designers – which sit independent and apart from one another, having little or no connection or crossover. Rather, each group (if indeed they form a group) will, to a degree, share something akin to a 'common language', a code which unites their combined efforts and smoothens over disciplinary divides. Obviously, in the case of the Helix centre, this language or code is 'human centred design'. Elsewhere the unifying language/code might be 'user centred design' (e.g., uxlabs 2022), or 'innovation

16 *Introduction*

design' (e.g., Den Ouden 2011) or 'transformation design' (e.g., Burns et al. 2006), depending on the specific orientation of the organisation in question.

This leads to a situation where some practices may be subsumed by others. For example, it has been argued that visual communication design is destined to become an 'invisible' discipline – dissolving into an array of tasks, which fall under other disciplinary titles, such as the mapping approaches found within the service design process (see Roxburgh and Irvin 2018). While visual design processes would still 'exist' in this scenario, those who engage in producing visuals would no longer identify *only* as visual designers.

Some suggest that such developments are not to be feared and that design can function without its classic disciplinary divisions. Bremner and Rodgers (2013), in acknowledging the need for reorientation within the present context of globalisation and digital transformation, note a certain underlying flexibility in the field. In this new era, design, they propose, can be 'both undisciplined and responsible' as well as 'disciplined and irresponsible' (p. 13). In taking such an approach, it would operate in what they refer to as 'alterdisciplinary' terms – that is, 'make connections and generate new methods' as required by the situation at hand.

This flexibility, or adaptability if you will, can be detected in the emerging horizons of contemporary design practice. Complementing (and often linking to) the many examples of interdisciplinary/multidisciplinary problem solving such as that demonstrated by the Helix Lab above, one may identify a clear push to explore the potential of drawing non-designers (i.e., members of the public who do not identify as designers) into the design process – essentially 'decentring' the designer. Here, various 'categories' of co-creation – for example, user-centred design (briefly mentioned previously), participatory design, critical design and 'design and emotion' (e.g., Sanders and Stappers 2008, 2014a) – seek to ground a particular model for bringing designer and non-designer together within the design process. As Sanders and Stappers note in their landmark paper, 'Co-Creation and the New Landscapes of Design' (2008), there are a number of parameters which can define such collaborations. They might be design-led (i.e., focusing creative outcomes for new products and services) or they might be research-led (i.e., focusing on gaining a new understanding in a given area, relating to use and meaning). In terms of the non-designer's involvement in the collaboration, two diverse poles emerge. The non-designer might simply act as a 'subject' (i.e., an individual whose role it is to produce data for later analysis) or alternatively, as a partner, working with the designer to define the creative direction of the project at hand. The scope of roles for non-designers in the design process and, indeed, the desirability of their involvement remains an open question today with many commentators having proposed novel possibilities that have yet to be fully integrated (e.g., Sanders and Stappers 2014b; Inns 2009; Press and Cooper 2003; von Hippel 2005).

Complementing this, and, again linking to the repositioning of design-as-multi/interdisciplinary-problem-solving, another highly diverse horizon can be identified in the exploration of how design can have a role in what might be referred to as 'non-commercial contexts' located wholly in the social or cultural spheres, and (almost) free from any profit motives or shareholder concerns.

Historically, this push towards the social-cultural spheres can be traced back to theorists such as Victor Papanek – who, in his *Design for the Real World* (1984),

Introduction 17

famously proposed that designers might cultivate an altruist strand within their existing practice – and the *Scandinavian* participatory design movement of the 1970s and 80s. While Papanek's influence is diffuse (see, e.g., the following 'social design'), Scandinavian participatory design presents a more definite historical path. Linking to the co-creation horizon noted above, early participatory design projects in Scandinavia saw designers come together with researchers from computer science and the social sciences to explore how workers could contribute to the process of managing technological change in particular workplace settings (e.g. Ehn 1988). Today, participatory design is undertaken beyond the workplace in complex civic contexts, which may or may not require technological intervention. Generally, in this more recent work, designers engage with what are essentially fluid groups – for example, suburban communities (Olander 2015) or young forced migrants (Duarte et al. 2018) – to explore how small-scale initiatives[1] might equip them to begin to cohere a collective approach to a larger challenge.[2]

Beyond participatory design, explorations of the social-cultural in design continue to proliferate. For example, a new and dynamic agenda focusing on engendering local sustainability has been set out by Ezio Manzini in an approach he refers to as 'design for social innovation' (e.g. Manzini 2015). Here, designers are called upon to operate at the interface between community development and creative strategy, working to support groups to both define and realise desirable long-term goals which interweave social, infrastructural and environmental concerns.

This work sits alongside an emergent and as yet undefined area, referred to as social design. Linked to the legacy of Papanek (1984) and others (e.g., Margolin 2015), the social design label loosely groups a number of contributors who speculate as to how design can be seen to function in truly social terms (e.g., Chen et al. 2016). One of the movement's leading voices, Ilpo Koskinen, a design theorist with a background in sociology, has argued that social design, as it stands, has largely been founded upon utopic, grand visions, arising from various technological, architectural and political theories of the future. Writing with Gordon Hush, another sociologist turned design theorist, he argues for two new, alternative forms of social design – referred to as the 'molecular' and the 'sociological' – that aim to operate on a smaller scale. The first seeks to effect change 'one step at a time' without a wider vision; the second applies sociological theory as a directive aid to guide action with the aim of reducing inequalities (see Koskinen and Hush 2016).

The foregoing presents a tangle of change and shifting boundaries, a field (i.e., design) in the process of testing its own limits. Be this as it may, it is important to note that, alterdisciplinary or not, co-creative or not, socially or culturally focused or not, specific design practices are not, as yet, on the verge of outright dissolution. There is (and, in the medium term at least, will be) a need for specific specialisations. The tasks of defining and producing particular design outcomes, whether digital or physical, have not disappeared and job roles such as 'graphic designer' or 'product designer' remain for now. The broad point is that disciplinary boundaries are blurring and, against this, there is a slow but definite coming together of design. Through innovation, through the needs of the market and technological change, we may observe a constant tacit sensing-out of new ways of working, which are, as yet, unimagined, even unimaginable.

This sketch of design practice brings us to the question of design research.

18 *Introduction*

A Brief Sketch of Design Research in the Past and the Present

As with the understanding of contemporary design practice set out in the above sketch, design research, as a field of inquiry, presents as a highly dynamic arena, drawing together many different design disciplines and sub-disciplines (as well as perspectives within these) – e.g., engineering, architecture, product-service-interaction design, psychology, anthropology and sociology. Uniting under the banner of 'design research', researchers from each of these disciplines/sub-disciplines contribute to a somewhat disjointed[3] process of attempting to cohere a shared narrative around a shifting subject matter around areas such as the history of design, the structuring of the design process and the social/cultural meanings of design (e.g., Buchanan 2007; Cross 1999). Thus, like design *practice*, design research also resists easy definition.

In seeking to give it *some* definition, it will be useful to first trace out a brief history of the field. Here, we can say that since its inception in the mid-1950s, design research has cycled through a number of ways of approaching the study design practice and its application, i.e., conceiving of what matters in design, and trying to establish a means of investigating it. In the early days, there was the push to form a science. This agenda emerged in the immediate postwar period, where, at an international level, various proposals were advanced for how such a science might be framed, with early advocates including Buckminster Fuller (e.g., Fuller 1963) and Sydney Gregory (e.g., 1966). Reflecting on the push, Nigel Cross, an eminent design researcher and theorist, has noted that, through the early twentieth century, many of the supplementary fields surrounding design had developed a solid scientific basis for their subjects, e.g. 'materials science, engineering science, building science and behavioural science' (Cross 2018, p. 698). He notes that, from this, it was possible to claim that designers drawing on such knowledge bases were engaged in, what he terms, 'scientific design'. A *design science*, he believed, would take things a step further, with the design process itself being approached in wholly rational, systematic terms, which would essentially avoid the need for any intuitive decision-making (e.g., Cross 2001).

The most widely referenced vision of design science was put forward by Herbert Simon, in his 1969 text *The Sciences of the Artificial* (Simon 1996/1969). This vision revolved around a marriage of problem definition and problem solving to knowledge of the natural world and our human involvement therein. It has never been realised and, indeed, has been criticised by many on the basis of its proposal that design can adopt a step-by-step technical-rational approach to problem-solving (e.g., Schön 1983; Grant 1979).

Linking to these moves to formulate a design science, a complementary design *methods* movement gradually gained momentum through a series of conferences held in the 1960s in Britain (Jones 1992, p. xviii). Those involved in this movement generally sought to study and define what Cross refers to as the 'the principles, practices and procedures of design' (2018, p. 698), such that these principles-practices-procedures might be rendered more accessible to designers and non-designers alike. As another ambition, some also hoped that the movement might lead to the development of a platform enabling design's expansion into areas which, at the time, were seen to lie beyond its remit – for example, systems design, public decision-making and education (see Mitchell 1992, p. ix).[4] Despite these underpinning motivations to both explicate and innovate, the idea of 'methods' came to be seen as too rigid a framework for design. Many interpreted its *prescriptive* aspect (i.e., its detailing of how design should

Introduction 19

proceed) to be absolute and, as such, stultifying to creativity (see Cross 1984, for an early retrospective assessment of the movement).

The period which stretches from approximately the early-to-mid 1980s through to the present can be seen to hold a dual focus for design research. First, as a consequence of the apparent failure of the design methods movement, the focus of those who had previously dedicated their energies to developing *prescriptive* methodologies turned, instead, to a *description* (McDonnell 2015, p. 109). This strand of work, known as 'design studies', continues. Its adherents have explored the dimensions of the design process through a rigourous analysis of designers' actions and interactions (see Cash 2020 for a contemporary overview). Among the insights which have surfaced it is now possible to assert that, in designing, designers tend to: take a solutions-focus (Lawson 1979); 'frame' their problem (e.g., Schön and Rein 1994; Dorst 2015); and progressively develop their conception of both problem and solution as they advance (Dorst and Cross 2001) through a strategy of constant, ongoing reflection and evaluation (Schön 1983).[5]

Alongside this design studies strand, the second key strand of development relates to the emergence of design research involving practice (i.e., research through design or 'RtD'). Here, it was Sir Christopher Frayling (1993), then Rector of the UK's Royal College of Art, who first wrote of the possibility of enfolding design practice within the research process in order to achieve specific goals. This was set alongside two additional categories, referred to as: 'research into design' which loosely refers to the descriptive design studies just discussed; and 'research for design' which may be loosely related to the underlying prescriptive ethos of the earlier design methods movement.[6]

Though Frayling may have been the first to identify the 'research through design' approach as a definite strand within design research, it should be noted that the notion that design research *may* involve practice or aspects of practice had been explored for some time prior. As with descriptive design studies, its genus can be traced through some of the work undertaken by those associated with the design methods movement. For example, in the 1960s and 1970s, Nigel Cross was involved in research work investigating computer-aided design at the University of Manchester, which can be seen to conform to the basic RtD format (i.e., that something is designed/prototyped in order to answer a question) (see Cross 2018). Additionally, though the work of the historical development of the participatory design movement is not often directly associated with the RtD tradition, a simple analysis of the design-research relationship it proposes – i.e., that things (e.g., a software interface) are best made together with the input of others and, in this, knowledge is produced – aligns well with RtD.

It must also be noted that Frayling may not have been the first to formalise the RtD concept. Indeed, in spite of the frequent citation of the 1993 paper, some have cast doubt on the originality of his research on into-through-for terminology, with Pedgley and Wormald (2007) crediting Bruce Archer (a Royal College of Art contemporary of Frayling) with having first coined the latter expressions during his tenure at the same institution.

Beyond the direct connection to Frayling, it should also be acknowledged that the notion of researching *through* a practice is not unique to design. From the 1970s onwards, other disciplines were trialling means by which practice might play a role within their research processes. Nursing, for example, has a history of practice-based doctorates which extends at least as far back as the late-1970s (e.g., Lash 1987).

20 *Introduction*

Regardless of its originality or the precise genus of the approach, Frayling's publication marks the beginnings of broader and, at times, tense discussion within the field of design.[7] In the early years, several commentators explored a number of problematic issues that were emerging in relation to design (and arts-based) research which involves practice. Key among these has been the matter of what precisely is the role of practice here and the forms of knowledge it allows for.

Some noted that while art and design rely on tacit, implicit 'know-how' and aesthetic understanding – sometimes referred to as experiential knowledge (e.g., Biggs 2002) – it is often explicit, 'propositional' (i.e., theory based) knowledge which is valued most by external research audit frameworks; for example, the UK's research excellence framework or 'REF' (e.g., Niedderer 2007). This frustrates many and has led to confusion over the decades as to what can or cannot be positioned as research (e.g., Gray and Mallins 2004, p. 3). It remains a contentious issue, with several recent publications continuing to present arguments which favour the primacy of a practical, lived expression of knowledge in design, over and above the propositional-theoretical (e.g., Redström 2017).

Directly related, another core concern has been what constitutes a reasonable outcome when either the design process or the aim of achieving positive transformation forms a core project concern. Here, in the early years at least, driven largely by the emergence of PhDs which involved a significant level of practical work, the question arose as to whether or not an artefact – i.e., a made object or possibly a live performance or some form of process – might somehow be positioned as the final outcome of a research project and, as such, function as a stand-alone contribution to knowledge (without textual accompaniment). Though some institutions, such as the Glasgow School of Art in the UK, did, for a period of time, allow for almost artefact-only submissions (see Candy and Edmonds 2012)[8] in the context of art and design doctorates, the idea of artefact-only submissions was viewed as highly problematic from the off (e.g., Biggs 2002; Mäkelä 2007). Latterly, few, if any, institutions permit such submissions and, over the intervening period, more muted proposals regarding the presentation of practical outcomes have emerged – for example, the concept of an annotated portfolio, which centres practice but insists upon an accompanying textual explanation (see Gaver 2012). As an additional point, the importance of aiming speak to practitioners, i.e., to offer insights aimed at *nonacademic* designers, has also been highlighted (Koskinen and Krogh 2015).

Despite the apparent diversity and complexity of this discourse, it is possible to glean the trace of what might be termed an emerging pattern for design research involving practice by exploring its landmark proposals. As regards a starting point, we can say that such research will generally commence in response to a *motivational context*. For Zimmerman and Forlizzi (2008), these will fall into one of two types: either they will be 'grounded' in a real world qualitative situation (e.g., a community which is seeking to address the challenges of post-industrialisation); or alternatively, they will relate a 'philosophical' problem, that is an intellectual challenge which might benefit from design-based experimentation. Latterly, it has been suggested by Bang and colleagues (2012) that such contexts are better understood in more expansive terms, drawing in, for example, the ethical, the political and the technological, as well as how such areas can link to practice.

Beyond this, as has been noted, we see an emphasis on the process of experimentation. Many authors, particular in the late 2000s, endeavoured to identify and define

the process of design experimentation in an academic context. Initially, the process was characterised as being driven by the formulation of *research questions* linked to a wider research programme (e.g., Brandt and Binder 2007). Here, questions were seen to help the designer-researcher to frame experiments, which, when complete, would yield a result that would then, in turn, help to guide further questions. Next to this, others have proposed that the framing of a design *hypothesis* in response to some contextual motivation will act as the initial guide in the experimental cycle (e.g., Bang and Eriksen 2014). Here, hypotheses would support both the framing of the experiment as well as the research question. The whole is seen to hang together under the notion of 'drifting', i.e., the progressive, iterative pursuit of a trajectory of experimentation (see Krogh and Koskinen 2020).

The endpoint of such research will, as noted above, often be an artefact or artefacts, whether made objects or some form of representation of a given process (i.e., a diagram or system map). This is because, in seeking to address a contextual issue, be it grounded, philosophical or other, designer-researchers will construct, formulate and propose made objects or processes which provide a response to that issue. On the basis that they are working in a contextual as opposed to a 'controlled' setting (e.g., with a precisely defined sample of the population) their efforts will, for the most part, not be presented as generalisable. Instead, they must endeavour to offer *transferability*, i.e., a sufficiently rich outline of their research and its conclusions to allow for the trialling of the results in another context (see Dixon 2020a, p. 87).

Of course, this pattern is not definite, only an outline of possible concerns. Ultimately, regardless of whether a particular research project is identified as 'research through design', practice-based, practice-led, or constructive design research, we can group the whole within a general exploration of design's potential role in research. The point is that this exploration continues to extend and develop. Not only through the gradual output of design doctorates involving practice (i.e., in the UK, Scandinavia, the European Mainland and Australia) but also through large-scale, generously funded research programmes hosted by academic institutions across the globe – for example, the UK-based Imagination at Lancaster University (e.g., Cooper et al. 2018) and the Helen Hamlyn Centre at the RCA (RCA 2020). There are also a growing number of conferences which to a greater or lesser extent centre upon the role of design practice in research, with perhaps the most prominent being the: biennial RtD conference, which aims to provide a forum for RtD researchers to convene and share; and the PhD by Design conference which aims to offer practice-oriented doctoral students a space in which they may forge a common identity.

In relation to the position put forward in the present text, it will be recalled from the Prologue that my argument is as follows. When taken as a whole, such an approach opens up questions of transformation, participation and uncertainty entering into the knowledge production process. To recount this next to the previously-mentioned, we may say that, in engaging in design research involving practice, designer-researchers will generally aim to *transform* a context for the better. In order to do so, they must *participate* in that context, i.e., actively contribute to that process of bringing about positive transformation. As there is no guarantee of success here (i.e., one's efforts to positively transform through participation may fail), the designer-researcher must operate with a certain degree of uncertainty. The value of their outcome too will be uncertain. It cannot be known if any result or outcome is the best possible result/

22 *Introduction*

outcome (i.e., the one 'right' answer). All there is is better or worse as set against the context.

Then there is the question of difference and diversity too, briefly introduced at the end of the Prologue in relation to what a Dewey-Wittgenstein-Heidegger baseline might allow in the context of knowledge production. In an essential outline, those who engage in design research involving practice are already committed to tackling difference and diversity within their work. The fact is that each context and set of issues will be unique, i.e., no exact set of circumstances, intersections of space and time are ever repeated precisely as before. Following on, no issue (or problem if preferred) will ever exactly resemble another. As a result, designer-researchers must be open and attendant to difference and diversity as a general rule, whether this relates to such areas as those already highlighted (i.e., ethnicity, colonialism, gender and the environment/biosphere) or others; in the end, their approach – methodologically, epistemologically – must be capable of responding to and accommodating such diversity and difference.

This, in sum, gives us a sense of the historical arc of design research as well as some of the contemporary forms. In moving to conclude this section by reflecting on the wider history of design research in the round, it is possible to draw two alternative conclusions. On the one hand, one might say that design research as a field of inquiry amounts to a series of failures, things that didn't work. For example, despite its evolution, there is no unifying position or theory. If anything, with the advent of descriptive design studies and design research involving practice, the field has become more diverse, more pluralist, not less. On the other hand, we can say that decisions have been made regarding what does not work in design research, which theories and approaches do *not* have meaning or value for the field and do not extend inquiry (e.g., the design methods movement). It would seem that given emergent strength and attraction of design research, the field will continue to expand into new territories as well as continue to develop novel modes and methods of inquiry. The challenge lies in finding a way to hold it together at both a community level (if such an ambition is even possible)[9] and, in relation to the aims of this book, at an epistemological level (again, if such an ambition is even possible or desirable).

Thus, from design research, we turn to sketch out a history of philosophy, the home of epistemology.

A Brief Sketch of the History of Western Philosophy (and Epistemology)

Western philosophy, as is well known, has a long history. In terms of the written works, we can trace its origins back to ancient Greece, with the texts of Plato and Aristotle marking the beginning of a discourse, which has, at this point, come to span approximately 24 centuries.

With such a legacy, a challenge arises when trying to offer out a history of the field. How does one bring some semblance of narrative coherence such that a holistic and connected picture can be presented?

Many historians of philosophy – for example, Bertrand Russell (1946) or Will Durant (2006/1926) – will group voices within specific historical periods, e.g., 'modern philosophy'. Others, perhaps balancing more recent contributions with the historical, will lean towards grouping voices within a series of 'schools', that function as

Introduction 23

more or less appropriate labels for the collective efforts of several individuals who may or may not have interacted with one another (e.g., Grayling 2019).

Without grouping voices, in some way, it becomes very difficult to maintain a hold on the whole. Nonetheless, the specifics of any one individual philosopher's system, their precise offering as it were, will inevitably be obscured through this process. This is a point worth bearing in mind when considering how individual philosophers 'fit' together – even if they are called, say, analytic philosophers, continental philosophers, poststructuralists, pragmatists, phenomenologists and so on – their work will still be distinct and distinguishable; they each remain individuals after all. This is one of the reasons why, in this book, I will tend to focus on the contributions of individuals (e.g., John Dewey) as opposed to 'schools' (e.g., pragmatism).

Here, however, in the present context, grouping remains perhaps the most accessible approach and, within this, in turn, it would appear that the simplest strategy would be to follow the historical timeline. In the orthodox framing, as per Russell (1946) for example, the key phases will most often be presented as follows: ancient philosophy (generally Greek in origin), medieval and modern. Thereafter the sequence blurs somewhat and contemporary trends and allegiances come into play. One way of tackling this is to group nineteenth- and twentieth-century philosophies together and thereafter to note separations and differences.

To turn first to ancient philosophy, it can be said that this grouping not only incorporates the works of the Greeks Socrates, Plato and Aristotle but also many other perhaps less well-known voices, who are sometimes overlooked in the recounting of the great philosophic story. Key philosophers here include such early names as Thales, Pythagoras and Heraclitus.[10] Individuals such as these lived before or around the time of Socrates-Plato-Aristotle. There are also contemporary or later *schools* that are worth note: for example, the Stoics who placed an emphasis on logic and prised virtue over the pursuit of pleasure and the avoidance of pain; the Epicureans who valued simplicity above all else, believing that a life grounded in pleasure and without pain represented the highest good; and the Cynics who sought to live 'naturally', shunning convention and societal norms.[11]

In terms of the Socrates-Plato-Aristotle grouping, it can be noted that Socrates was Plato's 'teacher' and Plato was Aristotle's 'teacher'. Because we have access to their insights through text (i.e., written words) that can be read and referenced, their work is seen to form the beginning of classic Western philosophy, with Socrates-Plato being positioned as the 'sourcepoint' or founding voices within this. Accordingly, it is worth briefly considering their contributions.

Socrates's philosophy, what we know of it, is perhaps best understood as a demonstration of a method, that is, a way of doing philosophy. This way of doing philosophy – usually identified as the 'Socratic method' – is based on a process of inquiring via questioning: asking something of someone (e.g., a definition of a given attribute or quality) and, from the response, asking further questions which gradually unpack the implicit assumptions and potentially flawed understandings that have been exposed. So far as is known, he did not author any text himself, rather the Socrates we know today is represented through the works of Plato in his 'dialogues' – the recounting of what Socrates said and did, who he spoke to in relation to which subjects. Often in these dialogues, we see that his focus will generally relate to broad questions regarding the nature of virtue and what it means to live a good life (e.g., Morrison 2011).

24 *Introduction*

While Plato 'represents' Socrates in his work, it is debatable as to whether this representation always stands a faithful account of his views or whether, at times, Plato is merely invoking the character of Socrates to express his own beliefs on the subjects under discussion. The likelihood is that both of these are true. As a result, Plato's work requires a level of interpretation as to whether it may be seen as a record or philosophy in its own right.

When we begin to look beyond the representation/characterisation of Socrates, it becomes possible to detect a more or less fully-formed philosophic system, which offers a way of approaching the world (in the broadest sense of the word) through philosophy. Here, Plato tackles what will go on to become philosophy's grand themes relating to knowledge, reality, ethics, politics and society (e.g., Kraut 1992).

While his handling of all of these themes are important in relation to the subsequent development of Western philosophy, it is his treatment knowledge and reality that most concern us here. He argues that the world as we encounter it through our senses – changing, chaotic, unclear – is *not* the real world. The real world is something else and somewhere else, unchanging and perfect. Our 'encountered real world' is merely a flawed copy of this. Following on from the latter position, knowledge may only be considered knowledge if it too is unchanging and perfect, and properly gains purchase on that which is really real, or true (e.g., Fine 1999; Dancy 2004).

We can see that, in the context of design research involving practice, this view of knowledge is jarring and, indeed, oppositional to its agenda. Designing in the context of research doesn't result in the unchanging and perfect, nor the really real. It results in a solution to a contextual concern, something that the designer-researcher(s) was/were motivated to respond to and make better. Nonetheless, this Platonic vision of the senses as flawed and the world as encountered (i.e., changing, chaotic, unclear) as *not* the *real* world would inform the work of many other philosophers.[12] Its basic tenants can be seen to underlie the modernist Western conception of knowledge, briefly set out in the last chapter, whereby knowledge is to be understood in static, fixed terms, describing and explaining what is or isn't the case in certain (or near-certain) terms.

From Plato, it is also helpful to also get a quick sense of Aristotle's work, which can also be seen to form a system.[13] On the common understanding, Aristotle is said to have developed a bipartite vision of the philosophic domain, based on a theoretical-practical division. His theoretical philosophy draws together what we today call the sciences, including physics, astronomy, biology and psychology. Next to this, his practical philosophy links the ethical, the political and the economic. Some have argued that it is possible to detect a third, 'forgotten' strand within Aristotle's system, making it a tripartite vision. This latter strand is said to concern art, in particular, rhetoric (i.e., the art of persuasion) and 'poetics', which, for Aristotle, in the context of ancient Greece, relates to drama (e.g., Anagnostopoulos 2009).

Beyond the Socrates-Plato-Aristotle source-point of ancient philosophy, with some exceptions such as the schools of Stoicism, Epicureanism and Cynicism noted above, philosophy became constrained by the rise and eventual dominance of the Christian faith across the former Roman empire – firstly, via its becoming the official religion of the empire and thereafter its taking on the role of a supranational power structure connecting individual states via their acceptance of the ultimate authority of the church (e.g., Freeman 2009). Perhaps inevitably, during this time, the insights of ancient Greek philosophy were obscured and largely lost.

Introduction 25

Here, it was necessary for philosophy to reposition itself and essentially become a tool for theology (i.e., the study of God and religious concepts). At this point, the discipline entered what can loosely be termed the scholastic and medieval period.[14] Some key contributors across this period include Augustine of Hippo and St Thomas Aquinas, who both helped to frame early Christian doctrine through references to prior sources in ancient philosophy (in Aquinas's case to Aristotle), as with their own insights. Also notable is the work of Roger Bacon who, unusually for the time, advocated for an empirical (i.e., experimental) approach to philosophical problem solving, which of course is compelling in the context of design; and William of Ockham who, in his dealings with theological questions – and within this metaphysics[15] (i.e., the investigation of existence) and epistemology – is said to have put forward his famous 'Occam's Razor'[16] principle, which proposes that theoretical explanations/solutions should not include any more content (concepts or entities) than is strictly necessary for the explanation – again, a valuable insight from a design perspective (e.g., Weinberg 1964 for an overview of this period).

It was only after the developments of the Renaissance (which saw a rediscovery of ancient philosophy),[17] the advent of the printing press in the mid-fifteenth century and subsequent social and political upheaval of the Reformation[18] that *independent* philosophical inquiry was renewed. This marks the beginning of what is referred to as the *modern* period of philosophy.

The modern period can, in its initial phase, be characterised as a period of awakening, a casting off of the historical constraints placed upon thought by theological authority. It is also to be seen as a time of competing visions for how knowledge was to be both understood and best secured (here we see the dawn of epistemology proper).

Two key and entirely divergent visions emerged here. On the one hand, there was the perspective of the *rationalists* who believed that the only way to establish secure knowledge was via logic and mathematics (e.g., Phemister 2006 for an overview). The key advocate of this position was Rene Descartes.

Descartes is key figure in Western philosophy, and, indeed, in many ways, a defining figure for Western civilisation, with his work informing both how we see the world and how we relate to ourselves as human beings. From the point of view of contributing to epistemology he argued that certain knowledge was possible but only if we proceeded step by step *certainly*. Here, it is important to note that Descartes believed that the body and the mind were separate and independent – literally formed of two separate, unrelated 'substances'. The body was to be seen as imperfect, with the senses, in particular, prone to error. The mind however was seen to have access to 'pure' reason, that is, the ability to interrogate and understand on the basis of rational reflection and argument, i.e., thought alone.

Thus, focusing in on reason, and seeking to foreground the powers of the mind, Descartes sought out a starting point for certainty. To do so, he employed what is termed the 'method of doubt', whereby absolutely everything that could be doubted *was* doubted, leaving only the fact that we can doubt (i.e., think), as *the one* remaining point of certainty. With this in hand, Descartes had a baseline from which investigation and inquiry could move outwards, reasonably, via such forms as mathematics and logic (e.g., Clarke 1982; Cottingham 1992). Here, we have a point of origin for the ideas of certainty we associate with classical conceptions of knowledge (noted

26 *Introduction*

earlier), which of course cannot be mapped to the 'messy' and apparent illogic of design and design research involving design practice.

Those forming an opposing camp to the rationalists such as Descartes were the *empiricists*. This group believed that knowledge is acquired through the senses and that our human competencies (reasoning, for example) are *learned* skills which we develop through our gradual interaction with the world over time. In their view, the best route to secure knowledge was via scientific experimentation, i.e., testing and observing results in the real world (e.g., Woolhouse 1988). The perspective was given an initial form by Francis Bacon, an English philosopher-statesman. Bacon's key contribution was to formulate an early outline of what we would now recognise as 'the' scientific method for investigating natural phenomena. Crucially, from the point of view of design research, he believed that this emergent mode of inquiry would gain the most from engaging with those who regularly 'manipulate' nature, i.e., the workers on the ground, the makers and the doers. It was here, he believed, that that most valuable insights regarding nature's underlying structure might be yielded (e.g., Urbach 1987 for an overview of Bacon's work).

Following on from Bacon, key advocates for this position included John Locke, George Berkley and David Hume, with Locke setting forth the first substantial account of 'empirical knowledge'. Here, offering a psychological perspective, he proposed a vision of knowledge grounded in our senses, which are seen to act as mediators of the interactions of mind and world. The basic claim is that the intake of sensory information is seen to lead to the formation of ideas, which, in turn, we may be able to reflect on and, possibly, develop further. It is true that our ideas may be incorrect, but nonetheless, they will be testable – that is, we can check and amend them (e.g. Lowe 2005, for an introduction).[19]

The value of the empirical stance will be obvious for those involved in design research involving practice. In essence, it insists that we centre experience, *relying* upon *it* as we gradually build up our understanding of something, and experiment in order to gain knowledge. This is what those engaged in design research involving practice do[20] – an alignment which we will pick up on later.

Returning to history, we can say that these two camps, i.e., the rationalists and empiricists, remained oppositional for some time, with Berkley and Hume extending and refining Locke's work, pushing empiricism to its limits. Then, in the late eighteenth century, the German philosopher Immanuel Kant made his famous attempt to cap the rational-empirical divide through the argument set out in *The Critique of Pure Reason*. Here, the basic claim was that rather than it being a case of having to pin the source of true knowledge exclusively to a pre-given reasoning faculty (rationalism) or exclusively to sensory data and experience (empiricism), both aspects could be found to play a role in the process of coming to know.

As human beings, Kant argued, we rely on sensory data in order to acquire knowledge, but also on what he claimed to be an innate ability to comprehend the world on its own terms. Regarding the latter, he believed that we are born with the capacity to process and frame the perceptual data of our senses such that valid understanding is possible. Thus, we can know things and hold a valid understanding but, crucially, we cannot know 'things-in-themselves' *beyond* our perception (e.g., Strawson 1965).

From Kant's work, we arrive at the early nineteenth century. Here, the sciences became established, formally peeling off from philosophy and declaring themselves as independent fields of study. This was largely due to wide-ranging technological

advances, such as the accuracy of instrumentation associated with specific types of inquiry (e.g., microscopes). From this, the standardisation of appropriate methods of inquiry across a number of subject area (e.g., physics, chemistry and biology) became possible and, with appropriate methods of inquiry in hand, it was simply a matter of applying the method and reporting the results. There was no need to argue out a philosophic stance (e.g., Ede and Cormack 2017 for a history).

As a result of these changes, philosophy's role changed. Rather than standing at the forefront of knowledge production, it became the background. The discipline, as we have seen, was called upon to provide the epistemological arguments necessary for inquiry in certain areas, be it physics or chemistry, but no longer to conduct those inquiries itself.

The nineteenth century's other important turning point, at least from the perspective of philosophy, is the arrival of Darwin's evolutionary theory. It is difficult to understate how much Darwin's work disrupted society's worldview – whereas religion had previously acted as a centring narrative for the public at large, biology was now offered as a powerful and persuasive alternative vision of humanity's origins and status. Again, philosophy was required to recognise and, in some way, accommodate this shift (e.g., Ruse 2009).

These developments were both celebrated and feared. In Britain, empiricism continued its march via Jeremy Bentham's and John Stewart Mill's 'utilitarianism' – an approach to philosophy which proposed that the ultimate good was to be found in maximising a population's wellbeing/living standards (e.g., Eggleston and Miller 2014). Next to this, internationally, reactionary idealisms and romanticisms took hold – visions for philosophy which sought to extend beyond the 'merely' empirical and connect to, what were judged to be, higher values and eternal truths (e.g., Stone 2011). On this front, the work of the German philosopher Georg Wilhelm Friedrich Hegel stands out as particularly significant, both in terms of its broad scope (Hegel offered a full system) but also in terms of its influence (both Dewey and Heidegger were influenced by his work).

Though Hegel's philosophy is notoriously difficult, it is possible to capture its basic offering in two ideas. The first is that humanity, in their actions and interactions, can ultimately be seen as unconsciously participating in a collective spirit or 'mind'. The second is the proposal that this collective spirit/mind has, throughout history, been moving progressively towards a final fulfilment or perfect realisation.

Hegel's vision relied on an adaption of an earlier philosophic technique termed the dialectic. Historically, the dialectic had referred to a process of presenting opposing arguments, with a view reconciling the differences of both in a synthesis, i.e., a 'coming together' of two original, counter-posing arguments within a single, newly formed argument.[21] Hegel's adaption saw the dialectic scaled up to become a grand modelling of the historical process, where the whole of human society was seen to be engaged in the gradual unfolding of a perfect synthesis (i.e., the final fulfilment or perfect realisation mentioned).[22]

The adaption inspired a young Karl Marx, who, while discounting the metaphysical aspect of the proposal (i.e., its theory of reality), saw value in its dialectic basis. However, rather than this dialectic being solely mapped to a shared spirit or mind, Marx also focused in its would-be connection to material reality. As such, his concern lay not with how a shared spirit/mind had developed over time, but rather how humanity's shared collective interests could be seen to have resulted in tangible real-world

28 *Introduction*

changes, whether in agriculture or industry. On this rendering – termed 'historical materialism' – the dialectic functioned as an explanatory device for historical progress, in *real*, material terms (e.g., Elster 1986).

This vision underlies famous Marx's economic and political theories regarding labour and capitalism, as well as his deterministic belief that communism would, in time, come to replace the latter as the preferred system for organising society. As we will briefly consider, due to this general concern for societal welfare, Marx is an important figure for anyone considering knowledge in relation to the concept of transformation.

All of the above brings us to the twentieth century and the gradual development of the two key strands of contemporary philosophy: the analytic and the continental. The analytic emerged out of the work of Bertrand Russell, who was most immediately concerned with defining the foundations of logic and mathematics. Today, the link to logic remains, but analytic philosophers focus instead on language, seeking to *ground* the underlying character of its structure through a deep consideration of its constituent elements (e.g., Beaney 2013).

Continental philosophy – which functions as a catch-all label for many different but related strands of work – draws a variety of links, some of which lie beyond philosophy. These include: the offshoots of Marx (e.g., critical theory and poststructuralism); linguistic theorists such as Ferdinand de Saussure (e.g., structuralism/poststructuralism); in some cases, to the psychoanalysis of Sigmund Freud; as well as older connections to, say, the work of Descartes, Hegel and Kant, which go right back to the modern era (e.g., in the case of phenomenology and, to a lesser degree, existentialism) (e.g., Leiter and Rosen 2007).

Broadly speaking, those who align to either the analytic or the continental traditions prefer to remain apart. With both sides apparently suspicious of one another there is little crossover (e.g, Prado 2003). As a consequence, philosophy today remains as open-ended and unresolved as ever. But perhaps this is to be expected – it is first and foremost a means of responding to what is encountered, to what has come before. If one thing links the various trajectories sketched out above it is constant, inevitable change – from ancient philosophy (in Greece and beyond); to the scholastic and medieval theologically-orientated work; to the rise of the modern era with the empirical-rational divide; to its repositioning as set against the emergence of science in the nineteenth century; and, finally, to its analytic-continental split in the twentieth century.

Some epistemological issues relevant to design research have been pointed to along the way. However, the fullness of what I am noting as a key offering of philosophy for design will only become apparent gradually as we progressively tackle the work of Wittgenstein, Dewey, Heidegger and others over the remainder of this text. However, before proceeding to explore their general orientation and positioning, it will be worth briefly reflecting on the idea of the radical within philosophy – that is, how breaks occur and why.

A Brief Note on the Concept of the Radical in Philosophy

If we reflect on the above sketch, we may note points of departure and divergence, points at which the importance of work of a specific philosopher or group of philosophers cedes to that of another individual or group. If one were so minded one might

Introduction 29

decide it fair to characterise such work as 'radical' on the basis of its divergence and difference alone. To do so however would be problematic. Philosophy requires progressive evolving inquiry. It relies on new questions and problems. It can't simply be that *any* determined movement away from the norm is 'radical'. Otherwise, the idea of the radical loses all meaning and comes to be only natural progress. As a result, it has to point to something else, something distinct.[23]

Seeking to give some form to a contemporary 'radical philosophy' grounded in critique, Chad Kautzer[24] (2015) combines insights drawn from the perspectives of Marxism, Feminism, Queer Theory and Critical Race Theory to cohere a general philosophical vision. In offering a definition of the word 'radical' in this context, he returns to its etymology source in the Latin word '*radix*', meaning root and, from this, suggesting that to be radical is to be concerned with the 'root, origin, or foundation of something'. Radical philosophy then is said to target 'the root of a problem, rather than just a symptom' (Kautzer 2015, p. 3). Here, it is not so much the extent to which impact is or isn't achieved that matters, but rather that a core issue is identified and, in some way, addressed.

Though our focus is not directed towards the same philosophic threads (i.e., Marxism and so on), we have here a basic criterion against which to reflect upon the above contributions and appraise the extent to which any one philosopher or philosophies get to the *roots* of problems they encounter. As an obvious example, we might turn to the Empiricists's proposals on the basis that they offer a 'radical' alternative to the Rationalists. From their perspective, the 'root problem' would have been that the latter group were operating on the basis of a flawed understanding of human-world relations (i.e., a flawed psychology). Their response, as we have seen, was to rearticulate the centrality of experience and the senses. Picking up on a further obvious example, we might also turn to Marx. Marx diagnosed a root problem in what we might term philosophy's 'historical passivity', i.e., the fact that it had not been a force for change. His philosophic project can be viewed as an exercise in working to shape an active role for the discipline within the economic and political contexts of his day.[25]

This brings us to Dewey, Wittgenstein and Heidegger. At this point, having sketched out a history of Western philosophy and briefly discussing the idea of radical philosophy, we will now consider how Dewey, Wittgenstein and Heidegger may be located next to the previously mentioned milieu, and alongside this give form to their specific radicality.

Where do Dewey, Wittgenstein and Heidegger fit into Philosophy? How are They Radical?

In terms of timelines, all three philosophers – Dewey (1859–1952), Wittgenstein (1889–1951), Heidegger (1889–1976) – were born in the mid-to-late nineteenth century and all three became active in philosophy in either in the late-nineteenth (in Dewey's case) to the early-twentieth century (in Wittgenstein's and Heidegger's cases). Ultimately, their work contributes to (or, in Dewey's unique case, avoids) the beginnings of the analytic and continental philosophy as we know them today.

We have seen in the Prologue how, in taking a pragmatist perspective (e.g., Rorty 2009/1979), it is possible to claim that all three contributed to a *radical* break in Western epistemology tradition (Rorty 2009/1979; Toulmin 1984; Brandom 2002; Bernstein 2010), which, among other aspects, sees an emphasis being placed on primacy of

30 *Introduction*

practice within knowledge production, formal or informal. Here we can see *their core root problem*, that practical aspects of what it means 'to know' and 'to be' required a greater consideration and articulation. As Rorty noted, when viewed in this way, their efforts can be seen to have opened up the space for philosophy to ask questions which had previously been considered beyond its remit. In order to gain a sense of the space that *was* opened up, we will now turn to reflect on their individual contributions.

Dewey began his philosophic career proper as a Hegelian (i.e., he sought to extend Hegel's insights). This placed him in what he termed an 'absolutist' category, wherein his worldview was informed by a definitive metaphysics (Dewey 1984, pp. 149–160). Things changed however. Through direct work in education and the then-burgeoning field of psychology in the 1890s, he quickly moved to reject notions of the 'absolute' (e.g., Sleeper 1986). Here he became deeply concerned with human experience and, set against this, questioned our understanding of logic, knowledge, scientific inquiry, democracy, ethics and aesthetics. As we have noted, he is considered a 'classical pragmatist'.[26] Though pragmatism is not considered to be a mainstream philosophy today, there are a number of individuals who associate with a 'neopragmatist' label. Broadly, in historical terms, pragmatism and Dewey's work, in particular, can be seen to have informed aspects of early analytic philosophy (e.g., Baghramian and Marchetti 2017). Dewey continues to inspire many, whether those engaged in neopragmatist philosophy (e.g., Rorty) or beyond (e.g., the sociologist Bruno Latour).

In very simple terms, beyond his epistemology critique (as highlighted by Rorty and others; see the Prologue), Dewey's work may be seen as radical because he was calling for a renewed form of empirical philosophy (e.g., Dewey 1982/1920, pp. 77–202), a philosophy which would be duty-bound to continually test its claims in the real world. Viewed in this light, his efforts may be seen to amount to call for the embedding of an *experientialist approach* across all areas of life, whether social, political, ethical, religious or aesthetic and so on.

Wittgenstein, as we shall see, was fascinated by logic. Through his association with the prolific Bertrand Russell, he contributed to the development of analytic philosophy. He would later reframe his philosophical position, offering a novel perspective, that also sits under the analytic umbrella. His latter or 'later' offering may be understood as radical on the basis that he sought to affect a shift in philosophy's role, i.e., what it should be/do. Whereas prior, philosophy's method had been couched singularly in *thinking* alone, Wittgenstein wanted to introduce the idea of *looking* (i.e., observing) too. As far as he was concerned, thinking, on its own, had allowed philosophers to become 'betwitched' by language and, consequently, to invent 'problems' which were in fact only linguistic in character (i.e., the products of an incorrect use of language without real-world bearing).[27] It has been claimed that the full potential of this perspective has yet to be explored in philosophy (e.g., Genova 1995).

Heidegger, for his part, was most concerned with the question of being, i.e., what it is and what it means, believing that these questions had not received the attention they deserved. Indeed, he is to be considered radical on the basis that, in moving past classic questions of ontology and epistemology, he sought to ground a way in which what it means to be might be investigated. In undertaking this project, he is generally considered a phenomenologist[28] – a branch of continental philosophy, which, broadly, seeks to examine the structure of consciousness in terms of how things 'appear'. Heidegger's contribution here was to investigate the role *meaning* (linked to the processes of interpretation and understanding) plays in our encounters with the world. Even to

Introduction 31

this day, he continues to be upheld as one of philosophy's most significant and influential philosophic voices, with many important recent philosophers drawing on his work (e.g., Jacques Derrida).

In short, the value of these individuals' work, both historical and current, is still being sorted and unpicked. Their contributions stand out because, ultimately, they disrupt what came before – especially with regard to the area epistemology. A more extended outline of these contributions will follow in due course. For now, however, we will turn to consider directly the present relationship between design research and philosophy.

The Present Relationship between Design and Philosophy

Though a notional disconnect between philosophy and design was noted in the Prologue (i.e., that design researchers have not paid enough attention to philosophy/epistemology), it is important to note that there are quite a few significant exceptions. Recent decades have seen more and more design theorists advance important arguments which draw their key insights from the field of philosophy.

In terms of this general trend within design, two key factors stand out. In the first instance, a new awareness has developed around design's role and purpose within these disciplines. Whereas, previously, a designed product might have been judged on the basis of its functionality or the aesthetics of its form, a new locus of value has been sourced in the concept of 'experience'. The concept of experience opens up the vast arenas of action, interaction and, most importantly, the emotional forward-and-back between product and person. No more is a design reducible merely to its physical dimensions, or its material specifications, or the structure of its visual form (e.g., in the case of graphic design). Rather its meaning for what is referred to as 'the user' – the feeling, thinking, doing human – is now front and centre. Seeking to tackle the user-design relationship, whether in the early or later stages of designing, greatly complicates the complexity of the design process. References to philosophy, in particular to texts which have handled the concept of experience, allow the field to develop frameworks or what might be referred to as 'ways of seeing', which can begin to process this complexity (e.g., Moggridge 2006 and Rodgers 2012 for histories).

The second reason links to the concerns of the present book: in a word, *research* or what we might refer to as design's *academization*. Briefly touched upon in the last chapter in relation to the development of design research involving practice, academization denotes a process of converting and translating a subject – its theories, values, methods, principles and application – into academic terms, terms that ultimately conform to the institutional standards expected by universities and other places of higher learning. In the case of design, academization has meant that faculties and departments, which might previously have held an exclusively practice-based orientation in their teaching and general scholarly practice, must now demonstrate a more theoretically attuned approach.

This manifests in a number of ways. In many countries, particularly at a postgraduate level, there will be an institutional requirement that programmes embed research methods training, along with a well-defined strand of historical and critical studies within their curricula. Equally, institutionally, in keeping with the general expectations placed upon academics, there will be pressure to seek out grant funding from research councils or other such bodies, as well as publish in high-ranking academic

32 Introduction

journals. This trend has led to an expansion in the provision of design-based research degrees globally (e.g., Friedman and Ox 2017; Margolin 2010; Durling and Friedman 2000), with a doctorate increasingly becoming a requirement for entry into teaching (Koskinen et al. 2011, p. xiii).

Arguably, interaction and product design form the vanguard of this push towards the academy. Most often, it is these disciplines in particular which sit at the centre of prominent design research texts, driving new perspectives forwards (e.g., Krippendorff 2006; McCarthy and Wright 2004). Their prominence is reinforced through the outstanding popularity of major international conferences such as the Computer Human Interaction (CHI) and Designing Integrated Systems (DIS) series, which have secured wide, energetic forums around these subjects.

This is not to say however that interaction and product design are singularly driving the academization of the field. Other disciplines have themselves undertaken efforts to frame an academic position out of their practical contexts. Increasingly, practice-based research perspectives have been made available in areas such as visual communications (e.g., Bestley and Noble 2016), fashion (e.g., Jenss 2016) and interior (e.g., Vaux and Wang 2021; Robinson 2020). Equally, more and more, emergent academic discourses have been established around such subjects, with specialist journals (e.g., Visible Language in the context of visual communications) and conferences providing an opportunity for academics working within these emergent disciplinary subfields to interact.

Returning to the question of philosophic insight being drawn upon within these emergent arenas, it is possible to note that a number of key voices may be readily identified as preferred references. First, given our baseline of Dewey-Wittgenstein-Heidegger, it is important to point out here again that all three do indeed figure prominently within this literature. For example, Wittgenstein's thinking underpins aspects of Klaus Krippendorf's semantic (i.e., meaning-orientated) theory of design (2006), where meaning is presented as the basis for understanding both the process of designing and its outcomes. Equally, Johan Redström's recent vision for a 'practical' design theory (2017) also draws significant links to Wittgenstein.

Designerly explorations of Dewey's work are common, taking in multiple themes such as reflection, inquiry, aesthetics and politics. Indeed, such explorations have a long history in the field, that extends at least as far back as Schön's presentation of the reflective practitioner in the early 1980s (e.g., Schön 1983, 1992, 1995).[29] More recently many have picked up on his work in interaction design (e.g., McCarthy and Wright 2004; Dalsgaard 2014). Exploration continues today with two recent wide-ranging expositions/explorations extending the discourse further (Dixon 2020; Bousbaci 2020).

Heidegger's work, lastly, is a key reference for design-based discussions of sustainability and technological overreach (e.g., Fry 2011), as well as understandings of how human-computer interaction might be approached in relation to the themes of embodiment and context (e.g., Dourish 2001).

Alongside these, other voices are perhaps even more significant. Here, the attention given to the work of Bruno Latour is particularly noteworthy. His writings on what is called 'actor network theory' (e.g., Latour 2005a) and democratic participation (e.g., Latour 2005b) have been appropriated within participatory design discourse (e.g., Telier 2011; Björgvinsson et al. 2012) as well as interaction design (e.g., Jenkins 2018). In these contexts, Latourian theory allows for a reimagining of how people and

Introduction 33

material things come together, and how design has a role to play in helping to shape outcomes: ultimately, decentring the individual and the isolated object, in favour of foregrounding the collective (or in Latour's vocabulary, the network).[30]

The value of other voices too are increasingly being drawn into high relief in a series of select contexts. Richard Buchanan, for example, has examined Richard McKeon's work on rhetoric and patterns of thought (e.g., Buchanan 2001, 2015), noting, in particular, how McKeon's rhetoric offers a frame for conceiving design practice. Elsewhere, some have given over considerable effort in exploring the value of Gilles Deleuze's work (e.g., Marenko and Brassett 2015),[31] with a focus being directed towards its potential as a conceptual basis for managing innovation in contexts which might otherwise appear overly complex and intangible. In another example, Clive Dilnot advanced a perspective on the applicability of Jürgen Habermas's work on 'instrumental rationality' in the context of design practice and theory (2017). Beyond these references, Hannah Adrent's political writings on such issues as the danger of creeping totalitarianism have recently been given designerly consideration (e.g., Tassinari and Staszowski 2020). While, lastly, a final, broad but noteworthy line of inquiry has emerged in a recent effort to undertake a series of deep explorations which aim to link aspects of critical theory to concerns within interaction design (e.g., Bardzell et al. 2018).

Alongside these enfoldings of philosophical insight within design theory there is another relevant strand of directly philosophical work, which must be highlighted – what is referred to as the *philosophy of design*.

The Philosophy of Design

The strand of work sitting under the banner 'philosophy of design' may be broadly understood to comprise of a series of philosophical inquiries into *what design is* or *what design might be*. While it is arguable that such inquiries have been undertaken for as long as design has been recognised as a special human activity – i.e., individuals have offered distinct, personal narratives or reflections (e.g., Potter 1969) – formal consideration of these questions can only be traced back to the turn of the twenty-first century (e.g., Galle 2002; Vermass et al. 2008). In introducing a special issue of *Design Studies* on the subject, Per Galle was reluctant to offer a definition which was too closed or precise – the field, he believed, was too young and still forming. So far as it was possible to offer any such statement, he proposed that the philosophy of design was 'whatever philosophers of design do, or could reasonably do' (2002, p. 212). Its use, he went on, is to offer 'insights about design which we couldn't obtain otherwise' (ibid, p. 216).

The philosophy of design discourse has advanced in the intervening years, with several multi-author publications emerging over the last two decades. Throughout this work, contributors tend to draw focus in on aspects of design or designing and set out their particular visions by linking to particular, preexisting philosophic perspectives. Two edited texts by Pieter Vermass and collaborators (Vermass et al. 2008; Vermass and Vial 2018), appearing roughly a decade apart, offer a series of philosophical horizons that either have been opened up or, alternatively, *might* be opened up. In the first, *Design and Philosophy*, design philosophy is explored across a relatively narrow spectrum linking engineering to architecture (Vermass et al. 2008). Here, we encounter a relatively coherent mix of philosophic references. In the second, Advancements in the

34 *Introduction*

Philosophy of Design, this spectrum is opened up through a more general attending to such areas as design epistemology, design research, design concepts, aesthetics, ethics, politics and so on (Vermass and Vial 2018). As a consequence, the philosophic reference points are also expanded to the enfolding actor network theory and phenomenology along with cognitivism and logical epistemology.

Grand, systematic statements aiming to offer a 'totalised' philosophy of design are relatively rare, though these too do exist. Two recent examples are worthy of mention here. Glenn Parsons (2015) offers a presentation which gives consideration to the design process itself, the history of modernism, the concepts of function and form, as well as the areas of aesthetics and ethics as these pertain to the field. Vilém Flusser (2013) takes a somewhat more exploratory approach, deconstructing and reconstructing design on the basis of linguistic analysis. In this, he traces out a series of possible dimensions by which design might be apprehended linking: the designer; design concepts (e.g., form); design contexts (e.g., the factory); design outcomes; and technology.

Beyond the previously mentioned, there is another, final design-philosophy strand, which must also be noted. It might be best referred to as the 'theory sitting at the edge of philosophy', such is the fine line theorists here walk. In this context, three names in particular demand attention: Michael Polanyi, Donald Schön (who, as has just been noted, drew heavily on Dewey) and, more recently, Tim Ingold.

Polanyi, Schön and Ingold: Theory at the Edge of Philosophy

Though Polanyi, Schön and Ingold were not necessarily aware of design when first writing, their perspectives have been found to chime with the field's basic commitments/interests in relation to the concepts of action and creativity.

Polanyi was originally from Hungary but later settled in Britain. A polymath, he traversed a number of fields over the course of his career – at various times linking to science (in particular chemistry), economics and, later philosophy. Through insights developed over the course of this work, he came to reject the basic worldview prevalent in the natural sciences at the time – positivism, a perspective which links to historical areas of analytic philosophy (i.e., 'logical positivism'). Positivism, in essence, honoured the Cartesian vision of certain knowledge (discussed previously) and, as such, saw inquiry as, by necessity, reliant on definite and explicit understanding, both in terms of its procedure (i.e., its methods) as well as its outcomes (e.g., theories, models and so on). In rejecting the positivist worldview, Polanyi suggested that, instead, in many, if not most cases, inquiry and human action in general, relied not on definite and explicit knowledge, but rather 'tacit' knowledge (i.e., implicit, intangible understanding) (e.g., Polanyi 1966).

Tacit knowledge, while appealing and useful on a general level, is ultimately problematic in the context of knowledge production. This is because it is, by definition, ultimately un-surfaceable (i.e., we cannot render it explicit and as such sharable) – we are able to say that we 'know more than we can tell' (Polanyi 1966, p. 4) but not exactly what it is that we know. The idea of knowing more than we can tell will likely be recognisable (and possibly even appealing) to those who are familiar with the design process, however it does not support the justification of research. Accordingly, while much of the 2000s debate surrounding the inclusion of creative practices in research processes centred upon this idea of there being a tacit dimension at play (e.g.,

Niedderer 2007), no formal recognition of the value of the tacit aspects of research has followed.[32]

From Poylani, we encounter the work of Tim Ingold, an anthropologist. Over a long career, he has advocated for an embodied, situated perspective – linked to the tenants of ecological psychology – to be foregrounded within his discipline (e.g., Ingold 2000). He has also commented on the value of 'making' as a general orientation within the process of knowledge production (e.g., Ingold 2013). At the heart of this vision, we find a basic core argument that perception, tool use, language and, ultimately, knowing as a process are all bound together in a productive, mutually codependent unfolding.

Schön's contribution to design theory is widely known and regularly discussed (e.g., Buchanan 2009). Objecting to then-prevalent understandings of professional action (i.e., in the 1970s and 80s) as both technical and rational, Schön laboured over several decades to specify an alternative model of professional action, which was, instead, grounded in the paradigm of constructivist sensemaking – that is, a form of sensemaking which sees reality as being shaped by our very efforts to engage with, and interpret, 'what is'. Within this model, the design process is said to rely on acts of 'framing', whereby the designer is seen to actively work to develop to a productive way of seeing the contexts in which they are working. Framings, in turn, are to be tested and progressed through various forms of experimentation, which will allow the designer to arrive at a meaningful solution to the problem at hand (e.g., Schön 1983). In promoting this model and acknowledging that his project remained partly unfinished, Schön called for what he termed an 'epistemology of practice' (see. e.g., Schön 1995), that is a way of theorising knowledge that recognised the indivisible relationship between action and knowing, which of course is a core concern for this text.

Such work – that of Polanyi, Ingold and Schön – allows us to glimpse how it might be possible to define the special knowledge offering of design by diverting through the perspectives of other disciplines, be it the broad polymathic approach of Polanyi's philosophy, Ingold's first principles of immediate-experience anthropology or Schön's constructivist model of professional action. All three offer powerful reference points which might readily be drawn upon (and often are) in any effort to counter theories of knowledge that rely on notions of absolute certainty and objectivity.

The Design-Philosophy Nexus as a Whole

Reflecting broadly on all of the above references, we may note that such work is, of course, of immense value. Text by text, such contributions have/are gradually opening up and unpacking the (often) implicit background assumptions of design and design research, as well as drawing new connections to existing bodies of work in Western philosophy. There is the potential that points of consilience may be identified and the field of design's intellectual undergirding strengthened.

However, though the value of this work is clear, as the range of available texts expand, a related challenge opens up. The texts and the arguments they offer are, by necessity, limited. This is not a failing on its own. To be effective, a text or an argument must limit itself. What is lacking is oversight. In focusing on a specific set of philosophers or philosophies, the perspectives opened up will inevitably remain contained and fragmentary. In other words, though there is the potential that points of

36 *Introduction*

consilience may be identified, this has not yet happened in full. We have yet to see a comprehensive, focused attempt to coordinate and cohere any insights.

So how might we go about coordinating and cohering the insights that have emerged over the years and say something general about the design-philosophy relationship? Or, perhaps more realistically, even begin to make a first step towards saying something general? Regrettably, this a is long-term undertaking and cannot be addressed in full here. As stated in the Prologue, the limited contribution of the present text relates of course to development of a justificatory epistemological narrative for design research involving practice via the work of Dewey, Wittgenstein and Heidegger and, set next to this, a sketch map.

Thus, having mentioned their names frequently enough, it is now time to turn our attention to these three philosophic voices, exploring first what they offer and, then, why it matters to us here.

Dewey, Wittgenstein and Heidegger: Their Backgrounds and Some Quick Intersections

It has been acknowledged that to those with a philosophical background, the linking together of Dewey, Wittgenstein and Heidegger will not necessarily feel natural. Though more or less contemporary, we may note a number of distinguishing differences, which separate them.

First, they each come from different countries. Dewey was from the United States. Wittgenstein was from Austria (then the Austrio-Hungarian Empire). Heidegger was from Germany. Second, as noted, their work aligns with different philosophic traditions – pragmatism, the analytic tradition and continental philosophy.

Their individual attitudes to the academy were also very different. Wittgenstein, though deeply committed to philosophy as a general practice, often threatened to abandon the discipline altogether due to a general disillusionment with Cambridge University life – even becoming a schoolteacher for a period of time in the 1920s in rural Austria (e.g., Monk 1991). Dewey was an academic in the absolute sense, working at a senior administrative level for a period of time and acting not only as a philosopher, but also as a researcher within the then-burgeoning fields of psychology and pedagogy (e.g., Martin 2002). Heidegger was, like Dewey, an absolute academic, and also held a senior administrative role as rector at Freiburg University. However, he also became misguidedly aligned with the Nazi party in the early 1930s and, as a consequence, his reputation suffered (e.g., Safranski 1999).[33]

When it comes to what they have to say philosophically, whether relating to epistemology or another area, the fact is that, if they were brought into a room together, they would likely not agree on many points. For example, the early Wittgenstein and Heidegger would not argue on the importance of logic. As another example, they would not agree on the value and role of science in our lives. Wittgenstein and Heidegger would be deeply sceptical of the scientific worldview and its impact upon culture, while Dewey (e.g., Dewey 1981/1925) would likely praise scientific discovery and the basic methods and assumptions which underlie it.

However, despite the many ways their views differ, there are, nonetheless, intersections to be found in their work. More importantly, such intersections have been connected to the epistemological concerns of design research (Dixon 2021).

We can start to unravel these by noting simple similarities.

Introduction 37

As indicated above, all three were active at approximately the same time in history – a period stretching from the 1880s (in the case of Dewey) through to the late 1960s (in the case of Heidegger). Of particular interest is the fact that all underwent a 'turn' in their work and, as a consequence, may be understood as having a corpus which includes a before and after dividing line. Though Heidegger is a special case, we can see that,'in turning', both Wittgenstein and Dewey gradually moved away from the abstract and ethereal, to the 'situated' and 'grounded' in their work.[34]

We have already noted Dewey's turn (i.e., from 'absolutism' to experimentalism) in the last chapter. Wittgenstein, for his part, moved from investigating logic as an abstract means of representing the world (e.g., Wittgenstein 2013/1921), whereby the world was literally seen as something that could be perfectly 'pictured', to holding the view that meaning is inseparable from the context – understood as both physical and cultural – in which it is formed (Wittgenstein 1963/1953).[35] Heidegger more or less started with the situated and grounded as a centre point in his work (e.g., Heidegger 2010/1927). For him, the later 'turn' (such as it was) meant focusing, in greater detail, in on certain themes such as the role of poetry, technology and art in human existence (e.g., Heidegger 2001/1971, 1977). In this, he envisaged a 'turning', where humanity might undergo a profound transformation such that it might develop a special, undefined means of coming to terms with 'being' (Pattison 2000, p. 4);[36] his view, in essence, was that philosophy could act as an aid to this process.

Reflecting on these individual shifts – whether profound (in the cases of Wittgenstein and Dewey) or more subtle (in the case of Heidegger) – we can say that each was, on some level, hoping to challenge what they felt to be the flawed aim of certainty, which lay at the heart of the Western conception of knowledge.[37] In the end, it was the idea of practices, of *doing* things, and, indeed, of *being* human, that came to play a central role in their revised vision of what knowledge means or should mean (if anything at all in Heidegger's case, as we will see). It allowed Dewey to focus in on dynamic experientialism, Wittgenstein to focus in on contextual meaning and Heidegger on the poetic as a primary mode of existence.

Here, to varying degrees, we may say that, in their move away from notions of certainty, all three were foregrounding themes of experience, along with action and communication, with language and meaning coming into play in relation to the latter. In this, we can see them asking a series of questions, even if these questions were never explicitly stated outright and preferred terms would have varied.

As a first set of questions relating to experience, we can say that all three would have been interested in getting a clearer sense of: What does it mean *to* experience something? Or put it another way: What *is* experience? What happens within it? What are its scope and limits?

Then as a second set of questions, they are also asking: What does action entail? How does it function? How does it connect to communication, in particular to language? And within this: What is meaning? Or, approached from another angle, looking back to the questions of experience laid out above, we might also say that they are asking: What do we *do* with words? What is their function in our everyday affairs? How do language, meaning and the world interact?

As they attempted to provide answers to such questions, they would each come to shape fresh perspectives on the question of knowledge (in Wittgenstein's case, this occurred almost by accident). These eventual perspectives would, in time, come to

38 *Introduction*

challenge how knowledge is understood philosophically. Or, at the very least, throw it open to question.

As we will see, in essence, by focusing on the particularities of experience and language, Dewey-Wittgenstein-Heidegger note that change and transformation are inevitable and, indeed, desirable features of our existence. We are also called upon to recognise that we are always, inevitably, participants in any activity, no matter how directly or indirectly we may be involved in shaping outcomes. This has profound implications for knowledge production. For example, for the scientist, 'involvement' in the process of producing knowledge might seem minimal but, nevertheless, scientists, too, still frame and conduct experiments. Just as with designer-researchers, they *do* things to produce knowledge, even if only as they seek to control the variables at play within any given investigation.

In recognising these aspects of transformation and participation, Dewey-Wittgenstein-Heidegger also ask us to confront the idea that knowledge can *never* be certain. On their view, the project of coming to know will never end, only keep going. We might possibly gain a deeper understanding of what is known, but we won't know it in any absolute or total sense. This is not something to fear but, rather, something to be embraced as a creative endeavour held within the process of knowledge production.

Beyond transformation, participation and a denial of certainty, Dewey-Wittgenstein-Heidegger also point to the inevitability of there being differences and diversity at play both in our encounters with reality as well as what we come to know of it. This, again, is not something to fear. It's a given that we may choose to work with and around. It may be positive. It may be negative. It's up to us to decide which. What cannot be achieved however, is a final, flat, absolute form of oversight on a subject. No matter what, difference and diversity will endure as qualities within our existence.

Even now, as noted in the Preface, these Deweyan, Wittgensteinian, Heideggerian insights continue to point to the opportunity for researchers across all fields to work to formulate novel modes of inquiry more in keeping with any implications, which might be drawn.

In seeking to devise a baseline for the development of an epistemological narrative for design research involving practice via such bearings, we may note of course that they map directly to characteristics of the latter approach as outlined in the last chapter. The fact is that both align well. Exploring this alignment and its implications for design research involving practice will form the basis of the subsequent chapters. Here, we too will be asking how our understanding of knowledge production might be formally rearticulated in order to accommodate the realities of transformation, participation, uncertainty and difference/diversity.

Why Dewey, Wittgenstein and Heidegger Over Anyone Else?

The question of why this text focuses on the work of Dewey, Wittgenstein and Heidegger over other, (potentially) promising possibilities such as Marx, Foucault, Deleuze or Latour remains outstanding. It has already been noted that Dewey, Wittgenstein and Heidegger offer a profound revision of the Western conception of knowledge. We have of course begun to explore this and, I hope, the value of their work for design and, in particular, for design research involving practice, is becoming apparent. Nonetheless, before proceeding I would like to provide a brief rationale for not centralising the latter alternative philosophers (i.e., Marx, Foucault, Deleuze or Latour). It must

Introduction 39

be noted at the outset that it is beyond the scope of the present text to fully distinguish between the epistemological offerings of these individuals and Dewey-Wittgenstein-Heidegger. As such, what follows is not presented as a definitive rejection, merely a reasoning on my part, as author of *this* book.

We begin then with Marx. It was previously highlighted that Marx *does* offer a vision of transformation via philosophy – he explicitly argued that the discipline needed to become a force for change (see Marx 1941/1888).[38] Marx also focused in on the inherent value of human creativity, seeing it as an essential characteristic of who we are and something to be supported and engaged (e.g., Sayers 2011; and Pathway 1.2). Not only that, along with Frederick Engels, in his *Communist Manifesto*, he set out an *emancipatory* vision for the future of society. This vision is based on his mapping out of a reorganisation of capitalism's systems of property ownership, as well as production and consumption. In essence, in this, he and Engels offer an economic 'design' for, what they *believe* would be, a better alternative.

These facts would appear to recommend Marx (and Engels). However, to put it lightly, Marx has issues. As will be apparent to many, picking up Marx in the present era is complicated. In the first instance, there is the inevitable, negative historical associations. Those who acted in Marx's name over the last century – whether Lenin, Stalin, Mao or Pol Pot – are not generally held in high regard to today. One might say that this is unfair. Marx cannot be held entirely responsible for how he was interpreted by later generations. Perhaps this is true, but the negative association nonetheless remains. It is very difficult to pick up the Marxist (or, if preferred, the Marxian) banner and not have a response to such associations. I, I regret to say, have none.

In the second instance, to note an exclusively philosophical issue, from an epistemological perspective, Marx's offer is flawed because, like Hegel and unlike Dewey-Wittgenstein-Heidegger, he upholds the idea of their being a determined path ahead for humanity. While Hegel believed that history was moving towards a perfect absolute in his present-day Prussia, Marx believed that history was moving forwards on the basis of economic patterns of production and consumption and, that one day, an ideal (or absolute) form would be achieved in communism (or at least could be) (e.g., Marx and Engels 2004/1848).

The insights of the intervening century and a half point to the idea that there can be no certainty as regards the future of human progress or lack thereof (e.g., Prigogine 1997). Deterministic models of what is to come are generally no longer seen to be valid. This reduces the appeal of Marx somewhat. Though, of course, that is not say that there is no value in the perspectives he offers. Indeed, meeting this issue head on, some have endeavoured to shape a reconstructed 'Marxian' philosophy by reworking any deterministic aspects (e.g., Resnick and Wolff 2006). This will likely be invaluable to those who are seeking a more contemporary, 'cleansed' Marx. For my part, however, I do not believe that benefits of a reconstruction outweigh the challenges of the lingering negative associations – Marx and failures of Marxism are still difficult to separate. Equally, a reconstructed project is an altered project, something new and original in and of itself. Dewey, Wittgenstein and Heidegger do not need reconstruction (at least for the most part).[39] They are ready to go.

Nonetheless the already-existing 'presence' of Marx-inspired work within design theory cannot be denied or, indeed, underestimated. As such, two concessions are made in the present text: in the next section, I give direct consideration to the historical influence of Marx within design research (see below); and then, following on,

40 *Introduction*

in the next chapter, I will consider how Marx can be seen to offer design research involving practice a potential model for 'positioning' the designer-researcher within a process of design-based knowledge production.

From Marx, we turn to the work of Foucault. Foucault is somewhat of an oddity because, though his work is philosophical in *character*, some would argue it does not technically constitute philosophy.[40] Rather, he can be seen to have focused on social history and the history of ideas over time. His key insights relate to the theme of power – how it is acquired, how it is exercised and how it is maintained within society. Here, he examined language, text, architecture and the practices these arise from as well as give rise to. What emerges is a unique perspective on how our daily existence and, indeed, the course of lives, in general, is organised and regulated by a shifting framework of deeply embedded controlling structures – finding form in speech, laws, buildings – which are often hard to detect and articulate (e.g., Foucault 1975).

Foucault's work is important and deserves attention within the context of design. We are challenged to give careful consideration to what we are designing and what such designing supports. Ultimately, it is a question of the practices our designs will encourage/enable in the world and of who will benefit.

Looking beyond the questions of whether or not he is to be categorised as a philosopher proper, Foucault does present an epistemology of sorts, in the sense that he connects knowledge and power and calls upon us to acknowledge and examine the inherent links between both (e.g., Foucault 1970). As regards the usefulness of this offering, I take the view that through Foucault we stand to gain a valuable conceptualisation of knowledge processes, something to reference, but not quite the beginnings of an epistemological narrative for design research involving practice. In short, his focus on power is helpful but, on its own, limiting. As such, we shall explore Foucault's potential, in due course, in the context of two philosophical 'pathways' – one linking to language, the other to the broader area of critical theory (briefly touched on previously), which has much to commend it to design research.

Next, from Foucault, we encounter Deleuze. Through his work with the psychoanalyst Felix Guattari, Deleuze can be seen to present what is perhaps the most compelling alternative (or potential addition) to the voices of our three baseline philosophers. His work revolves around the idea that empiricism is absolute – that there are no 'layers' or hierarchical tiers to reality but rather only a single here and now of relating/relatable elements set across a connected plane of things and events (e.g., Deleuze and Guattari 2004/1980). Focusing in on the concepts of identity and difference (i.e., what allows us to understand people/things as the same or not the same), he believed that true thinking occurs when our expected 'categories' – what we believe in relation to a given person/thing – are 'ruptured' (e.g., Deleuze 1994/1968). To put it another way, we might say that, on the Deleuzean view, true thinking occurs when the identity of people/things do not conform to our existing frames of reference or, more simply, the beliefs we hold in relation to them. In such scenarios, we must work to resolve this tension, reframing our references and revising our beliefs.

In considering Deleuze, it is important to note that he saw himself as primarily a *metaphysician* – a 'theorist of reality' if you will. His is a metaphysics which centres upon the process of 'becoming' as opposed to being (i.e., that which is fixed). Consequently, what matters here is what 'happens' as opposed to 'what is'. There is undoubtedly meaning for design here, as others have shown (e.g., Merenko and Brassett 2015) but a metaphysics is not in itself an epistemology. This of course does not

preclude his work from epistemological consideration. Rather, if we are to properly interpret the offering, we must approach both Deleuze-Guattari with this understanding in mind.

When it comes to Deleuze (and, with him, Guattari) there however is a more immediate challenge to overcome – it relates to the sheer depth of the work and, against this, our ability to arrive at a definitive understanding, one that properly 'represents' an 'underlying' position (if that is even possible or desirable). The point is that in coming to their texts we are *supposed* to be challenged. We are supposed to engage in 'true', essentially difficult, thinking. Following on, with Deleuze-Guattari, we, as readers, are *not* supposed to aim to directly lift 'theory' and claim it as theirs. Such an approach goes against the spirit of the project. Although, arguably, the same might be said of Dewey, Wittgenstein and Heidegger, this is especially the case for Deleuze-Guattari. In approaching the work faithfully, we must form our own view and claim it as ours. This naturally limits the potential of Deleuze as a possible baseline voice. Ultimately, we cannot claim that he offers a specific or specifiable epistemology. As a means of dealing with this and repeating the treatment dealt to Marx and Foucault, Deleuze-Guattari will be approached very briefly via a philosophical pathway, adding to the existing opportunities for a more detailed and dedicated consideration in the context of design epistemology in the future.

Next, we move on to Latour, the final alternative noted here. In the context of design research, Latour presents another compelling case. Again, one that might easily be added to our list of baseline voices. However, he is technically not a philosopher, but rather a sociologist. His actor network theory, discussed previously, acts as a methodology, a way of seeing in sociology, which – much like Deleuze's empiricism – asks that we approach the world not as a set of strict and contained hierarchies, with some things being held as more significant than other things, but rather as a 'flat ontology' – that is, one continuous level of value spreading across the world and all it contains. Such a perspective allows us to trace connections across multiple seemingly disconnected domains – whether related to technology or human interactions or animal species and so on, which can all be joined up in unexpected, productive ways (e.g., Latour 2005b).

In terms of examining this offering from an epistemological perspective, we can say that, as demonstrated by participatory design theorists such as Pelle Ehn, it allows us to conceive of design processes and practices from a novel viewpoint (e.g., Telier 2011). This is enriching. We are now in a position to discuss the relationships between humans and all forms of nonhumans (alive or not alive) in a manner which was previously impossible. This, in turn, opens up the potential for political issues to be mapped to the real world in a way that extends beyond the presentation of a mere abstract argument – to be either for or against (e.g., Latour 2005a). Latour instead emphasises connections and centres relations. We are called upon to recognise the inherent complexity that underlies issues and, as such, are dissuaded from expecting simple solutions.

There is however a key drawback with Latour. If applied to design, his work does not readily allow for the identification of strategies for change or creative action (see Jenkins 2018). Rather, as has been indicated, his offering operates more as a reflective device, allowing one to trace or map connections. Dewey, Heidegger and Wittgenstein on the other hand, all, in some way, work to highlight the potentiality and essential creativity at play within everyday life. Unlike Latour they are essentially

42 Introduction

future-orientated in their intellectualising of practice. For them, things are always *about* to happen. For Latour – in sociological terms at least – things *have* happened; it's the researcher's task to reveal how. Such an approach may be useful as an analytic lens, or an ontological stance (i.e., as a theory of reality), nonetheless it does not, immediately at least, support creativity, making things happen, in the context of knowledge production. Dewey, Wittgenstein and Heidegger do.

Pathway 0.1 An Historical Pathway: The Marxist Influence

It would appear that, on the face of it, Marxism and design are well matched. In simplistic terms, adherents of both (i.e., Marxists and those who advocate in favour of design) would generally subscribe to the idea of aiming to bring about positive transformation, of being committed to remaking society for (what is seen as) the better. It will be unsurprising therefore to learn that Marxism (in its various forms)[41] has acted as a touchstone throughout the history of the discipline's development in the twentieth century.

As a starting point, early historical intersections of Marxism and design are to be found threaded through the work of William Morris – a nineteenth century English designer who launched what is referred to as the Arts and Crafts movement – and in the Bauhaus, a famous design school founded in Germany in the aftermath of the First World War. Weingarden (1985) outlines how Morris read and was inspired by Marx's critique of what he perceived to be the dehumanising bent of then-contemporary industrial production processes (see Marx 1992/1844; and Pathway 1.2). His establishment of the Arts and Crafts movement[42] in response is, in turn, seen to have inspired the agenda of the early Bauhaus, which famously sought to bring about a union of craftsmanship and the machine (e.g., Scheidig 1967).

In the postwar period, Marxism made appearances at intervals, acting as a philosophical reference point for certain individuals and groups. Among the most famous of these is the Italian designer and cofounder of the famous Memphis design group, Ettore Sottsass, whose work ranged from product design through to architecture. Guided by a Marxist perspective, he sought to explore how particular design approaches might disrupt (as opposed to further) crude consumerist agendas, leading, in turn, to a questioning of the discipline's broader social role. This meant designing products in ways that allowed for unexpected uses by expected groups. An early example of this is the Olivetti typewriter produced in the late 1960s. Made of robust, bright red plastic, the aim was to avoid any associations with monotonous work routines. Instead, it was hoped that its bold aesthetic form would act as a prompt for spontaneous creativity (Brennan 2015, p. 246). Later work at the Memphis (established in 1980), can be seen to invite critique and questioning of the product forms, as well as the role of technology in our lives. Those encountering the work were, in essence, being asked to 'participate actively in the argument of the design' (Buchanan 1985, p. 13).

Beyond the above cases, participatory design (PD) (discussed above in this chapter) presents another, more recent instance of a design movement which, at least in part, has drawn inspiration from Marxism. PD famously arose in the late 1960s out of trade union concerns relating to automation in the workplace. Projects were commissioned on the basis of researchers and designers coming together to interrogate a particular technological change (e.g., the context of printing). Here, design, in particular collaborative prototyping, became a means by which management and workers

might negotiate a consensus around the final form of a new technology. Cementing the Marx-design relationship here, Pelle Ehn's PhD thesis (1988) drew attention to the emancipatory role of trade union action as means of responding to 'capitalist rationalization' (p. 100). On this account, design becomes an active epistemology enabling transformative social action in the Marxian vein (see pp. 82–102).

While the linkage between PD project work and trade unionism was maintained through to the 1980s, this fell away as the political and economic landscape shifted (see Kensing and Greenbaum 2013). The Marxist commitment in PD is now effectively historical as more contemporary philosophic perspectives have gained ascendency – for example, Bruno Latour's Actor Network Theory (2005a) (e.g., Storni 2015 & Bannon et al. 2018 for a discussion of new directions).

So, one might ask, has Marx's influence run its course in design, is it spent? The answer is not quite. While direct reference to Marx's work has become less prominent (if not unheard of) in recent years, his influence can still be found to sit behind some key philosophic references which continue to hold weight in the field. Key among these is the work of critical theorists, who to varying degrees can be understood to offer Marxist perspectives aimed at enriching design agendas (see Bardzell et al. 2018 and a final Pathway in the last chapter, which maps out a potential thread of interest). Another important example is found in activity theory, which locates its origins in Marxist pre-Second World War Russian psychology. As a key contribution, activity theory provides human computer interaction (HCI) practitioners with a framework for conceiving of relations between subjects (i.e., people) and objects (i.e., things) in social terms and, in this, foregrounding social activity as the means by which the design of digital interactions should be approached (e.g., Kaptelinin and Nardi 2009). While the approach has not gained significant traction in the field, it does represent a potential Marxist-inspired perspective which contemporary practitioners might link to (see Rodgers 2012, pp. 55–60).

This concludes our outline of the historical Marxian/Marxist influence in design. In due course, we will consider what I believe to be an under-considered aspect of Marx's work relating to creativity.

The Dewey-Wittgenstein-Heidegger Baseline as a Means of Carrying Things Forwards

As was noted at the end of the last chapter, in drawing a baseline around Dewey, Wittgenstein and Heidegger as (the) key individuals who worked to overturn the western epistemological tradition, we are able to work outwards and create further linkages and open up additional pathways. Taken as a whole, this will allow us, in the end, to shape our eventual justificatory epistemological narrative for design research involving practice.

Having explored the background, growth and development of both design research and philosophy and, next to this, looking at the role that philosophy has played up in the field of design, up to the present, it may now be asked: How are things to be taken forward from here? Where might a Dewey-Wittgenstein-Heidegger baseline lead us?

We have already seen that, through a focus on the broad themes of experience, action and communication, Dewey-Wittgenstein-Heidegger worked independently to devise a vision of knowledge framed around the concepts of *transformation*, *participation*, *uncertainty* and *difference/diversity*. These will remain our central concepts.

44 *Introduction*

But there is more. These concepts will be explored via a sequential consideration of the ideas of 'positioning', 'processing' and 'producing' in research – the opening terms for Chapters 1, 2 and 3 respectively. While the meaning of these terms will emerge gradually, it will be helpful to briefly define the specific meaning of each here:

- Positioning refers to starting points for research – how one models one's role as a researcher, both in terms of a relationship to context but also in terms of one's individual capabilities and inherent personhood (i.e., who you are and what perspective you bring).
- Processing refers to the direct activities of conducting research, focusing in on what happens and when, and researchers' roles within this.
- Producing refers to the endpoint of research, what underscores or marks out validity in knowledge production and, again, the researchers' role within this.

By exploring these ideas next to the work of Dewey, Wittgenstein and Heidegger we begin to shape our epistemological narrative for design research involving practice.

Having introduced the basic premises of the book and covered the latter points, we will now, finally, consider the overall structure of this book and how it links together as a whole.

The Structure of this Book

This book will proceed as follows. Moving on from this Introduction, the next chapter, Chapter 1, entitled 'Positioning: Working with Context in Experience,' explores *'positioning'* in the context of knowledge production. After a consideration of relevant design literature, as well as the notion of objectivity and how this is approached, the handling of the themes of experience and existence are explored across the work of Dewey-Wittgenstein-Heidegger as a means of handling positioning in design research involving practice.

It is shown that, in their own unique and separate ways, Dewey and Heidegger offer a useful account of how we find ourselves in the world and how, within this, we gradually find the world. The central principle drawn out here is that these philosophic accounts of contextual grounding may act as a starting point for launching/ conducting research/inquiries in specific, located, constrained situations as occurs in design research involving practice. The point is to explore ways of articulating and modelling our human presence and concerns in relation to our domain of interest, whether social, cultural, political or environmental. In this chapter, the examples of the transition design movement at Carnegie Mellon University and the Decolonising Design movement will be noted.

Following on from this in Chapter 2 – 'Processing: Making a World Together through Meaningful Inquiry' – the focus turns from experience and 'positioning' to *'process'*, which is here approached through the concepts of action and communication, with the latter pointing in particular to the areas of language and meaning. The chapter will open with a consideration of existing interlinkings of the design process and the methodological. Thereafter, I move to the offerings of Dewey-Wittgenstein-Heidegger. With Dewey, we look to his 'pattern of inquiry' and connect this to his theory of communication. Next, I consider Wittgenstein's presentation of how language and, more especially, meaning is grounded in the contexts of action and use,

Introduction 45

i.e., in saying and doing things with others. From here I set out Heidegger's framing of 'discovery' as well as his presentation of 'poetic thinking'. The chapter closes with a reflection on what all three mean collectively, as well as individually, in relation to design research involving practice.

The central principle drawn out here is that designer-researchers (who are seeking to enact change) must consciously attend to, and harness, the power of language-meaning in any negotiation of contextual concerns. It is the form/tool/space by which we make and remake our world together.

Key examples for this chapter will include the Women's Design + Research Unit led by Teal Triggs and Siân Cook, and the significance of tools in co-creative design processes.

The next chapter, Chapter 3 – entitled 'Producing: Knowing Value' – focuses in on the later stages of conducting design research involving practice, with the concepts of evidence, claiming and validity, along with knowing/knowledge being foregrounded. To begin, the existing positions of design researchers and theorists are explored. Then attention turns to how Dewey, Wittgenstein and Heidegger worked to reconstruct modern Western understandings of knowing and knowledge. Holding constant relation with design research involving practice, their perspectives are explored in relation to the idea of identifying when an endpoint has been reached and being satisfied that one's results may be seen to hold validity. A key example for this chapter is the Designing Quality in Interaction group at TU Delft in the Netherlands, who used philosophy to guide their efforts to move beyond the constraints of their original alignment to cognitive psychology and, instead, develop a designerly approach to knowledge production grounded in experience and emotion.

From here, the final chapter, entitled 'Understanding the Boundaries: An Early Map of Philosophic Insights, a Justificatory Narrative and What Next?', acts as a conclusion to the wider book by summarising and collecting together the core philosophic insights surfaced across the prior chapters. This begins with a concise recapitulation of the positions of Dewey, Wittgenstein and Heidegger. Then, a wider summary of the other perspectives touched upon through the pathways is offered.

Next, a map enabling decision-making in relation to one's position as a designer-researcher is presented. This acts as a visual presentation of the established alignments, which may be drawn across the field (i.e., highlighting those perspectives/approaches who are explicitly linking to specific philosophies), as well as those who might be seen to demonstrate implicit alignments, such as those that been noted. Brief consideration is also given to some additional philosophies which might offer the field of design valuable insights in the future.

Taken as a whole, the recapitulation, summary and map assembles as a series of accessible reference points, which begin to articulate the range of alternatives to the modernist Western conception of knowledge and knowledge production relevant to design research. From this, it is possible to issue a final general statement in relation to how design research involving practice might use these reference points to ground its handling of transformation, participation, uncertainty and difference/diversity. It is argued that this amounts to a renewed understanding of knowing and knowledge, which celebrates experience, process and progress. Seeking to anchor this claim, a key practical example will focus on the work of the Everyday Design Studio at Simon Fraser University in Vancouver, which, among other things, explores how philosophic principles can be derived from practical design research experience, e.g., by creating

46 Introduction

novel IoT devices and embedding these in real home environments to observe emergent human-technology relations. This points to the possibility of design research involving practice being positioned as a central activity in making sense of the world and our (human) position within it. Further examples will explore how – by adopting a clear philosophic stance – design research involving practice might be positioned as a guiding force in the framing of interdisciplinary research (e.g., the 'antidisciplinary' stance of MIT's Media). The chapter, and so the book, draws to a close with a final argument for a deeper philosophical fluency in design research. Here, the view being taken is that this would further enhance design's positioning within the context of knowledge production and, potentially, impact on the practice of philosophy too.

Notes

1. Duarte and colleagues (2018), for example, describe a process of supporting young forced-migrants to collaborate with members of the local community in a city in Germany to develop an app design that might support other migrants to navigate to both the city and the relevant services.
2. There is no limit to the nature of such challenges. Examples might be economic, social, political and so on. With Duarte et al. (2018) it is the issue of integration for young forced-migrants. For Olander (2015) it is the relationship between citizens and local government.
3. I boldly say disjointed because, with the exception of a few journals (e.g., Design Studies and Design Issues) and conferences (e.g., the Design Research Society), there are a few fora in which the various independent disciplines and sub-disciplines (you might say fields in the case of psychology, anthropology and sociology) have an opportunity to come together to listen to and begin to understand one another. Rather, the field presents itself in fragments, with some areas connecting to others and some not. The result is a general lack of consilience and consensus. Though not necessarily a problem on its own, it does limit the likelihood of exchange and growth.
4. It will be noted from the prior section and, perhaps, through general familiarity that design now operates in all of these areas and more.
5. See Lawson and Dorst (2011), for a comprehensive outline of design expertise.
6. Frayling himself does not make this link but it is possible to present him as doing so on the basis that he considers how insights derived from one's own practice might, conceivably if not desirably, be seen to constitute a form of research for practice.
7. Speaking as part of an RtD conference provocation in 2015, Frayling (2015) noted that he was disappointed by what he referred to as the 'theology' which had emerged within the field over the years. Concern for precise definitions he suggested was misplaced. As far as he was concerned, research through design was akin to action research and best understood as design being applied to solve a problem beyond design (see Frayling 2015).
8. Candy and Edmonds (2012) highlight a Glasgow 'written commentary' option which sees the artefact/creative work foregrounded (p. 134). Today, most institutions, in the UK and Australia at least, will still allow for such foregrounding with the caveat that there will likely be highly regulated, minimal rules for formatting and word count attached to the accompanying written component.
9. In spite of the existence of the conferences and journals named, it remains a significant challenge to properly open up a productive discourse across design academia, whether across national or disciplinary frontiers.
10. The figure of Thales is identified as the first known ancient philosopher, exploring questions relating to nature, metaphysics and ethics (e.g., O'Grady 2017). Pythagoras appears to have launched a cult centred around the study of mathematics and geometric form (e.g., O'Meara 1989). Heraclitus proposed that we attempt to approach the world with a focus on dynamic processes (e.g., Kahn 1979) (e.g., Blackson 2011 for a holistic account of their context; also see the last chapter for more on process philosophy).
11. See e.g., Blackson (2011) for a recent focused account of this period.
12. And, indeed, Christianity.

Introduction 47

13. Aristotle was deeply interested in what would now be termed science and the physical world. Indeed, it has been suggested that were he alive today he would most likely be a biologist (Grayling 2019, p. 80).
14. As is noted below, this period extends right through to the Reformation (when gradually the authority of the Roman church began to wane).
15. Though it has not been discussed, metaphysics was one of the foundational areas of philosophy, formerly outranking epistemology in importance. In this older philosophic model the discipline was divided into three key domains: natural philosophy (focusing on the natural world); moral philosophy (focusing on human concerns); and metaphysical philosophy (focusing on grand questions of existence) (e.g., Gaukroger 2002, pp. 37–38).
16. 'Occam' is a common variation of the original Ockham, within William of Ockham's name.
17. See e.g., Lepage (2012) for a consideration of this recovery of ancient philosophy.
18. See Gilmont (2016) for a consideration of the relationship between the Reformation and the printing press.
19. Wider critical perspectives can be obtained from Anstey (2004).
20. As an aside point, Dewey, one of our baseline philosophers, may be seen as an heir of the empirical perspective.
21. The Socratic method can be seen as a special form of dialectic, in that it is based on an exchange which aims to develop a higher degree of clarity.
22. An introduction to Hegel can be found in Houlgate (2005).
23. The matter is further complicated by the fact that, in the late 1960s, the term 'radical' was formally attached to then-divergent perspectives such as Marxism and feminism, which challenged the academic orthodoxy of the time, i.e., analytic philosophy. A Radical Philosophy group was formed with the view of establishing publications and forums for publication, which led eventually to the founding of the *Radical Philosophy Journal*, which is still in print today (see Osborne and Sayers 2013).
24. It must be acknowledged that Kautzer (2015) is approaching radical philosophy via critical theory. Nonetheless, his definition of the radical is still of value to us here.
25. This angle within Marx's work is best articulated in his famous quote from Theses on Feuerbach: 'The philosophers have only interpreted the world, in various ways. The point however is to change it' (1941/1888, p. 84).
26. While it is not possible to offer a full history of classical pragmatism, the following can be noted. We have already briefly explored in the Prologue how pragmatism first took form at the close of the nineteenth century (see Thayer 1968 for a very useful early history; also see Wiener 1949). The movement faded at the onset of the second world war as certain forms of analytic philosophy (e.g., logical empiricism) began to gain traction in the United States (Bernstein 2010). It is difficult to trace this decline historically as, in many cases, it might be claimed that pragmatism lived on conceptually in new forms. For example, through the work of C. I. Lewis, who was also linking to emergent strands of work such as Logical Empiricism (e.g., Murphey 2005). There is also the contention that classical pragmatist themes may be traced out both historically prior to or alongside pragmatism proper (e.g., Brandom 2002; Putnam 1995; Okrent 1988), as well as in contemporary philosophy (e.g., Philström 2015).
27. For example, if we ask 'What is virtue?' we are dealing with an abstract concept and must therefore operate on an abstract basis, removed from real world concerns. However, if we ask 'What does virtuous action involve', we are, to a degree, required to refer to cases and examples which will have to reference (or be compared with) recognisable scenarios.
28. Though some would question the extent to which his work can be seen as 'phenomenological', we can certainly say that he was inspired by a prominent phenomenologist – its founder in fact – Edmund Husserl, and that he, in turn, continues to inspire those who seek to contribute to this area.
29. Some would say it even extends further. Research has for example revealed that Dewey's texts were mandatory reading in some design departments are far back as the 1930s (see Findeli 1990).
30. As an aside, in political writings, Latour (2005b) draws a key reference to Heidegger's Thing theory (see Heidegger 2001/1971), which, in turn, has been imported into design via the work of Ehn and others (e.g., Telier 2011). This Heideggerian Thing reference will be explored in the next chapter in Pathway 1.1.

48 *Introduction*

31. Marenko and Brassett see their Deleuzean exploration of design as sitting within the bounds of what is referred to as the philosophy of design, highlighted shortly. I highlight it here because of its explicit focus on one voice, or set of voices (i.e., it draws in Felix Guattari too) over the philosophy of design more broadly.
32. For example, while the U.K.'s Research Excellence Framework will allow for submissions, which rely on practice as an aspect of their method, research itself is defined 'as a process of investigation leading to new insights, effectively shared' (REF 2020, p. 119). Here, the idea of effective sharing (i.e., dissemination) honors the idea of explicit knowledge.
33. This will likely be a startling fact to those not already aware (see Young 1998, for an overview). It remains a highly challenging and controversial aspect of his legacy, and for many renders his work untouchable. The view taken here is that careful acknowledgment of Heidegger's Nazi past, where relevant, can go some way to mitigating any potential harms that might result from reference to his corpus and tacitly legitimatising his former politics.
34. There are some compelling biographies available on all three. For Wittgenstein see e.g., Monk (1991). For Dewey see Martin (2002). For Heidegger see Safranski (1999).
35. This of course links directly to his attempt to reorientate philosophy (see the Introduction). We can in a sense see the proposed reorientation as an offshoot of the insights which gave rise to the later work (i.e., that the meaning of words *relies* on use).
36. This is an especially complex aspect of Heidegger's philosophy and its full depth cannot be properly conveyed in a single sentence or, indeed, a footnote. However, in simple terms, 'turning' may be considered as follows. Heidegger was deeply troubled by what he saw as the technological 'enframing' (termed Gestell) of our existence. The only way he believed that this might be overcome was via the 'turning' referred to above – an inward collective shift that would bring about an absolute change in humanity's relationship with the world, drawing us into an immediacy with being. As George Pattison puts it, man would change from 'man the maker, Lord of creation, Master of the Universe, in the Shepard of Being, the one who waits' (2000, p. 4). This envisaged turning was in part what drew him to National Socialism. Here, he believed that the Nazis might be capable of enabling such a profound ontological transformation, giving rise to a completely new outlook in Western civilisation (e.g., Young 1998).
37. In essence, this notion of having to seek certainty when pursuing knowledge would be exemplified by the work of Descartes (see previous).
38. Dewey argued this very point 70 years later in his work *Reconstruction in Philosophy* (Dewey 1982/1920).
39. Of course, I must again underscore that Heidegger's association with the Nazi regime has to be properly acknowledged in any representation or appropriation of his work. How this is to be done will depend on the individual effort.
40. Such a claim is of course debatable and would likely meet with much opposition, particularly among those who adhere to a critical theory perspective. I here align with the position put forward by Antony Grayling in his *The History of Philosophy* (2019), where he categorises Foucault (and others including key critical theorists) as 'having primary interests in sociology, politics, social and critical theory and the history of ideas' (p. 519) as opposed to philosophy.
41. It is important to note that the label Marxism is not to be seen as representing a single homogenous agenda. Rather there are many 'Marxisms', which each subscribe to specific readings of Marx's work. Some will focus on economic aspects, others political or social, or even environmental or feminist. Notionally they will share certain abstract concerns but ultimately operate according to an individually located framework. For a discussion of the historical development and branching of the movement, see Wallerstein (1986).
42. The Arts and Crafts movement marks a special early rejection of industrialism in favour of more traditional, holistic approaches to art and design. Though Morris acted as a key figurehead, many others would link to the movement from the late-nineteenth into the early twentieth century. For a history of the movement's evolution and the personalities involved, see Greensted (2010).

References

Anagnostopoulos, G. (Ed.), 2009. *A Companion to Aristotle*. Oxford: Oxford University Press.
Anstey, P. R. (Ed.), 2004. *The Philosophy of John Locke: New Perspectives*. Abingdon: Routledge.

Baghramian, M., and Marchetti, S., 2017. *Pragmatism and the European Traditions: Encounters with Analytic Philosophy and Phenomenology Before the Great Divide*. Abingdon: Routledge.

Bang, A. L., and Eriksen, M. A., 2014. 'Experiments all the way in programmatic design research'. *Artifact: Journal of Design Practice*, 32, pp. 4.1–4.14.

Bang, A. L., Krogh, P., Ludvigsen, M., and Markussen, T., 2012. 'The role of hypothesis in constructive design research'. In *4th the Art of Research: Making, Reflecting and Understanding*. Helsinki, Finland: Aalto University School of Arts, Design and Architecture, 28–29 November.

Bannon, L., Bardzell, J., and Bødker, S., 2018. 'Reimagining participatory design'. *Interactions*, 26(1), pp. 26–32.

Bardzell, J., Bardzell, S., and Blythe, M. A. (Eds.), 2018. *Critical Theory and Interaction Design*. Cambridge, MA: The MIT Press.

Bason, C., 2016. *Policy Design*. Abingdon: Routledge.

Beaney, M. (Ed.), 2013. *The Oxford Handbook of The History of Analytic Philosophy*. Oxford: Oxford University Press.

Bernstein, R., 2010. *The Pragmatic Turn*. London: Polity Press.

Bestley, R., and Noble, I., 2016. *Visual Research: An Introduction to Research Methods in Graphic Design*. London: Bloomsbury.

Biggs, M., 2002. 'The role of the artefact in art and design research'. *International Journal of Design Sciences and Technology*, 102, pp. 19–24.

Bjögvinsson, E., Ehn, P., and Hillgren, P. A., 2012. 'Design things and design thinking: Contemporary participatory design challenges'. *Design Issues*, 28(3), pp. 101–116.

Blackson, T., 2011. *Ancient Greek Philosophy: From the Presocratics to the Hellenistic Philosophers*. London: John Wiley and Sons Ltd.

Bousbaci, R., 2020. *L'Homme comme un "être d'habitude": Essai d'anthropologie et d'épistémologie pour les Sciences du design*. Québec City: Presses de l'Université Laval.

Brandom, R., 2002. *Tales of the Mighty Dead: Historical Essays in the Metaphysics of Intentionality*. Cambridge, MA: Harvard University Press.

Brandt, E., and Binder, T., 2007. 'Experimental design research: Genealogy, intervention, argument'. Paper presented at International Association of Societies of Design Research conference, Hong Kong, China, 12–15 September.

Bremner, C., and Rodgers, P., 2013. 'Design without discipline'. *Design Issues*, 29(3), pp. 4–13.

Brennan, A., 2015. 'Olivetti: A work of art in the age of immaterial labour'. *Journal of Design History*, 28(3), pp. 235–253.

Buchanan, R., 1985. 'Declaration by design: Rhetoric, argument, and demonstration in design practice'. *Design Issues*, pp. 4–22.

Buchanan, R., 2001. 'Design and the new rhetoric: Productive arts in the philosophy of culture'. *Philosophy & Rhetoric*, 34(3), pp. 183–206.

Buchanan, R., 2007. 'Strategies of design research: Productive science and rhetorical inquiry'. In M. Ralf (Ed.), *Design Research Now*, pp. 55–66. Basel: Birkhäuser.

Buchanan, R., 2009. 'Thinking about design: An historical perspective'. In A. Meijers (Ed.), *Philosophy of Technology and Engineering Sciences*, vol. 9, pp. 409–453. Amsterdam, NH: Elsevier.

Buchanan, R., 2015. 'Worlds in the making: Design, management, and the reform of organizational culture'. *She Ji: The Journal of Design, Economics, and Innovation*, 1(1), pp. 5–21.

Burns, C., Cottam, H., Vanstone, C., and Winhall, J., 2006. *RED Paper 02: Transformation Design*. London: The Design Council.

Candy, L., and Edmonds, E., 2012. 'The role of the artefact and frameworks for practice-based research'. In M. Biggs and H. Karlsson (Eds.), *The Routledge Companion to Research in the Arts*, pp. 120–140. Abingdon: Routledge.

Cash, P., 2020. 'Where next for design research? Understanding research impact and theory building'. *Design Studies*, 68, pp. 113–141.

50 Introduction

Chen, D. S., Cheng, L. L., Hummels, C., and Koskinen, I., 2016. 'Social design: An introduction'. *International Journal of Design*, 10(1), pp. 1–5.

Clarke, D. M., 1982. *Descartes' Philosophy of Science*. Manchester: Manchester University Press.

Cooper, R., Dunn, N., Coulton, P., Walker, S., Rodgers, P., Cruikshank, L., Tsekleves, E., Hands, D., Whitham, R., Boyko, C. T., and Richards, D., 2018. 'Imagination Lancaster: Open-ended, anti-disciplinary, diverse'. *She Ji: The Journal of Design, Economics, and Innovation*, 4(4), pp. 307–341.

Cottingham, J. (Ed.), 1992. *The Cambridge Companion to Descartes*. Cambridge: Cambridge University Press.

Cross, N. (Ed.), 1984. *Developments in Design Methodology*. Chichester: John Wiley and Sons.

Cross, N., 1999. 'Design research: A disciplined conversation'. *Design Issues*, 15(2), pp. 5–10.

Cross, N., 2001. 'Designerly ways of knowing: Design discipline versus design science'. *Design Issues*, 17(3), pp. 49–55.

Cross, N., 2018. 'Developing design as a discipline'. *Journal of Engineering Design*, 2912, pp. 691–708.

Dalsgaard, P., 2014. 'Pragmatism and design thinking'. *International Journal of Design*, 8(1), pp. 143–153.

Dancy, R. M., 2004. *Plato's Introduction of Forms*. Cambridge: Cambridge University Press.

Dearden, A., 2006. 'Designing as a conversation with digital materials'. *Design Studies*, 27(3), pp. 399–421.

Deleuze, G., 1994 [1968]. *Difference and Repetition*. Translated by P. Patton. London: Continuum.

Deleuze, G., and Guattari, F., 2004 [1980]. *One Thousand Plateaus: Capitalism and Schizophrenia*. Translated by B. Massumi. London: Continuum.

Den Ouden, E., 2011. *Innovation Design: Creating Value for People, Organizations and Society*. London: Springer.

Dewey, J., 1981 [1925]. *The Collected Works of John Dewey: The Later Works, 1925–1953, vol. 1, Experience and Nature*. Edited by J. A. Boydston. Carbondale, IL: Southern Illinois University Press.

Dewey, J., 1982 [1920]. *The Collected Works of John Dewey: The Middle Works, 1899–1924, vol. 12, Essays, Miscellany and Reconstruction in Philosophy*. Edited by J. A. Boydston. Carbondale, IL: Southern Illinois University Press.

Dewey, J., 1984 [1929]. *The Collected Works of John Dewey: The Later Works, 1925–1953, vol. 4, the Question for Certainty*. Edited by J. A. Boydston. Carbondale, IL: Southern Illinois University Press.

Dilnot, C., 2017. 'Design, knowledge and human interest'. *Design Philosophy Papers*, 15(2), pp. 145–163.

Dixon, B., 2020. *Dewey and Design: A Pragmatist Perspective for Design Research*. Cham: Springer.

Dixon, B., 2021. 'Scoping a justificatory narrative for design practice in research: Some epistemological intersections in Dewey, Wittgenstein and Heidegger'. *Design Issues*, 37(2), pp. 77–88.

Dorst, K., 2015. *Frame Innovation: Create New Thinking by Design*. Cambridge, MA: The MIT Press.

Dorst, K., and Cross, N., 2001. 'Creativity in the design process: Co-evolution of problem – solution'. *Design Studies*, 22(5), pp. 425–437.

Dourish, P., 2001. *Where the Action Is*. Cambridge, MA: The MIT Press.

Duarte, A. M. B., Brendel, N., Degbelo, A., and Kray, C., 2018 'Participatory design and participatory research: An HCI case study with young forced migrants'. *ACM Transactions on Computer-Human Interaction (TOCHI)*, 25(1), pp. 1–39.

Durant, W., 2006 [1926]. *The Story of Philosophy*. New York: Pocket Books.

Durling, D., and Friedman, K. (Eds.), 2000. *Doctoral Education in Design: Foundations for the Future*. Staffordshire, UK: Staffordshire University Press.

Ede, A., and Cormack, L., 2017. *A History of Science in Society: From Philosophy to Utility*, 3rd edition. Toronto: Toronto University Press.

Eggleston, B., and Miller, D. E., 2014. *The Cambridge Companion to Utilitarianism*. Cambridge: Cambridge University Press.

Ehn, P., 1988. *Work – Oriented Design of computer Artifacts*. Ph.D. Dissertation. Stockholm: Arbetslivscentrum.

Elster, J., 1986. *An Introduction to Karl Marx*. Cambridge: Cambridge University Press.

Findeli, A., 1990. 'Moholy-Nagy's design pedagogy in Chicago (1937–46)'. *Design Issues*, 7(1), pp. 4–19.

Fine, G. (Ed.), 1999. *Plato I: Metaphysics and Epistemology*. Oxford: Oxford University Press.

Flusser, V., 2013. *The Shape of Things: A Philosophy of Design*. London: Reaktion Books.

Foucault, M., 1970. *The Order of Things: An Archeology of Knowledge*. Translated by A. M. Sheridan-Smith. London: Penguin.

Foucault, M., 1975. *Discipline and Punish: The Birth of the Prison*. Translated by A. M. Sheridan-Smith. London: Penguin.

Frayling, C., 1993. 'Research in art and design'. *Royal College of Art Research Papers*, 1(1), pp. 1–5.

Frayling, C., 2015. 'RTD 2015 provocation by Sir Christopher Frayling, part 1: Research through design evolution'. [Online]. Available at: https://vimeo.com/129775325 [Accessed: 29 September 2020].

Freeman, C., 2009. *A New History of Early Christainity*. New Haven, CT: Yale University Press.

Friedman, K., and Ox, J., 2017. 'PhD in art and design'. *Leonardo*, 50(5), pp. 515–519.

Fry, T., 2011. *Design as Politics*. London: Berg.

Fuller, R. B., 1963. 'Phase I document 1: Inventory of world resources, human trends, and needs'. In J. McHale (Ed.), *World Design Science Decade*, pp. 1965–1975. Carbondale, IL: Southern Illinois University.

Galle, P., 2002. 'Philosophy of design: An editorial introduction'. *Design Studies*, 23(3), pp. 211–218.

Gaukroger, S., 2002. *Descartes' System of Natural Philosophy*. Cambridge: Cambridge University Press.

Gaver, W., 2012. 'What should we expect from research through design?' In *Proceedings of the SIGCHI conference on human factors in computing systems*, pp. 937–946. New York: ACM.

Genova, J., 1995. *Wittgenstein: A Way of Seeing*. Abingdon: Routledge.

Gilmont, J. F. (Ed.), 2016. *The Reformation and Book*. Translated by K. Maag. Abingdon: Routledge.

Grant, D. P., 1979. 'Design methodology and design methods'. *Design Methods and Theories*, 13(1), 46–47.

Gray, C., and Mallins, J., 2004. *Visualizing Research: A Guide to the Research Process in Art and Design*. Abingdon: Routledge.

Grayling, A. C., 2019. *The History of Philosophy: Three Millennia of Thought Form the West and Beyond*. London: Penguin.

Greensted, R. P., 2010. *The Arts and Crafts Movement*. London: Bloomsbury.

Gregory, S. A., 1966. 'Design science'. In S. A. Gregory (Ed.), *The Design Method*, pp. 323–330. London: Butterworth.

Heidegger, M., 1977. *The Question Concerning Technology and Other Essays*. Translated by W. Lovitt. New York: Harper and Row.

Heidegger, M., 2001 [1971]. *Poetry, Language, Thought*. Translated by A. Hofstadter. New York: Harper and Row.

52 Introduction

Heidegger, M., 2010 [1927]. *Being and Time*. Translated by J. Stambaugh. Albany, NY: State University of New York Press.

Helix Centre, 2020. 'Helix centre: The healthcare innovation exchange centre'. [Online]. Available at: www.rca.ac.uk/research-innovation/research-centres/helix-centre/ [Accessed: 24 September 2020].

Hollis, R., 1994. *Graphic Design: A Concise History*. London: Thames and Hudson.

Houlgate, S., 2005. *An Introduction to Hegel: Freedom, Truth and History*. London: Wiley.

Ingold, T., 2000. *The Perception of the Environment: Essays on Livelihood, Dwelling and Skill*. Abingdon: Routledge.

Ingold, T., 2013. *Making: Anthropology, Archaeology, Art and Architecture*. Abingdon: Routledge.

Inns, T., 2009. *Designing for the 21st Century: Volume II: Interdisciplinary Methods and Findings*. London: Gower.

Jenkins, T., 2018. *Co-Housing IoT: Designing Edge Cases in the Internet of Things*. Unpublished Ph.D. Dissertation. Atlanta, GA: Georgia Institute of Technology.

Jenss, H., 2016. *Fashion Studies: Methods, Sites and Practices*. London: Bloomsbury.

Jones, J. C., 1992. *Design Methods: Designing Designing*. London: Wiley.

Jones, P., 2013. *Design for Care: Innovating Healthcare Experience*. New York: Rosenfeld Media.

Kahn, C. H., 1979. *The Art and Thought of Heraclitus*. Cambridge: Cambridge University Press.

Kaptelinin, V., and Nardi, B. A., 2009. *Acting with Technology: Activity Theory and Interaction Design*. Cambridge, MA: The MIT Press.

Kautzer, C., 2015. *Radical Philosophy: An Introduction*. Abingdon: Routledge.

Kensing, F., and Greenbaum, J., 2013. 'Hertiage: Having a say'. In J. Simonsen and T. Robertson (Eds.), *Routledge International Handbook of Participatory Design*. Abingdon: Routledge.

Kimbell, L., 2011. 'Rethinking design thinking: Part I'. *Design and Culture*, 3(3), pp. 285–306.

Kimbell, L., and Bailey, J., 2017. 'Prototyping and the new spirit of policy-making'. *CoDesign*, 13(3), pp. 214–226.

Koskinen, I., and Hush, G., 2016. 'Utopian, molecular and sociological social design'. *International Journal of Design*, 10(1), pp. 65–71.

Koskinen, I., and Krogh, P. G., 2015. 'Design accountability: When design research entangles theory and practice'. *International Journal of Design*, 91, pp. 121–127.

Koskinen, I., Zimmerman, J., Binder, T., Redström, J., and Wensveen, S., 2011. *Design Research Through Practice: From the Lab, Field, and Showroom*. Amsterdam: Elsevier.

Kraut, R. (Ed.), 1992. *The Cambridge Companion to Plato*. Cambridge: Cambridge University Press.

Krippendorff, K., 2006. *The Semantic Turn: A New Foundation for Design*. Boca Raton, FL: The CRC Press.

Krogh, P. G., and Koskinen, I., 2020. *Drifting by Intention: Four Epistemic Traditions from with Constructive Design Research*. Cham: Springer.

Lash, A. A., 1987. 'Rival conceptions in doctoral education in nursing and their outcomes: An update'. *Journal of Nursing Education*, 26(6), pp. 221–227.

Latour, B., 2005a. 'From realpolitik to dingpolitik or how to make things public'. In B. Latour and P. Weibel (Eds.), *Making Things Public: Atmospheres of Democracy*, pp. 14–41. Cambridge, MA: The MIT Press, ZKM, Center for Art and Media in Karlsruhe.

Latour, B., 2005b. *Reassembling the Social: An Introduction to Actor Network Theory*. Oxford: Oxford University Press.

Lawson, B. R., 1979. 'Cognitive strategies in architectural design'. *Ergonomics*, 22(1), pp. 59–78.

Lawson, B. R., and Dorst, K., 2011. *Design Expertise*. Abingdon: Routledge.

Leiter, B., and Rosen, M., 2007. *The Oxford Handbook of Continental Philosophy*. Oxford: Oxford University Press.

Lepage, J. L., 2012. *The Revival of Antique Philosophy in the Renaissance*. Basingstoke: Palgrave Macmillan.

Lowe, J., 2005. *Locke*. Abingdon: Routledge.

Mäkelä, M., 2007. 'Knowing through making: The role of the artifact in practice-led research'. *Knowledge, Technology & Policy*, 20(3), pp. 157–163.

Manzini, E., 2015. *Design When Everyone Designs*. Cambridge, MA: The MIT Press.

Marenko, B., and Brassett, J. (Eds.), 2015. *Deleuze and Design*. Edinburgh: Edinburgh University Press.

Margolin, V., 2010. 'Doctoral education in design: Problems and prospects'. *Design Issues*, 26(3), pp. 70–78.

Margolin, V., 2015. 'Social design: From utopia to the good society'. In M. Bruinsma & I. van Zijl (Eds.), Design for the Good Society, pp. 28–42. Utrecht: Stichting Utrecht Biennale.

Martin, J., 2002. *The Education of John Dewey*. New York: Columbia University Press.

Marx, K., 1941 [1888]. 'Thesis on Feuerbach'. In F. Engels (Ed.), *Ludwig Feuerbach and the Outcome of Classical German Philosophy*, pp. 82–84. New York: International Publishers.

Marx, K., 1992 [1844]. 'Economic and philosophical manuscripts' In K. Marx (Ed.), *Early Writings*, pp. 279–334. London: Penguin Classics.

Marx, K., and Engels, F., 2004 [1848]. *The Communist Manifesto*. London: Penguin.

McCarthy, J., and Wright, P., 2004. *Technology as Experience*. Cambridge, MA: The MIT Press.

McDonnell, J., 2015. 'Gifts to the future: Design reasoning, design research, and critical design practitioners'. *She Ji: The Journal of Design, Economics, and Innovation*, 1(2), pp. 107–117.

Mitchell, C. T., 1992. 'Preface'. In J. C. Jones (Ed.), *Design Methods: Designing Designing*, pp. ix–xiii. London: Wiley.

Moggridge, B., 2006. *Designing Interactions*. Cambridge, MA: The MIT Press.

Monk, R., 1991. *Wittgenstein: The Duty of Genius*. London: Vintage.

Morrison, D., 2011. *The Cambridge Companion to Socrates*. Cambridge: Cambridge University Press.

Murphey, M., 2005. *C. I. Lewis: The Last Great Pragmatist*. Albany, NY: State Univerity of New York Press.

Niedderer, K., 2007. 'Mapping the meaning of experiential knowledge in research'. *Design Research Quarterly*, 2(2). [Online]. Available at: www.drsq.org/issues/drq2-2.pdf [Accessed: 24 October 2020].

O'Grady, P., 2017. *Thales of Miletus: The Beginnings of Western Science and Philosophy*. Abingdon: Routledge.

Okrent, M., 1988. *Heidegger's Pragmatism: Understanding, Being, and the Critique of Metaphysics*. Ithaca, NY: Cornell University Press.

Olander, S., 2015. *The Network Lab: A Proposal for Design – Anthropological Experimental Set-Ups in Cultural Work and Social Research*. Ph.D. Dissertation. Copenhagen: Royal Danish Academy of Fine Arts, Schools of Architecture Design and Conservation.

O'Meara, D., 1989. *Pythagoras Revived: Mathematics and Philosophy in Late Antiquity*. Oxford: Oxford University Press.

Osborne, P., and Sayers, S. (Eds.), 2013. *Socialism, Feminism and Philosophy: A Radical Philosophy Reader*. Abingdon: Routledge.

Oxman, R., 2006. 'Theory and design in the first digital age'. *Design Studies*, 27(3), pp. 229–265.

Papanek, V., 1984. *Design for the Real World: Human Ecology and Social Change*. London: Thames and Hudson.

Parsons, G., 2015. *The Philosophy of Design*. Cambridge: Polity.

Pattison, G., 2000. *Routledge Philosophy Guidebook to the Later Heidegger*. Abingdon: Routledge.

54 Introduction

Pedgley, O., and Wormald, P., 2007. 'Integration of design projects within a Ph.D'. *Design Issues*, 23(3), pp. 70–85.

Phemister, P., 2006. *The Rationalists: Descartes, Spinoza and Leibniz*. Cambridge: Polity.

Philström, S., 2015. *The Bloomsbury Companion to Pragmatism*. London: Bloomsbury.

Polanyi, M., 1966. *The Tacit Dimension*. London: Routledge & Kegan Paul.

Potter, N., 1969. *What Is a Designer: Things, Places, Messages*. London: Studio Vista.

Prado, C. G., 2003. *A House Divided: Comparing Analytic and Continental Philosophy*. Amherst, NY: Humanity Books.

Press, M., and Cooper, R., 2003. *The Design Experience: The Role of Design and Designers in the Twenty-First Century*. Abingdon: Routledge.

Prigogine, I., 1997. *The End of Certainty: Time, Chaos, and the New Laws of Certainty*. New York: The Free Press.

Putnam, H., 1995. *Renewing Philosophy*. Cambridge, MA: Harvard University Press.

RCA, 2020. 'The Helen Hamlyn centre for design'. [Online]. Available at: www.rca.ac.uk/research-innovation/research-centres/helen-hamlyn-centre/ [Accessed: 24 September 2020].

Redström, J., 2017. *Making Design Theory*. Cambridge, MA: The MIT Press.

REF, 2020. *Guidance on Submissions*. London: HEFCW. [Online]. Available at: www.ref.ac.uk/media/1447/ref-2019_01-guidance-on-submissions.pdf [Accessed: 24 September 2020].

Resnick, S., and Wolff, R. (Eds.), 2006. *New Departures in Marxian Theory*. Abingdon: Routledge.

Robinson, L. B., 2020. *Research Based Programming for Interior Design*. London: Bloomsbury.

Rodgers, Y., 2012. 'HCI theory: Classical, modern, and contemporary'. *Synthesis Lectures on Human-Centered Informatics*, 5(2), pp. 1–129.

Rorty, R., 2009 [1979]. *Philosophy and the Mirror of Nature*, 30th anniversary edition. Princeton: Princeton University Press.

Roxburgh, M., and Irvin, J., 2018. 'The future of visual communication design is almost invisible or why skills in visual aesthetics are important to service design'. In *ServDes2018: Service Design Proof of Concept, Proceedings of the ServDes. 2018 Conference, Milano, Italy, No. 150*, pp. 199–215. Linköping: Linköping University Electronic Press, 18–20 June.

Ruse, M. (Ed.), 2009. *Philosophy After Darwin*. Princeton, NJ: Princeton University Press.

Russell, B., 1946. *History of Western Philosophy*. London: George Allen and Unwin Ltd.

Safranski, R., 1999. *Martin Heidegger: Between Good and Evil*. Translated by E. Osers. Cambridge, MA: Harvard University Press.

Sanders, E. B. N., and Stappers, P. J., 2008. 'Co-creation and the new landscapes of design'. *Co-Design*, 4(1), pp. 5–18.

Sanders, E. B. N., and Stappers, P. J., 2014a. 'Probes, toolkits and prototypes: Three approaches to making in codesigning'. *CoDesign*, 10(1), pp. 5–14.

Sanders, E. B. N., and Stappers, P. J., 2014b. 'From designing to co-designing to collective dreaming: Three slices in time'. *Interactions*, 21(6), pp. 25–33.

Sayers, S., 2011. *Marx and Alienation: Essays on Hegelian Themes*. Basingstoke: Palgrave Macmillan.

Scheidig, W., 1967. *Crafts of the Weimar Bauhaus, 1919–1924: An Early Experiment in Industrial Design*. New York: Rheinhold.

Schön, D. A., 1983. *The Reflective Practitioner: How Professionals Think in Action*. New York: Basic Books.

Schön, D. A., 1992. 'The theory of inquiry: Dewey's legacy to education'. *Curriculum Inquiry*, 22(2), pp. 119–139.

Schön, D. A., 1995. 'Knowing-in-action: The new scholarship requires a new epistemology'. *Change: The Magazine of Higher Learning*, 27(6), pp. 27–34.

Schön, D. A., and Rein, M., 1994. *Frame Reflection: Towards the Resolution of Intractable Policy Controversies*. New York: Basic Books.

Simon, H., 1996 [1969]. *The Sciences of the Artificial*, 3rd edition. Cambridge, MA: The MIT Press.

Sleeper, R. W., 1986. *The Necessity of Pragmatism: John Dewey's Conception of Pragmatism*. New Haven, CT: Yale University Press.

Stickhorn, M., and Schneider, J., 2012. *This Is Service Design Thinking: Basics, Tools, Cases*. Amsterdam: BIS Publishing.

Stone, A., 2011. *Edinburgh Critical History of Nineteenth-Century Philosophy*. Edinburgh: Edinburgh University Press.

Storni, C., 2015. 'Notes on ANT for designers: Ontological, methodological and epistemological turn in collaborative design'. *CoDesign*, 11(3–4), pp. 166–178.

Strawson, P. F., 1965. *The Bounds of Sense*. London: Metheun.

Tassinari, V., and Staszowski, E. (Eds.), 2020. *Designing in Dark Times: An Arendtian Lexicon*. London: Bloomsbury.

Telier, A., Binder, T., De Michelis, G., Ehn, P., Jacucci, G., Linde, P., and Wagner, I., 2011. *Design Things*. Cambridge, MA: MIT Press.

Toulmin, S., 1984. 'Introduction'. In J. A. Boydston (Ed.), *The Collected Works of John Dewey: The Later Works, 1925–1953, vol. 4, the Quest for Certainty*, pp. i–xxii. Carbondale, IL: Southern Illinois University Press.

Tsekleves, E., and Cooper, R. (Eds.), 2017. *Design for Health*. Abingdon: Routledge.

Urbach, P., 1987. *Francis Bacon's Philosophy of Science*. La Salle, IL: Open Court.

uxlabs, 2022. 'User experience research + design solutions'. [Online]. Available at: http://uxlabs.co.uk/ [Accessed: 12 April 2022].

Varga, D., 2017. 'Fintech, the new era of financial services'. *Vezetéstudomjny-Budapest Management Review*, 48(11), pp. 22–32.

Vaux, D. E., and Wang, D. (Eds.), 2021. *Research Methods for Interior Design: Applying Interiority*. Abingdon: Routledge.

Vermass, P., Kroes, P. A., Light, A., and Moore, S. (Eds.), 2008. *Philosophy and Design: From Engineering to Architecture*. Dordrecht: Springer.

Vermass, P., and Vial, S. (Eds.), 2018. *Advancements in the Philosophy of Design*. Cham: Springer.

von Hippel, E., 2005. *Democratizing Innovation*. Cambridge, MA: The MIT Press.

Wallerstein, I., 1986. 'Marxisms as utopias: Evolving ideologies'. *American Journal of Sociology*, 91(6), pp. 1295–1308.

Weinberg, J. R., 1964. *A Short History of Medieval Philosophy*. Princeton, NJ: Princeton University Press.

Weingarden, L., 1985. 'Aesthetics politicized: William Morris to the bauhaus'. *Journal of Architectural Education*, 38(3), pp. 8–13.

Wiener, P. P., 1949. *Evolution and the Founders of Pragmatism*. Cambridge, MA: Harvard University Press.

Wittgenstein, L., 1963 [1958]. *Philosophical Investigations*. Translated by G. E. M. Anscombe. Oxford: Basil Blackwell.

Wittgenstein, L., 2013 [1921]. *Tractatus Logico-Philosophicus*. Abingdon: Routledge.

Woolhouse, R. S., 1988. *The Empiricists*. Oxford: Oxford University Press.

Young, J., 1998. *Heidegger, Philosophy, Nazism*. Cambridge: Cambridge University Press.

Zimmerman, J., and Forlizzi, J., 2008. 'The role of design artifacts in design theory construction'. *Artifact: Journal of Design Practice*, 2(1), pp. 41–45.

1 Positioning
Working with Context in Experience

This chapter marks a first step in our exploration of the Dewey-Wittgenstein-Heidegger baseline as a means of developing a justificatory narrative for design research involving practice. Our focus here is directed towards the idea of 'positioning', which, as was discussed at the end of the last chapter, relates to the starting point for research – the modelling both of one's relationship to the context of the work, as well as one's understanding of one's self (i.e., as a person with a particular historical, sociocultural background and accompanying set of beliefs).

With regards to drawing links to the work of Dewey-Wittgenstein-Heidegger, two key themes are foregrounded throughout the following discussion: experience, which as has been seen is core to their basic philosophic offering and, next to this, existence. As we will see, their perspectives vary, but they can be drawn together to offer a meaningful set of reference points, which, in turn, point outwards to other perspectives (e.g., the ecological or the decolonial) that extend beyond their direct individual visions.

The detail of all of this, however, is for later and will be covered in due course. First, in order to situate ourselves, we will turn directly to design research. Accordingly, the chapter commences with a discussion of how the initial phase of design research involving practice is often characterised or modelled around there being 'motivational contexts', i.e., an interest or set of interests which open up a space of or for research. In the next section, we will then move on to look at characterisations of the 'role' of researchers and the designer-researcher in particular, examining, in detail, the notion of objectivity and how it is approached in research. Here, calling up a number of presentations, it will be noted that researchers must define a position in regards to their role in the space of the research, and in the case of design for change this presents a special challenge. Both of these discussions – on motivational contexts and the role of the designer-researcher – will lead into a consideration of how Dewey-Wittgenstein-Heidegger tackle the theme of experience, as well as the bigger question of existence. From this, we consider the general relevance of their insights for design research involving practice. The chapter then closes with two relevant examples of how design research may be 'positioned'. The first is the transition design movement which links to an ecological orientation. The second and last is the decolonising design movement, linking of course to the decolonial perspective.

We begin then with motivational contexts – the starting points for design research involving practice.

Motivations in Design Research

When it comes to research, especially design research involving practice, we have to start somewhere. In the simplest possible terms, there must be something which would

DOI: 10.4324/9781003194309-3

Positioning 57

benefit from a process of change/transformation, be it a problem or, conversely, an opportunity that might open up certain possibilities. This much will be obvious. The challenge lies in characterising this point of commencement.

If one were inclined to be cynical, one might focus on *extrinsic* motivations and say that, no matter what the problem or opportunity, it will be funding opportunities and the need to generate research income that mark the starting point for such research or, indeed, all forms of research. This will be true to an extent and indeed cannot be ignored. Such imperatives will inevitably motivate a great deal of work but realistically, within design research involving practice, there must also be willingness to work within the bounds of the real world, to get 'stuck in' so to speak, to make things happen. If we are to characterise this initial part of the process appropriately, there needs to be thought given to what *intrinsically* motivates design research involving practice.

Recent years have seen a discussion develop around the subject of what may be characterised as *intrinsic motivations* in design research involving practice. As was noted in the last chapter, Zimmerman and Forlizzi (2008) suggest that there were two key motivational orientations in such research: the 'philosophical' and the 'grounded'.

Most often, it would seem that it is the latter – the grounded – which is held in focus when design involving practice/for change is considered. Here, in sketching out a picture, we may envisage a dedicated designer-researcher, with sleeves rolled up, passionately engaged in the 'problems' of the world, using design as a central, indispensable tool within their research process as they set about working to resolve an otherwise intractable situation. This would appear to represent 'classic' design research involving practice.

Next to this, the philosophical presents what is perhaps a less obvious image or set of possibilities. Here, the designer-researcher is said to be guided by intellectual concerns, which relate to a given area of practice (e.g., ways of approaching/framing interaction design) and may be explored through a process of making. This category is not as easily imagined as the previous but notionally we might picture a group of scholarly designer-academics with a deep concern for the process of theorising practice but who also hold a strong *empirical* orientation, and are able to move from one to the other.

From Zimmerman and Forlizzi, Bang and colleagues (2012) – whose contribution here was, again, also noted in the last chapter – sought to expand this binary presentation, arguing that the grounded-philosophical categories alone were inadequate when seeking to cover the full range of possible motivational contexts within design research. While they ultimately suggest that this range may essentially be seen as infinite (because each project, be it a PhD or otherwise, will be unique), they also propose that a possible motivational starting point may be identified in the process of juxtaposing two separate but related areas. Their presentation includes a discussion of six separate examples, with the relationship between ethical concerns strongly represented within the grouping. Here, specific juxtaposing combinations include ethics and practice, ethics and technology and ethics and politics. In other combinations, we see the 'empirical' and the technological being brought together, as well as the 'practice-based and artistically-inclined' being linked to the technological. The group also notes that it appears as though 'theory', i.e., external framings of given entities or phenomenon, does not often act as a motivational context within such research.

Looking beyond these explicit treatments of motivations, elsewhere in the literature we may identify implicit reference to the subject. A good example is to be found in Joyce Yee's consideration of methodological innovation in what she terms practice

58 *Positioning*

doctorates in the design (2010). Here, Yee explores six early examples of design PhDs which involve practice as part of their method. Though she is not concerned with motivations as such, the subject matter of each PhD project does suggest a strong motivational context at play in each.

Many take on a specific practical issue and seek to resolve it through focused experimentation. In relating her examples to the above presentations, we may detect a strong 'philosophical' orientation across a majority. In this, it is possible to infer that many seek to explore the viability of potential intellectual framings of specific practices or aspects of practice and use the space of doctoral research to resolve their framework.

The work of Catherine Dixon may be presented as an example here. Dixon focused on typography, looking in particular at ways of describing type forms (i.e., the historical/structural categories to which particular typefaces or fonts could be seen to align). According to Yee the research was 'initiated for the purposes of enriching or modifying aspects of a particular profession' (p. 8). Dixon's method was practice-based in that she engaged in visual experimentation – the outcomes of which were tested through reflection and peer reviews – to progressively develop her eventual descriptive framework. The resultant outcome is seen to amount to research *through* design *and* research *for* design, as per Frayling's categories (see the Introduction).

The *'for'* is worthy of brief consideration here. It would seem that philosophically motivated work in design research involving practice, i.e., work seeks to ask/answer intellectually bound questions, will, at least in most cases, offer a contribution which may stand as a contribution *for* design. This is because any resultant frameworks or theories will inevitably link back to the conduct of practice – how it is conceptualised, approached and enacted. Be it a descriptive framework for typography as developed by Dixon, or an interlinking of such areas as technology and ethics, as presented in the Bang et al. examples (2012).

The picture of motivations revealed by the above is thus complex. While Zimmerman and Forlizzi's (2008) binary categories are sensible, they are not, as Bang et al. (2012) note, adequate in and of themselves. In design research involving practice, motivations seem to form and develop in unexpected ways, whether in juxtapositions as the latter authors propose or through the conduct of practice in research.

From this consideration of motivations as starting points for design research, we turn to consider how we might approach the 'position' designer-researcher in the context of design research involving practice, first giving consideration to how, in 'classical terms', the researcher is supposed to position themselves in relation to their work.

Objectivity in Research: The Position of the Researcher and the Designer-Researcher

In the Prologue, it was noted how, based on the necessity of participation, design research involving practice challenges the classical notion of objectivity as a central value within research. In essence, the issue there is that if one is participating and seeking to achieve a particular result (i.e., bringing about a particular *form* of *change*) one can hardly claim to have been impartial, either at the outset or within the process. Accordingly, any attempts to uphold a commitment to notions of objectivity will eventually falter, if not fail entirely.

While this may seem unsettling, it is not the first time that such questions have arisen within knowledge production. Indeed, as we see below, the questioning of the

role of the researcher is not unique to design research involving practice. Over the last number of decades, there has been much discussion and debate around the role of researchers within almost all disciplines and fields of study, including the natural sciences. At its heart, this discussion is concerned with the possibility of practicing true *objectivity* in knowledge production, i.e., the idea that, through appropriate conduct, one might obtain a clear and definite understanding of the 'object' of study, whether an atom, a type of social interaction, or particular psychological phenomenon.

One of the first and, perhaps, still one of the most powerful critical examinations here came from Thomas Kuhn in his well-cited text, *The Structure of Scientific Revolutions* (2012/1972). In this work, Kuhn proposed that, historically, science did not develop in a linear fashion with the objective experimental observations of various researchers leading to expansion in the agreed 'facts', as was (and often still is) commonly supposed. Rather, on his analysis, its progress was found to be episodic and abrupt, with a series of short, sharp 'revolutions' that each overturned the prior assumptions of earlier approaches and opened up new horizons in inquiry.

For Kuhn, such revolutions did not happen by chance but instead arose as a matter of necessity. Ultimately, when a particular, prevalent model of science began to accumulate too many anomalies, research communities would gradually open up to the potential of new theories or conceptual frameworks that were found to be more productive accounts of reality, i.e., one that accommodated the apparent anomalies and allowed for new and hitherto unimagined advances. In essence, through these revolutions, one belief system, or 'paradigm' as Kuhn put it, gave way to another. With this, the thinking, the terminology and the practices all changed – and on the basis of the new theory/frameworks, a new 'objectivity' emerged.

For many, Kuhn's work was unsettling because it called into question the idea that science was guided *only* by rationality, that it did *not* maintain a *constant* standard of objectivity. Some went so far as to interpret his proposals as suggesting that all science was *relative*, i.e., that it was bound only to *subjective* beliefs (e.g., Scheffler 1982).[1] Others however, saw this opening as an opportunity to instigate reform. From the publication of Kuhn's work in the early 1970s, a vigorous 'sociology of science' emerged, which sought to examine the culture of science – how its members acted, interacted and ultimately generated meaning together (e.g., Restivo 1994 for a history). Alongside this, those associated with the perspectives of feminism and social theory began to advocate for a reframing of our understanding of science and research, of how both should be understood and how they might operate in the future.

Feminist contributions here are often characterised as offering a 'feminist epistemology', i.e., a feminist theory of knowledge (Alcoff and Potter 1993). Initially, such theorists did not view science's claim to objectivity as problematic in and of itself. Rather, they argued that it needed to be enhanced. This would be possible, some claimed, if a more careful approach were taken to analysing and reworking its assumptions – rebuilding it, as it were, to accommodate a feminist outlook (e.g., Harding 1986). More radical views were put forward by others, such as Donna Haraway, who argued that rather than claiming absolute objectivity it would be more sensible to acknowledge the situated, partial nature of one's work. Here, by abandoning any claims to holding a neutral position, a view from 'nowhere', a revised form of objectivity becomes possible (see Haraway 1988).

Compared to the feminists, the arguments of the social theorists were more diffuse. Two key strands stand out however. Here, firstly, we may note again the work of the

60 *Positioning*

critical theorist, Michael Foucault, who, as we have seen in the last chapter, developed an historically bound argument which posited that knowledge was not, in actuality, the neutral product of an abstract process but rather a social outcome which was defined and controlled by those in positions of power and was often used as means of maintaining that power (e.g., Foucault 1970). In many ways, this mirrors the criticism of feminists who sought to surface what was seen as an unarticulated masculine bias within scientific practices; only the distinction here is that what is unarticulated and problematic extends beyond mere gender bias and relates to broader economic and cultural issues.

Next to this, there is also the recent work of those aligned to the arenas of science and technology studies, with contributors such as Bruno Latour and Stephen Woolgar (1986) calling for a revision of the grounding ontology (i.e., the theory of being) within science and social research more generally. Here, focus is directed towards what is perceived to be the contradiction at the heart of modernist conceptions of the world and how things connect to other things. We have already encountered Latour's actor network theory in the last chapter, where the social world is presented as a series of relationships between humans and nonhumans. In prior work, Latour also critiqued the idea that humanity and the man-made constitute one reality, and 'nature' another (e.g., Latour 1993). Similarly, and importantly in the context of our present discussion, he and Woolgar also rejected the classic notion of objective truth underwriting 'facts' as definite, existential things. Their ultimate claim is that rather than truth and facts, we only have *discourse* – that is, sustained interpersonal interactions which are bound by sociocultural norms (see Latour and Woolgar 1986).

In broad terms, such work may be characterised as *pointing* to, if not quite defining, the possibility of a *social* epistemology. Here, the essential argument is that, despite appearances to the contrary, knowledge production is not an individual enterprise but rather finds its grounding in the regulation of normative practices of given communities, be they scientists or another group of researchers (e.g., Haddock et al. 2010).

Reflecting on that, we can say that, quite simply, all of this has had and continues to have implications for our present-day understanding of the role of the researcher and the status of the natural and social sciences. In the natural sciences, there is now an increasing acceptance and recognition that all conclusions are *contingent*, i.e., that they may, in time, be overturned by future research. This is generally termed a 'post-positivist' stance, i.e., it amends the classical 'positivist' view somewhat. As was suggested in relation to Kuhn's understanding of science, notions of objectivity persist here. However, it is perhaps best understood as an evolving concept rather than a constant standard – something which changes and will change based on methodological and theoretical adaption (e.g., Machamer and Wolters 2004, p. 9).

Nonetheless, even today, there are still those who struggle with the idea that *pure* objectivity is no longer possible, that reality can't somehow be grasped outright. For example, some voices will still argue in favour of maintaining a neutral or value-free view of science on the basis that this has important implications in the context of policy recommendations and in relation to politics (e.g., Axtell 2016, pp. 158–159). Equally, there is a lingering insistence on continuing to use the word without acknowledging the idea that objectivity may vary in quality. For example, in defining science, the UK's Science Council still insists on the idea of 'objective observation' based on 'measurement and data' (Science Council 2020).

Positioning 61

Within the social sciences – which, broadly speaking, enfold the disciplines of sociology, psychology, economics, anthropology and archaeology, amongst others – things are somewhat different and perhaps more complicated. This is because there is no outright agreement, as such, as to what the overarching principles, aims and (even) the methods of each constituent field should be. To use Kuhn's terms, they are to be seen as 'pre-paradigmatic' in that they have not yet, as a community, settled on paradigm or belief systems. Indeed, it might be argued that, across the board, that things have become more diffuse, not less.[2]

From the late 1960s and early 1970s onwards,[3] there was an expansive opening up to the possibilities of alternative ways of approaching social research. In large part, this 'opening up' centred around the possibility of conducting *qualitative* research – that is, research which focuses on investigating the dimensions of human meaning and values and the ways in which these are established and shared as opposed to simply quantifying or measuring a given object (whether behavioural or meaning/value based) (e.g., Brinkman et al. 2014, for a history).

Guba and Lincoln (1994), two eminent sociological theorists, argued that this resulted in a situation where there are at least four competing paradigms at play within social research – positivist (see Chapter 1 and Polanyi), post-positivist (see previous paragraphs), critical theory (see Chapter 1) and constructivist (a perspective, which holds that knowledge is constructed between participants and inquirers; see Guba and Lincoln 1985). These competing paradigms each hold their own means of evaluation. As in the natural sciences, objectivity is retained as an absolute value in the context of positivism. Alongside this, it is also retained as a notional (if not fully achievable) ideal in the context of post-positivism. This is not the case, however, in the areas of critical theory and constructivism. For critical theory, the pair proposes that what matters is stimulating action, making change – a view that would make it very compatible with and appealing to design research involving practice. For constructivism, it is about seeking to maintain (and later demonstrating) trustworthiness and authenticity (see Guba and Lincoln 1994, p. 112). This clear divergence has its source in the expected role of the researcher in both of these latter paradigms, i.e., critical theory and constructionism. Ultimately, in both cases, it is expected that the researcher will *participate*, i.e., be part of the research as an actor in their own right.

Considering the idea of 'competing paradigms' within the social science more broadly, it would now be fair to say that many social science researchers and theorists would now generally accept the idea that knowledge may be derived by a variety of separate agendas and approaches, with plurality sometimes being upheld as a positive (e.g., Keating and Della Porta 2010). Here, what matters is the internal coherence of the method(s) applied and the way in which these are brought together within the project.

Indeed, today, there is an increasing acknowledgement that qualitative and quantitative approaches need not be separated in research. This is backed up by a growing *mixed methods* movement which, despite their apparently divergent commitments and background beliefs/worldviews, seeks to bring these two 'ways of working' together. Intriguingly, in the context of our present concern with philosophy and design research, those who theorise and advocate mixed method approaches tend to highlight the potential of *pragmatism* (i.e., the philosophic 'school' to which Dewey aligned) as a guiding background theory for such work[4] (e.g., Teddle and Tashakkori 2009; Creswell and Plano Clark 2011). This, in turn, has been picked up on within

62 Positioning

the design research literature, with the argument being presented that the coupling of pragmatism with a mixed methods approach offers academic design an ideal mode of inquiry/inquiring (see Melles 2008). While this proposal has not as yet received much direct attention within the literature, it remains available as a compelling thread to be picked up in the future.

This latter reference of course brings us back to design research proper. Reflecting on the broad shift described above in sciences – i.e., the movement from notions of absolute objectivity through to a more inclusive plurality (at least, in the social sciences) – what has the impact been in this field? What does it mean for the role of the researcher within design research?

Firstly, we may note that, in general terms, design research too has undergone a similar shift to that of the sciences. In the most straightforward sense, if we look back to the design methods movement, described in the last chapter, it is possible to detect a strong commitment to objectivity with such work (see Cross 1984). Tracing a forward path from here to design research involving practice, it possible to observe an 'opening up' to the possibilities of pluralism and values which eschew formal notions of objectivity. Indeed, the outline of this shift has been observed by some (e.g., Dorst 2008).

The designer-researcher, like the social scientist or social researcher, is now entitled to align with any coherent theoretical or philosophical perspective they choose so long as they do so consciously, with full awareness as to the implications and meaning of the decision they are making. They may wish to preserve the claim of objectivity, perhaps in a manner in keeping with the post-positivist perspective (i.e., that it is important to remain removed, personally and emotionally, from the research activities). This might, for example, be desirable in a project which singularly aims to test the efficiency of a digital product for example, evaluating whether or not it meets a set of predefined criteria.

However, with regard to the broad agenda of design research involving practice and, in particular, with regard to any commitment to enact change/transformation within the research process itself, it is simply not possible to uphold such a sharp view of objectivity – even if this is seen as desirable. As was noted at the beginning of this book – and as with critical theory and constructivism described above – in design research involving practice the designer-researcher's *participation* is a *necessity*. Again, this is because change and transformation must be *made* to happen. They have to be *brought* about; the designer-researcher must immerse themselves in the contexts of the research, they must imagine, propose, plan and act *for* change. In all probability they will have to *keep* acting, doing more and more, iterating and progressing to ensure that change (as measured against the specific goal of the research) is delivered in an appropriate matter.

This need for participation within design research involving practice – which requires personal investment, imagination, proposing, planning, acting – negates the possibility of a designer-researcher maintaining a disinterested or aloof stance. Ultimately, through their immersion in the research context, they cannot reasonably claim to somehow *stand apart* from the work, personally and emotionally. They are in it and of it, involved.

The question then arises: how is this to be handled? Should design research involving practice hold on to a *qualified, partial* understanding of objectivity? Or should it seek out an alternative, more appropriate means of characterising what it stands for, and how the role of the researcher is to be conceived?

We have noted some of the alternative participation-centred proposals of the social sciences previously, i.e., the idea of the researcher working to stimulate action from critical theory and maintaining trustworthiness and authenticity from constructivism. Are these concepts perhaps appropriate as a notional model of the 'role' of the designer-researcher? Could they be adapted or might something else be needed?

The design research literature does acknowledge the social sciences as a methodological reference point. Key texts such as *Design Research Through Practice: The Lab, the Field and Showroom* (Koskinen et al. 2011) detail the ways in which designer-researchers have adapted methods from such fields (p. 69). Equally, others talk about how designer-researchers might conform to conventional, social-science-based expectations as they frame starting points for their work. For example, when considering the formulation of research questions in design, Meredith Davis (2015) offers a series of tried and tested rules for the shaping of research questions, which would not be out of place in a standard social science textbook.

Nonetheless, throughout such work, we can detect a clear, if implicit, suggestion that designer-researchers' positioning is perceived as distinct. With Koskinen et al. (2011), when talking about work in the contextual 'field', it is noted that designer-researchers (design ethnographers in their words) will likely produce prototypes, i.e., made objects that did not exist before, to 'create dialog' with the participants (p. 70). The point is made that such work is about imagining 'new realities' and then building them 'in order to see if they work' (p. 42). Equally, Davis notes that design, 'by its very nature' is 'situated' (2015, p. 139) and that any attempt to frame positivistic questions which seek to *prove* something in yes/no terms should be approached with caution, if not entirely avoided. For Davis, contextually bound, nonobjective questions are seen as the most appropriate for design research. These are said to relate to, for example, what 'the context demands' and the 'consequences of design actions' (p. 134).

Here, we can see how the inherent agenda of change/transformation through design marks out a *special* role for the designer-researcher. The key point is that the designer-researcher is aiming for change *within* the research, not beyond it, as with, say, critical theory. Ultimately, personal investment, imagining, planning and most importantly *acting*, render a context *materially* different. So, while the social science concepts may well be appropriate starting points for considering how the designer-researcher's work is to be 'positioned', they cannot provide a fully satisfactory model which can accommodate the idea of seeking to achieve change/transformation through design, understood in creative, generative terms.

It would seem that what is required is a way of understanding the initial context for creative action – how the designer-researcher(s) and the world, as a broader contextual space of happenings with attendant problems and opportunities, interact. This, I believe, is matter of understanding *experience* as formed and forming, informed and informing.

In order to begin to tackle such a challenge, here, at last, we turn to the theme of experience and the bigger question of existence (i.e., what is) as presented in the work of our baseline philosophers of John Dewey, Ludwig Wittgenstein and Martin Heidegger.

Moblising Dewey-Wittgenstein-Heidegger

In the last chapter, I sketched out an initial overview of Dewey, Wittgenstein and Heidegger's concerns and positions, with experience and language/meaning emerging

64 *Positioning*

as key themes which connect to their understanding of knowledge. As we will see, the wider theme of existence connects to this.

Before proceeding, it is worth making the point at the outset that while all three can be seen to draw meaningful connections to experience and existence, there is a variation in the terms used and meaning applied. As we will see, Dewey is the key advocate for the theme of experience. It is, for him, a central concern. He asks questions of the concept and offers some answers. Heidegger directs his attention to the broader theme of existence and against this explores the idea of being, of having presence within existence. It should also be noted that Dewey too has a keen interest in existence – drawing connections between it and experience. Wittgenstein, lastly, is somewhat of an outlier here. Neither experience nor existence are foregrounded as central discussion points within his works. Nonetheless, they are there and we may trace out relevant considerations of such themes across his extensive examinations of language (as well as culture). For Wittgenstein, experience is a background theme.[5]

However, all these differences and distinctions will become clearer over the coming sections. In beginning to define them, we will turn first to Dewey's treatment of experience and, within this, its interlinking with the wider notion of 'existence'.

Dewey's Interlinking of Experience-Existence

Many will already be aware of Dewey's strong emphasis on the theme of experience. For a large portion of his readers, this emphasis defines him. Indeed, in the context of design discourse and particularly interaction design or human-computer interaction (i.e., HCI), his expansive body of work is often referenced singularly via this theme alone.

Trying to gain a handle on Dewey's approach to experience is however complicated to say the least. There are two key reasons behind this. First, the theme is discussed regularly across a very extensive body of writing which was published over a period of approximately 50 years. There is not one source to reference but many sources to draw on as we seek to come to terms with his proposals. However, that said, this challenge can be overcome by referencing his later works – in particular *Experience and Nature*, often considered his magnum opus – where his views on the subject are set out in (mostly) clear (enough) terms.

Experience and Nature (Dewey 1981/1925) is, essentially, a Deweyan metaphysics – that is, a Deweyan theory of existence. However, in presenting as a metaphysics it comes with a twist. Whereas, historically, most metaphysical efforts aim to define an underpinning, organising system for what is (i.e., what exists), Dewey sought to avoid any such systematising. Instead, he envisaged a process by which we might seek to get closer to existence through the medium of *experience*. Here, it was his proposal that experience and the senses do not cut us off from what is, but rather allow us direct access to the things of the world. In this presentation, the values and qualities that we 'feel' or 'have' on a daily basis, whether emotional (i.e., anger or fear) or perceptual (e.g., the colour red) are presented as *really* 'real' (e.g., ibid, p. 59). They are registers of the environment, which, as living 'organisms' of that environment, we are interacting with. They belong not only to the person or organism who is 'experiencing' but also to the 'situation' (a key word for Dewey) in which they find themselves (ibid, p. 199). Through situations, the organism and the environment enter into a dialogue.

Positioning 65

By being able to register things in this way, we are able to explore and investigate 'nature', i.e., what things are, what they do. This exploration and investigation of things takes place initially in the here and now – what Dewey calls 'primary experience' – but, also, through such direct encounters, we are able to reason and infer, as well as connect to any preexisting data and knowledge that we may already have (whether scientific or otherwise) (ibid, p. 17). This is in turn allows us to develop insights which extend to the past and also, ahead, into the future, such as we are to make predictions, to plan.

Such an ability to understand and come to know things through our encounters with them as well as through reason and inference in reflection means that gradually, over time we are able to get a sense of the world (or existence) in *broad* and *general* (if imperfect) terms, a sense which amounts to a metaphysics of sorts. Dewey suggests that this 'metaphysics' is attained through the slow identification what he refers to as the 'generic traits of existence' – that is, the features or characteristics of the world as they present themselves to us generally in experience (or beyond, through reflection and so on). Little by little, we may gather a list of these traits (ibid, p. 308). In this way, experience, informally and formally framed, begins to connect us to the wider arena of existence.

The thing to bear in mind however is that we can never 'know' existence. Though Dewey offers us some of its possible traits, these are not final or absolute. Put simply, in his view, there is no final modelling of all that exists, i.e., 'this', 'this' and 'this', all contained within 'that'. Rather we are being offered a presentation for how metaphysical inquiry *might* operate, as well as how, in everyday terms, it does operate (i.e., the way in which ordinary men and women might go about defining 'existence'). The point here is that it will always be ongoing, as the world (what is) will always be *in* process, changing.

This general presentation is quite useful when it comes to the challenge of trying to frame the idea of positioning in design research involving practice. First and most significantly, there is the *given* of change, as just noted. If the world is always in process and change, then design research involving practice is a sensible proposal. Then there is the idea that the values/qualities we encounter are really real, not deceptive perceptions to be suppressed in favour of some form of 'certain' reasoning as Descartes would have it. No, we are *able*, permitted if you will, then to reference our situational register as we seek to frame a starting point for further investigation. Indeed, as we will see in the next chapter, this is precisely what Dewey believes *should* and *does* happen when we encounter a situation we cannot quite understand or define, what he refers to as an 'indeterminate' situation.

These insights will be drawn together shortly. From Dewey, we turn to consider the work of Wittgenstein.

Wittgenstein's Forms of Life and Ways of 'Seeing'

As has been noted, Wittgenstein's work presents a challenge when it comes to attempts to define his understanding of 'experience' or, indeed, the bigger question of existence. With regard to experience, this is because the theme is not isolated as a standalone subject in his texts. Instead, in his earlier work, *Tractatus Logico Philosophicus*, we have a presentation on how the world and logic interact without any explicit reference to human experience as such. Here, he discounts questions surrounding existence,

66 Positioning

pointing out that it would require that one move beyond the world in order to be able to represent it (Wittgenstein 2013/1921).

As was noted in the last chapter, Wittgenstein gradually moved away from the general position taken in the *Tractatus*, eventually arriving at a perspective which saw meaning as inherently connected to context, to how it was used. Here, it was not so much logic that mattered but how it was possible to communicate, how, through the medium of language, we are able to interact with others and act together in the world.

This idea will be explored in greater detail in the next chapter with reference to the key Wittgenstein concept of 'language games' as we consider language and meaning directly. What matters here, in relation to considering the themes of experience and existence, is the idea of the *power* of language – in particular its apparent ability to *affect* how we *apprehend* and, ultimately, *see* things. For the later Wittgenstein, it is the source of what we find meaning*ful*, shaping our perception, determining what we find appropriate and inappropriate, or, ultimately, valid and invalid.

Underneath this basic position, Wittgenstein also holds the linked view that language *and* culture are conjoined – each is believed to relate to the other, each is believed to feed into the other. To illustrate this, he argues that a language may be understood to mark out what is called a 'form of life'. In the Wittgensteinian 'system', a form of life is, in essence, a way of being – the *implicit* but definite existential socially bound frame of reference which we all share and, for better or worse, cannot easily move beyond. The essential idea here is that, in *speaking* a language, we take on a set of perceptual and conceptual registers and so conduct ourselves in a particular way.

Surprisingly, the term 'form of life' is used sparely in Wittgenstein's work. For example, it appears only five times in the important *Philosophical Investigations*. Nonetheless, where it does appear, it emerges as a striking proposal. We are told, for example, that 'to imagine a language means to imagine a form of life' (Wittgenstein 1963/1958, p. 8e [§ 19]). Wittgenstein also draws upon the phrase as he seeks to emphasise the *active* character of language, i.e., its relation to what people *do*. We are told, for instance, that 'speaking a language is part of an activity, or a form of life' (ibid, p. 24e [§ 23]). Intriguingly, in a later section, our form of life is also identified as the ultimate source of agreement in relation to what a group believes to be true and false (ibid, p. 88e [§ 241]).[6] Behind these vectors, the point to take away is that we are *bound* by language and its meaning-making – the modalities it enables and disables – for language *encultures*, coming to define and shape experience and (as such) human existence.

Wittgenstein may be seen to offer two related 'ways' of interrogating how language encultures. These ways are found in the concepts of the 'world-picture' and the 'perspicuous representation', with both allowing for the exploration of what we know and believe on the basis of language.

The world-picture refers to what one takes as *given*, the 'matter-of-course foundation' sitting behind what we do (Wittgenstein 1969, p. 24e [§ 167]). We are told that it is the 'inherited background' against which we live our lives, one that we acquire *'purely practically'* (ibid, p 15e [§ 95], italics added). While mostly presented in stable terms, there is the suggestion that our world-picture may become *unstable* or questionable. It is suggested we may eventually come to doubt what we have learned from experience or have been told by others or read in textbooks. However, he points out that 'doubt comes after belief', i.e., we believe first and doubt second (p. 23e [§160]). As such, the world-picture only provides a way in to questioning a form of life once we *are* part of that form of life and have been given reason *to* doubt.

A perspicuous representation is a more active concept, referring to the 'form of account' we give, the way we 'look at things' with regard to language and meaning. In introducing the concept Wittgentstein says: 'our failure to understand [broad questions or problems] is that we do not *command a clear view* of the use of our words' and '[o]ur grammar lacks perspicuity' (1963/1958, p. 49e, [§ 122], italics in the original). As a means of amending this and so obtaining perspicuity, we are encouraged to imagine 'intermediate cases', aiming to gain as broad a *perspective* as possible on one's language and its embedded constraints, i.e., the scope and potential impact of one's use of words. This, according to Judith Genova, amounts to *surveying* a form of life (Genova 1995, p. 25).

In mobilising these concepts – i.e., the world-picture and the perspicuous representation – Wittgenstein ultimately proposes that, through reflection, one may both examine our assumptions (with regard to doubting our world-picture), as well as our use of words and what these do (with regard to pursuing perspicuity). Here we may imagine how things (ways of being, speaking, doing) might be otherwise, through the identification of alternatives and their contrasting against what is. In this latter, such alternatives will reveal both what is known with regard to assumptions and language, as well as how meaning operates with regard to language.

Though the above (i.e., terms/concepts of forms of life, world-pictures and perspicuous representations) do not deal with experience directly, they at least point to relevant issues with regard to our experience and how it may become open to inquiry. Here, with considering the idea of grounding positioning in the context of design research involving practice, we may quickly draw out the general proposition that our language and form of life are bound together. These are open to exploration via doubting our world picture (because belief has faltered) or through an effort to 'command a clear view' of what language permits or does not permit.

From Wittgenstein, we turn lastly to the work of Heidegger.

Heidegger's Dasein, Care and b/Being

As we will now be aware, Heidegger's philosophy centred upon the question of *being* – of what it was and what it meant. Though this question may, on the face of it, seem oddly straightforward, prolonged consideration of the matter reveals it to be especially complicated. Heidegger himself went so far as to contend that it had been left unaddressed by prior Western philosophy and, through the course of his career, gradually, sought to devise an answer (see Safranski 1999).

His most prolific work – *Being and Time* (2010/1927), published early in his career in 1927 – may be seen to present a powerful initial response, which in many ways has defined his legacy. Through this text, we are introduced to the concept of 'Dasein' meaning 'being there' or 'there being'. As an isolated concept, Dasein is simple enough. It relates to a human being's concern '*about* its very being' (2010/1927, p. 11, italics in the original). There is then the concept of 'being-in-the-world', the unitary phenomenon, where being, the quality of being in and the quality of 'worldliness' are indivisibly drawn together.

From here, however, the presentation quickly complicates, as Heidegger proceeds to explore and extend the subject of being across a multitude of increasingly complex dimensions. Section by section, chapter by chapter, layer after layer of additional conceptual scaffolding is introduced. Through this, being is gradually related to areas such as spatiality, temporality, the social and death.

68 Positioning

In terms of the question of the *meaning* of being, as per the book's title, it is here seen to be 'time' or the temporal quality of existence. Intriguingly, Heidegger does not centre the social aspect of being. Rather it is considered as yet another dimension of what it means to be, referred to as 'being with'. Being with is viewed in a negative light. It is an inauthentic state, where we are not being in a way which is true to our being.

Beyond temporality, what *is* centred however is the grounding idea of *care*. Heidegger's understanding of care is key to our present interests with regard to positioning in design research involving practice. Within *Being and Time*, it is identified as the background, against which the foreground of daily activity takes place. With regard to Dasein (i.e., being there), we are told that our being 'towards the world is essentially *taking* care'. We do – for example, produce, order, use, undertake, accomplish, find, ask, observe, speak about (to point to some of Heidegger's examples) – because, unavoidably, we *care* or, rather we 'take care' in our 'being in' (2010/1927, p. 57).

However, as with most aspects of Heideggerian conceptualising, care does not stand alone without any further underlying sub-concepts or categories. Rather, our inherent caring is seen to arise through the given of *attunement* – that is, our primordial connection to what is (i.e., the world) through *mood* (Heidegger's specific word) (p. 130). In keeping with Dewey's theory of values (see the last section), Heidegger's mood relates to our feeling or noting a quality as something definite. Again, as with Dewey, 'mood' is not attributed only to those who 'experience' it alone but rather is seen to belong to both being and the world. 'Mood assails', he writes. It comes from 'neither "without" or "within", but arises from being-in-the-world itself' (p. 133).

Further, attunement or mood, in turn, disclose two key aspects of Dasein. Firstly, what is referred to as the *throwness* of our existence, i.e., the way we find ourselves where we are. Secondly, the ever-present given of *possibility* for Dasein, i.e., there are always choices available to us, things to be done within our present. In our throwness, we are essentially always *already* culturally informed, what we encounter in the world *matters* to us in a particular way (p. 133). When we undertake particular actions, as part of a 'taking care', we are seeing '*something as something*' (p. 144). Here we connect to the given of possibility. Coming off the back of our throwness, possibility points to our inherent *understanding* of what is before us and, from this, 'seeing' what *might* be. Heidegger states that through this understanding of things, 'Dasein projects its being upon possibilities'. This is said to reveal the inherent 'potentiality of being', i.e., the fact that a spectrum of doing, options for *doing*, is/are an ever-present given, available to us because we understand.

So, in short, in attunement, we are *compelled* to 'take care' of things. We find ourselves where we are, with things mattering to us in a particular way. This finding that things matter to us (because we are where we are) discloses our inherent *understanding* of such *things* as 'something'. This inherent understanding, in turn, means we are able to identify *opportunities* within the course of activities. Of course, this outline of care, or taking care – of throwness, possibility, potentiality – offers us a promising starting point for considering the idea of positioning in design research involving practice.

Before considering this further, however, it is important that we also draw out an additional kernel from Heidegger's broader handling of the question of being, relating to the dynamic between the understanding of being that is represented in Dasein (i.e.,

Positioning 69

being there) and how he would later go on to treat being. As has been noted, in his later work, Heidegger continued to explore being but, beyond *Being and Time*, went on to investigate the subject across a wide range of contexts relating to, for example, poetry, technology and art, looking at how such media effect and affect being. This has been referred to as 'a turn', i.e., a definite change in direction, however, what emerges here might be better understood as a shift in emphasis or focus, along with a shift in method (e.g., Dreyfus and Wrathall 2005, p. 9; Olafson 1993).

Within this work, we encounter a consideration of being which is wider, more all-encompassing than that conveyed through the singular 'being there' of Dasein. This consideration is, in essence, abstract, suggesting the conceptual 'drawing together' of the near-infinite plurality of beings beyond one's own individual being. Sometimes it will relate only to the human. Other times it will relate to both human and nonhuman. In taking up this idea, Julian Young points to a number of revealing phrases, which appear in the later work. Here, we encounter for example: 'the house of being' (which, as we will see, refers to language); the 'destiny of being'; and the 'truth of being' (Young 2002, p. 13). For Young, these mark out a second level of being which he believes is best distinguished with a capital B – to appear as 'Being'. This Being may, according to Young, be seen as the 'generative ground' of being in the singular sense (i.e., in the sense represented by Dasein) (p. 15). Such a presentation calls up the possibility of singular being's (i.e., Dasein's) working to apprehend or 'grasp' Being (i.e., the general beyond the particular), which, in essence, defines the grand challenge of all metaphysical questioning, as we have seen previously. Young explores this being-Being relationship, going so far as to suggest that Heidegger may be seen to identify a mode of thought, the poetic,[7] which might allow being to begin to get close to the 'enigma' of *Being*. This form of thought is seen as unbounded, allowing one to move to think beyond one's context and direct noticings and consider things which are beyond us. We will return to this form of thought in the next chapter, to consider its 'how' and what implications it has for design.

With regard to Young's proposal that Heidegger promotes this mode of thinking as a means of getting close to the *enigma* of Being, it is important to note that the word 'enigma' is integral here. It is not being claimed that we may *know* Being via poetic thought, only grasp a *sense* of its 'ungraspablity' (Young 2002, p. 19), the fact that it is a *mystery*. Accordingly, such a proposition may be considered to offer a means of *responding* to the notion of broad, all-encompassing 'existence', i.e., all that is and its meaning. This connects to Dewey's idea of a naturalistic metaphysics but does not equate to it insofar as it does provide a means of accounting for what is determined in relation to broad existence.

Here we round out our consideration of Heidegger's offering on the themes of experience and existence. In terms of how this may support positioning in the context of design research involving practice, we are able to draw out two key concepts. First, of course, there is 'care' and Heidegger's outline of the thrownness/understanding/possibilities/potentiality of being. This offers a very compelling notional grounding proposition for design research involving practice, which points to the dual aspect of our own individual existence, i.e., always unavoidably finding ourselves where we are but also understanding this. Next, there is also, it would seem, the possibility of mediating between being and Being (i.e., being there and the being(s) beyond there) via poetic thought. Though this may not present the obviously compelling idea in the context of design research involving practice, it will nonetheless be drawn upon

70 Positioning

shortly, notionally allowing us to navigate, or at least attempt to approach, the general against our particular.

Having explored the treatments of experience via Dewey-Wittgenstein-Heidegger, we will now turn to consider how these might allow for an approach to 'positioning' in design research involving practice on aggregate.

Pathway 1.1 Two Established Pathways: Heidegger on Things and Technology

As has been highlighted, Heidegger's work already forms a significant reference point in design literature. Here, we have noted how there is a key sustainability angle, which will be briefly touched on shortly. Beyond this, we also noted a technological angle (e.g., Dourish 1991), which we will briefly consider here as part of this present Pathway. Before doing so, however, it is important that we also highlight a further, additional design link to the Heideggerian corpus – the concept of 'Things'.

Things, as a general domain of conceptual interest, are particularly important in Heidegger's philosophy. At the basic level, we can draw a relationship between phenomenology and things, the philosophical 'school' out of which Heidegger's work emerged. The school's founder, Edmund Husserl (an early mentor of Heidegger's), called for a return to the 'things themselves' (Husserl 2001/1900, p. 168), with phenomenology being positioned as the philosophic method that would enable such a return.

In his own work, Heidegger went on to explore the broad notion of what it was that defined a 'thing'. Here, in one key essay, entitled 'The Thing', he examines how it is that things are what they are. Through this examination, he advances the idea that things can be understood as an active process, a coming together or gathering.[8] At one point in the essay, as a means of underscoring this position, he notes that historically, in old German, the word 'thing' referred to a 'gathering' to 'deliberate on a matter under discussion, a contested matter'. We are told that this was extended such that the word came to mean 'affair or matter of pertinence' (Heidegger 2001/1971, p. 172).

It is this latter aspect of Heidegger's examination of things that forms basis of the 'Things' concept in contemporary design literature. Yet, while Heideggerian in origin, this concept did not enter the design literature via direct reference to Heidegger's work. Rather, it entered via reference to the work of the French sociologist Bruno Latour, who was himself referencing Heidegger (Latour 2005a). Here, Latour was aiming to flesh out a vision for a new form of politics referred to as 'dingpolitic' or 'thing politics'. In doing so, he appropriated and progressed the notion of Things as gatherings. Gatherings were not to be understood as gatherings for the purposes of human-to-human debate as per Heidegger; in Latour's hands, the notion of gathering was expanded to draw in more-than-human entities too, i.e., animals and material objects and artefacts.[9] Equally, the idea of gathering was not to be restricted to formal parliaments; other connected networks such as markets, technologies and ecological crises were to be considered too (Latour 2005a, p. 27). Within this enlarged framework, it was to be matters of concern, contested issues, that were to act as the bedrock of democratic engagement, not fixed facts (ibid, p. 31).

In referencing Latour and his dingpolitics, PD theorists challenged designers to reframe their understanding of practice, of what it was that they were making happening and how (Ehn 2008; Telier 2011). On this reframing, design projects were

now to be imagined as a coming together of human and nonhuman collectives in the context of issues that needed to be addressed. This constituted a move away from an understanding of design as a restricted practice taking place at a fixed location with limited participants, and a shift towards a vision of design as a process taking place in the world, which seeks out controversy and multiple voices (Telier 2011, p. 193). Though Heidegger is not foregrounded within this, his thinking regarding things as active gatherings is most definitely present.

From Heideggerian things, we move to the Heideggerian view of technology. In terms of referencing the design literature, the picture here becomes a little more diffuse, with both positive and negative readings emerging. On the one hand, from the positive side, we may note that a key linkage has been drawn on in relation to his treatment of embodiment and technological use in the context of human computer interaction (HCI). In particular, his work is referenced to provide conceptual support to the notion that the use of technology must be considered not only in relation to a specific task or set of tasks but also in relation to the broader context in which the 'use' was taking place. A first step was taken by HCI researchers Terry Winograd and Fernando Flores (1986). In relation to Heidegger, their key contribution lay in highlighting the potential value of his distinction between equipment being either 'ready-to-hand' or 'present-to-hand' (in his example a hammer). In the first instance (ready-to-hand), we do not see the equipment, it is all but invisible, embedded in the context of action. In the second instance (present-to-hand), we see the equipment, it becomes visible because (for whatever reason) it is not supporting our action. Winograd and Flores referred to the latter as a 'breakdown', highlighting its potentially productive aspect as a means of noting issues in the context of interaction and allowing this to become a space in which new design could emerge (Winograd and Flores 1986, pp. 77–78). Following on, another HCI theorist Paul Dourish (1991) went on to further examine the potential of drawing on the Heideggerian perspective. Linking to a broad swath of philosophers (e.g., Schutz, Merleau-Ponty, Wittgenstein), his Heideggerian focus was specifically directed towards the value of foregrounding the latter's being-in-the-world concept, arguing that from a Heideggerian point of view we are 'inseparable from the world', and functioning technology forms part of the 'unspoken background' against which 'our actions are played out' (Dourish 1991, pp. 109–110).

Alongside this use-embodiment thematic, here is another highly significant aspect of Heidegger's treatment of technology which has also been referenced and considered in design: the concept of 'Gestell' or, in English translation, 'enframing'. Enframing, most prominently described in the key later essay 'The Question Concerning Technology' (Heidegger 1977, pp. 3–35), refers to the apparently total hold that technology has come to gain over our thought. The ultimate claim is that, through this entrenchment, we have become unable to see the world apart from its potential as a store from which we might draw resources to enable further technological activity.

In terms of its referencing within design, enframing has been most prominently deployed by the key theorist Tony Fry. Here, through a prolific series of texts (e.g., Fry 2012, 2011, 2009, 1999), Fry has worked to progressively explore the disastrous ecological implications of humanity's current unsustainable trajectory, while, at the same time, present an alternative vision for the discipline, which he refers to as 'design futuring'.

In mapping out this vision, he ties contemporary design practice to the concept of enframing. Here, design is seen as enframing's 'form-giving' (2011, p. 189), literally its

72 *Positioning*

enabling process. As an alternative, design futuring would see a self-conscious mobilisation of the discipline such that it would shift from its current enabling of unsustainability and, instead, towards an engendering of a new revised notion of what sustainability could be. In essence, this would see humanity work to radically reorientate its current ontology (i.e., its being) via design – an ontological design project. If successful, it is proposed that such an undertaking would contribute to the realisation of a new age for humanity, which Fry terms the age of 'Sustainment' (Fry 1999).

This rounds out our discussion of Heidegger in relation to things and technology. While these themes are disconnected in the discourse, they nonetheless represent key meeting points for Heidegger and design.

Positioning via Dewey-Wittgenstein-Heidegger: Design Research and Organism-Environment Relations; Being-in-World; and Forms of Life

As we have seen with regard to themes of experience – where it starts, what it is – as well as the question of existence, Dewey, Wittgenstein and Heidegger each offer us something slightly different and distinct but ultimately related. There is Dewey's idea of 'primary experience' and the notion that the values and qualities we encounter are real, belonging to the situation as much as to us. Alongside this, there is also his interlinking of experience and existence in his naturalistic metaphysics, with the argument being that through reflection and research, we are able to take register of the general traits of existence, understood as a broad arena. There is Wittgenstein's idea of forms of life, which connects language and the way we 'see' things. As has been noted, forms of life may be examined considering our 'world-picture' as we doubt what we might otherwise accept as given or, alternatively, by actively pursuing a 'perspicuous representation' of our language as we consider the many ways in which things might be otherwise. Then lastly, from Heidegger, there is the concept of care, of being thrown in our 'there' and being able to identify possibilities. Additionally, we have his linking of the being of Dasein with general Being through the poetic thought.

On their own, each of these presentations on the theme of experience have bearings for the idea of how one might model one's role in relation to the context of change within a live design research project. Taking Dewey first, we are offered a model which centres upon the situational encounter of existential (i.e., really 'real') values/qualities. The proposal here is that if these are troubling, if they render the situation 'indeterminate', we may be moved to act in response, to *inquire* about that which troubles us. Next to this, the metaphysics and the experience-existence relationship it contains also open up the possibility that inquiry may over time yield more general insights in relation to the type of world we live in.

With Wittgenstein's forms of life we are offered a model in which language, culture and perception are all linked. As has been noted, our forms of life may be examined by considering our 'world-picture' as we doubt what we might otherwise accept as given. Alternatively, we may actively pursue a 'perspicuous representation' of our language (as well as, by default, our culture and perception) as we consider the many ways in which things might be otherwise.

Heidegger's care presents us with a model of individuals as holding an intrinsic understanding of their 'there' and, in this, being able to identify opportunities for change (i.e., noting possibilities). Here, in being care-bound, we are almost unable to avoid responding to what we encounter – through our inherent understanding we

Positioning 73

readily 'project'. Alongside this, of course, poetic and meditative thought offer routes to the consideration of broader ungraspablities (Being), opening up a being-Being relationship. Individuals may consider general questions that arise within their experience, but not gain definite answers. In this way, our research might move outwards from context speculatively, taking on non-horizon-bound directions.

Grouped together, these models point to the impossibility of a fully 'objective' stance, (i.e., with the researcher seen to be standing apart from the research). They may be linked through the emphasis on the notion that we are in some way *compelled* to act in *relation* to our experiences, to what *we* encounter and what happens to *us*. As living organisms (Dewey), or linguistic performers (Wittgenstein), or caring beings (Heidegger), we are bound to *contextual* forces, whether presented in terms of Dewey's situational values/qualities, Heidegger's inherently understood possibilities of our 'there', or doubts relating to our world-picture. In each case, person and circumstance come together in a triggering. It is not merely a matter of attending to something, we are *part* of the process. Our placement in a context cannot be avoided. In this, we do not so much choose to respond to what we encounter, rather it is more the case that we find ourselves *having*, in some way, to *act* or *react*. Returning to our starting point for this chapter, the theme of experience, we can say that in beginning to engage in a process of design research involving practice – i.e., seeking to produce knowledge via an effort to transform through design – we may see ourselves as being always already motivated by our experiences. The intrinsically bound motivation to bring about change through design research will be formed in context. Such motivations may of course relate to practice or technology or ethics or any number of issues that might arise. What matters is that we are alert to it, to what is happening and, within this, what we are doing, feeling, thinking or understanding. The point is that we note the challenge, and in noting it seek to work to resolve it. How we might go about this, or at least how Dewey, Wittgenstein or Heidegger understand our 'going about this', will be the focus for the next chapter.

Pathway 1.2 A Pathway to Consider: A Marxist Positioning on Creativity

Marx's work is commonly considered in relation to the intertwining fields of politics and economics. We have his perspectives on communism, outlines and appropriations of his handling of the concepts of production, consumption, labour and so on. What is not often considered, however, is the underlying positioning which gives rise to these general theories – his general understanding of what it means to be human. From a design perspective, the vision he offers is in fact quite compelling. In short, Marx understood humanity as an essentially creative species, with the ability to create representing a defining characteristic of who we are.

To sketch this out, it is important to highlight that, for him, the human individual is to be understood as a member of the wider species. All species are seen to engage in productive activity in order to ensure that they are able to sustain themselves, as well as produce and sustain offspring. Humanity, however, is marked out as distinct on the basis of human beings being able to 'freely confront [their] own product' (i.e., they are able to hold conscious awareness of what they produce) and, further, producing for needs beyond their own (e.g., for other species). This is made possible through an ability to operate in prospective terms. Speaking in gendered terms, Marx notes that the human being can 'contemplate himself in a world he himself has created' and claims

74 *Positioning*

that it is in 'his fashioning of the objective that man really proves himself'. We are also told that the human being is able to adhere to certain aesthetic values – they hold an awareness of 'standards' of production and, as a result, are capable of producing 'in accordance with the laws of beauty'. Held together, this outline of creative, productive life functions, in essence, to present a sort of idealised vision of 'work'. Through it – with its core reference points of conscious awareness, prospective thought and beauty – we gain a sense of work as continuous activity, i.e., the individual is to be involved in all the stages of meeting a need, material and psychological (see Marx 1992/1844, p. 328).

Set against this ideal, Marx argued that the then-contemporary working conditions of the nineteenth century were highly problematic. Here, as was briefly outlined in the last chapter, he believed that capitalism (i.e., money) and the particular forms of industrial production it enabled disrupted the continuous aspect of our experience of our work, resulting in what he termed *alienation*. Alienation is a key concept for Marx and has been taken up by many subsequent scholars (e.g., Sayers 2011). In terms of how it was first introduced, it can be seen to operate on four key levels, all of which relate back to capitalism and industrial production.

In the first instance, workers become alienated from their product, i.e., they have no control over what is to be produced. Second, alongside the product, they are also alienated from the process of production, i.e., how the product is made. Third, they are alienated from the essence of who they are as a species. Here, returning to the previously mentioned vision of creative, productive life, the point is that the human being is unable to act as they would otherwise, i.e., by meeting needs consciously and prospectively, with an eye to beauty, all in dialogue with the 'objective world'. Fourth and finally, they are alienated from each other; their work is no longer a matter of cooperative exchange (i.e., the meeting of needs together) but competitive confrontation, whereby individuals are seen to act individually as opposed to communally. In short, the idea is that, in every case, the exchange of labour (i.e., work over time) for money is intervening to 'estrange' the worker from an otherwise integral aspect of their being, whether in personal, creative or social terms (see Marx 1992/1844, pp. 324–330). It is this same theory that is said to have inspired William Morris to establish the Arts and Crafts movement, as noted previously (see Weingarden 1985, and Pathway 0.1, in the last chapter).

So what does this mean for design research? In simple terms, in Marx we have an opportunity to develop humanistic grounding for our work. In this vein, his work stands in opposition to meaninglessness. As he would have it, to be fully ourselves as people, as a species, we must have continuity and ownership within and over our activities. Our life must involve creative productivity, which sees us act in accordance with the meeting of integral needs, cooperatively. It is, in the end, a matter of personal and collective experience.

Design's primary role here – whether in relation to research or in practice (e.g., in the context of service design), the workplace or other settings where life-sustaining tasks are to be performed (e.g., the act of cooking) – would be the development of holistic experiences.[10] The ultimate point would be to ensure that there is agency and control over individual and collective action. This will only go so far however. There remains the core issue of labour and monetary exchange and the consequent alienation/estrangement. Admittedly, this cannot be overcome by design alone but it would, nonetheless, be possible to explore the ways in which the influence and impact

of alienation-estrangement might be mitigated against in the context of production, social interaction or in relation to one's self-image (i.e., how the individual understands their humanity). An example here might be the design of systems of local currencies (e.g., Depraetere et al. 2019 in relation to local currencies as transformative) or exploring time banks in local communities.

Further, in seeking to respond to this aspect of Marx's philosophy, one might also move to foreground authentic, group-based co-creative approaches within the research and design process. The word 'authentic' is important here. Just applying a co-creative approach, on its own, because it is required for the purposes of a specific commission or brief, is unlikely to overcome the sense of alienation a designer or designer-researcher might have in relation to a given project. However, working collaboratively with others to focus on issues to which all parties are *definitely* committed points to the possibility that alienation (as outlined by Marx) might reasonably be avoided across most if not all levels. Here, if the co-creation is defined in truly open democratic terms, it would be possible to explore and agree on the form a meaningful product, service or general design response could or should take.

The group might also work to design/define the process of production, making key decisions about how something (be it a product, service or something else) is to be made or delivered. Taken together, this would allow for those involved to cultivate a stronger, more satisfying self-image in their humanity, perhaps feeling more fully 'themselves'. Then, alongside this, the social aspect of alienation is overcome on the basis that the cooperative exchange, the shared action, is initiated not for profit (though this may play a role) but rather for the mutual benefit of those involved.

In many ways, this basic proposition is mirrored in recent texts exploring the potential future of design. For example, we can see it in Manzini's social innovation proposals, where intrinsically motivated groups come together to achieve shared goals relating to sustainability (Manzini 2015). Equally, we see it in Sanders's notion of 'collective dreaming', wherein she envisages design processes based on collaboration between large-scale networks targeting multiple possible values (beyond the design of products and services (Sanders 2017). In these cases, and others (see Liedtka et al. 2017), design is positioned not as a for-profit force contributing to the general feelings of alienation as outlined by Marx, but rather as a creative, productive activity which enables the satisfaction of integral needs, cooperatively. While Marx took the view that alienation could only be overcome by total revolution, it would seem that if correctly framed, design also might support (albeit limited) efforts towards such ends.

This rounds out our direct consideration of the relationships (actual and potential) between Marx's work and design. At a later point, Marx's work will be briefly touched upon via a further pathway relating to critical theory.

Pathway 1.3 Pathways Which Have Opened up a Series of Key Horizons: Quick Notes on the Decolonial; Feminism; the Ecological; and Buddhism

In this Pathway, as a means of establishing an endpoint for the current chapter, I would like to briefly mark out what I see to be four key horizon lines which may accommodate particular and (in the present moment)[11] pertinent positioning in design research, alluded to in the book's opening. These are the decolonial, the feminist, the ecological and (perhaps surprisingly for some) the Buddhist. In doing so, I will note possible links to our philosophic baseline as well as some which extend beyond these.

76 *Positioning*

Additionally, the Pathway will lead to two project examples that can be connected to two of these horizons – the decolonial and the ecological. Other related project examples will emerge as we advance through the text, meaning that, over time, design research work will be surfaced and rendered visible.

Before proceeding, it is necessary to issue two points of clarification. In the first instance, these are not the only possible horizon lines by which particular positioning might be accommodated within design. Notionally, many other philosophic horizons might be drawn upon. We might, for example, wish to focus on the technological or the idea of the future, and so turn to perspectives, which specifically honour these angles over others. However, as I have already sought to make clear, the goal is not (nor cannot be) to trace all possible horizons. Rather, as noted at the opening, the idea is to draw lines of connection to what is seen to be pressing social/cultural/political concerns in contemporary philosophy and epistemology.

The second point of clarification relates to the inevitably limited scope of what follows. It will simply not be possible to offer any depth here in a single, standalone section, nor do true justice to the incredibly rich, multiform history of each of the traditions named. However, again, it is not a matter of presenting deep histories. Many such texts exist. As already noted, the point here is instead to mark out the ways in which these horizons connect to the philosophic baseline and, from this, to begin to examine the existent relationship to design. With these points made, we will now turn to explore the nominated horizons.

I line up the decolonial, the feminist, the ecological and Buddhist perspectives together here because I believe that to varying degrees and, for a variety of reasons, they can each be seen to offer a corrective outlook as set against problematic, entrenched positions regarding ethnicity/culture, gender and the environment/biosphere. The decolonial perspective seeks to confront the insipid legacy of colonisation across all areas of life, addressing its impact on our collective ways of seeing and being. Feminist perspectives seek to overturn long-entrenched societal inequalities relating to the treatment of those who hold a female gender identity, challenging belief systems, practices, along with wider institutional and organisational power structures. In the most general sense, we can say that ecological perspectives seek to overturn the historically dominant view of humanity and nature standing in opposition, with various approaches to addressing this being proposed as alternatives. Finally, from a Western perspective, Buddhism can be understood to offer a distinct and potentially valuable way of seeing and approaching our situation as living human beings, existing in the world.

What can be said about the important positions available in each?

Though, at a cultural level, deconiality can be understood to hold deep historic roots (Mignolo and Walsh 2018), academic decolonial perspectives only emerged in the late twentieth century in the context of sociology and cultural studies, with Latin American scholars leading the charge. Focusing on the theme of power, key early contributions sought to open up questions about colonial legacy and the residual Eurocentrism it has engendered (e.g., Quijano 2000; Mignolo 1999). Importantly, in relation to the present text, there is a core epistemological strand running throughout this work. Here, it is claimed that non-Western knowledge systems need to be recognised as holding value in their own right, offering legitimate means of apprehending and approaching the world, of acting within it positively (e.g., Isasi-Díaz and Mendieta 2018; de Sousa Santos 2018). Responding to these developments, the decolonising

Positioning 77

design movement has, as we will see shortly, emerged as an increasing strident programme, making important in-roads into the academy.[12]

Feminist philosophy and theory has a long history, emerging from many source points across the last two centuries as populations around the world underwent deep political, social and, ultimately, cultural transformation. The positions and visions offered are multifold – some are overtly political (i.e., aiming to bring about real-world change), others are more tempered, offering robust problematisations of specific philosophic and theoretical agendas. In broad terms, we may identify two important lines of inquiry. In the first instance, there is a questioning of the role a female perspective might bring to bear upon key areas of philosophic concerns, for example in relation to language, ethics, or, crucially in the context of the present text, epistemology, which we encountered briefly above. As was noted, key in relation to the latter is the notion one must abandon view from 'nowhere' and acknowledge one's situatedness, i.e., that one is always holding a particular position (Haraway 1988).

Alongside this, within feminist philosophy/theory, we can detect a broader exploration of thematic issues which have traditionally been seen to relate most particularly to a female domain. In this, there is a widening of the scope of philosophic questioning to encompass such under-considered areas as: family, care, the body, sexuality and disability. Feminist themes have, over the last number of decades, begun to enter the sphere of design research and practice, with researchers and practitioners working to explore the possible implications of adopting a feminist perspective across a range of contexts (e.g., Rothschild 1999; Buckley 1986). There is however a wider opportunity to consider how a feminist epistemological horizon might allow for the transformation of the conduct in design, particularly research involving practice (e.g., Bardzell 2010, who advocates for a feminist design research agenda in HCI).

Next, we have ecological perspectives. Given the present, deepening environmental crisis, there are surprisingly few fully formed ecological philosophies available. Most often, ecologically-orientated work is positioned in the context of 'environmental ethics' (Taylor 1986; Elliot 1995). These contributions explore the environment in moral terms, considering the scope of human responsibility in relation to what would traditionally be referred to as the natural world. Within this, focus is also directed to the question of whether or not it is possible for us to meaningfully escape our inherent anthropocentric outlook (e.g., Shoreman-Outmet and Kopnina 2015; Weston 1985).

It would appear that the ethical dimension is difficult to avoid. Even texts which aim to delineate the boundaries of wider environmental philosophy tend to hook back to the question of ethics. Nonetheless, broader perspectives have emerged and, here, two key particularly noteworthy contributions may be identified. In the first instance there is the 'deep ecology' work of Norwegian philosopher Arne Naess, which seeks to reorientate the way in which we approach the natural world in holistic, ontological terms. The key claim is that there is a spectrum of environmental beliefs and potential environmentalist action, which moves from the shallow to the deep, with the latter being referred to as 'deep ecology'. Rather than accept the status quo or only explore small changes, deep ecology, we are told, recognises the need for a total reexamination and reform of our use of natural resources and technology. The path to achieving this is to be found in the building up of personal ecologically-bound philosophies, referred to as 'ecosophies', which help us work through our environmental commitments and from this to begin to establish a collective understanding (Naess 1990).

78 *Positioning*

As a second noteworthy contribution, there is also the particular 'ecosophy' of Felix Guattari (2000). Although wide ranging and focusing in on the idea of subjectivity, this too is definitely environmental. Guattari offers a vision of philosophy, which centres upon drawing a holistic relationship between individuals as subjects, the technological and social contexts in which we exist and then, alongside all of this, the wider environment. The point is to see how everything connects and how who we are is informed and, ultimately, regulated by our contexts/environment.

Moving on to Buddhism, it is at the outset acknowledged that, for some, this may seem a strange horizon-line to draw; it is after all commonly understood to denote a particular set of related belief systems and practices as opposed to an explicit philosophy in and of itself. Nor would it seem to bear much relation to design research or practice. This is debatable however. Over the course of the twentieth century, many Western philosophers and commentators came to see the philosophic dimension underpinning the tradition, recognising it as philosophy in its own right (e.g., Siderits 2007). Equally, with regard to design, early work is drawing out potential points of intersection (e.g., James 2017; Wong 2011).

These are not the only issues here of course. Buddhism's famous diversity presents a challenge to anyone seeking to draw out general principles or commitments. As a consequence, in highlighting its potential value as a horizon line in the context of design research, I cannot make any claim to have precisely reduced or distilled Buddhism's total offer, nor to have isolated even the most relevant aspects.[13] Rather, in the context of tracing out an approach to positioning here, I limit myself to note two simplified ways in which a Buddhist outlook *may* allow one to frame one's role as a researcher and, within this, one's relationship to the context. The first is Buddhism's special view of reality, which moves away from the idea that the world and our place in it is to be approached in a fixed and absolute sense. The second is Buddhism's special ethical stance, which is centred around a commitment to compassion. Both of these will be explored directly in the next chapter.

At this point, having sketched the decolonial, the feminist, the ecological and Buddhist horizons, we will pivot back to the of Dewey-Wittgenstein-Heidegger baseline. With regards to the connections that can be drawn between these horizons and our philosophic baseline, it must be noted at the outset that existing well-defined *direct* connections between the two are relatively limited. This is not so much a matter of the two not relating (i.e., sharing aligning concerns) but rather a matter of their historical and cultural separation and as such a lack of direct interaction. As we are aware, Dewey-Wittgenstein-Heidegger were active from the late-nineteenth century through to the mid-twentieth century while decolonial, feminist and ecological concerns only rose to prominence beyond this point. From a cultural-historical perspective, the same goes for Buddhism. It was only in the later twentieth century that a productive dialogue emerged in between Western and Asian philosophic communities.

In terms of direct Dewey-Wittgenstein-Heidegger linkages with the decoloniality, it must be acknowledged that these are more limited than those pertaining to other horizons. However, work has begun relating the decolonial to pragmatism, and within this Dewey's to philosophy. Here it has been noted how the pragmatists/Dewey offers a compatible epistemological perspective which can be related to the general decolonial programme. Writing in the context of decolonising religion, Tirres (2012) has pointed to Dewey's understanding of knowledge production or 'inquiry '(see Chapter 2) as *necessarily* involving experience and emotion, thus highlighting its value in

Positioning 79

a decolonial context as a useful counterpoint to traditional Western epistemological convention (pp. 235–236), i.e., the focus of the present text.

In relation to feminism, connections have been drawn to all three baseline philosophers. Again, this is especially the case with Dewey, who, through his connection to what is now termed the 'feminist pragmatists' and in particular to Jane Addams, a Chicago social reformer, directly contributed to the development of a feminist programme of social reform/research. Addams was an early advocate for women's rights and, through real-world programmes of direct on-the-ground engagement, explored routes to female emancipation (Knight 2010; Schmider 1983).[14] This work is seen to have seen inspired Dewey's vision for pragmatism and, similarly, in turn, Dewey is seen to have inspired Addams's work (see Seigfried 1996). In general, as regards a feminist positioning, Dewey's pragmatism is seen to offer what Seigfried (2002b) refers to as an 'emancipatory' perspective, an ultimately democratic vision which aims to empower individuals to contribute to society in the fullest possible terms.[15]

With Wittgenstein and Heidegger, the connections are less apparent and, as such, presented in more tentative terms. However, recent years have seen a series of feminist interpretations being put forward. On these accounts, with Heidegger we have we an exploration of how the themes he draws out in relation to, for example, poetry, the body and the creativity of being relate to or compliment those of feminism (e.g., Holland and Huntington 2001). Similarly, with Wittgenstein, we see scholars focusing in on how his treatments of philosophic practice, language and human behaviour align with feminist concerns (e.g., Scheman and O'Conner 2002). According to Naomi Scheman, a key point of intersection between both is the shared 'suspicion that there is something fundamentally wrong with the ways in which what are taken to be "serious" questions are posed and answered' (Scheman 2002, p. 2).[16]

Beyond these examples of retrospective interpretation, there is a more general alignment to be noted here too. In particular, looking across Dewey-Wittgenstein-Heidegger, we can say that all the baseline philosophers can be found to enter an alignment with feminism on the basis of epistemology. In particular, the feminist questioning of objectivity (e.g., Harding 1986; Haraway 1988), noted earlier in this chapter, aligns well with their positions on knowledge and knowledge production. Equally, in relation to Dewey specifically, a number of scholars have recently examined how his special understanding of knowledge (to be elaborated upon in the next chapter) aligns with a situated feminist stance (Shuford 2011; Seigfried 2002b, 2002a). As will be explored ahead, on his account, knowledge is to be seen not in terms of subject-object relations but rather as a matter of always having a context and being a participant in the world.[17]

With regards to ecological perspectives, we encounter a more varied picture. Few, if any, scholars have sought to trace ecological themes in Wittgenstein's work and, across the board, there are no apparent connections to the work of Naess and Guattari. However, scholars have endeavoured to draw links between Dewey and Heidegger and environmental philosophy, in particular environmental ethics. Here, both have been seen to offer potentially valuable ways of positioning human-environment relations.

With Dewey, a number of scholars have honed in on his conceptualisation of the environment and humanity's position within this. In this vein, Hugh McDonald (2004) has recently endeavoured to draw deep alignments between Dewey's work and environmental ethics, surfacing and centring the ecological meanings found in his logic,

80 *Positioning*

metaphysics and, indeed, his own ethical theory. Beyond this, in recent years, scholars also have noted further convergences between his work and: the ecological aspects of Native American thought (Alexander 2013); the work of the American pioneering environmentalist Aldo Leopold (Hickman 2007); and the positions of prominent twentieth-century American ecological writers (Browne 2007).

In relation to Heidegger's work, as with the feminist horizon, recent years have seen an increasing number of scholars propose a variety of environmental and ecological readings of his treatment of such favoured themes as being, technology, poetry and dwelling. Here, again, the question of environmental ethics comes to the fore, with his perspective being mobilised in relation to the present environmental crisis which we face. For some, this pivots around his concept of 'enframing' (see previous) and, next to this, the predominance of the scientific outlook (Rentmeester 2016). For others, it is a matter of applying a Heideggerian perspective in order to think through our relationship with other forms of life, as well as the 'earth' we inhabit (McWhorter and Stenstad 2009). In this regard, the concept of a Heideggerian 'eco-phenomenology' has been proposed as an approach by which we might resolve human-environment relations (e.g., Zimmerman 2012).

This Dewey-Heidegger alignment carries over to connections with Buddhism too. It would appear that Heidegger's work in particular can be readily compared to Buddhist perspectives, with many scholars working to examine the correspondences, both clear and unclear (e.g., May 2005; Parkes 1987; Watts 2014, p. 244). In this, focus is most often directed towards the alignments that can be drawn between his particular philosophic approach (i.e., his mode of philosophising) and specific Buddhist practices regarding, for example, mediation.[18] Further alignments have been noted in relation to Buddhism's holistic understanding of existence (James 2000) and its modelling of 'man and being' as compared with Dasein (Steffney 1981).[19] In terms of interweaving Dewey's thoughts and Buddhism, convergences have likewise been noted between his work and the Buddhist view of reality (Chinn 2006), as well as Buddhism's emphasis of the interconnectedness of all things (Rosenthal 1997).

With regard to established relationships between these horizons, the philosophic baseline, and design, as a closing point it is worth highlighting it is in fact Heidegger who emerges as the most prominent connecting figure of the three. We have already seen how his work has been picked up on by key theorist Tony Fry in the context of sustainability. This alignment brings in the decolonial too. The recent work of Escobar (2017) interweaves both the ecological (with special reference to Fry) and the decolonial, centring and honouring the idea of indigenous ecological understanding as a force that might guide a programme of sustainable renewal across the globe.

This concludes our discussion of the horizons. From here, we will briefly consider design research projects, which relate to some these.

Design Research Projects 1.1 Transition Design

While environmental sustainability has been a concern for design since at least the early 1960s, it has only become central to disciplinary agendas in recent years (see Caradonna 2018 for a broad history). Many now contribute to an emergent discourse on the subject, with perspectives tracing a spectrum which

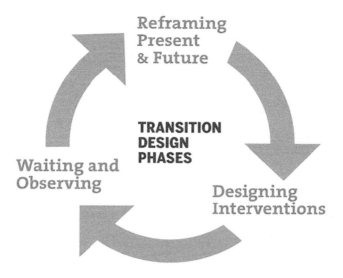

Figure 1.1 The phases of Transition Design (Irwin 2018, p. 6).

ranges from prosaic and incremental reform[20] through to a radical and absolute transformation of the field. At the latter end, the increasingly urgent agendas of Tony Fry (e.g., 2009, 2011, 2012) and Cameron Tonkinwise (e.g., 2011) stand as powerful examples of theoretical work, which calls for a profound recalibration of our approach to human-environment relations. Here, moving outwards from a Heideggerian frame, both specifically advocate in favour of shifting rapidly away from design's current unsustainable trajectory, warning again and again of the dire consequences of inaction. In terms of practical impact, their work can, to a degree, be seen to inform an emergent area of practice referred to as transition design (see Kossoff et al. 2015; Tonkinwise 2015).[21]

Transition design, as it is currently presented, aims towards a systems-level reorganising of society and the economy, with design positioned as the means by which change can be both explored and enabled. Its formal establishment as a defined approach can be traced back to the publication of a series of articles and papers authored by Terry Irwin, Geodon Kossoff and colleagues, which mapped out it's notional parameters through the presentation of a transition design framework (e.g., Irwin et al. 2015; Irwin 2015). The framework groups four 'coevolving areas' relating to vision, mindset, theories of change and, crucially, the ambition to engender 'new ways of designing' (Irwin 2015, p. 232). Beyond the Fry-Tonkinwise connections, a key philosophic link is drawn to Goethean phenomenology and science, whereby one is required to approach one's research context holistically, attending not only aspects of a given phenomena of study but, rather, to the fullness of the wider process (e.g., Bortoft 1996).

Anchoring the movement, a series of transition design initiatives are hosted at the Carnegie Mellon School of Design in the United States, where Irwin was until recently the Head of School. These include a doctoral programme, as well

82 *Positioning*

as a series of postgraduate-taught programmes. Today, the transition design movement continues to centre around Carnegie Mellon, with many of the core practical exemplars deriving from research project work undertaken here.

A recent example of how transition design is taking form has been set out by Irwin herself (2018), focusing on water shortage issues in Ojai, California. Here, Irwin proposes that transition design, in its emergent form, may be seen to involve three phases. In the first instance, in coalescing around a challenge, stakeholders must work to reframe both the present and the future (i.e., what is and what could be). Thereafter, in the second phase, it is a matter of designing interventions and, in the third phase, waiting and observing before the cycle begins again (2018, p. 972). Work in Ojai extended only to phase one, where a series of intensive mapping exercises were employed, allowing participants to gradually 'work through' the complexity of their present situation and re-envision the future as set against this. Two key moves were undertaken here. Firstly, participants were asked to surface and draw relationships between key issues in the present (e.g., the water shortage and a growth in tourism). Secondly, participants were asked to imagine a point in the future where the water shortage issue had been satisfactorily resolved and then, from this, to 'backcast' to the present imagining a means by which this future might be achieved, or in Irwin's words mapping a 'transition pathway' (2018, p. 978). Linking back to Goethean phenomenology, an important principle throughout is found in a commitment to holism, with activities requiring that participants see challenges in the round (ibid p. 976).

While this example does not extend especially far it does sketch a general orientation for the movement. Reflecting on the transition design movement thus far, it is possible to say that, viewed in broad terms, it functions as an ongoing inquiry, the asking of social-political-economic questions through small-scale design interventions. Irwin herself notes that it is better understood as an 'approach' rather than a 'prescribed' process (2018, p. 971). The ultimate proposal is that through the real-world interrelation of theory and better practical experimentation, more robust design approaches will emerge. As such, it is, in essence, the aim that matters, not the quality of the immediate outcomes and, though transition design is still to mature and find form, the work is ever more vital.

Design Research Projects 1.2 Decolonising Design

Arising off the back of, amongst other sources, the decolonial discourse noted above, recent years have seen the emergence of a movement known as 'decolonising design' in both Western and non-Western countries. In broad terms, the movement aims to problematise design practice, education and research, asking difficult questions regarding its political and ontological alignments, questioning the otherwise unquestioned in the discipline. Its theoretical and philosophical references are often shared with transition design (see above).[22]

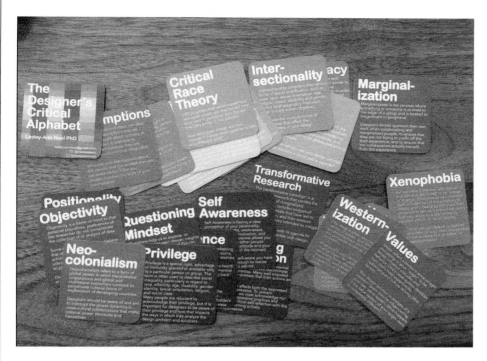

Figure 1.2 The Designer's Critical Alphabet Cards. Credit: Lesley-Ann Noel.

While the movement is still nascent, it is possible to note the emergence of two decolonising design strands in recent years. The first explicitly coheres around a formal Decolonising Design Group. The second takes form as a disparate continuum of scholars who explore the broad theme of decolonising often with reference to other concerns such as, for example, ecological sustainability.

The emergence of the first strand may be traced back to the Design Research Society conference of 2016, held at Brighton in the UK, where a collective of like-minded, early-career researchers announced the establishment of the Decolonising Design Group. This announcement was issued via the Design PhD Jiscmail, a shared mailing list for the global design academia.[23] While many on the list responded negatively, there was also a great deal of support expressed. Concurrent with the announcement, the Decolonising group launched an online presence, including a website which holds an 'Editorial' outlining the group's basic shared position.

In the editorial we are told that the group's goal is 'ontological' rather than 'additive'; they state that they are seeking to reorientate ways of seeing in design rather than simply making a plea for greater inclusivity within the field. From their perspective, small-scale institutional change will only delay wider systems-level change. Instead, in calling for a reorientation of the field's ways of seeing, they seek to draw attention towards 'non-western ways of thinking and being' and in doing so urge that design studies give greater consideration to design's

84 Positioning

political impact, in particular the 'politics of the artifacts, systems and practices that designerly activity produce[s]', which the group claims is threatening to 'flatten and eradicate ontological and epistemological difference' globally (Decolonising Design 2017).

Beyond this statement, another key moment for the group was marked by the publication of a decolonising special issue of *Design and Culture* in 2018, which draws together a range of perspectives from across cultures and geographies. We hear, for example, from an indigenous nation in relation to the non-colonial, 'in Country' forms of social design and knowledge; the UAE in relation to the participatory negotiation of histories; and Cape Town in relation to issues of sanitation and oppression. By way of a close, the final article is a roundtable discussion by the Decolonising Group, wherein they reflect on recent developments and possible trajectories in decolonising. It is noted that, already, at this early point (in 2018), the decolonising concept risked becoming a 'hollow gesture'. There is however a general consensus that questions need to be asked of design and the field of design studies (in relation to how practice is critiqued and represented), as well as the institutions that sustain both. No single solution is offered but the necessity and totality (i.e., the all-encompassing remit) of the decolonising project are pointed to throughout.

Beyond this formal collective, as noted above, there is another dispersed but growing community of researchers and scholars who align with the general decolonising commitment, applying a lower case 'd' to their specific decolonising contributions (Akama 2021). Here, away from the umbrella of the Decolonising Group there is no one set of leaders or key voices, only sets of voices, which each bring their own perspective to bear on the challenge at hand. That being said, it is possible to identify a number of exploratory decolonising design initiatives, which have been undertaken by such contributors over the last number of years.

For the most part, these take on the form of framework proposals, devices which offer designers and designer-researchers a means of challenging themselves and their assumptions, as well as the prevailing norms within the field.[24] A recent example of this comes from Leslie-Anne Noel, a design researcher at North Carolina State, through her recently issued Designer's Critical Alphabet (Noel 2020). The alphabet takes the form of a series of small prompt cards, which each sets out a definition of a concept (e.g., 'Marginalization'). The idea is that the cards might be selected at random or alternatively that particular terms might be sought out in reference to a given issue. In applying the alphabet in this way it is proposed that designers and designer-researchers will be supported in their efforts to examine or reexamine the orientation of their work, whether in advance of undertaking a specific project, during the process or beyond.

Another example comes from Boehnert and Onafuwa (2016) who present a 'framework for allies' in design. The framework is presented as a means of disrupting design's contribution to what is referred to as symbolic violence – the reproduction of various negative and oppressive values through 'cultural practices, processes and institutions'. Here, we see the intriguing overlap between decolonising and transition design (see previous) come to the fore as Boehnert and Onafuwa consider how design can support not only, for example, sexism

and racism, but also 'ecoism'. Their framework includes two stages, the first is grounded in conversation. Here, participants are asked to explore the extent to which certain practices contribute either to revealing or erasing oppression, and whether those involved can be drawn to 'allyship' with the oppressed. The second stage is grounded in 'narratives, scenarios and framing'. Here, participants are given scenarios representing intersectional issues spanning various forms of oppression and are asked to map possible 'reframed' responses onto a visual matrix, linking levels of oppression (i.e., cultural, institutional and individual) to levels of ally (i.e., individual, group and culture). The aim is to encourage participants to craft approaches to responding to 'conscious (explicit) and unconscious (symbolic) forms of oppression' and consider how these 'might translate over social scales and levels of intervention' (2016, p. 12).

These cases are undoubtedly limited and tentative but nonetheless begin to frame a response to decolonising's call. They offer a means by which we might begin to consider what is problematic at present and how this can be addressed. As the Decolonising group note, decolonising design is not a matter of removing some elements of the field and replacing these with that which might be termed 'non-colonised'. Rather it is to be seen as a process of reworking, rebuilding the whole from where we are now. As such, it forms a bridge between 'philosophy' or, at the very least, theory and the reality of design 'on the ground'. In this, it stands as an example of change being wrought through discourse.

Notes

1. For a refutation, see Brad Wray (2011).
2. An exception here would be economics which, in general terms, holds a clearly defined set of principles, aims and methods. Nonetheless, economic theory too is contested (see Resnick and Wolff 2012 for a consideration of neoclassical, Keynesian and Marxian alternatives).
3. It important to note here that qualitative perspectives did not originate in the 1960s and 1970s, rather we may identify intermittent stages of development through history. For example, it is claimed that, through its attachment to ethnography, anthropology has always been 'qualitative' (Allen 2016, p. 20). Another significant locus of development emerged in Chicago in the 1920s and 30s, where a number of influential theorists, including the key pragmatist George Herbert Mead, coalesced around the idea of a qualitative sociology, grounded in what is now referred to as 'symbolic interactionism'. This latter approach focuses on how, in interactions, groups create and share meanings through the use of signs, including spoken language, gestures and other forms of communication (e.g., Blumer 1969).
4. This is due to classical pragmatism's notional concern for the practical import of any intellectual positioning that might or might not be taken up within a research project or programme.
5. Here, in setting out to detail the substance of their work in relation to these themes and, indeed, the others which follow, we may note that, for the most part, our focus shall be drawn to a limited number of key works throughout. The fact is that though each left behind substantial bodies of work – in Dewey's case 37 volumes of collected works – the essence of their primary arguments or positions can be linked to a relatively small number of what we may call 'important' texts. While foregrounding some texts over others will undoubtedly be contentious for some, it will nonetheless be useful for us to note the 'important' texts here as they will reappear throughout the remainder of the book.

 For Dewey, the key texts are *Experience and Nature* (1981/1925) and *Logic: The Theory of Inquiry* (Dewey 1986/1938). The former is an attempt by Dewey to present what he

86 *Positioning*

terms a 'naturalised metaphysics'. The latter is a far-reaching and extensive presentation on logic, derived from the idea that logic emerges off the back of our efforts to define best practice within inquiry.

For Wittgenstein, the key works are the *Tractatus Logico Philosophicus* (2013/1922) and *Philosophical Investigations* (1963/1953). The former is an attempt to present his picture theory of logic, where logic is seen to act as a perfect picturing mechanism allowing for absolute truth or falsity to be determined. The former marks his final definitive divergence from this original view where meaning is seen to arise, not in the abstract, but rather in exchanges in context.

For Heidegger, the key text is *Being and Time* (2010/1927) which offers a temporally grounded account of the 'meaning' of being, which emerges off the back of a series of complex concepts which Heidegger groups together to form the underlying architecture of this vision (e.g., Dasein or being in the world). Beyond *Being and Time*, other works are significant too. These appear mainly in essay form and though not as wide-ranging as *Being*, are nonetheless important references in regard to their subject. A key example here would be *The Question Concerning Technology* (1977), which examines how technology can be seen to shape the modern world.

By highlighting these texts, I do not, of course, wish to diminish the value of the entirety of their individual bodies of work, only to highlight the primary significance of the latter contributions. These will essentially form the contents of our Dewey-Wittgenstein-Heidegger baseline, acting as the references from which most of our discussions will derive.

6. This latter proposal is one we will return to later (see Chapter 4).
7. There is another form of thought which is also relevant here and covered by Young – meditative thought. This is seen as related but distinct, it too allows one to move beyond context and understand being but is especially *philosophical* in nature and must follow a formal reasoning process. Importantly, it does not allow one to consider broader questions of 'Being', only to recognise it as a possible concept.
8. Making reference to the cosmology of ancient Greece, of which Heidegger was particularly fond, he specifically relates this coming together to what he designates as the 'fourfold' of earth, sky, divinities and mortals. Earth and sky relate to the performative, material features of a 'thing', while the divinities and the mortal relate to the *meaning* of the performative material (Heidegger 2001/1971, p. 171).
9. This is in keeping with Latour's notion of actor network theory or ANT, which relies on the idea that anything can become an 'actor' in a network, whether human or nonhuman, animal or material (Latour 2005b). In taking this approach, the human position is de-privileged in favour of a broader opening up to the idea that the world can be understood in terms of relationships.
10. There is a loose alignment to be drawn here with the work of McCarthy and Wright (2004): in particular, in relation to their call, via the work of Dewey and Bakhtin, for attention to be directed towards the development of an holistic aesthetic in the context of digital products.
11. This text took form in 2020, the year of the George Floyd protests across the globe.
12. While all of this indicates real change is afoot, notes of caution have been sounded. Key here, according to some, is the need to centre and foreground the scholarship of the Global South within the discourse of the Global North (e.g., Moosvai 2020).
13. This is a project in its own right and demands dedicated investigation which, in turn, would require the input of many stakeholders. It is well beyond the scope of a text such as this to even aim to give a basic history of Buddhism and its many schools. However, useful overviews are available, an example of which is *The Life of Buddhism* (Reynolds and Carbine 2000), which explores the cultural, the socio-material, as well as the practical aspects of the movement's development.
14. Interest in Addams's work is increasing in design (e.g., Lake 2014). Her work is relatively hard to access but Addams (2019) collects together some key texts.
15. Admittedly this is not covered in the present text to the extent that it might be. Nonetheless the emancipatory aspect of Dewey's work is explored elsewhere in design literature (e.g., Le Dantec and DiSalvo 2013; Le Dantec 2016; Dixon 2020a, 2020b).
16. This is something which will be explored in more detail in relation to Wittgenstein's language games concept in the next chapter.

Positioning 87

17. See Seigfried (2002b, pp. 5–7) for a brief outline in relation to feminism.
18. It would be perhaps more accurate here to see Heidegger's work as forming alignment with East Asian thought more broadly. His work has not only been compared with the tenants of Buddhist schools and practices but also to Taoism, a Chinese spiritual tradition focusing on harmony (see Chen 2005; Parkes 1987); as well as Daoism, a tradition which focuses on the 'practice of experiencing of nothing' (Yao 2010).
19. Steffney (1981) is specifically concerned with Zen Buddhism.
20. At this end of the spectrum, contributions tend to focus on a general preservation of the cycle of consumption, with compensatory adjustment taking place in the area of production. An example of a such a stance can be found in Fletcher's and Grose's *Fashion and Sustainability: Design for Change* (2012). While this text does consider the fashion system in the round, its proposals are tentative (e.g., clothes swapping services) and the whole is not contextualised as a programme for fundamental reform but rather for a gradual shift in practice over time.
21. Tonkinwise himself supported early efforts to frame this emergent area of practice.
22. Speaking broadly, many transition design researchers and students can also be found to have contributed to decolonising discourse. For example, in terms of projects to have emerged from Carnegie Mellon, Onafuwa (2018) has explored how design can support a 'recommoning' both from the perspective of transition design but also from a decolonising perspective. Equally, Ahmed Ansari's dissertation (2019a) sought to map a path towards decolonising design with a view to enabling societal transitions towards more sustainable modes of living (Ansari 2019b). In terms of the theoretical links backing both movements, two key links can be identified. The first is the Fry (2011, 2009) and Tonkinwise (2011) strand of work noted above in relation to transition design. The second and perhaps more significant is Arturo Escobar's seminal *Design for the Pluriverse*, which explicitly interweaves transition design and the general decolonising position, seeing sustainability and cultural plurality as codependent. Incidentally, Escobar acted as Ansari's external doctoral supervisor.
23. A considerable degree of controversy surrounded this move. The Group stated that while they had a conversation enthusiastically accepted, a paper was rejected leading to a collective decision to withdraw from the conference entirely. The fallout on the Design PhD Jiscmail was especially heated (Prado 2016).
24. It is worth noting that in the Roundtable article Danah Abdulla speaks disparagingly of toolkits (Abdulla et al. 2018).

References

Abdulla, D., Ansari, A., Canli, E., Keshavarz, M., Kiem, M., Martins, L. P. D. O., Vieira de Oliveira, P., and Schultz, T., 2018. 'What is at stake with decolonizing design? A Roundtable'. *Design and Culture*, 10(1), pp. 81–101.

Addams, J., 2019. *The Greatest Works of Jane Addams*. Prague: Madison and Adams Press.

Akama, Y., 2021. Email to Brian Dixon, 31 May.

Alcoff, L., and Potter, E. (Eds.), 1993. *Feminist Epistemologies*. London: Routledge.

Alexander, T., 2013. *The Human Eros: Eco-ontology and the Aesthetics of Existence*. New York: Fordham University Press.

Allen, M., 2016. *Essentials of Publishing Qualitative Research*. Abingdon: Routledge.

Ansari, A., 2019a. *Decolonizing Design Studies*. Unpublished Ph.D. Dissertation. Pittsburgh, PA: Carnegie Mellon School of Design.

Ansari, A., 2019b. 'Decolonizing design through the perspectives of cosmological others: Arguing for an ontological turn in design research and practice'. *XRDS: Crossroads, The ACM Magazine for Students*, 26(2), pp. 16–19.

Axtell, J., 2016. *Wisdom's Workshop: The Rise of the Modern University*. Princeton, NJ: Princeton University Press.

Bang, A. L., Krogh, P., Ludvigsen, M., and Markussen, T., 2012. 'The role of hypothesis in constructive design research'. In *4th the Art of Research: Making, Reflecting and Understanding*. Helsinki, Finland: Aalto University School of Arts, Design and Architecture, 28–29 November.

88 Positioning

Bardzell, S., 2010. 'Feminist HCI: Taking stock and outlining an agenda for design'. In *Proceedings of the SIGCHI Conference on Human Factors in Computing Systems*, pp. 1301–1310. New York: ACM.

Blumer, H., 1969. *Symbolic Interactionism: Perspective and Method*. Englewood Cliffs, NJ: Prentice Hall.

Boehnert, J., and Onafuwa, D., 2016. 'Design as symbolic violence: Reproducing the "isms" + A framework for allies. Intersectional perspectives on design, politics, and power'. Paper presented at the Intersectional Perspectives on Design, Politics and Power at School of Arts and Communication, Malmö University, Malmö, 14–15 November.

Bortoft, H., 1996. *The Wholeness of Nature: Goethe's Way Toward a Science of Conscious Participation in Nature*. Aurora: Lindisfarne.

Brinkman, S., Hviid Jacobsen, M., and Kristensen, S., 2014. 'Historical overview of qualitative research in the social sciences'. In P. Leahy (Ed.), *The Oxford Handbook of Qualitative Research*, pp. 17–42. Oxford: Oxford University Press.

Browne, N. W., 2007. *The World in Which We Occur: John Dewey, Pragmatist Ecology and Ecological Writing in the Twentieth Century*. Tuscaloosa, AB: The University of Alabama Press.

Buckley, C., 1986. 'Made in patriarchy: Toward a feminist analysis of women and design'. *Design Issues*, pp. 3–14.

Caradonna, J. L., 2018. *Routledge Handbook of the History of Sustainability*. Abingdon: Routledge.

Chen, E. M., 2005. 'How Taoist is Heidegger?'. *International Philosophical Quarterly*, 45(1), pp. 5–19.

Chinn, E. Y., 2006. 'John Dewey and the Buddhist philosophy of the middle way'. *Asian Philosophy*, 16(2), pp. 87–98.

Creswell, J. W., and Plano Clark, V. L., 2011. *Designing and Conducting Mixed Methods Research*, 2nd edition. London: Sage.

Cross, N. (Ed.), 1984. *Developments in Design Methodology*. Chichester: John Wiley and Sons.

Davis, M., 2015. 'What is a "research question" in design?'. In P. Rodgers and J. Yee (Eds.), *The Routledge Companion to Design Research*, pp. 132–141. Abingdon: Routledge.

Decolonising Design, 2017. 'Editorial statement'. [Online]. Available at: www.decolonising design.com/statements/2016/editorial/ [Accessed: 18 December 2021].

Depraetere, A., van Bouchaute, B., Oosterlynck, S., and Vandenabeele, J., 2019. 'Nurturing solidarity in diversity: Can local currencies enable transformative practices?'. In S. Oosterlynck and G. Verschraegen (Eds.), *Divercities: Understanding Super Diversity in Deprived and Mixed Neighbourhoods*, pp. 89–112. London: Policy Press.

de Sousa Santos, B., 2018. *The End of the Cognitive Empire the Coming of Age of Epistemologies of the South*. Durham, NC: Duke University Press.

Dewey, J., 1981 [1925]. *The Collected Works of John Dewey: The Later Works, 1925–1953, vol. 1, Experience and Nature*. Edited by J. A. Boydston. Carbondale, IL: Southern Illinois University Press.

Dewey, J., 1986 [1938]. *The Collected Works of John Dewey: The Later Works, 1925–1953, vol. 12, Logic: The Theory of Inquiry*. Edited by J. A. Boydston. Carbondale, IL: Southern Illinois University Press.

Dixon, B., 2020a. *Dewey and Design: A Pragmatist Perspective for Design Research*. Cham: Springer.

Dixon, B., 2020b. 'From making things public to the design of creative democracy: Dewey's democratic vision and participatory design'. *CoDesign*, 16(2), pp. 97–110.

Dorst, K., 2008. 'Design research: A revolution-waiting-to-happen'. *Design Studies*, 29(1), pp. 4–11.

Dourish, P., 2001. *Where the Action Is*. Cambridge, MA: The MIT Press.

Dreyfus, H. L., and Wrathall, M. A., 2005. 'Martin Heidegger: An introduction to his thought, life and work'. In H. L. Dreyfus and M. A. Wrathall (Eds.), *A Companion to Heidegger*, pp. 1–15. Oxford: Blackwell Publishing.

Ehn, P., 2008. 'Participation in design things'. In *Participatory Design Conference (PDC), Bloomington, Indiana 2008*, pp. 92–101. New York: ACM.

Elliot, R. (Ed.), 1995. *Environmental Ethics*. Oxford: Oxford University Press.

Escobar, A., 2017. *Designs for the Pluriverse: Radical Interdependence, Autonomy, and the Making of Worlds*. Durham, NC: Duke University Press.

Fletcher, K., and Grose, L., 2012. *Fashion & Sustainability: Design for Change*. London: Laurence King.

Foucault, M., 1970. *The Order of Things: An Archeology of Knowledge*. Translated by A. M. Sheridan-Smith. London: Penguin.

Fry, T., 1999. *A Design Philosophy: An Introduction to Defuturing*. Sydney: University of New South Wales Press.

Fry, T., 2009. *Design Futuring: Sustainability, Ethics and New Practice*. London: Berg.

Fry, T., 2011. *Design as Politics*. London: Berg.

Fry, T., 2012. *Becoming Human by Design*. London: Berg.

Genova, J., 1995. *Wittgenstein: A Way of Seeing*. Abingdon: Routledge.

Guattari, F., 2000. *The Three Ecologies*. London: Athlone Press.

Guba, E., and Lincoln, Y. S., 1985. *Naturalistic Inquiry*. London: Sage.

Guba, E., and Lincoln, Y. S., 1994. 'Competing paradigms in qualitative research'. In N. K. Denzin and Y. S. Lincoln (Eds.), *Handbook of Qualitative Research*, pp. 105–117. London: Sage.

Haddock, A., Millar, A., and Pritchard, D., 2010. *Social Epistemology*. Oxford: Oxford University Press.

Haraway, D. J., 1988. 'Situated knowledges: The science question in feminism and the privilege of partial perspective'. *Feminist Studies*, 14(3), pp. 575–599.

Heidegger, M., 1977. *The Question Concerning Technology and Other Essays*. Translated by W. Lovitt. New York. Harper and Row.

Heidegger, M., 2001 [1971]. *Poetry, Language, Thought*. Translated by A. Hofstadter. New York. Harper and Row.

Heidegger, M., 2010 [1927]. *Being and Time*. Translated by J. Stambaugh. Albany, NY: State University of New York Press.

Harding, S., 1986. *The Science Question in Feminism*. London: Cornell University Press.

Hickman, L. A., 2007. *Pragmatism as Post-Postmodernism: Lessons from John Dewey*. New York: Fordham University Press.

Holland, N. J., and Huntington, P. (Eds.), 2001. *Feminist Interpretations of Martin Heidegger*. University Park, PA: The Pennsylvania University State University Press.

Husserl, E., 2001 [1900/1901]. *Logical Investigations*, 2nd edition, vol. 2. Edited by D. Moran. London: Routledge.

Irwin, T., 2015. 'Transition design: A proposal for a new area of design practice, study, and research'. *Design and Culture*, 7(2), pp. 229–246.

Irwin, T., 2018. 'The emerging transition design approach'. In C. Storni, K. Leahy, M. McMahon, P. Lloyd, and E. Bohemi (Eds.), *Design as a Catalyst for Change – DRS International Conference 2018, vol. 3: Design as a Catalyst for Change*, pp. 968–989. London: The Design Research Society.

Irwin, T., Kossoff, G., Tonkinwise, C., and Scupelli, P. (2015). *Transition Design: A New Area of Design Research, Practice and Study That Proposes Design-Led Societal Transition Toward More Sustainable Futures*. Pittsburgh, PA: Carnegie Mellon School of Design.

Isasi-Díaz, A. M., and Mendieta, E. (Eds.), 2018. *Decolonizing Epistemologies: Latina/o Theology and Philosophy*. New York: Fordham University Press.

James, M., 2017. 'Advancing design thinking towards a better understanding of self and others: A theoretical framework on how Buddhism can offer alternate models for design thinking'. *Form Akademisk*, 10(2), pp. 1–14.

James, S. P., 2000. ' "Thing-centered" holism in Buddhism, Heidegger, and deep ecology'. *Environmental Ethics*, 22(4), pp. 359–375.

90 *Positioning*

Keating, M., and Della Porta, D., 2010. 'In defence of pluralism in the social sciences'. *European Political Science*, 9(1), pp. S111–S120.

Knight, L. W., 2010. *Jane Addams: Spirit in Action*. New York: W. W. Norton and Company Inc.

Koskinen, I., Zimmerman, J., Binder, T., Redström, J., and Wensveen, S., 2011. *Design Research Through Practice: From the Lab, Field, and Showroom*. Amsterdam: Elsevier.

Kossoff, G., Irwin, T., and Willis, A. M. (Eds.), 2015. 'Transition design provocation'. *Design Philosophy Papers*, 13(1).

Kuhn, T. S., 2012 [1972]. *The Structure of Scientific Revolutions*. Chicago: The University of Chicago Press.

Lake, D., 2014. 'Jane Addams and wicked problems: Putting the pragmatic method to use'. *The Pluralist*, 9(3), pp. 77–94.

Latour, B., 1993. *We Have Never Been Modern*. Translated by C. Porter. Cambridge, MA: Harvard University Press.

Latour, B., 2005a. 'From realpolitik to dingpolitik or how to make things public'. In B. Latour and P. Weibel (Eds.), *Making Things Public: Atmospheres of Democracy*, pp. 14–41. Cambridge, MA: The MIT Press, ZKM, Center for Art and Media in Karlsruhe.

Latour, B., 2005b. *Reassembling the Social: An Introduction to Actor Network Theory*. Oxford: Oxford University Press.

Latour, B., and Woolgar, S., 1986. *Laboratory Life: The Construction of Scientific Facts*. Princeton, NJ: Princeton University Press.

Le Dantec, C. A., 2016. *Publics*. Cambridge, MA: The MIT Press.

Le Dantec, C. A., and DiSalvo, C., 2013. 'Infrastructuring and the formation of publics in participatory design'. *Social Studies of Science*, 43(2), pp. 241–264.

Liedtka, J., Salzman, R., and Azer, D., 2017. *Design Thinking for the Greater Good: Innovation in the Social Sector*. New York: Columbia University Press.

Machamer, P., and Wolters, G. (Eds.), 2004. *Science, Values, Objectivity*. Pittsburgh, PA: University of Pittsbugh Press.

Manzini, E., 2015. *Design When Everyone Designs*. Cambridge, MA: The MIT Press.

Marx, K., 1992 [1844]. 'Economic and philosophical manuscripts' In K. Marx (Ed.), *Early Writings*, pp. 279–334. London: Penguin Classics.

May, R., 2005. *Heidegger's Hidden Sources: The East Asian Influences on His Work*. Translated by G. Parkes. Abingdon: Routledge.

McCarthy, J., and Wright, P., 2004. *Technology as Experience*. Cambridge, MA: The MIT Press.

McDonald, H., 2004. *John Dewey and Environmental Ethics*. Albany, NY: State University of New York Press.

McWhorter, L., and Stenstad, G. (Eds.), 2009. *Heidegger and the Earth: Essays in Environmental Philosophy*. Toronto: University of Toronto Press.

Melles, G., 2008. 'An enlarged pragmatist inquiry paradigm for methodological pluralism in academic design research'. *Artifact*, 2(1), pp. 3–11.

Mignolo, W. D., 1999. 'Coloniality at large: Knowledge at the late stage of the modern/colonial world system'. *Journal of Iberian and Latin American Research*, 5(2), pp. 1–10.

Mignolo, W. D., and Walsh, C. E., 2018. *On Decolonity: Concepts, Analytics, Praxis*. Durham, NC: Duke University Press.

Moosvai, L., 2020. 'The decolonial bandwagon and the dangers of intellectual decolonisation'. *International Review of Sociology*, 30(2), pp. 332–354.

Naess, A., 1990. *Ecology, Community and Lifestyle: Outline of an Ecosophy*. Cambridge: Cambridge University Press.

Noel, L. A., 2020. 'Critical alphabet'. [Online]. Available at: https://criticalalphabet.com [Accessed: 18 December 2021].

Olafson, F., 1993. 'The unity of Heidegger's thought'. In C. Guignon (Ed.), *The Cambridge Companion to Heidegger*, pp. 97–110. Cambridge: Cambridge University Press.

Onafuwa, D., 2018. *Design-Enabled Recommoning: Understanding the Impact of Platforms on Contributing to New Commons*. Unpublished Ph.D. Dissertation. Pittsburgh, PA: Carnegie Mellon School of Design.

Parkes, G. (Ed.), 1987. *Heidegger and East Asian Thought*. Honolulu, HI: University of Hawaii Press.

Prado, L., 2016. 'Launching the decolonising design platform'. [Online]. Available at: www.jiscmail.ac.uk/cgi-bin/wa-jisc.exe [Accessed: 4 April 2022].

Quijano, A., 2000. 'Coloniality of power, eurocentrism and Latin America'. *Nepantla*, 1(3), pp. 533–580.

Rentmeester, C., 2016. *Heidegger and the Environment*. London: Rowman and Littlefield.

Resnick, S., and Wolff, R., 2012. *Contending Economic Theories: Neoclassical, Keynesian, and Marxian*. Cambridge, MA: The MIT Press.

Restivo, S., 1994. *Science, Society, and Values: Toward a Sociology of Objectivity*. Bethlehem: Lehigh University Press.

Reynolds, F., and Carbine, J. A. (Eds.), 2000. *The Life of Buddhism*. Berkeley, CA: University of California Press.

Rosenthal, S. B., 1997. 'Scientific method and natural attunement: The illuminating alliance of Dewey and Buddhism'. *The Journal of Speculative Philosophy*, pp. 239–246.

Rothschild, J. (Ed.), 1999. *Design and Feminism: Re-Envisaging Spaces, Places and Everyday Things*. Piscataway, NJ: Rutgers University Press.

Safranski, R., 1999. *Martin Heidegger: Between Good and Evil*. Translated by E. Osers. Cambridge, MA: Harvard University Press.

Sanders, E. B. N., 2017. 'Learning in PD: Future aspirations'. In B. DiSalvo, J. Yip, E. Bonsignore, and C. DiSalvo (Eds.), *Participatory Design for Learning*, pp. 213–224. Abingdon: Routledge.

Sayers, S., 2011. *Marx and Alienation: Essays on Hegelian Themes*. Basingstoke: Palgrave Macmillan.

Scheffler, I., 1982. *Science and Subjectivity*, 2nd edition. Indianapolis, IN: Hackett Publishing Company.

Scheman, N., 2002. 'Introduction'. In N. Scheman and P. O'Conner (Eds.), *Feminist Interpretations of Ludwig Wittgenstein*, pp. 1–21. University Park, PA: The Pennsylvania University State University Press.

Scheman, N., and O'Conner, P. (Eds.), 2002. *Feminist Interpretations of Ludwig Wittgenstein*. University Park, PA: The Pennsylvania University State University Press.

Schmider, M. E., 1983. *Jane Addams' Aesthetic of Social Reform*, vol. 1. Ann Arbor, MI: The University of Michigan Press.

Science Council, 2020. 'Our definition of science'. [Online]. Available at: https://sciencecouncil.org/about-science/our-definition-of-science/ [Accessed: 5 December 2020].

Seigfried, C. H., 1996. *Pragmatism and Feminism: Reweaving the Social Fabric*. Chicago: The University of Chicago Press.

Seigfried, C. H. (Ed.), 2002a. *Feminist Interpretations of John Dewey*. University Park, PA: The Pennsylvania University Press.

Seigfried, C. H., 2002b. 'Introduction'. In C. H. Seigfried (Ed.), *Feminist Interpretations of John Dewey*, pp. 1–22. University Park, PA: The Pennsylvania University Press.

Shoreman-Outmet, E., and Kopnina, H., 2015. *Culture and Conservation: Beyond Anthropocentrism*. Abingdon: Routledge.

Shuford, A. L., 2011. *Feminist Epistemology and American Pragmatism: Dewey and Quine*. London: Bloomsbury.

Siderits, M., 2007. *Buddhism as Philosophy: An Introduction*. Aldershot, Hants: Ashgate.

92 Positioning

Steffney, J., 1981. 'Man and being in Heidegger and Zen Buddhism'. *Philosophy Today*, 25(1), pp. 46–54.

Taylor, P. W., 1986. *Respect for Nature: A Theory of Environmental Ethics*. Princeton, NJ: Princeton University Press.

Telier, A., Binder, T., De Michelis, G., Ehn, P., Jacucci, G., Linde, P., and Wagner, I. 2011. *Design Things*. Cambridge, MA: MIT Press.

Teddle, C., and Tashakkori, A., 2009. *Foundations of Mixed Methods Research: Integrating Qualitative and Quantitative Approaches in the Social and Behavioural Sciences*. London: Sage.

Tirres, C., 2012. 'Decolonising religion: Pragmatism and Latina/o religious experience'. In A. M. Isasi-Díaz and E. Mendieta (Eds.), *Decolonizing Epistemologies: Latina/o Theology and Philosophy*, pp. 225–246. New York: Fordham University Press.

Tonkinwise, C., 2011. 'Only a god can save us – or at least a good story: I♥ sustainability (because necessity no longer has agency)'. *Design Philosophy Papers*, 9(2), pp. 69–80.

Tonkinwise, C., 2015. 'Design for transitions–from and to what?'. *Design Philosophy Papers*, 13(1), pp. 85–92.

Watts, M., 2014. *The Philosophy of Martin Heidegger*. Abingdon: Routledge.

Weingarden, L., 1985. 'Aesthetics politicized: William Morris to the bauhaus'. *Journal of Architectural Education*, 38(3), pp. 8–13.

Weston, A., 1985. 'Beyond intrinsic value: Pragmatism in environmental ethics'. *Environmental Ethics*, 7(4), pp. 321–339.

Wittgenstein, L., 1963 [1958]. *Philosophical Investigations*. Translated by G. E. M. Anscombe. Oxford: Basil Blackwell.

Wittgenstein, L., 1969. *On Certainty*. Edited by G. E. M. Anscombe and G. H. von Wright. Translated by D. Paul and G. E. M. Anscombe. Oxford: Basil Blackwell.

Wittgenstein, L., 2013 [1921]. *Tractatus Logico-Philosophicus*. Abingdon: Routledge.

Winograd, T., and Flores, F., 1986. *Understanding Computers and Cognition*. Norwood, NJ: Albex.

Wong, B., 2011. *What Is Design? – A Pragmatist & Buddhist Perspective on Design Thinking*. Unpublished Ph.D. Dissertation. Hong Kong: Hong Kong Polytechnic University.

Wray, B., 2011. *Kuhn's Evolutionary Social Epistemology*. Cambridge: Cambridge University Press.

Yao, Z., 2010. 'Typology of nothing: Heidegger, Daoism and Buddhism'. *Comparative Philosophy*, 1(1), pp. 78–89.

Yee, J. S., 2010. 'Methodological innovation in practice-based design doctorates'. *Journal of Research Practice*, 6(2), p. M15.

Young, J., 2002. *Heidegger's Later Philosophy*. Cambridge: Cambridge University Press.

Zimmerman, J., and Forlizzi, J., 2008. 'The role of design artifacts in design theory construction'. *Artifact: Journal of Design Practice*, 2(1), pp. 41–45.

Zimmerman, M. E., 2012. 'Heidegger's phenomenology and contemporary environmentalism'. In C. Browne and T. Toadvine (Eds.), *Eco-Phenomenology*. Albany, NY: State University of New York Press.

2 Processing
Making a World Together through Meaningful Inquiry

In the last chapter, we explored the idea of positioning in design research involving practice and, from this, considered some of the potential models offered by Dewey, Wittgenstein and Heidegger. We also looked at where these models might begin to connect with existing work in the field (e.g., transition design and the decolonising design movement). The point being made, of course, is that, through the models, we may begin to consider our role as designer-researchers, who/what we are in relation to the context of the work.

From here, another need arises. We must start – start acting, start *researching*. Acting, researching is referred to here as *processing* – how one goes about conducting one's research, the steps one takes and how these hold together to form a single coherent structure. Processing is important because, ultimately, the qualities of one's outcomes derive from the quality of one's process. Our processing/researching must be appropriate to our aims, what we hope to achieve.

It is, in the end, a matter of *methodology,* and methodology is a crucial concern in research. As a term, it literally refers to the *study* of method. If we have clarity as regards our method (or methods), we are one step closer to having methodological rigour, i.e., ensuring that all of the parts stand up, on their own – that the project, in its totality, is sound and justifiable. As such, by considering processing with reference to our philosophical baseline of Dewey-Wittgenstein-Heidegger, we are considering means by which we might *frame* a clear methodology off the back of a clear understanding of our process. This will be the core concern of the present chapter.

I will proceed as follows. At the outset, we will briefly consider the intersection of design and methodological concerns. Here, focus is directed to the question of whether or not the design process may stand alone, as a unique and special methodology or whether it must inevitably turn to the sciences or the arts and humanities to furnish a legitimate methodology. From this, we return to our philosophical baseline. Here, our focus on processing guides us towards Dewey's pattern of inquiry, as well as his and Wittgenstein's treatments of communication/language/meaning and, lastly, Heidegger's separate but relevant characterisations of the discovery and poetic thought. The chapter closes with a reflection on what all three can be seen to offer design research. In navigating through this work, we, as designer-researchers, are ultimately exploring how our understanding of the 'method' of the design process might benefit from Dewey's-Wittgenstein's-Heidegger's treatment of the themes of action and communication (most especially in relation to language and what might be termed 'meaning-making').

DOI: 10.4324/9781003194309-4

94 *Processing*

I open then by turning to the question of the intersection between design and methodology in design research involving practice.

The Intersecting of the Design (Research) Process and the Methodological

The question of methodology is a challenging one in the context of design research involving practice. This is not because the idea of methodology itself is an inappropriate issue or concern; it is, of course, a very appropriate issue/concern. Rather it connects us to a bigger issue, the key problematic of this text – the question of how one frames an epistemological justificatory narrative for design research involving practice. In essence, within this problematic, methodology and epistemology bump up against each other. As before, what is at stake is whether design itself can be seen to present a unique, standalone domain with its own special form of knowledge production, its own epistemology and methodology; or instead, whether, in order to gain legitimacy, it must always seek to import its epistemological narratives and their attendant methodological procedures, whether related to data collection or analysis or experimental approach. Put it another way, one might ask, should design research openly acknowledge a debit to such diverse traditions as the natural sciences, the social sciences and the arts? Or, alternatively, is it better to foreground the design process itself as method, positioning its various inherent practices and internal pressures as the ultimate methodological (and by default epistemological) touchstone?

When it comes to the methodological literature, both sides are represented, i.e., there are those who explicitly link to sciences and the arts (e.g., Koskinen et al. 2011; Krogh and Koskinen 2020) and, equally, there are those who foreground the design process as a methodological touchstone (e.g., Binder and Redström 2006; Brandt and Binder 2007; Bang et al. 2012). The thing is that neither of these points of view dominate. Both are available. Both can be picked up.

If we look beyond these methodological sources to the 'non-methodological' – in particular, to texts which discuss design in its own terms, as an object of study – it would appear that some contributions do lend support to the idea that design can function alone, as a special methodology.

Among the most obvious of these will be the perspectives offered by Nigel Cross's *Designerly Ways of Knowing* (1982, 2007) and Herbert Simon's *Sciences of the Artificial* (1996/1969), both of which have been referenced earlier. On Cross's presentation, design has its own methods of producing (e.g., sketching, modelling) and evaluating (i.e., appropriateness, more on that later) its knowledge. For Simon, design is a scientific knowledge domain waiting to happen – all that is lacking is a clear definition of its parameters.

Beyond these we have, in the earlier chapters, also linked to some other forceful arguments on the design-knowledge question. For example, in the Introduction, reference was made to the theoretical-philosophical perspectives of Polanyi, Schön and Ingold, who each offer their own legitimation of the positioning of design and/or creative action more generally as a means of producing/gaining knowledge. Polanyi (e.g., 1966), with his centring of the notion of their being nonverbal (i.e., tacit) forms of understanding, notes that at a 'functional' level one may act with brilliant know-how but not necessarily be able to describe this conduct in abstract terms (as is often the case for designers, including expert designers). Progressing things, Schön (e.g., 1983,

1995) traces out the reflective, experimental aspects of professional action which, he believes, define the unarticulated/unarticulable underlay of successful performance for designers[1] and others. Ingold (e.g., 2013, 2000), for his part, emphasises embodiment and materiality and how both, in their interweaving, allow for an emergence of otherwise inaccessible layers of insight and understanding.

Looking past these obvious reference points, recent years have seen further important efforts to clarify this presentation, adding texture to these notionally distinct qualities of design as a standalone process of knowledge production. A key contribution here has come from Johan Redström (2017) who examines design practice as an embodied activity which finds form in lived experience. Taking a more cautious approach, Peter Murphy (2017) appears to accept that there is a special 'how' of design in his elaboration of aesthetic epistemologies for the field. On his view, and in keeping with the Redström, design research is also grounded in *media*, the shaping of artefacts. He argues that it is by 'mobilizing the imagination' that design 'achieves its most remarkable effects' (p. 118). This in turn is directed through the exploration of form and analogy – appealing ways of organising are sought, as are appealing ways of drawing equivalences and comparisons.

In another example, Matthews and Brereton (2015) seek to escape what they refer to as the 'methodological mire', offering a model grounded in what is termed 'practical epistemology'. The model, in effect, operationalises the process of conducting research *generally*, i.e., not only for design but across the knowledge production spectrum. Represented as a cycle, competent research is seen to require purpose, data, analysis, evidence and claims (p. 158). The idea is that, regardless of the means by which these are acquired/articulated (e.g., qualitative or quantitative approaches), one must be able to defend a rigourous process across each component. In essence, the external-internal division of methods (i.e., between methods which belong to design and those which do not) dissolve as set against the more important requirements of the research process.

Lastly, a further proposal regarding design's potential methodological autonomy comes from Wolfgang Jonas, who has developed a structured model of the design process in research. Linking to Dewey's work on inquiry (covered shortly), Jonas's model sees design as combining three interlinking logical patterns: analysis, projection, synthesis (Jonas 2007). Essentially, through analysis, problems are identified, with solutions being developed through projection and synthesis. Presented in this way, Jonas claims that the distinction between design and research '*becomes fuzzy*' (p. 201, italics in the original).[2] Jonas has gone on to claim that design (as a methodology) – i.e., RtD – may be understood to represent a 'trans-domain', bringing together multiple specialisms and ways of working, overcoming 'gaps between incompatible knowledge cultures' in order to address challenges (see Jonas 2015).[3]

These models all offer compelling perspectives on how, and in what ways, design might be seen to function as a standalone research methodology. It is important to note that, as yet, none has gained ascendency in the field – there is no *one* model, no one approach which takes precedence over the others. As such, each can only be understood to offer a *possible* framework for *conceptualising* design in knowledge production, offering theoretical or practical methods for applying the design process within a research context. While they may or may not draw on other research traditions in doing so, the important point is that, in each, design plays an integral, central role.

96 *Processing*

This does not mark the limit of the design-as-method discussion however.

At this point, before moving on, it will be worth briefly turning to consider another, relatable form of knowledge production, which can be seen to sit beside design research involving practice – the wide domain of *action research*.[4] Some have drawn an equivalence between RtD and action research (e.g., Frayling 2015), and it is fair to say that there is a basic alignment between the two, insofar as both see researchers undertake research by *acting* in context. Nonetheless, action research is itself a broad domain, with multiple, diverse interest groups and areas of study. Standard accounts will link together the areas of community-, educational- and organisation-based work, including emancipatory work taking place in the global South (e.g., Chevalier and Buckles 2019).

Over the decades various strands of action research have emerged including: participatory action research, critical action research, classroom action research, action learning, action science, soft-systems approaches and industrial action research (e.g. Kemmis and McTaggart 2005, pp. 560–562, for a concise but comprehensive overview). Examining these various strands, it is possible to argue that, of the group, it is participatory action research (PAR) which bears the closest resemblance to the essential outline of design research involving practice.

As compared with design research involving practice, it has a relatively long history. Emerging in the 1970s and gradually taking form over the intervening decades, the movement can claim multiple success stories across the globe from America, to Africa, to Asia (e.g., Chevalier and Buckles 2019, pp. 11–15). In terms of the generic process, it is expected that PAR researchers will work directly with communities or groups to engage in a joint analysis of community- or group-based issues and, from here, work collectively (i.e., *act*) to positively address these issues. Thereafter, the precise techniques of data collection and analysis are open but it is generally expected that reflection, i.e., a critical accounting of what was done and why, will play a key role. Intriguingly, PAR researchers will often draw on what might be referred to as creative or 'designerly' techniques, e.g., visual mapping or modelling alternative scenarios (e.g., Kindon et al. 2007; Chevalier and Buckles 2019). Exploring the general trajectory of the movement, some have noted a tension between *achieving* transformation and *making* knowledge claims (e.g., Kemmis and McTaggart 2005), which one might arguably say is also the case in design research involving practice.

Based on such parallels, some have argued in favour of drawing specific links between the PAR and design research involving practice. Katoppo and Sudradjat (2015), for example, propose an interweaving of PAR and design thinking in architecture, taking the view that such a combination would allow enhanced creative ideation. Coming from the perspective of design pedagogy, Rowe (2020) sees PAR as a means of infusing design with rigour. Regardless of the view one might take in relation to such proposals/positions, it would appear to be arguable that PAR and design research involving practice may already share much. However, if one were inclined to attempt to draw a strict distinction, one might say that while PAR foregrounds participation and action, it lacks an explicit commitment to *creative* action. As such, we might say that if PAR research exemplifies an explicitly social, transformative approach to the research process, then design research involving practice may be seen as research undertaken as an explicitly social, transformative *and explicitly* creative process.

Reflecting on the whole of the above, we may say that, in essence, there is, and likely always will be, a choice to be made here. If a designer-researcher so wishes, they may

of course align with PAR or any number of other alternative methodologies that suit their agenda or programme, as per the options offered by Koskinen, Krogh and others (Koskinen et al. 2011; Krogh and Koskinen 2020). Alternatively, if they wish, they may also align with and adapt the proposals of Cross, Schön and others, to claim a designerly *method* or, in stricter terms, methodology. In a research context, the latter approach would negate the need to reference any external discipline in order to secure a grounding for one's methodology and ultimately one's claims as was alluded to in the work of Binder, Brandt, Bang, Redström and others (e.g., Binder and Redström 2006; Brandt and Binder 2007; Bang et al. 2012; Redström 2017).

Nonetheless, here, with this latter option, we are still lumbered by the methodology-epistemology problem noted above. If design research involving practice does offer a unique and special methodology, it should be possible to articulate this in such a way as it carries a special epistemological narrative too. As has been argued, such an articulation is important because without one, design is cut adrift from other modes of knowledge production; no comparisons are possible, no rationale as to its special value may be set forth. One might say that the existing formulations presented in literature referenced previously and earlier (see the Introduction) fulfill this role (e.g., the Binder-Brandt-Bang-Redström line). There is a degree of truth in this, as far as clear procedures are offered and ways of operationalising are made available. However, continuing to push the central argument of this book, I maintain that in the absence of epistemological angles, these formulations/operationalisations lack the ability to properly 'stand alone' as methodological source points. To isolate a relatively simple issue that will inevitably arise here, we might ask how, without reference to an external discipline, does one justify a mode of data collection, or indeed, analysis? How does one discuss the framing of design experiment? How does one discuss the role of one's skills? We can see that such issues would quickly multiply, and the 'standalone' position would soon become difficult if not untenable to sustain.

My response, of course, is to return to philosophy and the Dewey-Wittgenstein-Heidegger baseline in particular to consider their handling of concerns which relate to the 'processing' of knowledge. Herein, I believe, we find clues as to how the story of the desginerly conduct of research may be given some credible, defendable form.

Processing and Dewey-Wittgenstein-Heidegger: Linking Action and Meaning in Coming to Know, See and Discover

It may seem strange that we are here considering processing with reference to both action and communication. In the context of design research involving practice, action will make sense. After all, as was noted with regard to PAR in the last section, we must act to effect change. Communication however is likely a less obvious concern in this context. Why would communication matter in the *process* of design research involving practice? Or, put another way, why would it matter as much as action?

The reason, of course, relates to our baseline and the *way* that Dewey-Wittgenstein-Heidegger address the activities of coming to *know*, to *understand* (as well as see connections) and to *discover*. The separate verbs here (i.e., knowing, understanding, discovering) relate more or less to how each of these philosophers respectively, in their own way, approach *processing* and, if we are to frame things more widely, *sense-making in and through acting/making*. For Dewey, there is a definite link to be drawn between communication – that is, the use of language – and knowing. For the later

98 *Processing*

Wittgenstein, language is key to his sense-making efforts. As we have seen it affects our 'forms of life', how we *understand* or 'see' the world. For Heidegger's part, though he does centre language in his later work, it is not so much communication that matters but rather the individually grounded forward-and-back meaning-making that occurs as we engage *with* the world in all its multiplicity. What brings all three together here is that, to varying degrees, the areas of processing/sense-making are seen to rely on forms of *doing/acting*.

Before proceeding, I should note that, as will become apparent, the latter two (i.e., Wittgenstein and Heidegger) are not immediately concerned with the activity or, to put it more accurately, the *activities* of knowledge production. Ultimately their focus lies with more specific forms of problem solving, i.e., the workings of language (Wittgenstein) and the meaning of being (Heidegger). Nonetheless, it is held that both have meaningful insights to offer to the context of 'processing' in relation to design research involving practice. Insights, indeed, which can speak to designer-researchers' concerns. With this in mind, we turn first to Dewey.

Dewey's Theories of Inquiry and Communication

Of all Dewey's theories and concepts it is arguably his 'pattern of inquiry' which has achieved the most prolific status, at least in design (e.g., Steen 2013; Dalsgaard 2009; Dixon and French 2020). In the pattern, Dewey outlines in direct, empirical terms the steps (or stages) that one, as an *inquirer*, would likely undertake in order to go about arriving at an outcome (i.e., a set of conclusions) that would qualify as 'knowledge'.[5] A key attraction of the pattern for design theorists is its heavy emphasis on *action* and *experimentation*. Equally, it relies almost entirely on terms that sit at the very core of design discourse – terms such as 'problem' and 'solution', 'ideas' and 'meanings'.

In setting out the sequence of the pattern, as noted in the last chapter, Dewey takes the view that an inquiry will commence when we encounter troubling values (i.e., really 'real' qualities in primary experience). This he calls an 'indeterminate' situation. We may be moved to act in response, to *inquire* about that which troubles us. At first our efforts will be directed towards asking questions and seeking to define the problem at hand. Thereafter, we move to envisage possible solutions and, through this latter process, will eventually come to arrive at a potential 'problem-solution'. From here, we must enter an experimental cycle, moving forward and back between developing hypotheses, testing these, observing the results and reformulating the hypotheses based on the results (see Dewey 1986/1938, pp. 106–122). Here, in relation to hypotheses, the acts of sensing, thinking, imagining and so on are seen as crucial. Dewey talks about the flickering into being of 'suggestions' which just ' "pop into our heads" ' (ibid, p. 114). Through iteration and development, these progress into ideas, which mark out possibilities which may be further developed into formal hypotheses (p. 113).

An inquiry's endpoint is to be found in achieving a recognisable point of finality – meeting what, at that point, represents an inquiry's aims, e.g., finding a 'problem-solution' that *works* (e.g., ibid, pp. 14–17). The way in which this is 'qualified' or defended as valid will be addressed in the next chapter when we address the question of 'producing' knowledge in design research involving practice.

It is important to note that Dewey does not see a sharp separation between what we might refer to as formal and informal inquiries – for example the distinction between

Processing 99

a scientist contributing to a research programme and a mechanic seeking to work through a problem with an engine. For Dewey, each is engaged in the task of resolving a problematic situation, moving from that which is indeterminate to that which is more *determined*. When the scientist and mechanic have finished, both have produced 'knowledge' of sorts in the form of a 'problem-solution' that works. The difference is that the scientist's outcomes will likely have very wide generality (e.g., a set of findings relating to particle behaviour), while the mechanic's, on the other hand, will be likely highly particular (e.g., identifying what's wrong with *this* engine at *this* point in time) (see ibid, pp. 66–102).

Dewey values the systematic aspects of science, and formal research more generally, insofar as these can be shown to have yielded useful results, conclusions that can be *reapplied* elsewhere and inform further work. However, he is open to the idea that other forms of inquiry may also offer value. At one point, in *The Quest for Certainty* – a text which examines the Western obsession with *surety* in the process of knowledge production – he notes that there is 'no kind of inquiry which has a monopoly of the honorable title of knowledge'. He asserts that regardless of the discipline (his immediate examples being, engineering, art and history) knowledge is attained on the basis that 'they employ methods that enable them to solve problems which develop in the subject-matter they are concerned with'. Here, each method will be judged on the basis of its problem-solving capabilities. 'By their fruits' Dewey writes, 'we will know them' (Dewey 1984/1929, p. 176).

A key underlying principle of the pattern of inquiry is that it is not *just* an outline of what happens when we inquire but, rather, acts as a theoretical mapping of the emergence of logical forms, i.e., the 'source' of where logic 'comes from'. On this account, logic or logical theory is not to be seen as a set of all-pervasive eternal truths, sitting apart from the everyday. Instead, Dewey believed that 'all logical forms (with their characteristic properties) arise within the operation of inquiry and are concerned with the control of inquiry' (Dewey 1986/1938, p. 11). As such, predefined logical theory was nothing more than the result of prior successful inquiries. Logic here was to be seen as natural, a human construct linked to human activities – as time passed and instruments become more and more accurate, better ways of resolving knowledge-based problems have emerged (ibid, p. 14). In remaining open-minded as to the possible value of all types of inquiry – as was suggested previously in relation to engineering, art and history – the idea is that new ways of navigating problems and arriving at new problem-solutions may yield new logics, new ways (and potentially better ways) of getting answers and coming to know.

Leading on from the pattern of inquiry, another important aspect of Dewey's understanding of *how* one goes about *conducting* research and arriving at knowledge is found in his theory of communication. Design research has not always picked up on this latter aspect of his work, but it has been argued that it offers potential significant insights for the field (see Dixon 2020, Ch. 4). The key proposal is that communication is both consummatory and instrumental; in other words, it allows both for enjoyment and celebration, *as well as* achieving shared goals together. In relation to the former, it is a matter engaging in communication for its own sake: we sing, dance, remember together (Dewey 1981/1925, p. 144). In relation to the latter, language, he says, is the 'tool of tools' (ibid, p. 146), it facilitates our engagement with each other and the things of the world. Here, socially, moving through the past-present-future, we are able to plan and agree on what we wish to do, as well as foresee and judge likely

100 *Processing*

consequences. Off the back of this view of language, meaning is understood as a collaborative endeavour – in using language we embark on a process of *making* things meaningful *together* (ibid, pp. 140–143). Indeed, Dewey sees language as forming part of a social framework which enables what he terms a 'naturalistic link' to be drawn between the physical world and our concepts/thoughts/beliefs relating to it (ibid, p. 7).

In terms of the relationship between inquiry and communication, and the process of conducting research more generally, it is this latter, instrumental aspect of language that matters most. Language here allows objects and actions to be named and identified, to come into view for inquirers so they may be drawn into the inquiry itself. As Dewey notes, 'things in acquiring meaning, thereby acquire representatives, surrogates, signs and implicates, which are infinitely more amenable to management, more permanent and more accommodating, than events in their first estate' (1981/1925, p. 132).

Importantly for design research involving practice, his naming and identifying allows new possibilities to be imagined as well as new, previously unconsidered relationships to be drawn. The meaning of things may be 'indefinitely combined and rearranged in imagination'. Further, outcomes from 'this inner experimentation' may 'issue forth in interaction with raw and crude events'; in other words, our approaches to and behaviours towards things may change as a result of these experiments in imagination (ibid). Here, we may directly reconnect to the pattern of inquiry. From the new meanings which emerge in imagination, new questions and newly indeterminate situations may arise (e.g., a situation which was settled may become doubtful). Here, we may identify that problems necessitate solutions and so properly embark on an inquiry. In inquiry, we are seen to identify and test the meaning of new ideas as they enter the frame. Equally, inquiries are seen to carry a 'system' of meaning which we reason against and use to cohere ideas together (Dewey 1986/1938, p. 115).

Another important aspect of language-meaning-inquiry relations arises at the endpoint of an inquiry. Having arrived at a set of conclusions, it is language which will support our efforts to ground what we have surfaced, as we may have new claims about things, drawing things into new relations with one another and, as such, about an ontological transformation. In other words, we change reality, the reality that existed before we embarked on our inquiry (see Dixon 2020, pp. 155–173; also Sleeper 1986). In this way, language comes to function as a tool of *transformation* within inquiry, opening up a space in which 'what is the case' is altered.

While this aspect of Dewey's work has yet to be properly appropriated within design, it will be apparent design-related concepts are threaded throughout the previously mentioned. Essentially, *meaning* is guiding us through the process of inquiry and, in the end, acts as the means by which we change our way of seeing.

From Dewey's insights, we now turn to Wittgenstein.

Pathway 2.1 An Established Pathway: Semiotics

Semiotics, the study of signs, has a long history. Indeed, it is possible to trace its development back across over, at least, the previous two millennia of Western philosophic inquiry, as questions of language, meaning and representation have been explored by innumerable contributors. Aligning semiotics with the history of logic, Deely (1982), for examples, draws together key figures as Aristotle, the Stoics, St Augustine and John Locke along an extended historical trajectory.

Processing 101

In modern terms however, the proposal that signs, linguistic and non-linguistic, can be formally studied is generally traced back to two key individuals, Ferdinand de Saussure and Charles Sanders Peirce. De Saussure was a Swiss linguist interested in relationships between the formal structure of language and its spoken form. Peirce was an American Pragmatist philosopher active in the nineteenth and early twentieth century and held a special interest in logic.[6] De Saussure referred to his proposal as semiology (which literally means the study of signs) and Peirce, to his, as 'semiotics', the term generally applied in the context of design. For Saussure, the field was to be centred around a relatively simple idea – that, in representation, there was always a dual aspect at play. On one hand there is the sign itself (e.g., the word 'dog'), on the other hand there is the thing being *signified* (e.g., the dog or the idea of a dog). For Saussure, it is the coming together of the former, as a system, that allows for signs to function in communication (e.g., De Saussure 2011/1916).

For Peirce, the set of relationships involved was somewhat more complex. There is the sign termed the 'representamen' and the signified referred to as the 'referent', but also the 'object', which refers to both the physical and mental realisations of the sign. Alongside this, Peirce also sets out various sub-typologies of each of these categories (e.g., Peirce 1991). While this renders his overall proposal somewhat unwieldy, it does allow for a compelling account of the various forms signs can take.

Beyond de Saussure and Peirce, Roland Barthes's work presents a further significant contribution to semiotic theory, particularly from a design perspective. Barthes, a French literary critic and philosopher, focused in on the question of how specific values were expressed symbolically at a wider cultural level. Key among his contributions was the proposal that signs can carry both direct (denotive) and indirect (conative) meaning for their audience. Seeking to demonstrate this proposal, through the 1950s and early 60s, he worked to surface examples of common indirect, conative messages circulating in, for example, advertising, fashion and photography. Here, through his analysis of specific cases we are shown how apparently simple visual and other symbolic devices (i.e., signs) can in fact be seen to harbour highly complex ideas relating to the wider society in which they were being produced (e.g., Barthes 1993/1957).[7]

Alongside Barthes, others have also made strong contributions to the subsequent shaping of the field through the latter half of the twentieth century. Here, a long list of mostly French philosophers drew on de Saussure's work to frame particularised semiotic perspectives related to, for example, psychoanalysis (Lacan), consumption (Baudrillard),[8] power-knowledge relations (Foucault) and literary studies (Derrida). Complimenting this, a concurrent, distinctly Peircean line of work focusing on Semiotics was progressed through the efforts of individuals such as the American philosopher Charles William Morris[9] and Emberto Eco,[10] an Italian philosopher and historian.

Within this milieu, the proposal that semiotics might act as a support in design practice and research first emerged in the 1950s, with various schools exploring the potential applicability of the semiotic perspective as a productive driver in the context of design education (Skaggs 2017). Noteworthy early work was undertaken in the Ulm Institute of Design in what was then West Germany (Betts 1998). The vision sketched out here, through the work of key individuals such as Tomás Maldonado, was of a reformed industrial design, decoupled from exclusively commercial agendas and, within this, merely aesthetic considerations.[11] The proposal was that, through the development of a 'critical semiotics' revealing the 'laws of motion of consumer culture', designers would work to coordinate the production process, intervening as

102 *Processing*

necessary to disrupt the manipulation of the consumers. It was suggested that, in this way, semiotics could support a programme of 'intellectual and political liberation' (Betts 1998, p. 80).

Generally, in the decades since, Semiotics has been found to be especially compelling in the domains of visual communication and graphic design, as well as product and industrial design.[12] Continuing in the tradition of Ulm, visual communication and graphic design theorists proposed that the semiotic could provide a strong theoretical base for the discipline (e.g., Kinross 1984). Here, Barthes's work is seen to hold special relevance as a framework for examining meaning and how it is constructed in the context of visual media (e.g., Dilnot 1984). More generally, from the 1970s onwards, it is possible to note the emergence of a series of broader semiotics-informed frameworks and theories relating to such areas as maps and diagrams (Bertin 1967), typography (White 1976; also Van Leeuwen 2006) drawing and design (Ashwin 1984) and advertising (Williamson 1978).

With product and industrial design, theorists have also sought to draw on aspects of the semiotic in order to address questions of meaning and understanding in relation to design (e.g., Krampen 1989). The emergence of this specific product-orientated perspective can be traced to the work of Krippendorff and Butter (1984) and their vision of 'product semantics' as a means of negotiating design decision-making. Here, although the visual is a key point of reference, form and material are also seen as central. Equally, while the semiotic was important, it was not fundamental. Krippendorff rejected the idea that the meaning and symbolic reference might be fixed, favouring the individual sense-making as a grounding concept of meaning in design (Krippendorff 1989): a vision he would later position as a potential theoretical 'foundation' for the field (Krippendorff 2006).[13] This general outlook can be seen to have informed the work of such famous design groups as Memphis and Alessi through the 1980s and early 90s (e.g., Hjelm 2002).

Though semiotics is no longer positioned as a central theory within design, it remains relevant today. Across both of the previously mentioned domains – visual communications and graphic design, product and industrial design – theorists continue to advocate its usefulness as a starting point from which to investigate meaning. For example, Barthes's work still guides analysis of visual design outcomes (e.g., Lee and Kim 2020), with many others continuing to propose more general frameworks in the context of visual communication and graphic design more broadly (e.g., Skaggs 2017). Equally, semiotics is still seen as a useful resource in product design education (Deni and Zingale 2017). It would appear that so long as questions of meaning remain relevant in design, so too will semiotics.

**Design Research Projects 2.1 Design Tools:
A Means of Meaning Making**

Over the last two to three decades, design tools have gained an increasing prominence within design practice and research. Tools are, in essence, made artefacts which support participant engagement, allowing individuals and groups to give expression to their experience, or give form to future possibilities. Today, advocates of design tools are among the most prominent contributors to the field,

Figure 2.1 A MakeTools workshop. Credit: Liz Sanders via MakeTools.com.

whether Elizabeth Sanders through her MakeTools initiative (e.g., Sanders and Stappers 2008; Sanders 2017) or Eva Brandt and Thomas Binder through the Centre for Codesign or CODE at the Royal Danish Academy of Fine Arts in Copenhagen (e.g., Halse et al. 2010).

On the face it would seem difficult to draw a direct link between these tools/artefacts and philosophy, at least in immediate terms. However, if we are to follow Dewey's view that language is the 'tool of tools', then a clear link can be drawn through language. Here, in supporting the communication of various categories of experiences or future-focussed speculation – whether through text, visuals, video, audio or various combinations of these – design tools can be seen to allow for an extension and furtherance of language beyond the verbal. They become spaces or surfaces which allow *more* things to come into view for inquirers than spoken words alone.

Sanders and Stappers, in particular, can be seen to lend support to this view. In outlining developments in 'co-creation' in the late 2000s, the pair place a special emphasis on tools, speaking of them in broad terms as elements which play a role in the enabling co-creation generally. By supporting expression specifically, 'appropriate' tools are said to allow non-designers to *enter* into the design process (Sanders and Stappers 2008, p. 12). Equipped in this way, they can confidently take on the 'role of experienced expert' required of them in *co-design* (ibid, p. 13). Similarly, reflecting on the work of CODE and the conscious 'incompleteness', underpinning its research programme, Halse suggests tools can support the development of 'open-ended design representations' crucial to collaborative modes of designing. On this view, tools here offer non-designers just

104 *Processing*

enough material to work through possibilities and consequences in relation to the issue(s) in question. In other words, without prescribing any outcomes, the imagining of outcomes become possible through sharing, thinking and rethinking (Halse 2010, p. 39).

Reflecting on such presentations, we can say that language as the tool of tools is strengthened by design tools – when words on their own fail, design tools are found to provide the framework to keep expression going and push ideation further.[14]

Wittgenstein's Language Games

As has been noted, Wittgenstein was not directly concerned with how one goes about conducting research in the sense outlined previously. Rather, broadly, he was concerned with trying to untangle the relationship between philosophy and language. This may not seem a very designerly perspective but, as I will try to surface, there are potential points of contact. We have of course already covered some of Wittgenstein's later views on language and meaning, noting in particular how he believed that the meaning of words depended on the *context* in which they are used. This view has contributed to Klaus Krippendorff's mature 'semantic theory' of design (2006).

However, there is more to Wittgenstein's later work than just the concept of meaning-context relations. As we saw in the last chapter, another important feature is to be found in the idea of *perspicuous representations* – that is, a way of seeing which seeks to acquire as broad a *perspective* as possible over one's language and its embedded constraints, i.e., the scope and potential impact of one's use of words in particular ways. While this was noted in the last chapter, we did not, however, cover *how* one was supposed to go about developing such a representation. And, here, in dealing with 'processing', this becomes important and, as we shall see, potentially relevant for design research involving practice.

At this point we properly encounter Wittgenstein's concept of *language games*, briefly mentioned in the last chapter. Language games have been picked up on design research, perhaps most significantly in the work of Habraken and Gross (1987) and Ehn (1988).[15] Habraken and Gross (1987) examined languages in relation to the design process in architecture and Ehn in relation to communication in participatory design projects.[16] The concept can be seen to offer potential in the context of design research involving practice too.

First and foremost, they are a technique, a device if you will.[17] Through this technique or device, we are expected to explore, investigate, reflect upon our use of language and how meaning becomes possible. The idea is that we focus in on *simple* examples, examples which allow for such explorations, investigations, reflections. We can look at the ridiculous, the probable, the possible. We can examine common everyday 'language games' too, the ones we know exist. Wittgenstein offers a host of examples here, naming among others: 'Reporting an event – Speculating about an event – Forming and testing a hypothesis – Presenting the results of an experiment in tables and diagrams – Making up a story; and reading it out' (Wittgenstein 1963/1958,

pp. 11–12 [§ 22]). In this way we may come to see what is and isn't possible in our language and come to learn how language and meaning works. Their purpose was to act as '*objects of comparison* which are meant to through light on the facts of our language by way not only of similarities, but also of dissimilarities' (1963/1958, p. 50e [§130]).

For Wittgenstein, languages games were not ends in themselves. Rather, as a technique or device, they formed the backbone of a new way of 'doing philosophy', one which contrasts with traditional approaches centred upon building up theory (or an explanation) around a given subject. On this view, philosophy comes to function 'like' therapy (ibid, p. 51e [§133]), *dissolving* rather than solving problems. Its aim was now 'to show the fly the way out of the fly bottle' (p. 103e [§309]).

This latter metaphor points to a particular issue that Wittgenstein identified in conventional philosophy. Here, he argued that conventional philosophy and, more importantly, conventional *philosophers* were trapped *by* language. In his words: '[p]hilosophy is a battle against the betwitchment of our intelligence by language' (ibid, p. 47e [§109]). The problem with language, he believed, was that once separated from the 'rough ground' (p. 46e [§107]) of real experience, it allows strange questions to be asked. Questions like 'What is language?' (p. 43e [§92]). Further complicating matters, away from the rough ground, it allows *permanent* answers to be sought, when realistically only partial, situated answers can only ever be possible in such instances.

Responding to these challenges, it was proposed that his language games technique allows idealised understandings of language, what it does and what it points to, to be unpicked. Language games *situate* language usage, mapping it to a context in which it is constrained and cannot 'go on holiday'. We (or the bewitched philosophers) are *shown* our errors, we can test what is or isn't possible, what is our isn't acceptable within the (unseen, lived) rules of language. In this, we must 'do away with all *explanation*,' he writes (p. 47e [§109]). Rather, in the first instance, instead of explanatory theories we are to aim towards *descriptions* of how things are, as well as to *see* the connections which may be drawn between things.[18]

The *seeing* of connections is particularly important for Wittgenstein. Within his new way of 'doing philosophy', he challenged philosophers to 'look' as well as 'think'. To illustrate this, at one point in *Philosophical Investigations*, he considers the variability of games in general. He notes that 'if you look at them you will not see something which is common to *all*, but similarities, relationships and a whole series of them at that.' To emphasise his point, he stresses again 'don't think, but look!' (1963/1958, p. 31e [§66]).

According to Wittgenstein scholar Judith Genova (1995), by stressing the role of looking and seeing and not *just* thinking, Wittgenstein was seeking to strike an implicit balance between rationalism (i.e., abstract reasoning) and empiricism (i.e., observation in experience). By looking and seeking out connections, we may, as Wittgenstein highlights, note what is similar and/or related. Then, the idea is that, with these observations in hand, we are able to take the next step and move beyond the immediate, to consider how (and to what extent) things might be than the way they are at present. Held in this combination, the failings of either approach on their own (i.e., just looking or just thinking) are avoided – as seeing on its own stays where it is, while, unconstrained thinking, removed from the rough ground, allows language to go on holiday.

106 *Processing*

In design research and 'processing' terms, as will covered below, there are a number of routes that open up here. The most important point being called up is to 'see-think' the relations and possibilities which confront us. In this, we are being offered a basic template by which to operate. Observe what is happening. Note the similarities and relationships. Imagine how these might be different. Explore these. The significant factor is that, within this process, imagination is to be tethered to the original observations of the 'rough ground'. Such tethering allows for comparison, and comparison, in turn, allows for evaluation. Do the imagined different scenarios work? Or do they jar? What does this tell us about the practices observed? Leaving Wittgenstein and languages aside for the moment, we now move on to Heidegger.

Design Research Projects 2.2 The Women's Design + Research Unit

Wittgenstein is not widely referenced in relation to processing in design research. But the basic idea behind his language games concept – i.e., that we can model alternatives as a way of scoping out the possibilities of meaning – does provide us with a potential way of thinking through alternatives. While the notion of thinking through alternatives is, of course, apposite in the context of design, it also allows us to link to one of our key philosophical horizons – feminism.

Feminist perspectives have, as we have seen, been picked up at points in design history (see Chapter 1 for a brief outline). In terms of a design research programme, a particularly noteworthy example is found in The Women's Design + Research Unit (WD+RU), established in the early 1990s by Siân Cook, Teal Triggs and Liz McQuiston. The initial aim of the Unit was to raise awareness around women's contributions to design practice and education, specifically in the area of visual communication design. Here, an iconic early project was the famous Pussy Galore typeface, produced in 1994 for FUSE magazine, an experimental typography journal (Cook 2014). Pussy Galore functioned both as an example of female-produced typeface (of which there were few at the time), as well as a visual alphabet of women's issues, linking the themes of empowerment, stereotypes, choices and language.

In the years since, Unit work has taken a variety of directions, moving from type to exhibitions to educational initiatives. While women-in-design remains a central concern, the Unit now claims a broader social focus with the more inclusive term 'womxn' being used in reference to the programme's demographic.[19] Despite a quarter of a century passing since its establishment, it would appear that womxn continue to face barriers within the design profession. A recent project, entitled a *Brave New Normal*, running from 2020–2022, is exploring how an 'intergenerational' mentorship programme might be of benefit to the professional graphic design community, allowing for a questioning of 'received narratives about career lifecycles', as well as an exploration of alternative models of understanding knowledge and value (WD+RU 2021).

Examined in the context of design-philosophy relations, the WD+RU can be seen to represent a practical response to the issue of female empowerment

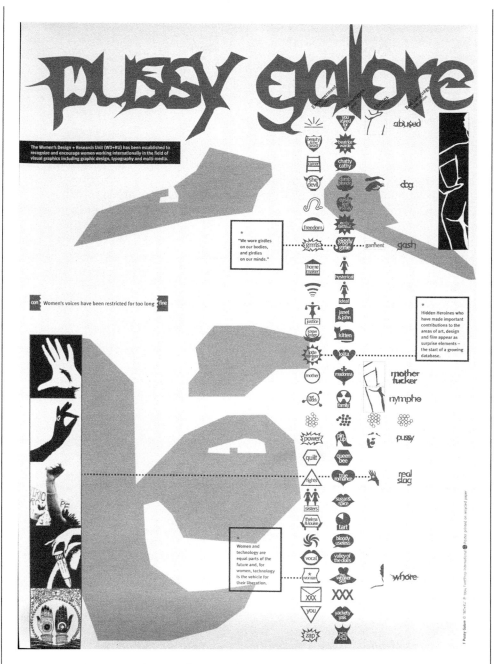

Figure 2.2 The Pussy Galore typeface. Credit: WD+RU and FUSE via wdandru.tumblr.com.

108 *Processing*

and the need to map an alternative course as set against taken-for-granted societal and professional norms. It might be argued that its programme relies on a looking-thinking process. The designer-researchers are observing what is and imagining what might be otherwise; we the audience are invited to reflect and ask questions in turn.

Heidegger's Discovery and Poetic Thinking

When it comes to processing, Heidegger's offering is seen as distinct from Dewey's and Wittgenstein's. First, there is the issue of language. He did not focus on language in quite the same way as either Dewey or Wittgenstein. It is not something we 'do' things with in the sense of the Dewey-Wittgenstein outline. Rather, for the later Heidegger, language is presented as the 'house of being' (Heidegger 1998, p. 239), a store where our means of apprehending the world are collectively contained, which in turn sustains our being-in-the-world (see Powell 2013). In this way, it functions more like Wittgenstein's form of life, discussed in relation to positioning (see Chapter 1).

Then, importantly, there is the issue of methodology itself. While Heidegger can be seen to have contributed to the methodological underpinnings of the philosophy of phenomenology,[20] he was not concerned with refining any particular *methodology* as such. The process of asking questions and seeking answers, pushing to resolve a problem, is not represented in quite the same systematic way as it is within Dewey's pattern of inquiry. Instead, Heidegger continues to operate on an 'ontological level' – i.e., his focus is directed towards exploring our being and how we conduct ourselves as beings.

Here, further distinguishing himself from Dewey, he adopts a negative stance in relation to the scientific perspective and its impact on our relationship with the things of the world. Science, he says, overlooks the qualities and 'place' of things. Beings are released from their 'confinement' within the complex totality of the world as we encounter it (Heidegger 2010/1927, p. 344) and rendered 'present' at hand. All is brought together through a designation of 'methods, the structures of conceptuality, the relevant possibility of truth and certainty', and so on. Everything becomes part of a themed 'projecting' (ibid p. 345).

Against this, he seeks to articulate an outline of how, in our being in the world, we are able to apprehend things in a process of uncomplicated immediate interaction. Here, there is no 'subject' and 'object' in the classical sense. There are only Dasein (i.e., being-there) and beings and what happens. Knowing is 'a mode of being of Dasein as being-in-the-world'. Its foundations are to be found 'in this constitution of being' (ibid, p. 61). The idea of knowing occurring 'inside' an individual, considering an 'outside' phenomenon, is seen as redundant within such a conceptualisation. Rather, in 'its primary kind of being' Dasein is 'always already "outside" together with some being encountered in the world already discovered' (p. 62). As a consequence, there is no 'problem of knowledge' as such (i.e., we do not have to untangle the question of how subjects can 'understand' separate, independent objects; they are not fully separate or independent to begin with).

Processing 109

In order to properly explore this idea, Heidegger offers us a practical vision of *discovery* – that is, of how things are encountered and come to be understood. Here, in the first instance, we are brought back to his core concept of 'care'. Care, as will be recalled from the last chapter, is something which is inherent to our 'being-there' (i.e., Dasein). We care because we are always already here in our 'thrownness'. Caring drives our engagement with the world as we go about meeting our needs and doing what we need to do. As was noted in the last chapter, we may be seen to *take* care through activities such as producing, ordering, using, undertaking, accomplishing, finding, asking, observing, speaking about and so on. Heidegger argues that, in these activities of taking care, we may enter into a process of *discovery*.

This involves two steps. First, we must come to understand things in their *own* terms, i.e., what they are, what they are for. In describing how this is achieved, Heidegger outlines a process of 'circumspection' where things are examined in relation to their 'in-order-to', i.e., what they might allow us to do (ibid, p. 144).[21] In this, things are said to come 'before sight' and are then taken apart and taken care of on the basis of how they are seen, while this will require a degree of understanding but nonetheless still relies on a cycle of forming an interpretation[22] which results in further understanding. Once understood, a being's possibilities are 'disclosed' and things are given *meaning*. Heidegger helpfully defines meaning as 'that wherein the intelligibility of something maintains itself' (ibid).

From this, in terms of the second step in discovery, once things have meaning and we see 'something as something', we are able to move outwards, *beyond* them. We essentially open up channels by which *further* understanding can be achieved. Here, the materials we *produce* with, the actions we *order*, the items we *use*, all provide us with points of access to the world in all its phenomenal fullness. We are able to explore and discover aspects of nature. As Heidegger puts it, nature may be 'discovered in the use of useful things'. As we seek wood we are brought in contact with the forest; as we seek rock the quarry; as we sail, the wind in the sails and so on. Equally, through interaction with one material, whether nails or leather, we are brought into contact with a web of related materials and beings (e.g., metal and cattle) (ibid, p. 70).

This connects us directly to the physical, embodied aspect of design research, wherein things are made, iterations are trialled, successes and failures noted. As designers will attest, the world reveals itself to us in making. If new tools or objects are drawn into the design process, we may explore their 'in-order-to'; i.e., what they allow us to do, their 'handiness'. We may also learn about the constraints of a given material, we note what is or isn't possible in terms of achieving a given form. Even the digital realm (though not 'natural' in the classic sense), reveals its own 'limits' as we run up against the capabilities of programming or mark-up languages. Then there is also the possibility that we will be able 'discover' broader relationships as well, by consciously or unconsciously finding ourselves connecting to the networks out of which materials arise.

This, as we will cover shortly, can be seen to represent Heideggerian discovery in action in a design context. Discovery, however, is not all that Heidegger offers in relation to the area of 'processing'. Additionally, we may draw further inspiration from the idea of the poetic mode of thinking, a concept briefly discussed in the last chapter.

As has been noted, Heidegger believes that poetic thinking allows us to move beyond one's immediate bounds to broader questions of Being in a general sense. The

110 *Processing*

'how to' of this might notionally have bearings for design and design research involving practice.

Poetic thinking is a reoccurring discussion point in Heidegger's later work, appearing in various guises across a number of texts. While it is most often discussed in relation to the work of his favourite poet, Hölderin (whose poetry is often used as an exemplar),[23] it also appears in a series of reflections on art, poets or poetry and thinking in general. Key among these is an important essay, entitled 'The Origin of the Work of Art'.[24]

The essay sets out to examine art, understood in terms of *'what from and by which'* art *'is what it is and as it is'*.[25] In doing so, Heidegger focuses in on both the artist and the work itself, seeing the two as relying on each other, as well as the broader, more general background of art itself, i.e., its broader history/trajectory (Heidegger 2001/1971, p. 17, italics in original). In focusing in on the work of the artist, he draws a line of separation between their *special* contribution and the more mundane, prosaic act of 'making' aligned to what we might think of as design,[26] e.g., making functional things such as 'shoes', which he offers as a particular example (e.g., ibid pp. 32–38). What emerges is a vision of art as a 'disclosure' of what things are in *truth*. Here, Heidegger moves to define artistic creation as 'a way in which truth becomes or happens' (ibid, p. 58). Beside this, art is 'the truth of beings *setting* itself to work' (p. 35, italics added).

Such a presentation leads, in turn, to the question of what *truth* is and how it is acquired in the process of artistic creation: a question that brings us back to the idea of the potential being-Being relationship noted in the last chapter. Here, as will be recalled, Being (with a capital B) was presented as the 'generative ground' of Dasein – the 'general' beyond the particular of being (with a lower case b), which is 'ungraspable' but can notionally be accessed via appropriate forms of thought. Against this, the possibility of truth relates to what Heidegger calls the 'reservoir' of the 'not-yet-uncovered' and 'the un-uncovered' – in other words, the space of the *concealed*. Through poetic thinking, artistic creation works to bring about an 'unconcealment'. Art thus becomes a 'mode of knowing', understood in terms of *seeing* what 'is present' – *unconcealing* and winning insight from 'Being' (pp. 57–59).

Having reached this point, we will temporarily pause the discussion here, with a view to giving focused consideration to the concept of unconcealment – an important phrase in the Heideggerian lexicon – in the next chapter.

Before moving on, however, it is important to underscore that this outline of poetic thinking is related to the practice of *art* and *not* design. Nonetheless, I believe, we are still in a position to draw insight here. Indeed, Fry (2014) has already done so, drawing out a potential meaning for design in relation to Heidegger's position. On his view, design *conceals*, covering over rather than 'unconcealing' what might be. The challenge is to recognise the all-encompassing force which design represents, giving form to our present and contributing to the course of our human future.

Fry's commentary will be briefly returned to in our consideration of Heidegger's work in the next section. For now, in relation to conducting design research involving practice, we may say that this vision of poetic thinking offers yet another outline of how a designer-researchers' process is linked to the context in which it takes place. It is not simply a matter of an individual (or group) giving form to something, but a process of negotiation, which must aim to *unconceal* the not-yet-uncovered (but there), if true truth, or a *knowing*, is to be demonstrated.

Having now considered processing from the perspectives of Dewey-Wittgenstein-Heidegger, we now turn to consider their offer here on aggregate.

Pathway 2.2 A Potential Pathway in Formation: Design and Buddhism

In the last Chapter, we noted some alignments which had been drawn between Heidegger and Buddhism, as well as Dewey and Buddhism. Here, it is proposed that, if a specifically Heideggerian approach to 'processing' were found to be appealing, then we might consider extending further and exploring the possibilities of what could be termed a Buddhist-inspired stance. The use of the word 'inspired' here is supposed to point to that fact that claiming a Buddhist stance without an in-depth knowledge of the tradition (either direct or indirect) would be disingenuous. As such, no claims towards a special depth of understanding are made here. Rather, this pathway aims to set out two potential 'points of contact' between Buddhism and design research.

Both points of contact relate to the 'worldview' that Buddhism sets forth. Essentially, this view holds that an egocentric approach to the world is fundamentally flawed and, in holding such an approach, the understandings we develop do not faithfully represent the true actuality of the situations we encounter and participate in – we are trapped in false patterns of perception, not seeing things as they really are. This failure of perception/understanding is said to lead to unnecessary suffering, which negatively impacts upon our experience of the world. Such suffering is however avoidable if, through practices such as mediation, we aim to cultivate a precise, reflexive appreciation of our position in relation to the world and others, as well as the meaning we can attach (or not) to this.[27]

In terms of the potential connections that can be drawn between Buddhism and design research, the literature is currently very limited (see however, e.g., James 2017; Wong 2011 shortly). Nonetheless, the two potentially useful threads are identified, which link both to this view of reality alongside the particular ethical stance which follows on from it. First, with regard to reality, some Buddhist philosophy maintains that there is no fixed reality as such, only a complex coming together of many things of which our conceptual understanding is but a part. Here, the 'real' is not to be located in objects or our understanding of them but, rather, in what is referred to as the 'middle', the intersection between both (e.g., Humphreys 1994). Here, from a design research perspective we are afforded a special positioning which recognises the inherently dynamic qualities which underpin our experience, we are also asked to look beyond our immediate impression of things and situations to see a wider reality extending beyond the self.

Second, from an ethical perspective, almost all Buddhist schools promote a commitment to compassion. The basic requirement is that, in engaging with others, one must endeavour to begin to understand individuals' situations and, in this, the suffering they may have endured or be enduring, as well as how this may be affecting their actions/interactions. In line with the previously mentioned extended view of reality, a Buddhist compassionate stance can also extend to a more general level, moving beyond the immediate to potentially encompass all living things and the wider sets of relations which exist between them, with all being seen as equal. This is essentially a meditative exercise but one with profound practical implications for how we encounter the world and aim to act within it (e.g., Anālayo 2015).

112 *Processing*

Returning to design research and considering how these threads – i.e., the particular view of reality and the ethical stance noted above – can inform the positionings in design research, early work is revealing potentially productive points of correspondence on both fronts. Focusing in on design thinking practices, James (2017) highlights how a Buddhist perspective may support the discipline's present move away from 'materialism' and, alongside this, allow practitioners to cultivate a greater self-awareness. Further, Wong (2011) notes an alignment between Buddhist compassion and human-centred design's commitment to empowerment. While these proposals are by no means final, they do point to the potential productive possibilities of drawing design-research-Buddhism alignments.

Ways of Processing via Dewey-Wittgenstein-Heidegger: Knowing, Understanding, Discovering

So what emerges from the baseline of Dewey-Wittgenstein-Heidegger on the general question of processing and its attendant themes of action and communication? In terms of what is common, across the three, we may observe an emphasis on *embodied, specifically located* activity. Ultimately, processing is seen to require someone, being somewhere and being involved in *something*. This, in essence, is the core within the processes of coming to know (Dewey), understand (Wittgenstein) and discovery (Heidegger). For Dewey, in coming to know, there is the situation which has its problems and us as the inquirer who is all but compelled to seek to resolve these problems. For Wittgenstein, in seeking to understand, there is the rough ground of the world, as it is, in constant battle with language's desire to go on holidays. Here, we as notional 'dissolvers' of the problems such a dynamic creates must work to either reframe our world picture or develop a means by which we can imagine alternatives. For Heidegger, in discovery, we are, before beings, *in-the-world*. We cannot escape our thrownness and our consequent need to take care and get by. In taking care and getting by, we encounter things, and in this encountering come to learn about these things, as well as, potentially, the world itself. Further, in poetic thinking we are able to explore and (possibly) give expression to the meanings we locate and draw out from a broad-based sense of Being (i.e., what is in general) that we encounter in the world.

In terms of communication, we can see that Dewey and Wittgenstein share much. Although Dewey does not propose anything like the latter's 'language games', we can see that he too is concerned with how meaning emerges in context, in relation to action. And though Heidegger's approach to language is distinct, we have seen how meaning as a concept is important within this interpretation-understanding cycle.

In the end, grouping all three, we can say that an emphasis on meaning-action and action-meaning relations is shared by each, with the common factor being our human relationship to the world and the unavoidability of the constraints it puts in our way as we seek to navigate a course within it/through it. With Wittgenstein, we might say that this is, in large part, grounded in the social. With Dewey and Heidegger, it is more a matter of the individual working with and through their immediate material circumstances, seeking to reason against the happenings and responses of the world. Though of course, importantly, we must remember that communication-meaning (and consequently the social) is crucial for Dewey too – a point to be picked up on shortly.

With this understanding in place the question now becomes: How are we to tackle these ideas within design research involving practice, i.e., how might they inform the

Processing 113

conduct of design research involving practice? For our present purposes, we may, at the outset, simply say that we have three relatable models of processing available to us.

Some links have of course already been drawn here. As we have advanced, both through previous sections as well as the early chapters, we have noted some of these. Of these three perspectives, it is Dewey who is the most widely cited, with his pattern of inquiry having already been largely appropriated in the literature. There is however, as we noted, a key distinguishing feature which is missing here – the role of communication.

Thus, the view taken here is that the pattern of inquiry is, on its own, a useful outline of design in the context of research – a device which allows for links to be drawn between practice and the act of research proper – but stands to be enriched by the enfolding of an additional emphasis on communication (i.e., language and meaning). In essence, as will become fully clear in the next chapter, Deweyan inquiry must be thought of *in relation* to communication, both in terms of what we do together in action (i.e., our shared process) and the agreed meaning of things in relation to other things.

As regards Wittgenstein's and Heidegger's offers, things are a little different. Beyond Habraken and Gross (1987), Ehn's work (1988) and a number of other tool-based conceptualisations (Brandt 2006; Vaajakallio 2012), language games have received surprisingly little airing in design. Equally, there are, to my knowledge, few if any treatments of Heideggerian discovery and poetic thinking in design research.[28] Both remain raw in the sense that they do not yet present defined options for designer-researchers.

As a result, we here have the opportunity to explore what an appropriation might look like for both offerings, i.e., Wittgenstein's language games and Heidgger's discovery (and poetic thinking).

With language games we are offered a model not of problem-solving in the classic sense but rather, following Wittgenstein's aim, of problem-*dissolving*. Here, problems are to be dissolved on basis of *seeing* connection and similarities between things and, from these connections and similarities, we are to imagine and work through alternatives (i.e., how situations might otherwise be). Here, the *design* aspect emerges in relation to *how* these alternatives are to be developed and presented. Where Wittgenstein maps scenarios in text or written remarks, the designer-researcher must work to sketch, trace out, illustrate, mock up, prototype and test. This might be physical (i.e., an exhibition or intervention). It might be digital, in the form of simulation. It might be representative, in the form of plans, diagrams, maps or, indeed, other forms of imaging. The point is to explore how designerly modes of envisaging can offer alternatives that *dissolve* what has become unnecessary, entrenched problematic – what prevents us from escaping from the 'bottle' in which we are unconsciously confined.

There is more to language games than problem-dissolving however. Beyond this process-based consideration, it may be that the concept also has wider applicability for design research involving practice in relation to comprehending the nature of the methodology itself. In particular, there is the potential of applying it as a means of accounting for the diversity of approaches design research involving practice offers. Here, speaking specifically of 'RtD', Boon et al. (2020) note that, at present, RtD does not so much exhibit one form as many forms, which they refer to as *genres*. These, in turn, are not fixed, static processes but rather dynamic reference points, always changing in action. Viewed in such a way, we can see how language games might trace

114 *Processing*

a route to managing method as an *evolving entity*, something which bears coherence over time but is never the same, never fully 're-applied', only ever carried forward and adapted.

This brings us at last to Heidegger's discovery and presentation of poetic thinking. With discovery, we are offered a model of how, in our Dasein, we are able to come to know the world on the basis of an ongoing ability to interpret-understand the things we encounter. This was related directly to the idea of 'handiness', the in-order-to of things. Ultimately the suggestion is that, as we use, test and experiment things, we as designer-researchers may come to *know* them. There is also the suggestion that wider networks of relationships and aspects of the world could be tracked and *also* be discovered through such a process: for example, coming to understand cattle farming through the need for and use of leather. Here, material exploration gives us access to things and concerns beyond us, if we 'care' enough to seek them out.

In terms of weaving in poetic thinking here, I wish to tentatively propose that Heidegger's vision of artistic creation traces an outline of how design might potentially aim to 'bring forth' and 'present beings as such out of concealedness'. This is a view that, in contrast to Fry's, would see design aligned to art. Here, we link to Koskinen et al.'s (2011) notion that design research may at times merge with the culture of arts research, conforming to the agenda of what they term the 'showroom' (see the Introduction). How change and transformation might fit into this model is debatable as, in the artistic mode of knowing presented by Heidegger, the emphasis is placed on revealing what is *already* there, but concealed. Yet this revealing may itself be seen as an act of change/transformation. Here we would be rendering the invisible visible – whether facts, values or viable propositions. This might be a matter of saying something about an existing set of circumstances (e.g., revealing the lifecycle of plastic through design) or it might be a matter of registering an as yet not existing but nonetheless possible set of circumstances (e.g., scoping out a new form of biodegradable plastics). An important point here (and one that will be reprised in the next chapter in relation to a discussion of unconcealment) is that Heideggerian poetic thinking, while maintaining a definite creative aspect (i.e., by honouring the poetic process), places its emphasis on the *revealing* of things, not the making of things as such.

In terms of the benefits of one or another of these perspectives in relation to 'framing' one's design research process, it is possible to divide them up along at least three separate lines. First, arising from the three separate philosophical backgrounds from which they originate, we may note a distinction in relation to what is highlighted by each. Here, Dewey's pragmatism attends to the mechanics of conducting an inquiry – the various sequential steps involved in making it an inquiry. Wittgenstein's proto-analytic perspective foregrounds the emergence of meaning, in relation to the possibilities of language and context. Heidegger's phenomenology, finally, has us focused on the individual and their own independent, practical endeavours.

Second, there is the choice to be made with regard to the social angle – a distinction touched on previously. With Wittgenstein, this is clear and apparent – contextual meaning-making requires that one consider the actions/interactions of actors in situ. Deweyan inquiry, though relatively asocial and individualistic when approached in isolation, becomes highly social when linked to the theory of communication in the terms presented previously. Here, knowledge cannot exist with meaning and meaning, in turn, requires social agreement. Heideggerian discovery and poetic thinking stand as the most individualistic of the three reference points. Both are about working

Processing 115

through things on your own, in your own way, to arrive at what is ultimately a personal position in relation to what is encountered.[29] It is important to note this is not the same as proposing a *subjective* position, as one is not operating on the basis of abstract, arbitrary insight, but rather on the in-the-world *feedback* one gets from things (beings) in relation to the active aims one has set oneself, which also arise in-the-world.

Third and finally, there is the agenda or vision one wishes to attach to one's work and again, the trio presents a range of alternatives. In Dewey's case, in line with classic contributions to design studies literature (e.g., Dorst and Cross 2001), it is all about progressively finding, defining and solving problems. Problems are the *positive, productive* driver of the process. For Wittgenstein, it is the opposite. Problems are *unproductive* and malignant, things to be *dissolved*. His model of processing amounts, as we have seen, to a form of therapy. We are to rid ourselves of problems by changing our way of seeing, by looking at what is and thinking through alternatives such that the problem is no longer a problem. With Heidegger, it is not so much problems that matter but a gap in understanding; the world and the things we have encountered have forced a practical question upon us. Our caring insists that it be answered, *practically*. As regards poetic thinking, it is, again, not the resolution of a 'problem' that is at stake but rather the expression of a truth – a need to unconceal or reveal what we have discovered.

This rounds out our consideration of processing and puts us in a position to take the necessary next step and move to consider the idea of *producing*, i.e., how one draws a research project to a *legitimate* close, which forms the focus of the next chapter.

Pathway 2.3 Some Additional Potential Linguistic Pathways: Austin, Foucault and Butler

Beyond the above contextualisation of processing via Dewey-Wittgenstein-Heidegger, it is important to note that additional, potentially productive philosophical pathways relating to language in the context of design research involving practice may also be identified. While we cannot hope to cover all or, indeed, even a short selection of these, we are able to consider one of the most relevant lines here – what I am referring to as the 'performative' line. The sense in which 'performative' is being used here will become clearer shortly.

In setting out, it is important to note that through the mid-to-late twentieth century, philosophy underwent what has been referred to as a 'linguistic turn' (e.g., Rorty 1967), with Wittgenstein's work being seen a precursor to the broader movement. The turn has taken philosophy in many directions, recasting the field and opening up new horizons within design. Here, the work of three philosophers in particular are seen as potentially compelling in the context of design. The first is the British Philosopher J. L. Austin, who explored how language allows us to make things happen, i.e., whereby the act of speaking may literally be seen to bring about change. The second is the French philosopher Michael Foucault, whose work on power was encountered in the Introduction. The third is American philosopher Judith Butler, whose focus is directed, in the main, towards gender but draws in concepts from elsewhere, including Foucault's work on power. To date, none has had a lengthy airing within the field of design, and so, the field stands to gain from a dedicated discussion of what they might offer design research in the context of 'processing'.

116 *Processing*

We will start with the work of Austin. Austin is best known for his concept of 'performative utterances' (Austin 1962). In essence, the idea here is that saying something can be equivalent to *doing* something. For example, saying 'I do' in the context of a marriage ceremony amounts to the act of getting married. On this account, our words and our actions are intertwined. However, it is not simply a matter of one's saying something making it so, there must also be the necessary social agreements and context in place for particular speech to amount to action. In the case of the marriage, this means that both parties must consent to the act of getting married and that they do so within a specific institutional setting (e.g., a church).

Next to Austin, Foucault can also be seen to give consideration to the performative. As was outlined in the Introduction, his work on power details the ways in which power takes form through action, with particular emphasis being given to the role of language as well as text and architecture within this process. Here, his key driving concept is 'discipline' – the all-pervasive wrap, which enables and sustains power relations. What matters is the effect of what is said, written, or given form, as well as how all these things are brought together to regulate the human subject (see Foucault 1975).

Following on from Foucault, as noted, Butler (1990) focuses on the question of gender[30] and, in doing so, both draws on and questions[31] the latter's treatment of power. Her basic proposition is that gender should be understood as performed, as opposed to a fixed state. We *act* it out by conforming to certain societal norms and standards. In linking to Foucault, she proposes that our adherence to these norms and standards must be viewed as taking place within the constraints of power relations and the activities permitted therein. Building on this work, Butler has gone on to explore in some detail how this is to be seen as bound up with the sphere of language, what is said and the effect it has (Butler 1997).

What might design research stand to gain from any potential appropriation of these insights? In the most immediate sense, these three philosophers can be seen to offer an entwined performative perspective. This, of course, centres on Austin, insofar as he developed the initial concept. Foucault, in exploring the means by which power is enacted, allows Butler to build on this. Hers is a realigned vision of the performative centred around the regulated expression of the subject who takes form through repeated and reenforcing enaction.[32] Combined, we have speaking as doing and doing as being, all bound together in power relations.

As mentioned, to date, the above contributions have not yet been widely represented in design literature. Nonetheless, there have been early performative positions put forward by some. These have included mobilisations of the performative perspective in relation to the design of packaging (Petersson McIntyre 2018), a consideration of how the collaborative use of design materials such as Post-its can be approached in performative terms (Matthews et al. 2021), as well as material-driven performativity (Barati et al. 2018).[33]

What further lines might we draw from the above? Most obviously, it would seem that there is the potential to expand on existing work and approach design as a whole via this perspective. Two key possible lines of inquiry open up here. As in the packaging reference mentioned previously, one might explore how design helps to define and regulate particular performative norms within society, whether relating to gender or conceptions of race or another pertinent area. There is also the possibility of studying design activity *as* performance, with focus potentially being

Processing 117

directed to the sayings[34] of and doings of designers in the enactment of particular design processes. On this account, such sayings and doings become the very substance of design itself.[35] Speaking would, potentially, amount to doing, and doing in and of itself would be akin to being. Questions of power would of course pervade the whole. What is being defined and regulated? What performances are possible, what performances are not?

Notes

1. Schön's well-known 'design' case is of an architect-student interaction. While architecture is technically positioned as a separate but related domain to design within this text, it is possible (and worthwhile) to map the insights Schön offers directly to what would here be considered design domains proper, e.g., interaction design, product design and so on.
2. This model aligns with earlier work by Nelson and Stolterman (2003), where design research is seen to explore the true, the ideal and the real, which Jonas aligns with the logics of analysis, projection and synthesis respectively.
3. Presented in this way, its form is seen to resemble characteristics of both 'transdisciplinarity' and 'Mode 2' research. Transdisciplinarity refers to an integrative approach whereby no one discipline is privileged over any other, and many, potentially divergent traditions (e.g., art and science) contribute to the process of acquiring insights and solving problems (e.g., Leavy 2016). Mode 2, which emerged in the 1990s as a new perspective on how and why knowledge was to be produced (see Gibbons et al. 1994), also seeks to solve problems. Like an RtD researcher, a Mode 2 researcher aims to produce effective solutions to problems. In Mode 2, this is achieved by bringing together many disciplines in relation to a given area of concern within what is referred to as 'the context of application', i.e., where the solution is to be realised. Again, like RtD, practical relevance usurps theoretical finesse.
4. Action research has a long history, much longer than research through design, extending as far back as the 1940s and the work of Kurt Lewin (e.g., Willis and Edwards 2014; Lewin 1948).
5. Donald Schön famously made use of a number of the key concepts and terms of Dewey relating to his idea of inquiry; see Schön (1992) for an overview.
6. Over the course of his long career, he and Dewey came into contact on a number of occasions, with the latter drawing some inspiration from the former (e.g., Menand 2002).
7. A common reference here is the example Barthes gives of a young, black French soldier appearing on the cover of a French magazine. The denoted meaning is that of a soldier saluting. The conative meaning, according to Barthes, is that 'France is a great Empire, that all her sons, without any colour discrimination, faithfully serve under the flag' (1993, p. 124). For an analysis of this example and its impact see Moudileno (2019).
8. Baudrillard's work has been picked up on in design generally, albeit in a limited way. Klein (2000) mobilises his perspective in relation to a critique of globalisation and the role of brands therein. Additionally, more recently, Holt (2016) has highlighted how Baudrillard's early political economy work centralises the role of design in the context of production-consumption. Key references here are *For a Critique of the Political Economy of the Sign* (2019/1981) and *The System of Objects* (1986/1968).
9. Morris worked at the University of Chicago and can be seen to fit with the general pragmatist mould, aligning the philosophy with the then-popular perspective of logical positivism (e.g., Morris 1967).
10. It is not possible to offer significant references for each of these listed philosophers. However, several highly accessible histories of semiotics exist, which afford an insight into their semiotic work. A useful overview of key contributions can be found in Nöth (1995).
11. For a succinct overview of the key contributors and contributions made at Ulm, including Maldonado's work, see Margolin (1989, pp. 270–272).
12. The momentum behind this, in graphic design at least, gathered pace through the 1970s and into the 1980s before fading in the 1990s (Skaggs 2017, pp. 3–5).
13. Alongside this, a more recent and comprehensive application of Peircean semiotics in product design can be found in Susann Vihma's *Products as Representations* (1995).

118 *Processing*

14. Intriguingly, practitioners who apply tools in design research contexts may not hold specific, explicit philosophical or theoretical commitments. Liz Sanders, for example, claims to draw on a wide array of general sources linking back to her psychological and anthropological education. Next to this, early industry work in the 1980s allowed her to openly experiment and explore the development of 'design research methods, tools and techniques', which connected theories of cognition to 'emotion, creativity and imagination'. There is no one reference point here but many. She also notes how the Scandinavian cultural background of her Norwegian parents may have informed her preference for co-design approaches over those which were designer-led (Sanders 2022).

15. Other contributions have picked up on the language games concept too. For example, Eva Brandt conceived of a form of design games aligned to language games (e.g., Brandt 2006). Further, more focused work has been undertaken by Kirsikka Vaajakallio, who, in doctoral work, sought to cohere a broad-ranging design games approach for the field based on Wittgenstein's work (Vaajakallio 2012).

16. Reflecting on a body of participatory design work, Ehn (1988) examined projects *as* language games. The aim was to shape a situation where all partners and participants, with their varied academic/professional backgrounds – in this instance, computer science and systems design, organisation theory, sociology and history (p. 17) – could come to shape a *common* language that allowed them to share their knowledge. Within this framing, participatory design becomes the mechanism by which a new, productive language game is brought about.

17. It should be noted that there is no theory of 'language games.' As I go on to explain, languages games act as a means of avoiding theory, allowing one to *dissolve* as opposed to *solve* a philosophy problem.

18. This is something Wittgenstein scholar Cora Diamond is quite emphatic about (1991, p. 28).

19. Usage of the term womxn is seen to denote an 'intersectional concept that seeks to include transgender womxn, womxn of colour, womxn of Third World countries and every personal identity of womxn' (Kunz 2019, p. 2).

20. To a degree, *Being and Time* is a methodological text as far as it outlines a special analytic strategy, grounded in hermeneutics, which allows Heidegger to undertake his exploration the meaning of being.

21. First, things may be unknown to us or not fully understood in terms of their potential use(s). To draw on Heidegger's terminology, we here have no sense of what their 'in-order-to' might be. This state of unknowing might be addressed either passively or actively. If passively, we likely have no immediate agenda, no immediate 'taking care of' to worry about. In such instances we may simply refrain from acting (i.e., 'production, manipulation') and linger with the thing we are trying to understand. Such lingering is described as 'dwelling' with 'the perception of what is objectively present' (Heidegger 2010/1927, p. 62).

22. Heidegger proposes that the process of arriving at an interpretation is based on three stages: 'fore-having', 'fore-sight' and 'fore-conception' (2010/1927, pp. 144–147).

23. For a discussion of Heidegger's extensive work on Hölderin see e.g., Goesetti-Ferencei's *Heidegger, Hölderin, and the Subject of Poetic Language* (2004). Key among Heidegger's works on the subject is a 1942 lecture course entitled *Hölderin's Hymn "The Ister"* (Heidegger 1996).

24. Design theorist Tony Fry describes this essay as 'well-trammelled' (2014, p. 5) and beyond design this may well be the case. Nonetheless, in turning to it here I take the view that there is still insight to be gained for design and design research, in particular from the angle of poetic thinking.

25. There are clear alignments and key differences to be drawn between Heidegger and Dewey on the subject of art: in terms of how each represents the artistic process and its meaning. A key relationship can be noted in their presentation of how work emerges via a gradual 'bringing forth' (Heidegger's term) of an outcome. A key difference can be noted in the fact that Heidegger confers a sense of what might be termed truth-bearing on the outcome or 'art product'. Dewey does not associate art with 'truth' but rather with *experience*. Thus, for Dewey, art is a matter of construction and communication on the part of the artist, and *reconstruction* (i.e., an attempt to interpret) on the part of the audience.

Surprisingly, it would appear that, surveying the literature, no in-depth comparison as yet exists. However, Thomas Alexander (2016), a key Dewey scholar, does note links between the two.

26. Heidegger talks specifically of the process of 'making equipment' and 'craft' as an oppositional undertaking set beside art. In contemporary terms, we might understand this contextualisation as amounting to an historical reference to what now constitutes 'design'.
27. This is of course only a cursory outline, which overlooks much. For example, I am not discussing the Buddhist understanding of enlightenment nor its many sects. A useful introduction to contemporary Buddhism can be found in Jerryson (2017).
28. This is not to say that these theories are not addressed or referenced – they are. Rather, they are not referenced in relation to conducting design research.
29. This is tempered by the idea that 'authentic' poetic thinking leads to an unconcealment of not-yet-uncovered aspects of Being.
30. Butler's consideration of gender arises out of a critique of feminism's traditional definition of the feminine (see Butler 2004).
31. For a focused consideration of Butler's critique of Foucault in relation to his conception of the subject and how their body is implicated in power relations, see Dudrick (2005).
32. There is also an alignment to be drawn with Wittgenstein's language games.
33. In addition to these references, it is also possible to detect an emerging performative agenda in architecture, see e.g., Kanaani (2015).
34. While doing in design have received considerable attention, less focus has been directed towards saying. For consideration of this see Lawson (2004). Equally, work by Lloyd and McDonnell (2009) also approaches this question.
35. A key line of work, focusing on performative instances of design, has been developed over the last two decades by Janet McDonnell and Peter Lloyd, alongside various collaborators. Core to this agenda, this work has been a focus on conversation and reflection (e.g., McDonnell et al. 2004; McDonnell 2012; McDonnell and Lloyd 2014).

References

Alexander, T., 2016. 'Dewey's philosophy of art and aesthetic experience'. *Artizen: Arts and Teaching Journal*, 2(1), pp. 59–67.

Anālayo, B., 2015. *Compassion and Emptiness in Early Buddhist Mediation*. Cambridge: Windhorse Publications.

Ashwin, C., 1984. 'Drawing, design and semiotics'. *Design Issues*, 1(2), pp. 42–52.

Austin, J. L., 1962. *How to Do Things with Words*. Edited by J. O. Urmson and M. Sbisà. Oxford: Claredon Press.

Bang, A. L., Krogh, P., Ludvigsen, M., Markussen, T., 2012. 'The role of hypothesis in constructive design research'. In *4th the Art of Research: Making, Reflecting and Understanding*. Helsinki, Finland: Aalto University School of Arts, Design and Architecture, 28–29 November.

Barati, B., Giaccardi, E., and Karana, E., 2018. 'The making of performativity in designing [with] smart material composites'. In *Proceedings of the 2018 CHI Conference on Human Factors in Computing Systems*, pp. 1–11. New York: ACM, April.

Barthes, R., 1993 [1957]. *Mythologies*. Translated by A. Lavers. London: Viking.

Baudrillard, J., 1986 [1968]. *The System of Objects*. Translated by J. Benedict. London: Verso.

Baudrillard, J., 2019 [1981]. *For a Critique of the Political Economy of the Sign*. Translated by C. Levin. London: Verso.

Bertin, J., 1967. *The Semiology of Graphics: Diagrams, Networks, Maps*. Madison, WI: University of Wisconsin Press.

Betts, P., 1998. 'Science, semiotics and society: The Ulm Hochschule für Gestaltung in retrospect'. *Design Issues*, 14(2), pp. 67–82.

Binder, T., and Redström, J., 2006. 'Exemplary design research'. Paper presented at the Design Research Society Wonderground Conference at Sociedade de Geografia de Lisboa, Lisbon, Portugal, 1–4 November.

120 *Processing*

Boon, B., Baha, E., Singh, A., Wegener, F. E., Rozendaal, M. C., and Stappers, P. J., 2020. 'Grappling with diversity in research through design'. In S. Boess, S. Cheung, and S. Cain (Eds.), *Synergy – DRS International Conference 2020, vol. 5: Situations*, pp. 139–151. London: The Design Research Society.

Brandt, E., 2006, 'Designing exploratory design games: A framework for participation in participatory design?'. In *Proceedings of the Ninth Conference on Participatory Design: Expanding Boundaries in Design*, Vol. 1, pp. 57–66. New York: ACM.

Brandt, E., and Binder, T., 2007. 'Experimental design research: Genealogy, intervention, argument'. Paper presented at International Association of Societies of Design Research conference, Hong Kong, China, 12–15 September.

Butler, J., 1990. *Gender Trouble: Feminism and the Subversion of Identity*. London: Routledge.

Butler, J., 1997. *Excitable Speech: A Politics of the Performative*. London: Routledge.

Butler, J., 2004. *Undoing Gender*. Abingdon: Routledge.

Chevalier, J. M., and Buckles, D. J., 2019. *Participatory Action Research: Theory and Methods for Engaged Inquiry*, 2nd edition. Abingdon: Routledge.

Cook, S., 2014. 'Pussy Galore'. [Online]. Available at: https://ualresearchonline.arts.ac.uk/id/eprint/6693/ [Accessed: 21 December 2021].

Cross, N., 1982. 'Designerly ways of Knowing'. *Design Studies*, 3(4), pp. 221–227.

Cross, N., 2007. *Designerly Ways of Knowing*. Basel: Birkhäuser.

Dalsgaard, P., 2009. *Designing Engaging Interactive Environments – A Pragmatist Perspective*. Unpublished Ph.D. Dissertation. Aarhus, Denmark: Aarhus University.

Deely, J. N., 1982. *Introducing Semiotic: Its History and Doctrine*. Bloomington, IN: The University of Indiana Press.

Deni, M., and Zingale, S., 2017. 'Semiotics in design education: Semiotics by design'. *The Design Journal*, 20(sup1), pp. S1293–S1303.

De Saussure, F., 2011 [1916]. *Course in General Linguistics*. Translated by W. Baskin. New York: Columbia University Press.

Dewey, J., 1981 [1925]. *The Collected Works of John Dewey: The Later Works, 1925–1953, vol. 1, Experience and Nature*. Edited by J. A. Boydston. Carbondale, IL: Southern Illinois University Press.

Dewey, J., 1984 [1929]. *The Collected Works of John Dewey: The Later Works, 1925–1953, vol. 4, The Question for Certainty*. Edited by J. A. Boydston. Carbondale, IL: Southern Illinois University Press.

Dewey, J., 1986 [1938]. *The Collected Works of John Dewey: The Later Works, 1925–1953, vol. 12, Logic: The Theory of Inquiry*. Edited by J. A. Boydston. Carbondale, IL: Southern Illinois University Press.

Diamond, C., 1991. *The Realistic Spirit: Wittgenstein, Philosophy, and the Mind*. Cambridge, MA: The MIT Press.

Dilnot, C., 1984. 'The state of design history, part I: Mapping the field'. *Design Issues*, 1(1), pp. 4–23.

Dixon, B., 2020. *Dewey and Design: A Pragmatist Perspective for Design Research*. Cham: Springer.

Dixon, B., and French, T., 2020. 'Processing the method: Linking Deweyan logic and design-in-research'. *Design Studies*, 70, p. 100962.

Dorst, K., and Cross, N., 2001. 'Creativity in the design process: Co-evolution of problem – solution'. *Design Studies*, 22(5), pp. 425–437.

Dudrick, D., 2005. 'Foucault, Butler, and the body'. *European Journal of Philosophy*, 13(2), pp. 226–246.

Ehn, P., 1988. *Work – Oriented Design of Computer Artifacts*. Ph.D. Dissertation. Stockholm: Arbetslivscentrum.

Foucault, M., 1975. *Discipline and Punish: The Birth of the Prison*. Translated by A. M. Sheridan-Smith. London: Penguin.

Frayling, C., 2015. 'RTD 2015 provocation by Sir Christopher Frayling, part 1: Research through design evolution'. [Online]. Available at: https://vimeo.com/129775325 [Accessed: 29 September 2020].

Fry, T., 2014. 'The origin of the work of design: Thoughts based on a reading of Martin Heidegger's "the origin of the work of art"'. *Design Philosophy Papers*, 12(1), pp. 11–22.

Genova, J., 1995. *Wittgenstein: A Way of Seeing*. Abingdon: Routledge.

Gibbons, M., Limoges, C., Nowotny, H., Schwartzman, S., Scott, P., and Trow, M., 1994. *The New Production of Knowledge*. London: Sage.

Habraken, H. J., and Gross, M. D., 1987. *Concept Design Games (Book 1 and 2)*. A report submitted to the National Science Foundation Engineering Directorate, Design Methodology Program. Cambridge, MA: Department of Architecture, MIT.

Halse, J., 2010. 'Programmatic vision'. In J. Halse, E. Brandt, B. Clark, and T. Binder (Eds.), *Rehearsing the Future*, pp. 38–41. Copenhagen: The Danish Design School Press.

Halse, J., Brandt, E., Clark, B., and Binder, T. (Eds.), 2010. *Rehearsing the Future*. Copenhagen: The Danish Design School Press.

Heidegger, M., 1996. *Hölderin's Hymn "The Ister"*. Translated by W. McNeill and J. Davis. Bloomington, IN: Indiana University Press.

Heidegger, M., 1998. 'Letter on humanism'. In M. Heidegger and W. McNeill (Eds.), F. A. Capuzzi (Trans.), *Pathmarks*, pp. 239–276. Cambridge: Cambridge University Press.

Heidegger, M., 2001 [1971]. *Poetry, Language, Thought*. Translated by A. Hofstadter. New York: Harper and Row.

Heidegger, M., 2010 [1927]. *Being and Time*. Translated by J. Stambaugh. Albany, NY: State University of New York Press.

Hjelm, S. I., 2002. *Semiotics in Product Design*. Stockholm: Centre for User Orientated IT Design.

Humphreys, C., 1994. *Studies in the Middle Way: Being Thoughts on Buddhism Applied*. Richmond: Curzon Press.

Ingold, T., 2000. *The Perception of the Environment: Essays on Livelihood, Dwelling and Skill*. Abingdon: Routledge.

Ingold, T., 2013. *Making: Anthropology, Archaeology, Art and Architecture*. Abingdon: Routledge.

James, M., 2017. 'Advancing design thinking towards a better understanding of self and others: A theoretical framework on how Buddhism can offer alternate models for design thinking'. *Form Akademisk*, 10(2), pp. 1–14.

Jerryson, M. K. (Ed.), 2017. *The Oxford Handbook of Contemporary Buddhism*. Oxford: Oxford University Press.

Jonas, W., 2007. 'Design research and its meaning to the methodological development of the discipline'. In R. Michel (Ed.), *Design Research Now*, pp. 187–206. Basel: Birkhäuser.

Jonas, W., 2015. 'A cybernetic model of design research: Towards a trans-domain of knowing'. In P. A. Rodgers and J. Yee (Eds.), *The Routledge Companion to Design Research*, pp. 23–37. Abingdon: Routledge.

Kanaani, M., 2015. 'Performativity: The fourth dimension in architectural design'. In M. Kanaani and D. Kopec (Eds.), *The Routledge Companion for Architecture Design and Practice*, pp. 125–148. Abingdon: Routledge.

Katoppo, M. L., and Sudradjat, I., 2015. 'Combining participatory action research (PAR) and design thinking (DT) as an alternative research method in architecture'. *Procedia-Social and Behavioral Sciences*, 184, pp. 118–125.

Kemmis, S., and McTaggart, R., 2005. 'Participatory action research: Communicative action and the public sphere'. In N. K. Denzin and Y. S. Lincoln (Eds.), *The Sage Handbook of Qualitative Handbook*, 3rd edition, pp. 559–603. London: Sage.

Kindon, S., Pain, R., and Kesby, M. (Eds.), 2007. *Participatory Action Research Approaches: Connecting People, Participation and Place*. Abingdon: Routledge.

122 *Processing*

Kinross, R., 1984. 'Semiotics and designing'. *Information Design Journal*, 4(3), pp. 190–198.

Koskinen, I., Zimmerman, J., Binder, T., Redström, J., and Wensveen, S., 2011. *Design Research Through Practice: From the Lab, Field, and Showroom*. Amsterdam: Elsevier.

Krampen, M., 1989. 'Semiotics in architecture and industrial/product design'. *Design Issues*, 5(2), pp. 124–140.

Krippendorff, K., 1989. 'On the essential contexts of artifacts or on the proposition that "design is making sense (of things)"'. *Design Issues*, 5(2), pp. 9–39.

Krippendorff, K., 2006. *The Semantic Turn: A New Foundation for Design*. Boca Raton, FL: The CRC Press.

Krippendorff, K., and Butter, R., 1984. 'Product semantics: Exploring the symbolic qualities of form in innovation'. *The Journal of the Industrial Designers Society of America*, 3(2), pp. 4–9.

Krogh, P. G., and Koskinen, I., 2020. *Drifting by Intention: Four Epistemic Traditions from with Constructive Design Research*. Cham: Springer.

Kunz, A. D., 2019. 'WOMXN: An evolution of identity'. *Summit to Salish Sea: Inquiries and Essays*, 4(1). [Online]. Available at: https://cedar.wwu.edu/s2ss/vol4/iss1/2 [Accessed: 28 December 2021].

Lawson, B. R., 2004. 'Schemata, gambits and precedent: Some factors in design expertise'. *Design Studies*, 25(5), pp. 443–457.

Leavy, P., 2016. *Essentials of Transdisciplinary Research: Using Problem-Centred Methodologies*. Abingdon: Routledge.

Lee, E., and Kim, B., 2020. 'Analysis on the book cover design using Roland Barthes' semiotics'. *Journal of Digital Convergence*, 18(3), pp. 357–362.

Lewin, K., 1948. *Resolving Social Conflicts, Selected Papers on Group Dynamics (1935–1946)*. New York: Harper.

Lloyd, P., and McDonnell, J. (Eds.), 2009. *About: Designing – Analysing Design Meetings*. London: Taylor and Francis.

Margolin, V., 1989. 'Postwar design literature'. In V. Margolin (Ed.), *Design Discourse: History, Criticism, Theory*, pp. 265–288. Chicago: Chicago University Press.

Matthews, B., and Brereton, M., 2015. 'Navigating the methodological mire: Practical epistemology in design research'. In P. A. Rodgers and J. Yee (Eds.), *The Routledge Companion to Design Research*, pp. 151–162. Abingdon: Routledge.

Matthews, B., Khan, A. H., Snow, S., Schlosser, P., Salisbury, I., and Matthews, S., 2021. 'How to do things with notes: The embodied socio-material performativity of sticky notes'. *Design Studies*, 76, p. 101035.

McDonnell, J., 2012. 'Accommodating disagreement: A study of effective design collaboration'. *Design Studies*, 33(1), pp. 44–63.

McDonnell, J., and Lloyd, P., 2014. 'Beyond specification: A study of architect and client interaction'. *Design Studies*, 35(4), pp. 327–352.

McDonnell, J., Lloyd, P., and Valkenburg, R. C., 2004. 'Developing design expertise through the construction of video stories'. *Design Studies*, 25(5), pp. 509–525.

Morris, C. W., 1967. *Signification and Significance: A Study of the Relations of Signs and Values*. Cambridge, MA: The MIT Press.

Moudileno, L., 2019. 'Barthes's black soldier: The making of a mythological celebrity'. *The Yearbook of Comparative Literature*, 62(1), pp. 57–72.

Murphy, P., 2017. 'Design research: Aesthetic epistemology and explanatory knowledge'. *She Ji: The Journal of Design, Economics, and Innovation*, 3(2), pp. 117–132.

Nelson, H. G., and Stolterman, E., 2003. *The Design Way: Intentional Change in an Unpredictable World*. Englewood Cliffs, NJ: Educational Technology Publications.

Nöth, W., 1995. *Handbook of Semiotics*. Bloomington, IN: Indiana University Press.

Peirce, C. S., 1991. *Peirce on Signs: Writings on Semiotic by Charles Sanders Peirce*. Edited by J. Hoopes. London: University of North Carolina Press.

Petersson McIntyre, M., 2018. 'Gender by design: Performativity and consumer packaging'. *Design and Culture*, 10(3), pp. 337–358.

Polanyi, M., 1966. *The Tacit Dimension*. London: Routledge & Kegan Paul.

Powell, J., 2013. *Heidegger and Language*. Bloomington, IN: Indiana University Press.

Redström, J., 2017. *Making Design Theory*. Cambridge, MA: The MIT Press.

Rorty, R. (Ed.), 1967. *The Linguistic Turn: Recent Essays in Philosophical Method*. Chicago: University of Chicago Press.

Rowe, A., 2020. 'Participatory action research and design pedagogy: Perspectives for design education'. *Art, Design & Communication in Higher Education*, 19(1), pp. 51–64.

Sanders, E. B. N., 2017. 'Learning in PD: Future aspirations'. In B. DiSalvo, J. Yip, E. Bonsignore, and C. DiSalvo (Eds.), *Participatory Design for Learning*, pp. 213–224. Abingdon: Routledge.

Sanders, E. B. N., 2022. Email to Brian Dixon, 21 May.

Sanders, E. B. N., and Stappers, P. J., 2008. 'Co-creation and the new landscapes of design'. *Co-Design*, 4(1), pp. 5–18.

Schön, D. A., 1983. *The Reflective Practitioner: How Professionals Think in Action*. New York: Basic Books.

Schön, D. A., 1992. 'The theory of inquiry: Dewey's legacy to education'. *Curriculum Inquiry*, 22(2), pp. 119–139.

Schön, D. A., 1995. 'Knowing-in-action: The new scholarship requires a new epistemology'. *Change: The Magazine of Higher Learning*, 27(6), pp. 27–34.

Simon, H., 1996 [1969]. *The Sciences of the Artificial*, 3rd edition. Cambridge, MA: The MIT Press.

Skaggs, S., 2017. *Fire Signs: A Semiotic Theory for Graphic Design*. Cambridge, MA: The MIT Press.

Sleeper, R. W., 1986. *The Necessity of Pragmatism: John Dewey's Conception of Pragmatism*. New Haven, CT: Yale University Press.

Steen, M., 2013. 'Co-design as a process of joint inquiry and imagination'. *Design Issues*, 29(2), pp. 16–28.

Vaajakallio, K., 2012. *Design Games as a Tool, a Mindset and a Structure*. Helsinki: Aalto.

Van Leeuwen, T., 2006. 'Towards a semiotics of typography'. *Information Design Journal*, 14(2), pp. 139–155.

Vihma, S., 1995. *Products as Representations: A Semiotic and Aesthetic Study of Design Products*. Ph.D. Dissertation. Helsinki: Alto University.

WD+RU, 2021. '2020/21/22: Research project'. [Online]. Available at: https://wdandru.tumblr.com/ (Accessed: 21 December 2021).

White, J. J., 1976. 'The argument for a semiotic approach to shaped writing: The case of Italian futurist typography'. *Visible Language*, 10(1), pp. 53–86.

Williamson, J., 1978. *Decoding Advertisements: Ideology and Meaning in Advertising*. London: Marion Boyars Publishers.

Willis, J., and Edwards, C., 2014. 'The twists and turns of action research history'. In J. Willis and C. Edwards (Eds.), *Action Research: Models, Methods and Examples*, pp. 3–20. Charlotte, NC: Information Age Publishing.

Wittgenstein, L., 1963 [1958]. *Philosophical Investigations*. Translated by G. E. M. Anscombe. Oxford: Basil Blackwell.

Wong, B., 2011. *What Is Design? – A Pragmatist & Buddhist Perspective on Design Thinking*. Unpublished Ph.D. Dissertation. Hong Kong: Hong Kong Polytechnic University.

3 Producing
Knowing Value

In the two prior chapters, we covered the ideas of 'positioning' and 'processing' in relation to design research involving practice. Now, lastly, we turn to consider the idea of 'producing'. As was highlighted in the Introduction, producing refers to the *endpoint* of research – how this is to be marked out by the researcher, both in relation to what they are expected to *show* (i.e., the particular materials) and to *do* (i.e., the particular actions they must preform). Here, we connect with important concepts such as evidence and claims. Linking to these, there is also of course the larger concept of knowledge itself, the inevitable endpoint, which must notionally be produced via the latter concepts and, of course, stands as the core concern of the present book.

Leaving the bigger question of knowledge aside for the time being, it seems fair to suggest that most designer-researchers will hold an awareness of the meaning of the key concepts of evidence and claims. These terms will thread through their research activities and form part of their professional lexicon. When it comes to articulating clear and precise definitions, however, such individuals will likely struggle. What does evidence look like *really*? What is good evidence versus bad evidence? Then, once one has evidence, what does it actually mean to make a knowledge claim?

The fact is that, while each of these concepts are to a degree definable in the abstract, they all, ultimately, take shape within the specific research project at hand. The form any evidence takes will depend on the question and context, as well as the methods used to conduct the inquiry. Any claims which are made will, in turn, link to the evidence.

Answering the question of whether or not the evidence or claims put forward in any project are appropriate requires *evaluation* and this, in turn, requires criteria, i.e., having a basis on which to *judge*. Traditional research has developed its own special set of criteria, around concepts referred to as reliability, validity and objectivity.[1] These all have a special meaning and focus, which as we will see shortly, is not necessarily appropriate in the context of design research (for example, as has already been covered in Chapter 1, the notion of maintaining a strictly objective position is problematic in the context of designing.) The ultimate function of such criteria is rounding back to the original source of the research and making sure that questions, context and methods (and equipment used) all marry as they should. In the end, just as much as processing, producing relies on *rigour*, on ensuring all the parts line up together as one to constitute a coherent whole.

Then beyond these questions of evidence, claims, evaluation and criteria, a further issue may be seen to arise in the context of design research, in particular in design research involving practice – the *mode(s)* of communication. Whereas previously, a

text-based outline of evidence-claims would have been a taken-for-granted expectation, it is now open to question in such projects. Numerous national research councils and research institutions (i.e., universities) allow artefacts to constitute a research *endpoint* or outcome. Here, the meaning of evidence-claims may be seen to undergo a subtle shift as artefacts and text interact to form a meaningful demonstration of what is being evidenced or claimed, as well as allow for an immediate, direct evaluation of the work.[2]

Producing, then, requires that one engages with a series of important, pressing considerations. As before, turning again to our philosophical baseline of Dewey-Wittgenstein-Heidegger will allow for a consideration of what philosophy (theirs and notionally others) can provide by way of answers/opportunities here. To begin, I progress the above outline by exploring how design researchers and theorists have, to date, approached the questions of 'endpoints' in design research involving practice. This calls up not only the above concepts, i.e., evidence and claims, but also how they have been explored in design research. Next, we turn to Dewey-Wittgenstein-Heidegger to examine each of their particular offerings in turn with a number of relevant pathways being flagged as we proceed (e.g., to Latour's work). Leading on from this, a final discussion aims to cohere the proceeding philosophic insights and relate these back to the design research concerns regarding 'research endpoints' noted in the opening section. Thus having covered producing in this chapter, we will then be positioned to draw the present book's mapping of design-philosophy relations together next.

Designing and Knowing in the Contemporary Field: Designerly Endpoints and Outcomes

Throughout the present book, we have seen that design*ing* in the context of design research presents a number of challenges, leading to questions which must be answered. The issue of endpoints is no different. As was noted previously, the concepts of evidence-claims[3] – the traditional endpoints markers – collide with design *outcomes*, whether proposals or actual, physical made things (i.e., artefacts). However, like the design process itself, the precise role of design outcomes in research has been the subject of much debate.

Here, in the introduction, we noted that, for a time, some boldly put forward the view that such outcomes can be seen, on their own, to communicate the project findings in totality – fully representing what has been investigated and established (e.g., Loi 2004). Most contributors, however, struck a cautious note (e.g., Biggs 2002). This contingent believed that design outcomes may play a *role* in the presentation of design research but that they cannot, on their own, fully represent a particular project's findings. A full representation required a 'linguistic' component – be it a dissertation (in the context of PhD), an article, a report – so that its 'argument' may be rendered as accessible as possible (Biggs 2002). Some went so far as to question the value of explicitly linking 'practice' to research at all, suggesting that use of the term unnecessarily separates the creative disciplines (e.g., art and design) from other, more established subjects within universities (Biggs and Büchler 2007).

This question has been resolved to a point. In places such as the UK, mainland Europe, Australia and New Zealand (which each have a relatively long history of practice-based and practice-led research),[4] it is now generally accepted that designer-researchers must include an explicit, linguistic component in any dissemination of their

126 *Producing*

work.[5] The precise form of such a component remains more or less open, depending on the specific community to which the work is being presented.[6] Nonetheless, over the last decade, human computer interaction (HCI) theorists and researchers have dedicated considerable attention to the question of how the results of practice in the research (e.g., artefacts) might be best represented.

A key proposal here is the idea of 'strong concepts' coming from Kristina Höök and Jonas Löwgren (2012). Strong concepts are defined as a form of 'intermediate' design knowledge: a form which is not so abstract as to be generalisable but, equally, not so particular as to be restricted to single instance. Focusing on the dynamic aspect of HCI work (i.e., the interactive behaviours that digital products or environment might support), the point of strong concepts is not explanation or prediction but rather that they may be applied generatively 'in the creation of new designs' (p. 23:2).

A relatable proposal comes from Dalsgaard and Dindler (2014), who suggest the idea of 'bridging concepts'. They define this as a form of 'intermediate design knowledge' which is similar to strong concepts but is not 'just' theoretical in focus – there will also be a practical aspect (i.e., the concept will rely on design artefacts). In essence, the idea is that both practice and theory are at play at all times, in dialogue. There will be a theoretical foundation and design artefacts (referred to as 'articulations'). Here, the 'concept' may be explored through the examples.

Alongside these, another particularly compelling half-way solution has emerged in the form of 'annotated portfolios', first proposed by Bill Gaver and J. Bowers (Gaver and Bowers 2012; Gaver 2012). In outlining this proposal in the context of RtD work, Gaver argued that artefacts are to be seen as the 'definite facts' of RtD projects, i.e., the empirical focus of work (Gaver 2012, p. 944). In his words, they 'embody the myriad choices made by their designers with a definiteness and level of detail that would be difficult or impossible to attain in a written (or diagrammatic) account' (p. 943). As with the contemporaneous strong concepts proposal, Gaver rejects the desirability of aiming to produce generalisability knowledge in RtD work and, similarly, also moves to promote the idea of 'generative' outcomes, i.e., outcomes which support further concept development and offer practical guidance for design work.

Here, the annotated portfolio is presented as a means of facilitating such generativity. In short, the proposal is that multiple, related design artefacts are presented together with explanatory text. This combined design-text presentation is seen to mark out a possible 'design domain', a space in which particular decisions have been made and dimensions traced out. The idea is that by exploring this presentation, a notional audience may 'start to tease the individual concerns and judgements involved in a single situated design out of the particular configuration to which they were applied'. A key point is that Gaver does not prescribe a definite form to the annotated portfolio. Rather, the possibilities are kept open; one will aim to balance description of individual design artefacts with articulation of what *relates* these examples (e.g., key themes or a shared problematic). The question of what constitutes an appropriate balance will depend on such factors as 'material, purpose and audience' (Gaver 2012, p. 944).[7]

It is arguable that both of the above proposals, i.e., strong concepts and annotated portfolios, may be seen to rely on an 'intersecting' of evidence *and* claims in their presentation of design research outcomes. With strong concepts, in terms of evidence, it is clear that researchers are required to reference the *concrete situations* of practice, i.e., the key interactive features that have been developed/identified. Claims emerge from

within this as the concept itself is framed off the back of the 'concrete'. With annotated portfolios, we see a definite link to evidence through the reference to 'artefacts as definite facts'. Equally, a further link may be drawn out by offering an overview of the designer-researcher's decision-making. In this context, claims are to be found in the designer-researchers' argument with regards to what this means when drawn together to form a whole, or 'design domain'.

A compelling question emerges here in relation to claims in the context of design research. In the last chapter, we questioned whether or not the design process could function as a method in its own right, exploring both the design literature as well as our philosophical baseline. Following on, here in the present chapter, we might also ask whether or not design might allow for a special form of 'knowledge claim', distinct from other forms in the natural and social sciences or humanities.

In this regard, Beck and Stolterman (2016) put forward the proposal that design may indeed offer a special form of 'knowledge-claiming'. The pair examines the types of claims made in design research and compares these with the types of claims made in the natural and social science literature. Against the latter, design is found to diverge markedly. Whereas the natural and social science work tends to primarily present *factual claims* (with 'interpretations' also coming into play too), the design research surveyed displays a greater variability. Facts are present but do not predominate at a primary level. There are also claims which relate to such areas as values, concepts and even policy (p. 207).[8] In terms of why this might be the case, no definite answer is given. The pair does however consider three possibilities. These relate to: design's relative immaturity and inherent multidisciplinarity; a potential merging with the values of science through the linking of concerns relating to the natural and artificial; and, finally, the necessity that design research speaks to the multiple audiences (p. 213). With these factors coming into play to greater or lesser extent across the spectrum of design research, it would seem inevitable that the claims made would by default be highly variable as compared with other forms of knowledge production. Key perhaps are the multiple disciplines and audiences. There is no one model and no one community and so no one set of expectations. It is arguable then that knowledge claiming in design cannot, as yet, be one thing.

Leading directly on from such considerations of evidence and claims, the question of evaluation arises by necessity. In essence, in encountering this presentation of practice and text, form and meaning, we, as a research audience are being called upon to *appraise* the extent to which the claims that are made *from* and *through* the evidence presented are valid, i.e., the extent to which they may be seen to hang together.

As with the potentially special approach to knowledge claiming in design, there is also the possibility that the evaluation might take on a different form here too. Though the issue has not received a great deal of attention in the literature, there have, over the years, been those who have put forward arguments regarding *how* design outcomes might be best judged and by what criteria.

As was noted in the chapter's opening, research, in particular scientific research, has traditionally applied the criteria of reliability, validity and objectivity. Here, reliability related to the requirement that one demonstrate that one's instruments or equipment were functioning as they should, i.e., that everything was calibrated and the readings were accurate.[9]

Validity has traditionally operated on two levels, referred to as internal and external validity. Internal validity requires that researchers must be able to demonstrate that

any causal relationship they identify, i.e., what causes what, may be seen to 'hold water' in the words of social methods theorist Alan Bryman (2008, p. 47). To demonstrate external validity the researcher must be able to demonstrate that their findings have arisen from a representative sample (e.g., of a given population) and, as such, will be *generalisable* beyond the context of the specific project itself.[10] For example, if one wished to gain an overarching understanding of the needs of older people in the UK, aged 65 and above, it would be desirable to connect with as many groups as possible from as many locations as possible who fall into that age group. Here, one would want to ensure that gender and economic profile across the sample was well aligned with the general gender and economic profile in the UK as a whole. One would also want to ensure a good geographic spread, linking not only to groups in England but also Scotland, Wales and Northern Ireland. The more participants, the wider the geographic reach, the greater the degree of generalisablity.[11]

Lastly, as was noted in Chapter 1, objectivity relates to the neutrality of the research. Here, the researcher is required to demonstrate that values, personal biases and beliefs have not affected their decision-making or the representation of their findings. Accordingly, the entirety of the research – the questions, the methods, the recruitment of participants, the data collection and analysis and the conclusions – must all be appraised with a view to identifying any personal values, biases and beliefs affecting/influencing the work.

Taken all together, these criteria – reliability, validity and objectivity – are seen to allow for a testing of the *truth* of the claims put forth, i.e., that they may be seen to provide an accurate account of 'how things really are'.[12]

However, that of course is the traditional view. We have already considered the challenges of objectivity in the context of design research involving practice (i.e., how it is all but impossible to design without values). It will now likely also be apparent that the criteria of reliability and validity present considerable challenges here too, not to mention the broader consideration of the *truth* of the research. In simple terms we may wonder, how is a designer-researcher to demonstrate that their instruments or equipment are functioning or that their 'measurements' are accurate? How are they to establish credible causal links or arrive at a point where they might claim that their findings are generalisable?

Such a clear ill fit between the mode of research and the criteria of evaluation are not exclusive to design research however. In essence, all forms of nonquantitative, non-instrument-based research[13] struggle to adhere to the demands set by the traditional definitions of reliability, validity and objectivity.

Seeking to resolve this apparent mismatch, a number of theorists, particularly those working in the area of qualitative social research, have, over the last four decades, put forward a variety of proposals for alternative approaches. Here, two key strategies have emerged. On the one hand, there are those who argue that the original criteria should be retained. Here the view is taken that any divergence would undermine the position of qualitative as set against quantitative work. In such cases, focus tends to be directed towards *redefining* reliability and validity in such a way as to recognise the distinct aims, methods and data of such research. For some it is a matter of remaining as faithful as possible to the meanings of the original criteria (Mason 1996). For others, it is a matter of radically adjusting the meanings and, as such, repurposing individual criterion markedly (e.g., LeCompte and Goetz 1982). Reliability is no longer a matter of instruments and measurements but rather comes to relate to the precision

of data collection and analysis, of being able to demonstrate pathways from raw data through to an eventual concept. Next to this, validity, in turn, is no longer a matter of causal relationships or generalisability but, instead, of the coherence of concepts.

In contrast to this, within a second grouping there are those who propose that the traditional criteria are simply inappropriate in the context of nonquantitative work. In such instances, focus turns towards the possibility of devising novel categories of evaluation. Here, reliability, validity and objectivity are replaced by proposals framed around concepts such as: credibility, transferability, dependability and confirmability (see Guba and Lincoln 1985); or even more broadly) sensitivity to context, commitment and rigour, transparency and coherence and impact and importance (Yardley 2000). While such proposals may differ in specifics, in general terms, each proposes detailed approaches to demonstrating rigour in relation to qualitative data collection and analysis (e.g., by allowing others to retrace the steps involved in their analysis).[14] Alongside this, they also suggest ways in which researchers may overcome the problem of generalisablity. Guba and Lincoln (1985), for example, deal with this through their concept of transferability whereby researchers are asked to provide a 'thick description' (Geertz 1973) of their project such that others may adapt and reapply relevant aspects in other contexts and so build on what has been achieved. Ultimately, underlying proposals such as these is the idea that qualitative work cannot and should not be evaluated in the same way as quantitative work.

When it comes to design research involving practice, it would seem equally reasonable that, as with qualitative social research, an alternative set of criteria be available to researchers who are not operating within the bounds of traditional research (i.e., nonquantitative, non-instrument-based). Of course, this will be especially pertinent where artefacts are positioned as research outcomes. Picking up on the issue in the context of HCI research, Zimmerman et al. (2007) propose that the criteria of *process*, *invention*, *relevance* and *extensibility* might offer such an alternative. Here, process would refer to the way in which a designer-researcher has undertaken their work and how this is represented. The key point is not that the process might be replicated but rather that its rigour and decision-making might be justified and appraised. With the criterion of invention, the group proposes that the core aim of design research should be to develop something novel, integrating 'various subject matters to address a specific situation' (p. 499). Here, through an extensive literature review, the designer-researcher must demonstrate the extent to which this has been achieved against the existing developments within the field. The next criterion of relevance requires that the designer-researcher outline the 'preferred state' that their proposal traces out and make a case (with supporting material) for why such a state should be considered desirable. To frame a notional example, a designer-researcher might outline the values underpinning a particular health-based digital application and, alongside this, provide medical and/or psychological evidence as to why such an application is indeed relevant.[15] The final criterion of extensibility refers to the extent to which the research outcomes (whether practical or otherwise) enable further work. Here, the group suggests that designer-researchers would be required to describe and document their research such that others may be able to build on what has been produced. This, of course, links back to the above proposals concerning the presentation/representation of outcomes such as annotated portfolios (Gaver and Bowers 2012).

The extensibility concept connects to a further and very important consideration in this area – how academic outcomes might link to the concerns of design practitioners.

Here, as was noted in the Introduction, Koskinen and Krogh (2015) argue that, when involving design practice in design research, designer-researchers should endeavour to maintain an accountability to a *design* audience, over and above any other that their work might speak to. This means seeking to advance the thinking (and theory) of the discipline (and not that of other disciplines); it also means foregrounding the methods and processes of design; and, lastly, it means seeking to maintain a dialogue with practice to the degree that research outcomes may be seen as predominately holding meaning for designers (and not, for example, art critics) (pp. 123–125).

An additional recent contribution comes from Prochner and Godin (2022). In drawing inspiration from pragmatism as well as existing established approaches to research evaluation criteria such as those outlined above, the pair devises a potential framework for assessing quality in 'research through design' work. It is based upon the categories of: traceability, which requires that the designer-researcher explain the structuring of their project and the emergence of its conclusions; interconnectivity, which requires that relationships be drawn between the context of the work and the concepts that guide the activity; applicability, which requires that the conclusions hold meaning for both research and practice; impartiality, which requires a clear positioning in relation to the researcher's 'bias, or lack thereof'; and finally, reasonableness, which requires that the research process be represented such that it can be both justified and, potentially, reapplied. The pair recommends that before aligning to this framework, designer-researchers first assess whether or not it is relevant to their work and, if not, to then adapt or appropriate existing evaluation criteria drawn from elsewhere (e.g., the social sciences).

Surveying these categories, it would appear that a high degree of variability remains in relation to what constitutes an endpoint in design research and how, within this, claims-evidence and, eventually, evaluation are to line up and be evaluated. We need only look at the number of potential evaluation frameworks available (Zimmerman et al. 2007; Koskinen and Krogh 2015; Prochner and Godin 2022). Beyond this there is also the role and presentation of artefacts-as-outcomes. As was noted, while it is now generally accepted that such work must be accompanied by a linguistic argument, the relationship between the two and scope of practice itself remains multilayered (Vaughan and Morrison 2014). Even with the proposals of strong concepts or annotated portfolios, robust though these are, one might reasonably suggest that there is still a sense that artefacts lack a clear positioning, in relation to how they might be examined and evaluated. While Zimmerman et al. (2007) have proposed a novel set of designerly evaluation criteria, it cannot be said that this has been widely accepted in the decade and a half since. Next to this, following on from Koskinen and Krogh (2015), it would appear the question of the relationship between research and practice – i.e., the question of design research's 'design accountability' – also stands unresolved in terms of the *form* it might take (not to mention the channels it might use).

Reflecting on the maturation of the design doctorate, Laurene Vaughan (2017) also notes that despite the points of agreement reached (i.e., that a linguistic argument must accompany an artefact or artefacts), there remain areas for exploration and expansion. On her view, the path ahead lies in exploring the potential of enabling greater 'design literacies' within academia. Here, 'literacies' refers to what design can 'do', what it is *best* at. For Vaughan, this relates to its capacities for communication, presenting findings through designed things. As she puts it, this means designing 'aesthetic, critical and articulate ways to convey actions and insights in an integrated

manner' (p. 117). Though it may seem otherwise, she is not here reprising arguments in favour of letting the artefact stand alone, but rather making the case for a more balanced integration of design within academic fora. The key message is that design can and should do more in the representation than at present. In following this outline, we might speculate that if one were to trace a truly designerly endpoint in research, it would involve the processes of evidence-claims-evaluation all coming together as one in an holistic, performed manner.[16] It is now merely a matter of having findings (i.e., sharable insights) and setting them out in a transparent manner. It is now also a matter of *framing* one's insights. She argues that it requires that the institutions of higher education open up to design in a way, that up until now, they have not.

Having considered the question of designerly endpoints as it has been approached in the literature, we will now move on to explore the potential offer of our philosophic baseline of Dewey-Wittgenstein-Heidegger in the context of *producing*.

Producing and Dewey-Wittgenstein-Heidegger

Dewey-Wittgenstein-Heidegger all have something particular to offer when it comes to the question of endpoints in design research involving practice. They do not quite approach the subject from the same evidence-claims-evaluation path outlined. Rather, their contribution is to be found in the ways they discuss such areas as belief, knowledge and truth. Here, each can be seen to (at least) sketch out ideas that link to the previous contextualisation of the concepts of evidence-claims-evaluation in the design literature. Dewey, following on from his practical pattern of inquiry, looks to replace abstract understandings of endpoints with a practical protocol, an idea for what inquirers (i.e., researchers) must *do* if they are to claim to have produced knowledge. Wittgenstein, in his later work, considers the concepts of knowledge and truth from the perspective of meaning – how everything must hang together such that we can recognise a claim as contributing to knowledge or holding truth. Heidegger, perhaps more so than the other two, works to carefully avoid traditional understandings of knowledge and truth. As we began to see in the last chapter, he maps a particular vision of truth – unconcealment – to Dasein. Thus, all may be seen to offer a separate, special viewpoint. Nonetheless, as always, there are definite alignments to be drawn, and not only this – again as always, there are also potential threads which might be picked up and explored further.

We begin with Dewey.

Dewey's Escape from Knowledge and Belief: Warranted Assertability

In the last chapter, we saw how Dewey's pattern of inquiry offers a theoretical mapping for the source of logical forms, i.e., the act of inquiry is seen to give rise to formal logic. This carries over to the question of *producing* knowledge – here again Dewey deals in empirical outline. In tackling the question of what marks the end of inquiry, i.e., the 'producing', he puts forward the view that the end of inquiry is marked by the attainment of knowledge in the form of belief. Where there was doubt (i.e., the point at which inquiry began), there is now 'the institution of conditions which remove the need for doubt', i.e., things are 'settled' (Dewey 1986/1938, p. 15). However, writing in the introduction to *Logic*, he notes how the key terms being applied here – knowledge and belief – have, to a large degree, lost any useful meanings they might

originally have held. This leads him to consider what might act as an alternative. How might something else fill the gap in meaning he identifies? The answer comes in the form of his concept of warranted assertability.

In essence, warranted assertability may be seen to offer a structural outline of the research evaluation process. What matters is having clear evidence against which particular claims can be made – this represents the 'settled' meaning of inquiry's findings (ibid). Implicit here is the notion of their being a *community*: individuals and groups of peers that may consider what is being presented (in terms of evidence and claims) and appraise the extent to which it holds. It is the researchers' or inquirers' job to *defend* their representation. This is evaluation (involving evidence and claims) by performance. We will here be able to show that whatever conclusions stand up. This is not all however. These conclusions will also be applicable to *future* inquiries; they become a 'means of attaining knowledge of something else' (Dewey 1986/1938, p. 122). The point here is that a well-conducted inquiry will lead to further inquiries. No outcome is ever finally settled. As Dewey puts it: '[t]he attainment of settled beliefs is a progressive matter; there is no belief so settled as not to be exposed to further inquiry' (ibid, p. 16). What matters is that, in the here and now, there is a settled belief sufficiently clear to allow us to 'act upon it, overtly or in imagination' (p. 15).

It would seem reasonable to expect that such a proposal would hold appeal for designer-researchers involving practice within their research. Indeed, it would appear that this is the case – warranted assertability has already had an airing in the field (e.g., Dalsgaard 2009; Jonas 2007). In such presentations, it often contrasted with classic interpretations of truth as offering a perfect representation of the world as it 'really is'. To a degree, this is fair; Dewey is offering us an escape route which avoids this entirely, however his bypassing leads us not around truth as such but rather, as has just been noted, around the concepts of knowledge and belief. Within the warranted assertability model, truth is a nonissue. There is no representation to be had. Instead what matters is whether or not we have an outcome, i.e., a set of conclusions, that can carry us forward, beyond the point at which we find ourselves. There are in essence two key items at stake here. Do we know something (i.e., have access to original, sound insights) that we did not before? Can we reapply this in future work?

If we were to enact this in the context of design research involving practice we might imagine that we present our evidence in the way that Dalsgaard and Dindler (2014) outline in relation to their bridging concepts (i.e., where theory and practice integrate). Design artefacts (or 'articulations') would interweave with theory and claims via a text. As regards structuring of this interweaving we would follow the proposal of Gaver and others (e.g., Gaver 2012; Gaver and Bowers 2012). The argument would be appraised on the basis of whether or not there is the evidence within the data and analysis, along with the artefacts themselves allowing for the claims which are being put forward.

For example, a designer-researcher might claim that a particular digital interface design – developed within a research project – supports a particular form of behaviour such as enabling people to spend less time focusing on screens in order to understand the information presented. It would then be incumbent upon the researcher to present the evidence, arising from data and analysis, that this is the case. Approaching the material for the purposes of assessing and judging the *warranted assertability* of this claim, a peer or group of peers would have multiple routes by which they might navigate through the argument. They might start with the practice (i.e., the interface and

accompanying work) and move through to the text (i.e., the evidence). Or go about it the other way around, i.e., text first, practice second. They might move through both together progressively. Either way, the point is that the above questions can be satisfactorily answered. Does all the material hold together such that we can say that it provides us with access to original, sound insights as regards digital interface designs and screen use? Will it be possible to deploy these insights in the development of new digital interfaces in order to address similar or related concerns in the future?

If the answer to both questions is yes, then the conclusions would, in Deweyan terms, be warrantable.

Wittgenstein's Grounding of Knowledge, Certainty, Judgement and Doubt

As has been noted prior, Wittgenstein did not discuss knowledge production as such. Despite this, in the last chapter, we nonetheless worked through his language games concept as means of exploring how we approach the idea of 'processing' through his work. This required that we examine the concept's essential outline and then trace a possible role for design therein. The proposal sketched out here offered a loose vision for an integration of the dynamics of looking and thinking in design research – identifying what is the case and then imagining alternatives. Though this certainly fits within designer-researchers' existing ways of working (e.g., linking to the core principle of imagining alternatives), it is nonetheless a particular, Wittgensteinian vision of how we might enact a research process in design.

When it comes to his perspective, producing and endpoints in research are a little clearer and possibly easier to appropriate. Here, we may reference his dedicated treatment of the subjects of knowledge, certainty and doubt. His firmest statements on these are made in *On Certainty*, a text that is said to have largely come together during Wittgenstein's last days between 1950–1951 (Anscombe and Wright 1969). As with most of his writings, *On Certainty* is comprised of fragments, short remarks, which make a brief point in relation to a given concern. Fragments may or may not relate to one another in sequence. Held together, the fragments offer a sequence of disconnected insights that allow us to think through the particular issues he draws into periodic focus.

Knowledge, certainty and doubt are perhaps the central themes which carry *On Certainty*'s discussion forward.[17] In keeping with the later Wittgenstein's concerns, these are all explored through the prism of the language games concept, i.e., focus is directed towards our use of language, what may and may not be said and how. He starts out with the proposal that the difference between knowing something and being certain of it is of no consequence, unless ' "I know" is meant to mean: I *can't* be wrong'. Yet, 'I know', he goes on to claim, does seem to 'describe a state of affairs which guarantees what is known' (Wittgenstein 1969, p. 3e [§8], italics in original). In other words, when we declare that we know something, we are often implying (consciously or unconsciously) that we cannot be *wrong*. As a result, words are not enough. Held within a knowledge-based language game, declaring that we know something means that we are expected (by the others involved) to have 'grounds' for our claims.[18]

This leads to a key point about the character of 'knowledge' itself. Knowledge, Wittgenstein proposes, is based on *acknowledgement* (ibid p. 49e, [§378]). We must

both agree that what is being presented or proposed is in fact knowledge. Things connect up or they don't. On this view, knowledge is to be seen as a system (ibid, p. 52e, [§410]) and the system is, in effect, our 'world picture' discussed in Chapter 1.

Having such a system allows us to test the likely truth or falsity of a proposal (p. 15e [§94]). For Wittgenstein, the truth of an individual's statements lies *in* their testing, which, in turn, is a matter of the form of language game that we are involved in. Who we are speaking to and in what context determines whether or not we will be judged to be offering accurate and appropriate accounts of this or that. When knowledge is held in systematic terms, it becomes apparent that belief too must follow a similar pattern. Here, *believing* something is not simply a case of believing one thing on its own, in isolation, but rather it is a matter of believing 'a whole system of propositions' (p. 21e [§141). Accordingly, when the truth of our statements is being tested it not just a matter of one thing being judged, but rather many things being judged. Returning to the idea of knowledge-as-a-system and the 'world picture' we hold, it is a matter of checking our entire 'frame of reference' (p. 12e [§80–83]).

Set against such an outline, the act of *doubting* becomes the key means by which such testing-judging-checking may be initiated and pursued. We may consider 'whether it can make sense to doubt' or, indeed, if we have any 'grounds' to doubt what is being presented as knowledge (p. 2e [§2–4]). If it does makes sense, if there are grounds for doubting, then the process of *actively* doubting will allow us to call certain statements or aspects of the work into question. As with knowledge and judgments, our doubts will be connected, forming a system. If one thing is to be doubted (e.g., whether the use of a design approach is appropriate) then other related things must be questioned too (e.g., the use of other design methods and the relationship between them). This may be useful. It may help to identify problematic aspects of our evidence-claims – areas for improvement, as it were. Equally, it may be unhelpful and even unnecessary. Doubt is self-limiting in that, at a certain point, it becomes *meaningless* to doubt. As a researcher or, indeed, a designer-researcher, we cannot 'investigate everything', and, as a result, certain aspects of our research must be exempt from doubt (p. 44e [§341–344]). We, as designer-researchers must be able to recognise these and stand by them. For example, we cannot be reasonably expected to investigate whether or not our participants *actually* hold the background they claim (e.g., that they *really* grew up in the place they say they did, that they are *really* the age they say they are). This is where the language game stops; there is no more doubting-investigating to do (ibid, p. 28e, [§204]).

Equally, in evaluating research, there will be a threshold where testing (i.e., actively doubting) becomes unreasonable and must 'come to an end' (p. 24e [§164]). Here, for the evaluator, it 'gradually loses its sense' (p. 9e [§56]). Acknowledging there might be a reasonable doubt threshold for all knowledge is, however, somewhat startling, for, according to Wittgenstein, it reveals the 'groundlessness of our believing' (p. 24e [§166]). However, so long as, through our testing-judging-checking, doubting becomes senseless, we must believe. Our participating in language games, with a shared world-picture and form of life, requires this. If through the language games (held within our form of life) we cannot meaningfully doubt, then it is our world-picture which must be questioned (opening up an entirely new investigation), not the presentation of the evidence-claims. This last point will be touched on again shortly.

In the previously mentioned, we have an outline which draws knowledge or knowing into direct relation with doubt. Within evaluation, doubt becomes our guard

against false or erroneous claims, fraudulent or incomplete evidence. This outline may be seen as Wittgenstein's core offer with regards to *producing* in research.

Applied to the context of design research involving practice, we have a notional structure which is perhaps not dissimilar to Dewey's warranted assertability. Again, we must present our evidence in the form of any design artefacts, coupled with a text that will situate the latter artefacts in theory and/or data analysis. On the Wittgensteinian view, through this act of presentation, we are essentially putting forward a claim or series of claims to knowledge. So far as can be, we will hold a degree of certainty regarding this claim or claims, we will *believe* it. Through a process of evaluation, involving another or others, we are required to defend the claims. Here, we enter a *language game* – one based upon the presentation and defence of research. The evaluator is required to test us by actively doubting – wherever and whenever this is reasonable. They will then judge our responses, checking the extent to which we are able to credibly defend the claim(s) set forth. After a time, doubt will either make sense or not. If it does not then the claim is, by default, to be accepted for now. The outcome of the language game, so far as it has gone, will have been the adjustment of the world-picture of those involved. It will likely be a minor adjustment but, depending on the depth and strength of the claims, there is always the possibility of more wide-ranging adjustments. Additionally, following on, if the accepted claims are effectively shared with a wider research community, there is the opportunity for a large-scale reorientation of ways of seeing in relation to a given subject (e.g., just as Einstein's theory of relativity reorganised physics). This in turn will impact on what is done going forwards, how we will approach future investigations and, indeed, potential whole areas of our lives.

Beyond this language game model and the reorientation of our ways of seeing, there is another aspect of Wittgenstein's work, which is also worth briefly drawing into focus in relation to design research and questions of production and endpoints – specially, Wittgenstein's proposals regarding the concept of *rules*. This concept, key to the later work, links directly to the concept of *games* (and of course, through this, to language games). At various stages in *Philosophical Investigations*, he explores how games function on the basis of rules. Rules distinguish appropriate 'play' from inappropriate play, correct moves from incorrect moves. A key point that emerges through his remarks on rules is that they are often not explicitly articulated – we learn them by 'watching how others play' (Wittgenstein 1963/1958, p. 27e [§54]). In other words, rules are acquired through *practice*; they can only be known through the 'game' itself.

Further to this, he also remarks that when it comes to 'establishing a practice', rules also require *examples*. This is because rules 'leave loop-holes open, and practice has to speak for itself' (Wittgenstein 1969, p. 21e [§139]). Here, examples become a definite reference point that we can choose to follow or not follow, take inspiration from, or compare our own actions/outcomes to. If we map this to the artefacts-as-outcomes debate, we may readily see the connection between the two. In this regard, one might argue that in seeking to establish a practice, offering examples of 'the rules' one envisages or proposes, the usefulness of artefacts-as-outcomes is to be found in the *demonstration* they provide. This does not remove the need for a text and, within this, a linguistic argument. That need remains. The point rather is that artefacts have a special role to play here for ultimately when it comes to practice, to *doing*, abstract theory is often not enough. In order to gain a sense of the affordances and constraints (i.e., the rules) of the 'game' that we are seeking to participate in, what is needed are

136 *Producing*

examples. These can be seen, examined and ultimately understood in their experiencing. In that understanding we are able to map out further possibilities for practice. Artefacts-as-outcomes, then, allow us to keep the practice of the game going. While abstract theory might arguably help here, it would not be able to represent the scope for action in quite the same way.

With this latter point we are brought back to Wittgenstein's proposal regarding 'thinking-looking' (see Chapter 2). According to Genova (1995) and other scholars (e.g., Diamond 1991; Cavell 1979), it is through this looking-thinking combination that Wittgenstein is calling on us to aim to change our general ways of seeing; that is our world picture. As has been indicated in the previous discussion, this matters because if you change a way of seeing, you change ways of acting/being. Producing takes us back all the way to positioning; by producing we (subtly or unsubtly) alter our position going forward.

Heidegger's Unconcealment: Truth as Discoveredness

Linking up the discussions of Heidegger's work presented in both Chapter 1 and Chapter 2, it is possible to say that we already have a sense of the concept of unconcealment; i.e., artistic creation is seen to allow for a *revealing* of aspects of Being in general, unconcealing an aspect of what is. This creation-unconcealment link is perhaps the most meaningful connection that can be drawn to design research involving practice and, for this reason, we shall consider it further shortly. Nonetheless, for the sake of clarity, it is worth first briefly approaching the concept of unconcealment in the direct terms that Heidegger initially presents it.

As a point of origin, unconcealment is given focus in *Being and Time*, where it is linked directly to the concept of truth. The link is not as straightforward as it might at first seem as unconcealment-as-truth diverges markedly from traditional framings of truth. Here, Heidegger was just as keen as Dewey to avoid definitions which pointed to notions of truth standing for an 'agreement' with how things 'really are'. Instead, unconcealment-as-truth is presented as the endpoint of a process of *discovery* (see Chapter 2 on Heidegger and discovery). In essence, when discovery comes to an end, when things or aspects of things have been 'discovered', they have been *unconcealed* and, as such, take on a state of *discoveredness* (Heidegger 2010/1927, p. 210).

Through this presentation, unconcealment is directly linked to *Dasein* (i.e., Heidegger's 'being-there' of the human person; see Chapter 1). As far as Heidegger is concerned, there is no unconcealment without Dasein. As an example, he calls up the case of Isaac Newton's laws of physics and proposes that before Newton, 'his laws were neither true nor false'. As far as he is concerned it was 'through Newton' that these laws became true (2010/1927, p. 217), i.e., his work disclosed them, brought them out of concealment. This version of truth, i.e., of truth as linked directly to Dasein, is seen to find form in *communication*. 'Dasein', he says 'expresses itself'. This expressing is said to rely on the given of discovering and discovery. Any statements we make communicate 'beings in the How [. . .] of their discoveredness' (ibid, p. 214). In other words, we might say that when we discuss or represent things we base this upon (and as such reveal) what has been discovered about them. Intriguingly, Heidegger pushes out further from this, claiming that when something is taken to be true (discovered, unconcealed) this *truth* itself becomes objectively present for Dasein alongside that which is considered to have been *discovered* and *unconcealed*. As he puts it: '*to the extent that in this discoveredness, as a discoveredness of . . ., a relation of things*

objectively present persists, discoveredness (truth) itself in its turn becomes an objectively present relation between objectively present things' (p. 215, italics in original). This essentially offers a creative vision of truth, which sees reality created for us (and through us) as we discover and unconceal.

In the context of design research, this presentation of unconcealment – particularly in relation to its latter aspect – may be intriguing but must ultimately be seen as somewhat problematic. The issue is that (beyond our apparent ability to render truth objectively present) it centres around the idea that we discover *pre-given* things, things which already exist (or might exist) as opposed to things which are brought into existence through a process of making or designing. Due to the strictness of this original presentation, there is no clear means by which this can be overcome. Nonetheless, I believe that, to a degree, the concept may be helpfully modified through reference to the 'The Origin of the Work of Art' essay discussed in the last chapter. As was noted, this essay does relate a version of creative practice (centring upon the idea of poetic thinking) and the concept of unconcealment, albeit by drawing a sharp line of separation between art and design (or least a functionalist understanding of design).[19] Against this, following Koskinen et al. (2011), I suggested that design research may at times merge with the culture of arts research, opening up the possibility of an alignment with Heidegger's *Origin*-based presentation of unconcealment.

This presentation is marked most fundamentally by its association of artistic creation with the 'becoming and happening' of truth (Heidegger 2001/1971, p. 69). While the artist clearly has a role here, the truth they bring forth is not to be associated with their individual genius. Rather, what emerges (or in Heidegger's words, is 'projected') relies on an openness to 'Being' (i.e., what is, in broad terms). It marks a beginning, which departs from norms and, as such, contains 'the undisclosed abundance of the unfamiliar and extraordinary'. In this way, art 'lets truth originate' (ibid, pp. 73–75). The work, which results from this process, is, in turn, seen to contain knowledge that has been derived from 'human being's entrance into and compliance with the unconcealedness of Being'. Following on, this is found to make 'its home' in the 'work's truth'. Individuals who then go on to encounter the work[20] are afforded the opportunity to enter into an 'affiliation' with this truth (pp. 65–66).

What do we gain from this presentation of unconcealment-as-truth? As was noted in the last chapter it is the revealing that is emphasized, not the creating or making. Nonetheless, we are, ultimately, able to draw a direct link between creating, i.e., making something, and the emergence and consolidation of a truth. Here, we are still 'discovering' aspects of Being (i.e., all that is), *producing* knowledge as it were, but we are doing so *through* the creation of something which did *not* exist prior.

The trade-off may be useful. In terms of presenting and defending our evidence and claims, we are here *allowed* to draw on an open process of creating, making, or even (if permissible) 'designing'. While it would undoubtedly be necessary to demonstrate an internal logic and rigour within any evaluation, our notional, underpinning relation to 'Being' in broad terms will also allow for expanded range of data sources. Artefacts-as-outcomes are clearly allowed for too because these are the 'home' of the truth/unconcealment. As will be noted shortly, a potential challenge inevitably arises with regard to justifying one's 'poetic thinking', i.e., the relationship between what is external (Being as all-that-is) and one's individual creativity. However, this might itself come to be seen as a creative endeavour, a process that requires consideration and resolution such that the 'unconcealment' that has been achieved might be rendered apparent to those who are evaluating one's evidence-claims.

Design Research Projects 3.1 The 'Reorientation' of the Designing Quality in Interaction Group at TU Delft

Based in TU Eindhoven's Department of Industrial Design in the Netherlands, the Designing Quality in Interaction (DQI) group operated for a period of just under two decades – from the early 2000s until the late 2010s. To this day, it stands as an exemplar for philosophically driven programmes of design research.

The group's central research question was 'How to design for . . .', with the specific 'what' being determined by broader research objectives of the department (Overbeeke et al. 2014, p. 193). While this line of inquiry implies an apparent simplicity, the group was in fact engaged in a deep reworking of the foundational principles upon which design itself was defined. Here, diverging from the norms of the time – especially those of its early years[21] – the DQI sought to place *aesthetic* concerns at the very core of their research programme. This meant abandoning questions relating to cognitive processes alone and turning, instead, to examine the relationship between design and the complexities of human action, emotion, concepts of value and social interactions, as *well* as cognitive processes (e.g., Overbeeke 2007, p. 6).[22] Experience and beauty, not use, were now positioned as central to the design of products and interactions.[23]

The group's practical efforts were supported by a specific set of philosophical and theoretical commitments. Here, a key link was drawn to phenomenology, specifically the phenomenology of Merleau Ponty and Heidegger,[24] whereby the agency of the body (Merleau Ponty) and the meaning which arises from our being-in-the-world (Heidegger) were foregrounded. Extending this focus on embodiment-being, another key link was the perceptual theory of James Gibson and its concept of affordances (i.e., aspects of the environment which are seen to hold meaning).[25] Beyond these, a further connection was also loosely sketched to classical pragmatism, with Kees Overbeeke – the group's director through the 2000s – seeing a connection between Gibson's work and that of Dewey and James (Overbeeke 2007, p. 7).

Over the years, DQI produced a series of frameworks for designing such as the famous Interaction Frogger Framework, which centralised action within the design process (e.g., Wensveen et al. 2004). The group also produced philosophically inspired work as well. Here, for example, working to uphold DQI's core philosophic and theoretical commitments, i.e., phenomenology and Gibson's perceptual work, Jelle Stienstra (2016) produced a framework for designing 'respectful embodied interactions'[26]. The framework aimed to provide an alternative to generalising tendencies within conventional methodological approaches within design. The uniqueness of experience was to be valued above all, with the researcher being required to investigate 'individual understanding' and, alongside this, maintain a deep and immediate involvement in the design process, focusing on the act of exploring as opposed to the development of an outcome. Such an approach, it was argued, offered a more appropriate methodological reference point for designerly knowledge production than those borrowed from the sciences (e.g., engineering) (Stienstra 2016, pp. 107–109).

> Though the DQI group has now disbanded,[27] their legacy continues to this day with former members, such as Caroline Hummels (still based at TU Eindhoven), continuing to engage in work which asks questions regarding the productive possibilities of philosophy in design. Here, for example, in recent years, Hummels and colleagues have explored the extent to which postphenomenology (see the next Chapter) can act as a 'generative lens for both design research and practice' (van der Zwan et al. 2020). Through such work, as well as the broader shift from use-to-beauty/aesthetics, the path opened up by the DQI will continue to resonate for many years to come.

Producing and Dewey-Wittgenstein-Heidegger: Asserting, Defending, Unconcealing

Perhaps one of the greatest challenges of designing in the context of a research project is identifying the point at which one may reasonably *stop*. With design, the desire to keep going is often too great. It may feel as though a further experiment, or workshop, or engagement will provide that additional level of resolution, which is, at the moment, not quite there. Such a sentiment and drive is understandable. Notionally, it will always be possible to build upon what has been achieved and imagine how the work might extend further, do more, be better.

This is further complicated by the idea that with design research involving practice, there will be the desire to both *achieve* and be able to *evidence* positive transformation of a given context. Such a drive is understandable. Nonetheless, endpoints must eventually be decided upon, whether out of necessity (e.g., a deadline or a budget closing) or simply because time is finite and we cannot go on forever. Positive transformation may have been achieved. It may not have. Here, it must be borne in mind that, fundamentally we are involved in a process of design *research* and *not* design practice. Anything we present as an end point must be *evidence-based*. It must arise from credible data and make reasonable claims as to the value that has been produced. Having credible data and reasonable claims is preferable to inauthentically or, worse, falsely representing the extent to which any positive transformation has been achieved.

In the early part of this chapter, we explored the relationship between evidence-claims-evaluation and the concerns of design research involving practice. Some key challenges and points for possible consideration were noted in relation to the role and representation of artefacts-as-outcomes, the evaluation of research and the final presentation or representation of project work in general. What emerged most keenly was the idea that design diverges from conventional academic norms – it has artefacts to show and qualities that require special attention. In this, there would appear to be a need to move away from classic evaluation criteria (of both the scientific and qualitative traditions, e.g., Zimmerman et al. 2007) and even consider whether academia might need to open up to novel, more designerly modes of framing one's research findings (Vaughan 2017)

From here we turned to Dewey-Wittgenstein-Heidegger to consider how they approached the idea of *producing*. In the end, what we can say is that each offers a set of proposals which give notional form to the *practical* aspect of producing – touching

upon both the question of how we can say that we have produced knowledge and what 'production' might actually mean.

For Dewey and Wittgenstein, it is perhaps best understood as a *process*. Dewey's process – warranted assertability – centres upon *defence* within the evaluation process; we are being called upon to consider the extent to which we might reasonably defend (to peers) the possibility our evidence supports our claims. This presents the endpoint of research as a social (and possibly an institutionally framed) event. In it, we might have gradations of assertability. Some claims will be easier to assert than others. Some evidence will hold more weight than other evidence. We are being provided with a means by which we can discuss and appraise *the quality* of endpoints, how well the work resolves the problem it set out to address.

Compared to Dewey, Wittgenstein's process focuses on the negative aspect. We must *defend* against doubt in particular and be willing to work collaboratively (within a formal language game) to get to the bottom of doubt – the groundless point where doubt no longer makes sense. A commitment is here made to engage in an exchange where, if doubt is overcome, we (as the one who is examining) will have to adjust our knowledge system and, as such, our world picture.

In contrast to Dewey and Wittgenstein, Heidegger's outline is less practical. For him, producing is an almost wholly personal matter, a process which is set beside the broadness of all that is (i.e., Being with a capital B). This account does not offer a model for the evaluation process. Unlike Dewey or Wittgenstein, there is no clear outline of what we might be expected to do, or show, or say. Rather our attention is directed towards what it is we, as individuals involved in a process of discovery, stand to gain from that process of discovery – unconcealment, a revealing of an aspect of what is.

So far as there is anything which unites these perspectives, I believe it is to be found in the centring of personhood. We have our inquirer (Dewey), our language game participant (Wittgenstein) and our Dasein (Heidegger). There is no endpoint to be had without these characters. Each has a clear role to play as they approach their endpoint. The inquirer must endeavour to fully represent the various phases and outcomes of their project so that warranted assertability of the whole may be reasonably demonstrated. The language game participant must prepare themselves for the doubt of another, sense-checking what can be doubted, seeking out ways of addressing any potential defects. Dasein, in an effort to share the 'unconcealment' achieved through their process of discovery, must find ways of representing this to others. If unconcealment has emerged through artistic creation then it will be a matter of finding a way to present the work, the outcome such that an audience may enter into 'affiliation' with its 'truth'.

Another point of connection emerges in relation to how each of these person-centred models may, on a fundamental level, be seen to challenge the classical understanding of endpoints. There is no final answer, no absolute truth, no absolute certainty. For Dewey-Wittgenstein-Heidegger these are unrealistic, inappropriate goals.

Then there are of course differences too. Connecting to the question of practical specificity, I believe difference is most clearly expressed in the absence or presence of the concepts of evidence-claims-evaluation. These are foregrounded in Dewey, there to a degree in Wittgenstein, but only implied in Heidegger. As was suggested in the last section and will be discussed shortly, this leads to challenges. This is paralleled by the extent to which each presentation is linked (or not) to the idea of conducting

a formal research project. Dewey's is embedded in the idea of conducting research. Wittgenstein alludes to it in places. Heidegger, although not explicitly discounting the possibility of a link (e.g., via reference to Newton's laws), does not draw any clear relationship to research as such.

What then do these three models, with their various similarities and differences, mean for design? In the end, we have three different (and to a degree relatable) ways of looking at the process of producing in our research. In the first instance, each of these can be seen to offer a model for drawing our research to a close. Here, we are offered new sets of terms, novel concepts (e.g., warranted assertability or unconcealnent). We are also offered a new 'process' (e.g., working through doubt as part of a language game) or way of envisaging a process (e.g., revealing aspects of Being). These terms, concepts and processes allow us to propose a break from the traditional terms, concepts and processes which attach to endpoints in conventional knowledge production.

We might follow Dewey and seek to apply a warranted assertability model. This would allow us to avoid abstract conceptualisations of knowledge and belief. As we have seen, any artefacts would be brought together with a text to set out the evidence-claims. Truth is of no concern here. It is only a question of whether our conclusions may yield immediate value in relation to the problem, and support the conduct of further inquiry. In an evaluation, with examiners (in a PhD) or peer reviewers (if an established researcher), we will either be found to be warranted in our assertions or not.

We might follow a language game approach, accepting that we will be doubted and aiming to defend against this. The artefacts (if relevant) and the text are still required here. We are still aiming to present the work in a combination which links the evidence such that the claims can be judged. Again, the 'truth' of one's conclusions is not at stake here. What matters is whether one's claims can withstand scrutiny. If they do, then we are adjusting our knowledge system with our way of seeing. Further, within the Wittgensteinian model, we can see our artefacts as examples which might act as rules for other designers or designer-researchers to follow.

Then lastly, we might work with the idea of Heideggerian unconcealment. Here, as discussed, we would likely be required to link to Heidegger's framing of artistic creation and, within this, draw it into an alignment with design. As noted, Koskinen et al. (2011) suggest that, in research terms at least, it is possible to draw such an alignment. On this account, design becomes a form of expression, which sees the maker work to give form to a truth that is observed in relation to things in general (i.e., Being with a capital B). In addition, following Heidegger's initial presentation of unconcealment in *Being and Time*, we may note that in ascribing to this model, we would be taking the view that our unconcealment alters what is objectively present by introducing a new objective presence, i.e., the act of unconcealing alters the objectively present. Artefacts clearly have a role to play here – these will allow an audience to enter into affiliation with the truth one has unconcealed. The role of text will be less apparent perhaps but is nevertheless necessary. We will need to clearly and explicitly outline what we believe has been unconcealed.

This Heideggerian model is not without issues of course. In aligning to it, we are essentially accepting the idea that there *is* a broad reality that we, as designer-researchers, can respond to and, through 'poetic thinking', come to 'know'. Then we must also accept the idea that this creative effort can unconceal aspects of this broad reality. Both propositions will likely jar with those who require definite, clearly

defined processes and criteria against which the quality of any knowledge claims can be judged. This is what Heidegger's model lacks. Ultimately, it would seem, we would be relying on the researcher's personal presentation and testimony as to whether or not they have meaningfully 'unconcealed' anything.

As a work-around, we might draw inspiration from Dewey and Heidegger. For the reasons outlined previously, both would likely find flaws in Heidegger's presentation as set against their modelling of alternatives. Nonetheless, we might still follow Dewey in asking that our notional unconcealment be judged on the basis of whether our evidence supported our claims to have revealed something specific of general value. We might also follow Wittgenstein, seeking to explore the extent to which our evidence and claims can be reasonably doubted.

Regardless of whether these models appeal or not, it is readily apparent that there are aspects of each that can help us to ask and answer questions of endpoints in design research involving practice. We can have new ways of looking at artefacts (e.g., as rules for practice) and the artefact-text relationship (e.g., as an interweaving of evidence and claims). New ways of approaching the process of evaluation. As has been underscored, in each case, we are being offered new ways of giving form to the final value being sought. Here, the idea of there being no absolute truth, no absolute certainty, no final answer fits especially well with design research involving practice. As we have seen, its agenda diverges from that of positivism, i.e., the pursuit of certain knowledge based on definite and explicit understanding (Dorst 2008). When you are researching as designer-researcher, classic objectivity is simply not possible – you are not aiming to maintain a neutral stance, to describe or explain in order to provide an accurate account of 'how things really are', but rather to bring about change through design (see Chapter 1). As such, there is no best outcome, no one 'right' outcome. Design research involving practice cannot be evaluated on this basis. There are only better or worse outcomes, outcomes which do or do not conform to the change one has sought to bring about. It is not about stopping and declaring anything definite and final, but rather about finding ways to keep going as we come up against troubling new situations in our environment (Dewey), the shifts in our forms of life (Wittgenstein) and unexpected aspects of the world that we, in our caring, must respond to (Heidegger).

What these models do not answer is the particular set of evaluation criteria that we might apply in evaluation itself. It will be clear enough we are not looking for a demonstration of classic objectivity – a removed, neutral stance which sets the designer-researcher apart from what they are researching in order for them to provide an account of how 'things really are'. Nor are we likely to be concerned with classical reliability and validity. Design research involving practice is unlikely to rely on instrument-based data collection and analysis (i.e., the focus for reliability). Equally, it is also unlikely to be exploring casual relationships, deal in large sample sizes or aiming for generalisability (i.e., the focus for generalisability). There will be caveats here, examples which go against this trend. These will however represent minor branches within the field. Design research is usually qualitative, framed in terms of experiences and value-orientated (Wright and McCarthy 2010; Koskinen et al. 2011). In this case, it is likely that the alterative, qualitatively orientated criteria may be more appropriate. It may be that Zimmerman et al.'s work (2007) is of value. Or it may be that a more appropriate set of criteria still needs to be developed (e.g., Prochner and Godin 2022).

As a final point, it will be worth briefly returning to Vaughan's contention (2017), discussed previously, that design has much more to offer within the process of presenting research findings than is currently permitted within academic norms, i.e., that its capacities for communication have not been probably explored or integrated. In this regard, I believe that Dewey's, Wittgenstein's and Heidegger's models all point to the need for a more focused, directed approach to re-representing what has emerged in the research process. Dewey and Wittgenstein at least call for a conscious *performing* within the processes they set out. We must act to convince others that our assertions are warrantable and do not merit doubting. Heidegger does not call on us to perform, as such, but we are nonetheless implicitly required to work to convince others that we have 'unconcealed' something previously concealed. Each model then calls for a clarity of purpose and a strong coordinated communication strategy – it becomes 'a creative endeavour', as was suggested in relation to Heidegger's proposal. We must tell the story of our data, evidence and claims. Link things together. Provide spaces for discussion. Invite and be open to questioning. Following Vaughan, it is clear in all of this that design has a responsibility to explore the extent to which the 'aesthetic, critical and articulate' aspects (to use her words) of conveying one's 'actions and insights in an integrated manner' (2017, p. 117) might be enhanced *through* design itself.

Pathway 3.1 An Establishing Pathway: Latourian Actor Network Theory and Design via Latour

As has already been noted, the potential value of drawing inspiration from Bruno Latour's work in the context of design is now well established. We have seen how, for example, his concept of 'dingpolitics' or 'thing politics' has allowed for the emergence of a novel perspective – Design Things – within participatory design, centred around an issue-based coming together of humans and nonhuman collectives.

However, he has more to offer. In particular, there is also his contribution[28] to the development of the 'actor network theory' (ANT), as well as a compelling philosophy of design proposal. We take one after the other.

ANT has, in recent years, become an important theoretical touchstone within the field of design. In simple terms, it can be seen to offer a special sociological outlook, wherein particular ontological and epistemological commitments give form to a methodological approach. Within this, humanity is decentred and focus, instead, is directed towards the wider networks of interaction in which both humans and nonhumans participate. Here, technology, materials and other lifeforms are all brought together within a framework that seeks to follow and trace actors, actions and interactions.[29] Anything can be an actor and everything is part of a network. As a researcher, the aim is a descriptive overview of affect, mapped across multiple trajectories, tracing what happens and why.

When connecting ANT to design, we see a similar decentring occur. In contrast to conventional theorisations of design (e.g., Lawson 2008/1980; Schön 1983; Simon 1996/1969), it is no longer a simple matter of observing human action being directed towards the production of material objects or immaterial experiences but, instead, something more all-encompassing. Ultimately, through an ANT lens, design becomes a grand networked activity which draws in many actors and contexts. It is now the relationships that matter, not the specifics of isolated, individual decision-making.

In the last decade, a number of authors have begun to explore the possibilities of ANT-design couplings. Some have been tentative, others bold and expansionist. At the latter end, Yaneva (2009) sets out the potential for a design-ANT programme of research framed around the relationships between objects and actions, examining design's role in giving form to the social.[30] Making a similarly broad pitch, Storni (2015) sets out a grand vision, drawing refined ontological, methodological and epistemological alignments between co-design, participatory design and ANT. From the ontological perspective, there is the suggestion that co-design and participatory design are seen to give from to 'design actor networks'. Then, methodologically, the suggestion is that co-design is seen as 'actor networking in public'. Finally, epistemologically, the proposal is that designers may be seen to draw on knowledge frameworks agnostically.[31] Beyond these more wide-ranging proposals, there are also an increasing number of contributions that explicitly seek to apply ANT as a methodological lens in an effort to reveal or support the dynamics of design activity in action. Here, examples include work looking at service innovation (Uden and Francis 2009), community project work (Ekomadyo and Riyadi 2020) and the extent to which ANT can equip designers to engage in 'socio-material speculation' (Wilkie 2019).

From ANT-design, we turn lastly to Latour's philosophy of design proposal, issued in the 2000s in a landmark paper entitled 'A Cautious Prometheus?' (Latour 2008). Here, Latour not only outlines a loose framing for a philosophy of design but also sets out what he believes to be the discipline's core positive attributes. These relate to: design's modesty, i.e., that it seeks to work with what is as opposed to transform absolutely; its attention to detail; its broad, flexible meaning; the idea that to design is always to redesign, i.e., one never starts at the very beginning; and its inherent ethical posture, i.e., the notion of there being good design and bad design. As per the title of the paper, design is, in essence, framed as both tentative and powerful. It is notionally capable of absolute transformation but, in this, is always tethered to that which came before, to working with it and, in doing so, is seen to always reference preexisting value frameworks.

In setting out his philosophical proposal proper, Latour proceeds via reference to the work of the contemporary German philosopher Peter Sloterdijk (and through him to Heidegger.)[32] In its Heideggerian aspect, Sloterdijk's work is seen to provide an ontological vision which allows for a grounding of humanity's inherent 'thrownness' and always-already constituted relationship to its various material support systems, i.e., that there is no humanity without a preexisting material situation. This is a philosophy which would inherently couple humanity to design, i.e., humanity here becomes design-based.

Pathway 3.2 A Pathway in Formation: Postphenomenology

As the term suggests, postphenomenology takes its reference from phenomenology, with the 'post' prefix denoting a movement 'beyond' the latter. In simple terms, postphenomenological philosophers will work with phenomenology's conceptualisations of perception and embodiment and, from here, draw lines outwards to link to contemporary technological contexts and concerns. The point is to draw out theories of human-technology relations, qualifying technology's role in shaping our experience and broader existence.

The approach was first proposed by the American philosopher Don Ihde. On his initial framing, postphenomenology was founded upon a coupling of Husserl's phenomenology of perception and Heidegger's hermeneutics (e.g., Ihde 1990). He later drew further inspiration from Dewey's technological account of inquiry, i.e., whereby the practice of inquiry (and logic) is seen to progress on the basis of advances in technological capability (Ihde 2009).[33] In this work, Ihde broadly explored the ways in which technology mediates our perception, surfacing a typology of four possible human-technology-world relations. These were: embodiment relations, whereby technologies are linked directly to the body (e.g., glasses); hermeneutic relations, whereby technologies represent aspects of the world (e.g., a thermometer); background relations, whereby technologies affect the context in which we find ourselves but are not present to us in conscious experience (e.g., central heating); and alterity relations, whereby technologies are experienced as a quasi-other (e.g., an ATM) (see Ihde 1990).

Following on from Ihde, others have contributed to the advance of this perspective. Key here is the work of Peter-Paul Verbeek (2005), who developed postphenonemology into a wider philosophy of technology and, in doing so, drew it into explicit relationship to design. In this, he rejects the more negative technological accounts of Heidegger and others,[34] and instead sets out to map a neutral vision, one in which technology's value was not preassigned. Idhe's work is here linked to aspects of Bruno Latour's Actor Network Theory (see previous). Human experience, perception and meaning remain present as concerns within the human-world-technology relations but are now seen to form part of the network of actions and interactions in which the role of technology is to be considered and explored. Things can now do things too. The result is a rebalanced postphenomenology, wherein empirical investigation becomes the fulcrum around which inquiry is to proceed.

Verbeek retains Idhe's typology of human-technology-world relations. Indeed, he builds on it. Alongside embodiment, hermeneutic, background and alterity relations, there were the additions of: cyborg relations whereby technology is implanted in humans (Verbeek 2011, p. 144); immersion relations whereby technology gives form to a context of interaction (e.g., internet of things, or IoT technology); and augmentation relations whereby technology adds an interactive layer to our experience (e.g., through smart glasses) (Verbeek 2015).

With regard to the field of design, in particular,[35] a grand challenge is set by Verbeek. On his account, the design of products is not simply a matter of designing interactions between humans and technology, but rather an ethical inquiry into 'the character of the way in which we live our life' (Verbeek 2015, p. 31). Here we see the discipline transformed into a moral space in which all are called upon to contribute to a dialogue around the specific behaviours that designed things ought to support and those that they ought not to (Verbeek 2011).

Over the last decade, Verbeek's work, and Ihde's with it, has begun to gain currency in design discourse, particularly in the context of design-led human computer interaction (HCI). Here, postphenomenology is being explored on two levels. On the one hand, an increasing number of contributors have set forth postphenomenological theoretisations of and for the field. These tend to trace out a vision, which seeks to move beyond human-centred design, productively complicating design's ontological status (i.e., its meaning in the context of our theories of reality). Perhaps one of the most prolific scholars operating in this area is Ron Wakkary of Simon Fraser University in Vancouver, Canada. Through practice-based work undertaken in his Everyday Design

Studio research lab (see the next chapter), Wakkery and colleagues have explored postphenomenology's potential meaning and application to considerable depth – with explorations examining how postphenomenology might be applied as a means of grounding the 'relations between theory and things' (Hauser et al. 2018).

Within this grouping, a key contribution has been made by Sabrina Hauser (2018) whose doctoral thesis explored how postphenomenology might act as a guiding theory for the application of design approaches within HCI. Here, she proposed that design's present focus on human-centreness may obscure potentially valuable perspectives which lie beyond the human. For example, human-animal relations and, as per postphenomenology's typology of technological mediation, the wider possibilities of novel technological relations as well as the role technology may be seen to play in actually *shaping* our humanity. This work has also recently been extended by Wakkary's *Things We Could Design* (2021), which also considers how design might progress beyond its current human-centreness to assimilate posthuman perspectives including aspects of postphenomenology. The aim is to frame a more inclusive and responsible agenda, underpinned by a 'designing with' approach. Here, again, the position of other species and lifeforms would be recognised as stakeholders within the wider process.

Alongside this, postphenomenological theorisations have also emerged at TU Eindhoven in recent years. Here, building on a prior focus on phenomenology proper (Hummels and Lévy 2013), key individuals such as Caroline Hummels and Peter Lévy are now asking questions around how postphenomenology might be applied as a 'generative lens' within design research (van der Zwan 2020).

Alongside these larger theorisations, a series of smaller-scale studies have begun to emerge, which aim to explore the extent to which the perspective might offer up valuable insights regarding specific human-technology relations. The focus of such studies tends to either gravitate towards a particular technology or, alternatively, a particular use context. With regards to technologies, Rapp (2021) has considered wearable technologies as an embodied extension and Goeminne (2011) examined the politics of sustainable technology. With regards to a specific use context, Secomandi and Snelders (2013) applied a postphenomenological approach in the design of interfaces within a larger service and, similarly, Botin (2015) considered hospital design.

Beyond these proposals and studies, we may ask what the further potential of postphenomenology might be for the field. In the first instance, it would appear that there remains a general opportunity to continue to explore the Ihde-Verbeek typology of interactions, particularly beyond an HCI context – for example, in relation to general product and service design where it has not yet been extensively applied as a theoretical lens. There is the possibility such an application may yield further productive insights as to the usefulness of the typology in the activity of designing itself. In the second instance, if approached via Ihde's later work (e.g., Ihde 2009) postphenomenology might offer a potentially useful theoretical bridge between the phenomenology of Husserl-Heidegger and the classical pragmatism of John Dewey, who, of course, is one of our baseline philosophers. Applied in this way, postphenomenology would open up a space in which specific aspects of both of the philosophies (i.e., phenomenology and classical pragmatism) could be mobilised in a design research context. Lastly, and perhaps most significantly, it would seem that, notwithstanding the work of Wakkary and others, postphenomenology can provide design research with a lens by which it can ask and seek answers to moral questions (Verbeek 2011), allowing design researchers to frame a space in which ethical inquiry is foregrounded. Here, the

key question becomes how design can support us in our efforts to positively shape 'the character of the way in which we live our life'.

Notes

1. These criteria are widely discussed in key methods textbooks (e.g., see Bryman 2008). They are also widely critiqued, with alternatives being offered in their place. For example, Guba and Lincoln present a special set of criteria by which constructionist research might be best judged (see Guba and Lincoln 1985).
2. A final point of relevance here, particularly in relation to design research, emerges with regards to value – the 'So what?' of the work being undertaken. Not all research projects will be clear about the potential value they deliver. For example, a psychologist researching particular behaviours or responses (e.g., how individuals reacts to different types of music) may not be able to identify an immediate application for their work. Nonetheless, it will be important that some consideration be given to this question. Design and value are closely interlinked. Why something should be designed and changed or transformed should be an answerable question. Someone(s) or some things should stand to benefit from what is being explored and developed, even if it is only designers themselves. If no one stands to benefit, not even the designers, then the work itself becomes questionable. This is something we will explore further in the latter part of the chapter.
3. The importance of evidence and claims to design research has been underscored by Matthews and Brereton (2015), in the their promotion of a 'practical epistemology'. As discussed in Chapter 2, along with the preceding categories of data and analysis, the pair sees these aspects as essential components within any research project and indispensable to producing valid work. Their proposal is that by foregrounding these essential concepts over and above any special theoretical commitments, it may become easier for early career researchers to navigate what is referred to as the 'methodological mire' in design research (see Chapter 2).
4. Tonkinwise (2017) suggests this is because the higher education systems in such countries is government funded and, as such, must conform to a government agenda. For Tonkinwise, this implies the predominance of a neo-liberalist economic worldview. Here, practice-based or practice-led research is seen to offer an instrumentalist approach to knowledge production. Rather than asking if an outcome is true as per traditional models, the question now becomes what use is it?
5. To the author's knowledge, every UK institution of higher education requires that a text accompany practice-based portfolios for all doctoral submissions. For example, the Royal College of Art's regulations state that any practical submission must be accompanied by 'a piece of written work in English'. This will define 'the purpose of the work, the factors taken into account in its conception and development and explain the results' (RCA 2021).
6. Reflecting on their collective encounters with doctoral design submissions, Vaughan and Morrison (2014) present a tentative framework, which gives form to some of the parameters and mechanisms at play within this context. The framework offers a more or less expected outline, linking up modes of study, milestones, submission format, examination processes and types of examiners. There are clear differences across all of these parameters but nonetheless a horizon of possibilities emerges in each case. For example, some programmes offer coursework, others research methods training. Some programmes require a thesis, others allow a PhD by project.
7. Working with others, Gaver has recently gone on to propose two further 'annotation strategies' for annotated portfolios which extend beyond the original proposal (Culén et al. 2020). These are: the trajectory strategy, which focuses on articulating the historical and motivational development of a given artefact over time; and the ecological strategy, which focuses on articulating the way(s) a set of artefacts work together. As with the original proposal, both are seen to function as a means of presenting knowledge which has been produced through the design process, whether in RtD or some other form.
8. Additionally, in the design literature, there was, on occasion, a lack of distinction between grounded (i.e., evidence-based) claims and those which were speculative. Equally, in some

148 *Producing*

cases, the foundational claims (i.e., the claims on which other claims rest) were seen to be value-based rather than grounded (Beck and Stolterman 2016, p. 208).

9. In scientific work, this demonstration will generally involve the additional criterion of *replicability*. This requires that researchers demonstrate that their results can be repeated if the procedures or experiments are conducted in another setting. This specific criterion has been found to be problematic in the context of social research however, as social conditions are ever changing and dynamic.
10. Alongside generalisability there is also a potential concern regarding 'applicability'. Here, one is asking if it is possible to infer whether or not one's results may have bearings beyond the population or phenomenon that was sampled, e.g., relevant not just to old people but also to young people (e.g., Murad et al. 2018).
11. Generalisablity has long been a prized aim in knowledge production. This is because, if obtained, it allows for *prediction*. If one is able to predict what will happen in a given situation whether in material or social terms, one will be able to *control* that situation, to plan for it and prepare accordingly. To take a basic example, if one were able to predict how a given group of people were likely to move through a given space within certain conditions – say an airport, with certain volumes of passengers – then one would be able to *control* flows appropriately by putting necessary checks in place to ensure safety. While this example is relatively benign, it is easy to imagine how an ability to predict and control might link to a less savoury agenda; shaping consumer behaviours, for example, by applying psychological cues within a retail space, would likely strike many as borderline unethical.
12. For an account of the social history of the concept of truth in a seventeenth-century English context, see Shapin (1994). Also see Kuhn's work on changing scientific paradigms (1972/2012), as outlined in chapter 1.
13. In this instance, the researcher is seen as the 'instrument' or 'equipment'. In essence, it is their 'calibration' and 'accuracy' that is at stake (e.g., Golafshani 2003).
14. This is a common feature of many such proposals. For Guba and Lincoln it fits under the criteria of confirmability and dependability (see 1985, pp. 323–324). For Yardley (2000) it is found under commitment and rigour, as well as transparency and coherence.
15. Intriguingly, in discussing this criterion, Zimmerman and colleagues (2007) suggest that up until then, those operating in the context of RtD had not done enough to argue for the relevance of their work. The risk, as they see it, is that such work may be viewed as a 'self-indulgent, personal exploration that informs the researcher but makes no promise to impact the world' (p. 500).
16. It is important to note that Vaughan does not see the possibilities as being limited to design alone. She highlights that other fields have also opened up to the opportunities of novel modes of communication and presentation, mentioning, for example, 'anthropology, sociology, management and organizational studies' and 'the sciences' (2017a, p. 116).
17. *On Certainty* takes reference of two of the English philosopher G. E. Moore's most celebrated arguments: 'Proof of the External World' (1939) and 'In Defence of Common Sense' (1925) – both of which seek to provide an 'everyday' grounding for questions of knowledge and validity. Within the text, Wittgenstein seeks to explore and, to an extent, resolve what is found to be problematic within these texts. We are informed in the Preface by G. E. M. Anscombe and G. H. Wright that he was encouraged to engage in this work by Norman Malcom, an American philosopher, during a visit to the United States in 1949 (Anscombe and Wright 1969).
18. Wittgenstein here notes that if two individuals are engaged in a language game involving 'I know' statements then the individual who is being told that something is known must 'be able to imagine *how* one may know something of this kind' (Wittgenstein 1969, p. 4e [§18], italics in original). In other words, they must be able to imagine what evidence would look like here.
19. We also noted that this work was picked up on by Fry (2014), who claimed that design *conceals*.
20. Heidegger discusses this encounter in the context of the work having been 'preserved'. He argues that this preserving is best 'cocreated and prescribed exclusively by the work'. Though he does not explicitly refer to such contexts as galleries or museums, or to use Koskinen et al.'s (2011) term 'showrooms', he does mention 'the art business'. Here, the

extraordinary is seen to be 'parried and captured by the sphere of familiarity and connoisseurship' (Heidegger 2001/1971, pp. 65–66).
21. Following the field of HCI, product and interaction design research in the late 1990s and early 2000s was dominated by a focus on the principles of cognitive psychology (e.g., Norman 1986).
22. Overbeeke claims to have been inspired to undertake this shift after becoming acutely aware of the differences between how taught design (which was experience-focused) and what he researched (which was perception-focused) (Overbeeke 2007, p. 7).
23. See Djajadiningrat et al.'s (2000) early pamphlet which sets out the initial proposals regarding the centring of experience and beauty.
24. In detailing this history, Overbeeke and colleagues often linked to Paul Dourish's important *Where the Action Is* (2001) text (e.g., Overbeeke 2007).
25. While Gibson's theory had already been drawn into design (e.g., Norman 1986), Overbeeke and colleagues argued in favour of approaching the concept with a focus on affect (i.e., the relationship between perception and action) as opposed to its structural aspects (i.e., the relationship between form, perception and meaning) (e.g., Overbeeke and Wensveen 2003).
26. Respect was here defined in relation to the embodied, with a view to foregrounding phenomenological primacy (Stienstra 2016, p. 8).
27. Kees Overbeeke sadly passed away in 2011 and the research groups at TU Eindhoven has since undergone a reorganisation, i.e., Caroline Hummels currently leads the Systematic Change group (TU Eindhoven 2021).
28. It is important to note Latour is not the sole originator of ANT. Others include Michel Callon (1999) and John Law (Law and Hassard 1999).
29. While everything is to be seen as equal, technology is a significant theme in Latour's work. Indeed, his ANT is positioned in an area of sociology referred to as Science and Technology (STS) studies.
30. Yaneva has since gone on to look at the potential of applying ANT to architecture in particular; see e.g., Yaneva (2016).
31. In setting out this latter proposal, Storni (2015) recasts Latour's designers from a 'cautious Prometheus' to an 'agnostic Prometheus'.
32. Sloterdijk's work rejects dualisms, e.g., the separation of body and mind, and, following on, seeks to advance a reformed ontology, which allows for a bringing together of all things, whether human or nonhuman, natural or 'artificial' (e.g., Sloterdijk 2011, 2014).
33. Prior to this explicit pragmatist alignment being drawn, the compatibility of Ihde's work and Dewey's had been noted (see Hickman 2008).
34. Of these, the work of Karl Jaspers in particular is noted as fitting into the negative category (Verbeek 2005, pp. 15–46).
35. In *What Things Do* (2005), Verbeek restricts his attention to industrial design in particular.

References

Anscombe, G. E. M., and von Wright, G. H., 1969. 'Preface'. In G. E. M. Anscombe and G. H. Von Wright (Eds.), D. Paul and G. E. M. Anscombe (Trans.), *L. Wittgenstein, On Certainty*. Oxford: Basil Blackwell.

Beck, J., and Stolterman, E., 2016. 'Examining the types of knowledge claims made in design research'. *She Ji: The Journal of Design, Economics, and Innovation*, 2(3), pp. 199–214.

Biggs, M. A., 2002. 'The role of the artefact in art and design research'. *International Journal of Design Sciences and Technology*, 102, pp. 19–24.

Biggs, M. A., and Büchler, D., 2007. 'Rigor and practice-based research'. *Design Issues*, 23(3), pp. 62–69.

Botin, L., 2015. 'Hospital architecture and design in postphenomenological perspective'. In *Technoscience and Postphenomenology: The Manhattan Papers*, pp. 83–103. Lanham: Lexington Books.

Bryman, A., 2008. *Social Research Methods*, 3rd edition. Oxford: Oxford University Press.

Callon, M., 1999. 'Actor-network theory – the market test'. *The Sociological Review*, 47(1), pp. 181–195.
Cavell, S., 1979. *The Claim of Reason: Wittgenstein, Skepticism, Morality, and Tragedy.* Oxford: Oxford University Press.
Culén, A. L., Børsting, J., and Gaver, W., 2020. 'Strategies for annotating portfolios: Mapping designs for new domains'. In *Proceedings of the 2020 ACM Designing Interactive Systems Conference*, pp. 1633–1645. New York: ACM.
Dalsgaard, P., 2009. *Designing Engaging Interactive Environments – A Pragmatist Perspective.* Unpublished Ph.D. Dissertation. Aarhus, Denmark: Aarhus University.
Dalsgaard, P., and Dindler, C., 2014. 'Between theory and practice: Bridging concepts in HCI research'. In *Proceedings of the SIGCHI Conference on Human Factors in Computing Systems*, pp. 1635–1644. New York: ACM.
Dewey, J., 1986 [1938]. *The Collected Works of John Dewey: The Later Works, 1925–1953, vol. 12, Logic: The Theory of Inquiry.* Edited by J. A. Boydston. Carbondale, IL: Southern Illinois University Press.
Diamond, C., 1991. *The Realistic Spirit: Wittgenstein, Philosophy, and the Mind.* Cambridge, MA: The MIT Press.
Djajadiningrat, J. P., Overbeeke, C. J., and Wensveen, S. A., 2000. 'Augmenting fun and beauty: A pamphlet'. In *Proceedings of DARE 2000 on Designing Augmented Reality Environments*, pp. 131–134. New York: ACM.
Dorst, K., 2008. 'Design research: A revolution-waiting-to-happen'. *Design Studies*, 29(1), pp. 4–11.
Dourish, P., 2001. *Where the Action Is.* Cambridge, MA: The MIT Press.
Ekomadyo, A. S., and Riyadi, A., 2020. 'Design in socio-technical perspective: An actor-network theory reflection on community project "Kampung Kreatif" in Bandung'. *Archives of Design Research*, 33(2), pp. 19–36.
Fry, T., 2014. 'The origin of the work of design: Thoughts based on a reading of Martin Heidegger's "the origin of the work of art"'. *Design Philosophy Papers*, 12(1), pp. 11–22.
Gaver, B., and Bowers, J., 2012. 'Annotated Portfolios'. *Interactions*, 19(4), pp. 40–49.
Gaver, W., 2012. 'What should we expect from research through design?' In *Proceedings of the SIGCHI Conference on Human Factors in Computing Systems*, pp. 937–946. New York: ACM.
Geertz, C., 1973. *The Interpretation of Cultures.* New York: Basic Books.
Genova, J., 1995. *Wittgenstein: A Way of Seeing.* Abingdon: Routledge.
Goeminne, G., 2011. 'Postphenomenology and the politics of sustainable technology'. *Foundations of Science*, 16(2–3), pp. 173–194.
Golafshani, N., 2003. 'Understanding reliability and validity in qualitative research'. *The Qualitative Report*, 8(4), pp. 597–607.
Guba, E., and Lincoln, Y. S., 1985. *Naturalistic Inquiry.* London: Sage.
Hauser, S., Oogjes, D., Wakkary, R., and Verbeek, P-.P., 2018. 'An annotated portfolio on doing postphenomenology through research products'. In *Proceedings of the 2018 Designing Interactive Systems Conference*, pp. 459–471. New York: ACM.
Heidegger, M., 2001 [1971]. *Poetry, Language, Thought.* Translated by A. Hofstadter. New York. Harper and Row.
Heidegger, M., 2010 [1927]. *Being and Time.* Translated by J. Stambaugh. Albany, NY: State University of New York Press.
Hickman, L. A., 2008. 'Postphenomenology and pragmatism: Closer than you might think?'. *Techné: Research in Philosophy and Technology*, 12(2), pp. 99–104.
Höök, K., and Löwgren, J., 2012. 'Strong concepts: Intermediate-level knowledge in interaction design research'. *ACM Transactions on Computer-Human Interaction (TOCHI)*, 19(3), pp. 1–18.

Hummels, C., and Lévy, P., 2013. 'Matter of transformation: Designing an alternative tomorrow inspired by phenomenology'. *Interactions*, 20(6), pp. 42–49.

Ihde, D., 1990. *Technology and the Lifeworld: From Garden to Earth*. Albany, NY: State University of New York Press.

Ihde, D., 2009. *Postphenomenology and Technoscience: The Peking University Lectures*. Albany, NY: State University of New York Press.

Jonas, W., 2007. 'Design research and its meaning to the methodological development of the discipline'. In R. Michel (Ed.), *Design Research Now*, pp. 187–206. Basel: Birkhäuser.

Koskinen, I., and Krogh, P. G., 2015. 'Design accountability: When design research entangles theory and practice'. *International Journal of Design*, 91, pp. 121–127.

Koskinen, I., Zimmerman, J., Binder, T., Redström, J., and Wensveen, S., 2011. *Design Research Through Practice: From the Lab, Field, and Showroom*. Amsterdam: Elsevier.

Kuhn, T. S., 2012 [1972]. *The Structure of Scientific Revolutions*. Chicago: The University of Chicago Press.

Latour, B., 2008. 'A cautious prometheus? A few steps toward a philosophy of design (with special attention to Peter Sloterdijk)'. In F. Hackney, J Glynne, and V. Minton (Eds.), *Networks of Design: Proceedings of the 2008 Annual International Conference of the Design History Society*, pp. 1–13. London: Design History Society.

Law, J., and Hassard, J., 1999. *Actor Network Theory and After*. London: Wiley-Blackwell.

Lawson, B. R., 2008 [1980]. *How Designers Think*. Oxford: The Architectural Press.

LeCompte, M. D., and Goetz, J. P., 1982. 'Problems of reliability and validity in ethnographic research'. *Review of Educational Research*, 52(1), pp. 31–60.

Loi, D., 2004. 'A suitcase as a PhD? Exploring the potential of travelling containers to articulate the multiple facets of a research thesis'. *Working Papers in Art and Design*, 3. [Online]. Available at: www.herts.ac.uk/__data/assets/pdf_file/0012/12360/WPIAAD_vol3_loi.pdf [Accessed: 14 September 2018].

Mason, J., 1996. *Qualitative Researching*. London: Sage.

Matthews, B., and Brereton, M., 2015. 'Navigating the methodological mire: Practical epistemology in design research'. In P. A. Rodgers and J. Yee (Eds.), *The Routledge Companion to Design Research*, pp. 151–162. Abingdon: Routledge.

Moore, G. E., 1925. 'A defence of common sense'. In J. H. Muirhead (Ed.), *Contemporary British Philosophy*, 2nd series, pp. 193–223. London: Allen and Unwin.

Moore, G. E., 1939. 'Proof of an external world'. In *Proceedings of the British Academy 25*, pp. 273–300. London: The British Academy.

Murad, M. H., Katabi, A., Benkhadra, R., and Montori, V. M., 2018. 'External validity, generalisability, applicability and directness: A brief primer'. *BMJ Evidence-based Medicine*, 23(1), p. 17.

Nelson, H. G., and Stolterman, E., 2003. *The Design Way: Intentional Change in an Unpredictable World*. Englewood Cliffs, NJ: Educational Technology Publications.

Norman, D., 1986. *The Design of Everyday Things*. New York: Basic Books.

Overbeeke, K. C., 2007. *The Aesthetics of the Impossible*. Eindhoven: TU Eindhoven. [Online]. Available at: https://research.tue.nl https://research.tue.nl/en/publications/the-aesthetics-of-the-impossible [Accessed: 6 December 2021].

Overbeeke, K. C., and Wensveen, S. S., 2003. 'From perception to experience, from affordances to irresistibles'. In *Proceedings of the 2003 International Conference on Designing Pleasurable Products and Interfaces*, pp. 92–97. New York: ACM.

Overbeeke, K., Wensveen, S. S., Hummels, C., Frens, J., and Ross, P., 2014. 'DQI interaction design research'. In C. Mareis, G. Joost, and K. Kimpel (Eds.), *Entwerfen-Wissen-Produzieren*, pp. 193–206. Bielefeld, Germany: Transcript-Verlag.

Rapp, A., 2021. 'Wearable technologies as extensions: A postphenomenological framework and its design implications'. *Human – Computer Interaction*, pp. 1–39.

RCA, 2021. *Regulations*. London: Royal College of Art. [Online]. Available at: www.rca.ac.uk/documents/917/RCA_Rules_Regulations_2018_19.pdf [Accessed: 6 April 2021].

Prochner, I., and Godin, D., 2022. 'Quality in research through design projects: Recommendations for evaluation and enhancement'. *Design Studies*, 78, p. 101061.

Schön, D. A., 1983. *The Reflective Practitioner: How Professionals Think in Action*. New York: Basic Books.

Secomandi, F., and Snelders, D., 2013. 'Interface design in services: A postphenomenological approach'. *Design Issues*, 29(1), pp. 3–13.

Shapin, S., 1994. *A Social History of Truth: Civility and Science in Seventeenth Century England*. Chicago: The University of Chicago Press.

Simon, H., 1996 [1969]. *The Sciences of the Artificial*, 3rd edition. Cambridge, MA: The MIT Press.

Sloterdijk, P., 2011. *Spheres, vol. 3: Bubbles*. Cambridge, MA: The MIT Press.

Sloterdijk, P., 2014. *Spheres, vol. 2: Globes*. Cambridge, MA: The MIT Press.

Stienstra, J., 2016. *Designing for Respectful Embodied Interactions: Towards a Phenomenology and Ecological Psychology-Inspired Approach to Designing for Interactive Systems*. Eindhoven: Technische Universiteit Eindhoven.

Storni, C., 2015. 'Notes on ANT for designers: Ontological, methodological and epistemological turn in collaborative design'. *CoDesign*, 11(3–4), pp. 166–178.

Tonkinwise, C., 2017. 'Post-normal design research: The role of practice-based research in the era of neoliberal risk'. In L. Vaughen (Ed.), *Practice-Based Design Research*, pp. 29–39. London: Bloomsbury Press.

TU Eindhoven, 2021. 'Caroline hummels'. [Online]. Available at: www.tue.nl/en/research/researchers/caroline-hummels/ [Accessed: 31 December 2021].

Uden, L., and Francis, J., 2009. 'Actor-network theory for service innovation'. *International Journal of Actor-Network Theory and Technological Innovation*, 1(1), pp. 23–44.

van der Zwan, S., Smith, M. L., Bruineberg, J., Levy, P. D., and Hummels, C. C., 2020. 'Philosophy at work: Postphenomenology as a generative lens in design research and practice'. In S. Boess, M. Cheung, and R. Cain (Eds.), *Proceedings of DRS2020 International Conference, vol. 4: Education*, pp. 1691–1706. London: The Design Research Society.

Vaughan, L., 2017. 'Embracing the literacies of design as means and mode of communication'. In L. Vaughan (Ed.), *Practice-Based Design Research*, pp. 111–127. London: Bloomsbury.

Vaughan, L., and Morrison, A., 2014. 'Unpacking models, approaches and materialisations of the design PhD'. *Studies in Material Thinking*, 11, pp. 1–19.

Verbeek, P. P., 2005. *What Things Do: Philosophical Reflections on Technology, Agency and Design*. University Park, PA: The Pennsylvania University Press.

Verbeek, P. P., 2011. *Moralizing Technology: Understanding and Designing the Morality of Things*. Chicago, IL: University of Chicago Press.

Verbeek, P. P., 2015. 'Beyond interaction: A short introduction to mediation theory'. *Interactions*, 22(3), pp. 26–31.

Wakkary, R. L., 2021. *Things We Could Design: For More Than Human-Centred Worlds*. Cambridge, MA: The MIT Press.

Wensveen, S. A., Djajadiningrat, J. P., and Overbeeke, C. J., 2004. 'Interaction frogger: A design framework to couple action and function through feedback and feedforward'. In *Proceedings of the 5th Conference on Designing Interactive Systems: Processes, Practices, Methods, and Techniques*, pp. 177–184. New York: ACM.

Wilkie, A., 2019. 'How well does ANT equip designers for socio-material speculations?' In A. Blok, I. Farías, and C. Roberts (Eds.), *A Routledge Companion to Actor-Network Theory*. Abingdon: Routledge.

Wittgenstein, L., 1963 [1958]. *Philosophical Investigations*. Translated by G. E. M. Anscombe. Oxford: Basil Blackwell.

Wittgenstein, L., 1969. *On Certainty*. Edited by G. E. M. Anscombe and G. H. Von Wright. Translated by D. Paul and G. E. M. Anscombe. Oxford: Basil Blackwell.

Wright, P., and McCarthy, J., 2010. 'Experience-centered design: Designers, users, and communities in dialogue'. *Synthesis Lectures on Human-Centered Informatics*, 3(1), pp. 1–123.

Yaneva, A., 2009. 'Making the social hold: Towards an actor-network theory of design'. *Design and Culture*, 1(3), pp. 273–288.

Yaneva, A., 2016. *Mapping Controversies in Architecture*. Abingdon: Routledge.

Yardley, L., 2000. 'Dilemmas in qualitative health research'. *Psychology and Health*, 15(2), pp. 215–228.

Zimmerman, J., Forlizzi, J., and Evenson, S., 2007. 'Research through design as a method for interaction design research in HCI'. In *Proceedings of the SIGCHI Conference on Human Factors in Computing Systems*, pp. 493–502. New York: ACM.

Conclusion – Understanding the Boundaries, A Justificatory Narrative and What Next?

What has been explored over the last number of chapters? We may briefly summarise the journey as follows. First, we engaged in a broad consideration of the relationships between design, knowledge, knowledge production and philosophy. Following on, focus was directed towards the emergent approach of design research involving practice, wherein a commitment to participation and transformation (i.e., actively aiming towards positive transformation) may be seen to guide the work forwards. It was noted that such an approach to research diverges markedly from the classical model of knowledge production, which actively seeks to *avoid* participation and transformation in its prioritisation of description, explanation and, ultimately, theory. As a consequence of this divergence, it was suggested that design research involving practice required a particular, explicit epistemological grounding, an 'epistemological narrative' that highlights and gives meaning to the key differences between classical understandings of knowledge and the new shape that knowledge may be seen to take on here.

Philosophy, it was argued, held the answer. At this point, I turned to the perspectives of John Dewey, Ludwig Wittgenstein and Martin Heidegger. Here, I moved outwards from the proposal that, approached from a pragmatist perspective, these three voices can offer a baseline from which to explore the wider potential value of philosophy in the context of design research. As a means of structuring this exploration, the ideas of positioning, processing and producing were introduced as three core points of reference within research and markers by which we might navigate philosophic material. From here, one by one, each chapter explored how these ideas related to both design research involving practice and to the perspectives of Dewey, Wittgenstein and Heidegger. In between, various pathways were opened up, allowing us to glimpse connections that were either established to a degree or else were seen to hold potential in relation to the issues at hand.

We arrive now at the point where we must reflect back on what has been covered and, against this, consider what appropriate next steps may look like. Accordingly, this chapter aims to draw the book's general arc together as well as offer something summative which might support both the efforts of individual designer-researchers as well as those who wish to explore even further still. It will proceed as follows.

To begin, a concise recapitulation of positioning, processing and producing via Dewey, Wittgenstein and Heidegger is offered, with the key linkages drawn to design research being highlighted. Following on, I briefly comment on the value of the pathways. Held together, these sections then lead to the presentation of a visualisation, or 'sketch map', of our specific survey of design-philosophy relations. It is intended

that this sketch map will support decision-making in relation to one's philosophic position as a designer-researcher, at least in relation to how this has been explored in the present text. From this, an 'early epistemological justificatory narrative for design research involving practice' is set out. This functions as a final general statement in relation to how design research involving practice might use the reference points presented in this book to ground its handling of transformation, participation, uncertainty and difference/diversity. Then, lastly, the chapter draws to a close with an argument being made in favour of promoting a deeper philosophical fluency in design research, alongside a final consideration of what philosophy might stand to gain from a more designerly perspective.

We begin then by reflecting back on our exploration of positioning, processing and producing via our Dewey-Wittgenstein-Heidegger baseline.

Positioning, Processing and Producing in the Round: The Baseline and Design Research Involving Practice

Though it is unlikely to happen consciously, we would be well advised to ask ourselves three specific questions at the point of embarking on a given research project. What is our position? What form will our research process take? What are we aiming to produce; or, to put it more precisely, how will we know we've arrived at our endpoint? With these areas covered in a clear, coherent and connected fashion, we can be confident that our work will be both easily communicable and likely of value to others. This is where, I believe, we find the contours of any epistemological justificatory narrative. As such, covering positioning, processing and producing via the *practice*-orientated philosophies of Dewey-Wittgenstein-Heidegger and linking this to design research involving practice amounts, in essence, to an inquiry into the extent to which these three voices can yield a clear, coherent and connected epistemological justificatory narrative for the approach.

So, the question arises, what, in the round, has been yielded? To answer this, I will aim to here briefly summarise the key aspects that have surfaced in relation to each area (i.e., positioning, processing and producing) and (briefly) how links have been drawn back to design research.

With positioning and design, we noted that each of the three baseline philosophers centred the human perspective by touching upon themes of experience and existence. For Dewey, we are organisms in the environment. Held in the environment, we encounter values, qualitative aspects of the situation, which are not just subject-bound but really-real, belonging to the situation as much as to the individual. These define the starting point of how we engage with the world. For Wittgenstein, we are all participants in particular 'forms of life', ways of being which are defined by the language we speak as we go about our day-to-day activities. These linguistically defined forms of life confer us with a particular 'world picture', a way of seeing which shapes our understanding of 'how things are'. For Heidegger it was about our Dasein (i.e., being there), how, in this, we are thrown (i.e., always already where are) and how unavoidably we *must* care – that is, by necessity, go about tending to immediate tasks which require our attention in order for things to keep on going.

Together, these perspectives were linked back to notions of motivational contexts in design, the idea that we will have personal, philosophical or 'grounded' (i.e., real-world) starting points from which our work as designer-researchers emerges

(Zimmerman and Forlizzi 2008). As the world is multiplicious and varied, so too are the motivational contexts. For example, motivations might be drawn from practice, technology or ethics.

Following on from positioning, we turned to processing. For Dewey-Wittgenstein-Heidegger, this was a matter of direct involvement in the world (one way or another) and called up themes of action and communication, with the latter drawing in both language and meaning. With Dewey, we considered both his pattern of inquiry and his theory of communication. Here, we, as inquirers, are seen to move outwards from a troubling situation and through an experimental process, working towards resolving what is troubling. In this, we move through a series of stages, progressing from an identification of the problem, to the identification of a problem-solution, and, following on, to a cycle of experimentation and observation in which the solution is progressively developed. The theory of communication links to this on the basis that, from Dewey's perspective, language allows us to name and identify objects and actions such that they are drawn into view and rendered visible within the inquiry. We are also able to relate things, draw them together and apart through the meaning that language confers. This, in turn, allows us to imagine possibilities, whereby we can engage in what Dewey calls 'inner experimentation'. Here, novel relationships can be tested and the inquiry's overall system of meaning revised. Equally, at the end of inquiry, the new meanings which emerge can be seen to lead to ontological transformation, where objects and actions are understood in a new light on the basis of the inquiry's conclusions.

With Wittgenstein, our attention was directed towards his concept of language games in particular. Here, language becomes an arena in which we conform to a system of rules that allow us to achieve certain goals or actions. The challenge lies in seeking to step outside of this and gain an oversight of what is happening – what he terms a perspicuous representation. The 'language game' is a technique or device that helps one achieve this. It is expected one will first observe what is at play within a particular 'game' (e.g., telling a story) and make comparisons across games. The point is to *see* the connections. Then, beyond this, the next step is imagining how things might be otherwise, noting what possibilities work and what possibilities don't. By pursuing the looking-thinking combination, we are able to remain grounded in our speculation but equally to move beyond what is 'merely' immediate.

With Heidegger, we explored his presentation of both discovery and poetic thinking. Discovery referred to our engagement in the world and was seen to involve two distinct stages. First, we, as Dasein, come to understand things in their own terms, i.e., what they are, what they are for. Second, once we have attained understanding, we can explore the potential and scope of the thing, whether it be raw material, a tool or a being. Here, we can test what it allows us to do, and equally, through it, we can be connected to a multitude of other materials and aspects of the world. Next to this, poetic thinking foregrounded the process of artistic creation as a means by which the 'artist' (in our case the designer-researcher) may be seen to set forth 'truth', understood as an 'unconcealing' of Being in general (i.e., all 'that is').

Together, these perspectives were linked back to ideas of method and methodology in design. Here, the possibility of aligning design research involving practice with a preexisting methodological approach (e.g., participatory action research) was contrasted with the proposal that design might function as a standalone method without the need for the support of such alignments. In relation to the latter, Deweyan inquiry,

Wittgensteinian language games and both Heideggerian discovery and poetic thinking were set out as reference points that might be drawn upon when framing one's methodological approach.

Additionally, the Wittgensteinian concept of language games was presented as a potential means of managing diversity in design research involving practice (i.e., RtD). Here, it was noted that RtD exhibits many forms or genres (Boon et al. 2020), which are dynamic in themselves. From a conventional perspective, this dynamic aspect might be seen as problematic (i.e., conventional method is seen as something to be reapplied). However, if RtD (or design research involving practice) is approached via the language games concept it becomes possible to see each project as contributing to the continuance of an evolving RtD 'game'. It will bear coherence over time but will never be 'the same' as previously.

Lastly, with producing, we saw in the last chapter how we are offered three relatable models of endpoints in research, i.e., the point at which we can claim to have *produced* knowledge. For Dewey and Wittgenstein these are best understood as processes in and of themselves. We are being presented with a scenario in which we are required to act in a particular way in relation to the material of our inquiry or research, which, in the case of design research, may well involve artefacts. For Dewey, it is about establishing whether or not what we are asserting (i.e., our claims) is warranted. For Wittgenstein, it is about gradually working to a point where we, and those we are seeking to convince, are no longer in a position to doubt what is being claimed.

Heidegger does not offer a process here but rather, as has been noted, his way of conceiving truth, referred to as unconcealment. Here, truth is not considered in terms of representing the world but rather revealing otherwise hidden aspects of 'what is' (i.e., Being broadly defined). By linking to his theory of art, we were also able to draw in the proposal that creative production can result in outcomes (i.e., 'works'), which give form to this unconcealment and allow others to enter into affiliation with it.

Beyond these models, while considering Wittgenstein's work, attention was directed towards his concept of 'rules' (relating back to the language games concept). A key point of note for design research was that while rules distinguish appropriate action from inappropriate action, they are often not explicitly articulated. Rather, we commonly learn them by 'watching how others play'.

These perspectives were considered in relation to discussions of endpoints and the concepts of evidence claims and evaluation in design research involving practice, with particular regard being given to the role of design artefacts. Through Dewey-Wittgenstein-Heidegger, it was possible to position artefacts in relation to the question of evidence and claims. Here, it was argued that they may act as material to refer to as we: go about establishing the warranted assertability of our inquiry; jointly work out whether or not a particular claim can be reasonably doubted; or make a case for our particular instantiation of 'unconcealment'. Links were also drawn back to the earlier contention that design research involving practice cannot claim to uphold a commitment to classical objectivity (i.e., offer an accurate account of 'how things really are'; see Chapter 1) and so cannot be evaluated on this basis. Here, the three models of Dewey-Wittgenstein-Heidegger were all found to offer alternatives to seeking absolute truth or certainty in research.

Additionally, beyond the previously mentioned, the potential relevance of Wittgenstein's concept of rules for the artefacts-as-outcomes debate was also noted; on this

view, artefacts can be seen to offer practical *demonstrations* in research contexts, i.e., by offering a reference point for other designers or designer-researchers to follow.

Having set this out, we will now turn to briefly note some of the key pathways which were highlighted as we progressed.

A Brief Note on the Pathways

As we progressed through the text, pathways to other philosophies or philosophers emerged. These linked to the specific theme or area of focus under consideration at the time. We had pathways to:

- Marx's existing influence in design;
- The links between design and Heidegger's treatment of things and technology;
- The potential of a Marxist positioning on creativity;
- The potential of a selection of positionings relating to ecology; the decolonial; feminism; and Buddhism;
- The strong existing links between design and semiotics;
- The potential of Heidegger's work to lead out and connect to perspectives in Buddhism;
- The potential of additional linguistic pathways via the work of Austin, Foucault and Butler;
- And postphenomenology.

Further pathways, which are more speculative in nature, relating to the areas of critical theory, the work of Deleuze-Guattari and process philosophy, will be considered at the end of the chapter. However, leaving these to one side for now and focusing on the above list, we may ask what it is that can be drawn out here in the round, as it were.

In response, I would like to note two aspects in particular. First, there is the compatibility and potential of the individual voices and perspectives that have been highlighted. Second, there are lines that lead out from these, which point to the possibility for further work. This work might again take a pragmatist stance, i.e., a stance whereby a perspective's value is appraised on the basis of its potential usefulness to achieving a specific goal. Then there is also the possibility that the baseline drawn out here might be rejected entirely in favour of one of the pathway perspectives (e.g., that of Marx). Here the peripheral (of this text) would become central (to another). To do so would of course amount to a refutation, and refutation requires justification, a rationale for why the selections and/or the position presented here should be adapted. Though divergent and dissenting, such a stance would be welcome as, ultimately, it would evidence the emergence of a more focused discourse on design-philosophy relations in the context of epistemology and design research.

With the latter overviews of both the baseline and pathways set out, I will now move to present the promised sketch map of both.

Mapping the Baseline Philosophers and Some Pathways: A First 'Sketch'

The below figure represents a first sketch map of the terrain opened up by our baseline and the pathways. It will be noted that the map divides into three columns: positioning,

processing and producing. Along these columns we see the varying stances of our baseline of Dewey-Wittgenstein-Heidegger presented across individual lines. We will also see that these lines are ranged vertically along an axis which spans between the poles of language/logic-focused and experience/aesthetics-focused. This latter separation is made on the basis that it helps us draw a subtle but helpful qualification in relation to the position each puts forward. Wittgenstein leans more towards language/logic – Dewey and Heidegger to experience and aesthetics.

Beyond the baseline material, we may note that, interspersed in the mapping, the stance presented by the various pathways encountered (as well as some which are covered below) has been loosely placed at particular points, allowing for a sense of how each relates to the broader whole. Finally, as a last point of note, the emergent horizons of the decolonial, feminism, the ecological and Buddhism have been pinned along the positioning-processing line. These positionings and indeed, all positionings are suggestive only, no absolute claims are made. Following on from what has already been stated, it is acknowledged that other, better, more precise and useful versions might be developed and these are of course to be welcomed. If anything, this version can only ever mark a first step. With luck, it may support designer-researchers' decision-making as they begin to explore potential design-philosophy alignments and, beyond this, inspire others to push further.

From this mapping, I now move to present what I refer to as an early 'epistemological justificatory narrative for design research involving practice'.

An Early Epistemological Justificatory Narrative for Design Research Involving Practice via the Baseline

This book has set about responding to a core aim: to explore certain philosophies with a view to outlining an epistemological narrative for design research involving practice. As was recalled at the outset of the present chapter and as has been grounded in the sketch map, the perspectives of Dewey-Wittgenstein-Heidegger have provided a baseline for how we can approach the ideas of positioning, processing and producing in research via: the themes of experience and existence (positioning); the themes of action and communication (processing); and the concepts of evidence and claims (producing). By examining their offering, in this way, chapter by chapter, we have ultimately surfaced the material upon which we may tell the story of transformation, participation, uncertainty and difference/diversity in design research involving practice (i.e., the core concepts which were seen to underpin design research involving practice; see the Introduction). This is because, as has been demonstrated, their perspectives are found to carry a designerly outlook and, ultimately, all, on some level, connect to how designer-researchers frame their work and what they do.

So, the question now arises, how does one move from these perspectives to craft an *early* epistemological narrative for design research involving practice? A narrative which might allow us to epistemologically *justify* our methodological choice.

Before seeking to offer an answer, however, we must define a means of proceeding.

On the face of it, it would seem to make the most sense to take it concept by concept, working through transformation, participation and so on in sequence. However, the concepts all intersect and overlap – one ultimately feeds into the other. What might work then? The answer comes when we ask: what is it that our three philosophers are saying *generally*? That is, what is the collective epistemological viewpoint that they offer; what is/are the basic connection(s) to design research with regards

160 *Conclusion*

Figure C.1 A sketch map of the relative positions of the baseline philosophers, pathways and horizons in relation to the areas of positioning, processing and producing in research. Image by Author.

to positioning, processing and producing and the concerns of design research? and how does all this connect to the concept of transformation, participation, uncertainty and difference/diversity? Here, we find the starting point for a narrative, as we get the interrelated outline of what it is they are saying about the themes coupled with a holistic modelling of design research involving practice.

In order to begin this process of asking the latter questions, it will be helpful to first recall how transformation, participation, uncertainty and difference/diversity were first introduced in regard to design research involving practice at the book's opening. Here, it was noted that design research involving practice, generally, insists upon action which *transforms*. The aim is, at least implicitly, to make things better, to bring about *positive transformation*. This, in turn, necessitates a direct engagement with context. It was noted that the designer-researcher must *participate*, they must involve themselves in what is happening. This process and its outcomes will be uncertain. We cannot know *with* certainty that the positive transformation we are aiming for can be achieved. We cannot know *with* certainty the value it carries (e.g., is it the *best* possible outcome, the best possible change?). But this should not be a barrier in and of itself – degrees of success are possible. Then, following on from this, there were the concepts of difference/diversity. It was noted that I would work to clarify the ways in which a means of handing difference/diversity can be drawn out from the Dewey-Wittgenstein-Heidegger baseline. Having now reached the end of the book, I will move to offer a statement on this shortly.

With the previously mentioned in hand, we return then to the question of how we may cohere their perspectives to craft an *early* epistemological narrative for design research involving practice. As a first step here, the following quick statements can be made as a means of summarising the basics of their offering via positioning, processing and producing, and how these link to the concerns of design research involving practice.

- A Dewey-Wittgenstein-Heidegger view on positioning is that, in our humanity (i.e., as Deweyan live creatures, Wittgensteinian linguistic performers or Heideggerian caring beings), we are always *compelled* to act in relation to our experiences, to what we encounter and what happens to us. The world is there for us and we must respond. This is the unavoidably entry point. Here, from a design research perspective we align with the notion of there being multiple motivational contexts from which design research projects might launch;
- Following on, a Dewey-Wittgenstein-Heidegger view on processing is that it is always, unavoidably, an *embodied, specifically located* activity which is grounded in meaning(s) (whether in Deweyan inquiry, Wittgensteinian language games, or Heideggerian discovery or poetic thinking). In essence, there needs to be at least some engagement with the 'rough ground' of the world and, here, meaning and action, action and meaning come together in cyclical interaction – we develop and (possibly) share meanings as we involve ourselves with the acts of inquiry, questioning, discovery or poetic thought. This in turn affects how we see things at the close of our research, whether framed as: inquiry; use of language games; or process of discovery/poetic thinking. Here, from a design research perspective, we have a series of reference points from which to frame our methodological stance in relation to the inclusion of design practice within the process;

- A Dewey-Wittgenstein-Heidegger view on producing is that it is, to a greater or lesser degree, *a process* and not an endpoint in and of itself (i.e., it is never definite or final). Here, we have a choice. We must either adopt a stance which accepts the necessity of performing-to-persuade (i.e., warranted assertability for Dewey or getting-to-the-bottom-of-doubt for Wittgenstein). Or we must acknowledge that what we have drawn out (i.e., unconcealment for Heidegger) is but an *aspect* of something greater and ultimately unknowable in totality (i.e., Being with a capital B or all 'that is'). Our knowing will always require adjustment as circumstances change. Here, from a design research perspective, we have ways of drawing in artefacts-as-outcomes via the concepts of evidence and claims. Further, we are also able to avoid notions of absolute truth or certainty as an ultimate aim within research.

If we seek to draw this together, what might an epistemological justificatory narrative look like?

Linking this back to our earlier initial outline of transformation, participation and uncertainty we can say the following. As designer-researchers, we may be *motivated* to *transform* or (at least) question a given context or set of circumstances which present themselves in our experience of the world. We, in our being-in-the-world, are care-bound, we notice things to attend to; we encounter certain troubling values; our world picture becomes questionable. Thus, possible *motivational* contexts are many and varied (e.g., concerns relating to practice, technology or ethics).

To go about our work, we must *participate*. Here, again as designer-researchers, a commitment to engaging in design practice and applying design techniques will likely guide our process. Within this, there are multiple ways of framing design's role. We may align with a formal methodology (e.g., participatory action research). Or design may, in essence, be seen as a method, i.e., the means by/through which we inquire, question, discover, engage in poetic thinking. Within this, we must maintain direct involvement with our situation, 'rough ground', or *with* the things of the world (i.e., materials, tools, other beings).

The outcome we are working towards will emerge via this designerly involvement. As such, we cannot be certain that we will achieve the particular transformation we are aiming towards. Nor can we be sure of its value, if/when achieved. There is no absolute truth or certainty to be had, only better or worse. As we have seen, transformation and participation does *not* often allow for the *generalisablity* of results (see Chapter 3).[1] Nonetheless, so long as we remain rigourous – that is, remain aware of our process and the steps we are taking – we will still be able to make *claims* against what is produced, i.e., identify the extent to which we believe that success has been achieved. Here, any artefacts (i.e., outcomes from our designerly involvement) can act as *evidence* which give form to our claims, should we deem this appropriate.

From here, with or without artefacts, we are obliged to test our evidence-claims with others in order to draw our research to a close. In doing so, we may seek to clarify the 'warranted assertability' of our inquiry; jointly work out whether or not our claims can be reasonably doubted; or make a case for our particular instantiation of the 'unconcealment' of 'what is'. If we are able to convince qualified others (i.e., experts drawn from within specific peer communities) via such routes, things (the world) will be different – an ontological transformation will have taken place/our way of seeing will have shifted/our understanding of Being expanded. From this, we can start again, do things differently. We will have novel ways of approaching troubling

new situations in our environment, the shifts in our forms of life, or the unexpected aspects of the world that we, in our caring, must respond to.

So against this, what can be said of the concepts of difference and diversity?

In a sense, we already have the answer. In introducing design research involving practice (see the Introduction), it was noted that for designer-researchers these concepts were inherently coupled to the uniqueness of context and the issues. In the end, because each context and set of issues *will* be unique, designer-researchers must be open and attendant to difference and diversity as a general rule, i.e., they must be methodologically and (crucially) epistemologically capable of responding to and accommodating this.

When we consider what the perspectives of Dewey-Wittgenstein-Heidegger add here, we can say that, in simple terms, difference and diversity are threaded throughout the whole of the baseline their combined perspectives provide. Combined, these concepts are in essence its single *crowning* principle; in the end, Dewey-Wittgenstein-Heidegger's offer, as set out, amounts to a programme for knowledge production based on difference and diversity. This is because 'the human person', in their organism-environment relationship, form of life and being-in-the-world, is threaded throughout the whole. Through Dewey-Wittgenstein-Heidegger, we have what I have termed 'personhood' as both the entry and exit point in knowledge production. A mix of motivations, issues and concerns act as a fulcrum against which change is sought, pursued and possibly realised. The success of the inquiry or process of questioning, discovery or poetic thought is largely dependent on whether or not what caused one to inquire-question-discover-think has been addressed.

Importantly, however, it is here again necessary to underscore this is not a matter of 'mere' subjectivity – the isolated, untethered 'thoughts' or 'feelings' of a lone individual without reference to anything beyond themselves. As we have seen throughout, it is always a matter of individuals-in-context, whether framed in relation to: encountering real 'values' in the 'environment'; a questioning of our ways of seeing as held within a form of life; or the caring of our being-in-the-world. Motivations, concerns and issues emerge from these couplings. They are always to be mapped back and linked to them. As a consequence, any knowledge which is produced relies on context. It is knowledge from, of and with a context, not the individual person alone. As such, it is knowledge which can give texture and pattern to difference and diversity. This is the key gain of avowed non-generalisability: being able to speak to the 'here' of our work, a celebration of experience and process in its direct meaning application.

In saying this, it must be acknowledged that, on its own, such a vision may not be enough. If 'power' is an issue, i.e., if groups do not have it and need it, we must be attendant to this and consider theories and approaches by which power relations can be addressed. Regrettably, the previously mentioned baseline and narrative do not offer any explicit tactics here. Nonetheless, even without 'built in' theories of power (or approaches/tactics), we do still have a means of addressing matters such that the contextual and the need for change are central to the process. Equally, we have a means of drawing such work together within a continuum. We don't have absolute truth or certainty as to our outcomes, but we have ways of moving forward. Through *transferability*, i.e., testing one's contextual results elsewhere, we may check our approach in a *different* context to produce a *diversity* of outcomes. Here, our resultant knowledge amounts not only to a celebration of experience and process, but also *progress*; always relating to someone, somewhere, but equally moving onwards from this.

This then is our early narrative, an outline of a designerly epistemology as emerging via Dewey-Wittgenstein-Heidegger. It has a relatively limited but nonetheless important function. As designer-researchers, we may deploy it as a means of telling a story of why, from an epistemological perspective, we believe our research holds legitimacy. It was noted earlier, in the Prologue, that such a story (whether relatable or divergent) will often have been absent from specific presentations of design research involving practice in the discourse. In such instances, we will likely have method, a way of operating, but *not* a means of justification as set against the possible alternatives, e.g., the postpositivism of contemporary science or the constructivism of some contemporary social science. This narrative, if deemed appropriate or useful, can fill that particular gap and, accordingly, make explicit what would otherwise be only implicit.

Importantly, it is not presented as a fixed offering. It too is a design artefact; it is there to be revised and changed, rescripted again and again, each and every time a project is undertaken – iterated if you will. This might possibly happen after the fact too, offering out a revised/changed/rescripted post hoc story of epistemological position for a design research project which brought about a positive transformation of a context through designerly participation. In terms of how it might be revised/changed/rescripted, others might wish to attend to the issues of power and seek to embed theories which offer ways of tackling power structures. They equally might wish to reduce the emphasis on the human centring.[2] These changes can be explored according to need or preference. The point, in the end, is to acknowledge and ground the essentials (so far as I have them) of transformation, participation, uncertainty and difference/diversity.

Having set these out, I will now move to consider a number of final philosophical pathways and design research examples. As a collective suite, these will sketch a lead-out in relation to a number of remaining possibilities and concerns. To finish, I will lastly give thought to two final questions: first, why this matters (i.e., what the wider value might be); and, second, how philosophy itself might gain from exploring the potential of a designerly perspective.

Pathway C.1 A Pathway to be Considered Further: A Quick Outline of the Potential of Critical Theory's Commitment to Transformation

The philosophy of critical theory received mention in the Introduction to this book but has not been considered at any length up until now. Here in this closing pathway, I would like to take the opportunity to highlight a particularly pertinent aspect of the perspective's overall agenda: namely, its commitment to transformation. Transformation pervades critical theory. Early critical theory was an avowedly transformational philosophic project, and while the perspective has evolved over time, a commitment to transformation can be seen to remain today, at least in part. In order to sketch this out, along with its implications for knowledge production, it will be worth briefly tracing out the perspective's historical development.

The first generation of critical theory emerged in the context of what is now referred to as the 'Frankfurt School', a grouping of academics associated with the Institute for Social Research, in Goethe University in Frankfurt. Established by Max Horkheimer in the 1920s, the Institute aimed to develop a bold programme of social reform, grounded in an interrelation of key social science domains including, among other

areas, history, economics, politics and psychology. The point above all was to be practical, to produce theory which not only explained but crucially enabled positive social change (see Horkheimer 2002/1972, pp. 188–243). No new methods or special modes of inquiry were proposed here, as such; rather it was a matter of orientation and application, of where theory went and what it was supposed to do (Tarr 2011/1972, pp. 29–33).

In this, alongside other influences, the school drew heavily on the Marxian perspective, in particular its special centring of the historical, economic and institutional within the social. However, as Marxist political regimes became increasingly authoritarian through the 1930s, the group's early faith in the potential for Marxist-orientated social change gradually ceded to a more democratically orientated vision centred upon *individual* as opposed to social emancipation.

From the late 1950s onwards, the original grouping ceded to what is now referred to as the second generation of critical theorists – a looser band of intellectuals distributed beyond Frankfurt, with the philosopher Jürgen Habermas acting as its most prominent global representative. Additionally, from this time onwards, a further shift occurred, with the critical theory label gradually expanding within the discourse to enfold other contributors not associated with the original Frankfurt school. Here, if deemed permissible, names such as Michel Foucault, Gilles Deleuze and Judith Butler may be drawn in on the basis of aspects of their work notionally aligning with general emancipatory concerns. It is also worth noting that later critical theorists began to move beyond the Marxian perspective, with efforts being made by Habermas, for example, to enfold insights drawn from classical pragmatism, in particular from the work of John Dewey (Antonio and Kellner 1992).[3]

As has been mentioned, there has been some consideration of the critical theory perspective within design, with key contributions being made by Jeffery and Shaowen Bardzell. Along with others, they have proposed that it may be productive to draw a relationship between design research involving practice and critical theory through the concept of designing for provocation (Bardzell et al. 2012). The contention put forward here is that critical theory demands an emergent, fluid research plan. Lines of connection have also been drawn between critical theory and critical design, as well as design and feminism (Bardzell 2012).

More recently, this work has been extended further by Bardzell, Bardzell and Mark Blythe, whose *Critical Theory and Interaction Design* (2018) explores how a wide-view critical theory[4] can inform interaction design and, conversely, how interaction design can inform critical theory. Within this work, we are offering a complex interweaving of various critical theory concepts and perspectives drawn into relationship with design-led HCI. For example, Butler's framing of performativity (see Chapter 2) is appropriated within an interaction design context (Light 2018).

Reflecting on such work, it is clear that with critical theory, as with our three baseline philosophers, we have a series of individual but related ways of positioning, processing and, at times, producing. Returning to the original proposal that critical theory's commitment to transformation can offer design research involving practice a compelling philosophic reference point, we may now ask what this might look like. The key, I believe, lies in its commitments to both a practical understanding of theory (i.e., the view that theory must emancipate), and interdisciplinarity (i.e., to achieve this, subject domains must be integrated). On this framing, design research involving practice can be positioned as the interdisciplinary meeting point, in which traditional

166 Conclusion

theory is applied, with its practical import and emancipatory potential being explored and tested in direct terms.

Critical theory may not provide one definite route to a justificatory epistemological narrative for design research involving practice, but it does offer a broad horizon line wherein disciplines can be interwoven in order to honour practical problems.

Pathway C.2 A Pathway that is Appealing but Challenging: A Quick Note on the Potential of Deleuze-Guattari for the Development of an Epistemology of Design Research Involving Practice

This text has consciously not engaged with the work of the French philosopher Gilles Deleuze and his long-time collaborator, the psychoanalyst Felix Guattari. In the introduction, this lack of direct engagement was rationalised on the basis that over the course of his career Deleuze clearly expressed a preference for *metaphysical* as opposed to epistemological questioning and, alongside this, that Deleuze-Guattari's work was, by design, resistant to definition and final interpretation. While this latter position is maintained, it is acknowledged that such a rationale does preclude the possibility that one might well seek to develop a Deleuzian-Guattarian epistemological horizon within design. Or, failing this, if not an epistemological horizon, then at the very least a Deleuzian-Guattarian framework in which questions regarding knowledge production might be considered and addressed. This would undoubtedly bring great benefit to the field.

What then do Deleuze and Guattari offer? While attempting even a simple overview of their thought would be beyond the scope of the present text, it is possible to briefly highlight some key aspects which may offer valuable insight here. It is important to note that what follows is non-comprehensive.

In the first instance, Deleuze and Guattari offer a helpful definition of philosophy. It amounts, in their view, to a process of the producing of 'new concepts' (Deleuze and Guattari 1994). Here, Deleuze was particularly keen to move away from the idea that philosophy was about having read specific philosophers or philosophies and building on this lineage. Rather, for him and Guattari, it was about the working through and creation of complex, novel ideas. In this, both were particularly keen on understanding the conditions under which 'the new' could be brought about via the production of concepts (Deleuze and Guattari 1994), an especially relevant concern in the context of design.

Next, they offer a compelling recategorization of some common philosophical categories through the concepts of 'multiplicities', the virtual and events. Multiplicities replace the traditional concept of essence, whereby beings were seen to hold fixed forms and a set of defined characteristics. With multiplicities, we are offered an alternative way of the conceiving of identities or 'Ideas'. Multiplicities stand for the recognition of the inevitable complexity of difference which surrounds 'what is' – an avoidance of focusing on one thing or many things but rather an allowance of both at once, untethered (Deleuze and Guattari 1994, p. 15).

Leading on from this, the virtual is applied as a means of referring to those aspects of reality which were traditionally referred to as *ideal* (e.g., our ideas of things). Though these are not real in the concrete sense, i.e., we cannot 'see' and 'hold' them, they do have presence in our lives as well as bearing on our beliefs and actions and, as such, are real in terms of affect (ibid, p. 156). From this, events replace substance. Here, our

attention is being directed to what happens in time, episodes of action and interaction, as opposed to the material relations of given situations (ibid, p. 36).

As a final, third aspect of relevance, returning to the performative aspect of their work noted in the Introduction, they argued in favour of embracing the inevitable complexity of our existence. In the opening of *One Thousand Plateaus* they suggest that we should not rely on clearly defined organisational structures as a means of coping with the world – other ways of negotiating 'what is' are necessary. In seeking to move beyond mere signification and towards a form of 'surveying' or 'mapping', they propose following a 'rhizome' structure (2004/1980, p. 7). The rhizome, a networked root structure, allows for innumerable connections, and breaks, as well as difference. Anything can connect to anything and, equally, not. It is the multiplicity concept given (indefinable) form (ibid, pp. 7–9). This, in turn, links to a further concept which the pair refers to as a 'nomad science', an approach to knowledge production where there are no boundaries to the direction of thought; rather, one follows the 'flow of matter, *drawing and linking* up smooth space' (ibid p. 420).

In relation to design, Deleuze's work, both his own and that undertaken in collaboration with Guattari, has recently begun to gain traction.[5] Examples of exploratory Deleuzian referencing can be found in, for example, Brassett and O'Reilly (2015), who, in referencing Deleuze, argue in favour of enfolding a concern for styling within strategic design activity. Equally, in considering the challenge of translating certain Deleuze-Guattari terms,[6] Goehring (2019) proposes that design can function as a 'suitable terrain for redescribing Deleuze's philosophy' (p. iv), deploying it as a case to illustrate concepts.

Beyond these is the more ambitious work of Marenko and Brassett (2015), whose *Deleuze and Design* text draws together a number of authors around Deleuze and the potential value of his work within the field. Here, across the contributions, Deleuzian thought is positioned as both a general approach and a space in which design may ask questions of itself in relation to what it is and what it can do. Introducing the work and general potential of the Deleuzian frame, Marenko and Brassett, note the value Deleuze offers in relation to the drawing together of the theory-practice relationship, his focus on the 'creation of the new' and the opportunity to engage in radical and unpredictable patterns of thought.

Across the chapter contributions, we are offered presentations of experiments which work through some of the key Deleuzian conceptual categories including multiplicity, the virtual and events. What emerges is a way of relooking at design's function, its place in the world and the 'becoming' of reality. Brassett, for example, notes the relationship that can be drawn between philosophy on the one hand, and design and innovation on the other. 'A philosophy of design/innovation', he writes, 'becomes an innovative/designed philosophy and, in this becoming philosophy, design and innovation are released on their own, ever-dynamic journeys' (Brassett 2015, p. 50).

However, following Deleuze's own position, the perspectives arrived at are not explicitly epistemological in outlook. This is not to say that a latent epistemology cannot be traced out within them. For example, an epistemological angle has recently been explored by Ron Wakkary (2020), who picks up on the concept of nomadic practice and its potential epistemological bearing for design.

Beyond this, the general call to engage in active thinking and explore how we can think about design through Deleuze (and philosophy more generally) are key points by which an epistemological stance might be framed. Here, rather than a fixed narrative

168 Conclusion

as such, we have a notional way of seeing knowledge production through design and, next to this, a potential way of operating that cannot at the outset be codified or defined.

More broadly, when it comes to Deleuze and Guattari and their potential offer to a justificatory epistemological narrative for design research involving practice, it would be possible to propose that the metaphysics of multiplicity, virtuality and event could form the basis of an epistemology which both enfolds novel modes of negotiating reality and centres upon the creation of the new. This, it would seem, is a project waiting to happen.

Pathway C.3 A Final Pathway, not yet Fully Formed but Needing to be Explored: Process Philosophy, Whitehead and the Potential for a Metaphysics for Design

Though we have covered many potential philosophic links as we have advanced through this text, until now I have refrained from referring to what is known as 'process philosophy'. This is not because of any wish to avoid the subject but rather because of its potential significance. It is my belief that process philosophy requires dedicated attention in the context of design research. However, what follows is, by necessity, non-comprehensive and, as a result, this pathway can only mark out the *potential* of process philosophy and not a definitive account.

As a first step, we must note that process philosophy does not represent a particular 'self-identifying' school of philosophy, but rather generally refers to a way of externally *grouping* individual philosophic projects, which each share a common ontological commitment, i.e., a commitment to a specific understanding of reality. Put simply, process philosophers and process philosophies will take the view that rather than a fixed, static world, we live in a world of constant and ongoing change, a world in which nothing is ever fixed and final, which is always dynamic, always in the making. Though there will undoubtedly be deep variation across any 'process philosophies groupings', an alignment across all can be drawn around an evident preference for 'activity over substance', 'process over product', 'change over persistence' and 'novelty over continuity' (Rescher 1996, p. 31).

It will perhaps be unsurprising that we have already encountered some key process philosophers within the present text: most notably John Dewey and, alongside him, the two other classical pragmatists William James and Charles Sanders Peirce.[7] Alongside these, some other important individual Western philosophers who held commitments linked to process philosophy include: Heraclitus, Plato, Aristotle,[8] Leibniz, Bergson, as well as Hegel (see Rescher 1996). Others might add those hard-to-characterise names such as Gilles Deleuze (e.g., Robinson 2017), though this will likely provoke a neagtive reaction from some.[9] In addition, there is a reasonable argument that it would be worth including philosophers within the Buddhist tradition here, on the basis of its of commitment to a dynamic reality (e.g., Jacobson 1988). Regardless of who is or isn't included, there is one name which cannot be overlooked when it comes to process philosophy: the famous Alfred North Whitehead.

Working alongside Bertrand Russell in the early twentieth century, Whitehead originally focused on the logic of mathematics before moving on to engage in philosophy directly in the 1920s. The result was a profoundly original metaphysical vision which departed from the accepted norms of the Western tradition. While he saw his vision as

presenting a 'philosophy of the organism', it has come to define what process philosophy stands for and, indeed, as a key reference point within the field. Unfortunately, it is a reference point which is often characterised as difficult. While this is no doubt attributable to Whitehead's writing style, it will be also be due to the sheer novelty of the perspective he sets out.

In loose outline, the general scheme goes as follows. At a fundamental level, in keeping with process philosophy generally, Whitehead argued in favour of the conceiving of a dynamic reality. On his account, it was 'entities' rather than matter which formed the basis of all that is. An entity (e.g., a person or a tree) is not to be seen as a fixed form, i.e., a being that always is what it is, but instead as a process of 'becoming', a thing which is changing and being changed through the 'occasions', i.e., temporal situations, in which it participates. Further, creativity is seen to be a fundamental principle of the universe; through a process of becoming in which the old gradually gives way to the new, novelty will arise as part of an inevitable cycle of ongoing change (Whitehead 1978/1927–28, pp. 3–30).[10] Creativity, via evolution, is to be seen as moving things onwards towards a form of perfection.

Whitehead's work continues to inform contemporary process philosophy. Here, one of the key thematic trajectories has been in theology (e.g., Cobb 2007). More recently, attention has expanded to draw in environmental perspectives (e.g., Gare 2017), as well as those pertaining to physics, education and psychology (e.g., Berve and Maaßen 2017), with others exploring the possibility of applying the approach in areas such as organisation studies (Langley and Tsoukas 2017).

Turning back to design, there are few, if any, existing explicit alignments with process philosophy in evidence in the literature. If anything, it may be argued that the perspective has yet to gain a foothold here. Where it has been introduced, it is presented as a novel way of seeing the design process and considering design's position within the human experience. For example, drawing on work undertaken in organisation studies, Wegener and Cash (2020) have proposed that a 'process theory agenda' might allow for both a synthesis and extension of existing design process research by enabling movement between the micro and macro level of analysis, i.e., by enabling a relating of insights obtained at one level to those obtained on another. In another example, Goricanec (2009) has argued in favour of a reconceptualisation of engineering design informed in part by process philosophy. On this account, engineering design becomes an essential means of managing modern humanity's position within the ever-dynamic, always changing world.

There is however an opportunity to push things slightly further still. Process philosophy, and the dynamic metaphysics which underpins it, holds immense potential in relation to the development of an epistemological narrative for design research involving practice. Specifically, it may be seen to offer a story about how reality works or 'is' – a 'positioning' in the terminology of this text – from which the design may seek to develop a wider story of knowledge production, i.e., processing and producing. To a degree, particularly, in relation to Dewey's work, the present text has sketched out a picture, early though it may be, of how such a narrative might work. There is, however, more to do. A deep investigation of process philosophy, ranging across, for example, Leibniz, Bergson, Whitehead, Deleuze and Deweyan metaphysics, has the potential to offer design research a clear way of discussing/representing the world and our place in it, a way which foregrounds change and creativity as intrinsic, unavoidable characteristics of both.

Figure C.2 The Olly project by the Everyday Design Studio. Credit: Jeroen Hol, Bram Naus and Pepijn Verburgvia via eds.siat.sfu.ca.

Design Research Projects C.1 Philosophy in Action at the Everyday Design Studio, at Simon Fraser University

Throughout this text, we have encountered a number of a design theorists who actively reference and draw in philosophy; we have not yet encountered a design theorist who has explored the idea of contributing to philosophy. This possibility has however been mooted by Ron Wakkary and colleagues – whose explorations of postphenomenology and posthuman discourse in design were discussed previously – at the Everyday Design Studio at Simon Fraser University in Vancouver, Canada. In keeping with postphemomenological and posthuman perspectives, the Studio's aim is to establish a space in which conventional human-centred approaches to design are problematised and challenged. Work proceeds on the basis of what is referred to as 'material speculation', whereby artifacts are produced in order to give form to particular proposition and, as such, allow for

Figure C.3 A tilting bowl from the Everyday Design Studio. Credit: Henry Lin via eds.siat.sfu.ca.

critical inquiry into the possible meanings, value and potential which arise as a result (Wakkary et al. 2015). The approach is, however, very much grounded first and foremost in design (Wakkary 2022).

This has led to a portfolio of work which collectively sketches out novel human-technology intersections, pivoting around the philosophic.[11] There is, for example, the Morse Things, where everyday household items such as cups and bowls are embedded with computational technology allowing for spontaneous, unpredictable interactions in the home (e.g., Wakkary et al. 2018). There are also various iterations of 'slow technology', where digital products and interfaces are configured to enable richer, more expansive interactions than are currently available. For example, the Olly project explores how digital music listening histories can open up new ways of engaging with one's past experiences, allowing for recollection and reflection (e.g., Odom et al. 2018).

Through such work, the Studio can be seen to map a way ahead for philosophy-design relations – a philosophically driven agenda is given definition through a wide-ranging experimental programme. The outcomes are design outcomes, they hold physical, tangible form, they can be seen and held, examined, considered and evaluated. However, they are also carrying an intellectual trajectory forwards, testing ideas in the real world, allowing new realities to be shaped and from here reporting back on the scope of what might be.

Design Research Projects C.2 Antidisciplinarity

The role and meaning of 'discipline' has long been a key question in design. While early contributors argued that the field required coherence in order to advance (e.g., Archer 1979; Cross 1982), these efforts have faltered over the years (Christensen and Ball 2019). Today, in the specific context of design research, a consolidated disciplinary agenda continues to remain elusive. For example, in the introduction we saw how loosely framed interdisciplinary and multidisciplinary perspectives tend to guide contemporary programmes of work in the field. Equally, alongside these, other perspectives have also entered the frame. For example, the terms 'transdisciplinary' (e.g., Jonas 2015), 'cross-disciplinary' (e.g., McComb and Jablokow 2022) and 'post-disciplinary' (e.g., Büscher and Cruickshank 2009) have recently gained footholds in the discourse.

In the last number of years, a further, additional term has also emerged – *antidisciplinarity*. As the 'anti' prefix suggests, this references a move away from *discipline*. In an antidisciplinary framework, there is no respect for fixed boundaries or set agendas, there is no necessary methods or required procedures; rather, in notional terms, the researcher follows the question where it needs to go in order to get an answer. While the term does not have a precise philosophical reference it can be seen to align with key aspects of the Deleuze-Guattari concept of the 'nomadic' (see previous) and how this has been contextualised in relation to design and epistemology (Wakkary 2020, 2021). In some ways, there are also pragmatist alignments, particularly in relation to Dewey's contextually-bound pattern of inquiry (see Chapter 2), where problem-definition and experimental action go hand-in-hand (Dixon 2019).

Over the last ten years, antidisciplinarity been taken up in the context of design research, with a number of programmes of work openly declaring themselves to be antidisciplinary in nature, in particular MIT's well-known Media Lab (Ito 2016, 2017) and Lancaster University's ImaginationLancaster unit (Cooper et al. 2018). As suggested, the idea here is that projects follow opportunities without predefined agendas. The approach undertaken will depend on the context. There is no one set process.

Media Lab's antidisciplinarity agenda is said to occupy the 'white space' between disciplines. Here, methodological emphasis is placed on collaboration, action, emergence, risk-taking and systematic thinking over individual expertise, theory, authority, caution and object-based thinking. The outcomes are said to be future-focused, pointing to potential value as opposed to immediate application (Ito 2017, pp. 23–25). For ImaginationLancaster, antidisciplinarity is a matter of celebrating methodological plurality, allowing all possible approaches to simultaneously coexist, from 'experimental, collaborative, speculative, inductive, explication-based, practice-based, hybrid and hacked'. The group openly states its commitment to 'borrowing' methods from the other disciplines 'if and when the situation arises' (Cooper et al. 2018, p. 310).

Broadly, then, we might say that antidisciplinarity denotes a commitment to adventure over convention – offering the design researcher a key of loosely defined philosophic reference point by which they can openly navigate projects methodologically. It may be a matter of seeking out the 'white space' with a view

> to prospecting potential (as per MIT) or allowing for methodological plurality in response to situational demands (as per Lancaster). A parting note of caution is important here, however. While flexibility is key in both cases, the need for rigour cannot be avoided or overlooked. It is a matter of keeping up: as the researcher goes where they need to and they must do what is needed, complying with the framework they are framing as they frame it.

Why Does This Matter?

The case for why all of this might matter has been made throughout. As we draw to a close, it is worth briefly restating the line of reasoning. Design is changing and with this change it is beginning to contribute to the shaping of what is held to be a distinct form of knowledge production, which, as has been argued, relies on a handling of transformation, participation and uncertainty. However, it has been contended that this form of knowledge production lacks a justificatory epistemological narrative. Giving form to this through reference to our philosophic baseline has been the first key aim of the book, with the outcome having been worked through previously.

However, this is about more than design's changing, its form of knowledge production, and its lack of an epistemological narrative. The hope is that what is presented here can contribute to the commencement of a wider dialogue within the field, a dialogue which might extend beyond knowledge production as such. As we have seen in the Introduction, the field of design does host a line of inquiry referred to as the philosophy *of* design, which may be understood to comprise a series of philosophical inquiries into *what design is* or *what it might be* with a view to surfacing insights that could only arise from design alone.

This is of course a valuable endeavour and one which should continue. Nonetheless, leading off from what has been explored here, there is an opportunity for an additional line of inquiry to declare itself, wherein existing philosophical perspectives might be explored and referenced against what design claims of itself. This would, in essence, amount to a comparative philosophy *for* design, i.e., philosophies which are found to be useful or potentially useful in the context of telling design's story, its narrative as it were, whether epistemologically, thematically (e.g., in relation to technology), in domain-specific terms (e.g., in relation to user-experience) or otherwise. This is an important and indeed necessary task for design. Not only would it allow for an exciting mapping of new and emergent theoretical horizons in the field (extending far beyond what is possible here), but also, and importantly, for a securing and contextualising of any insights believed to be special to design alone – a validating of the philosophy *of* design as it were.

In all likelihood, no clear answers would be arrived at with regard to the most appropriate or precise alignments, the 'best' philosophical perspectives for design. Nonetheless a set of possible answers or early alignments would still be possible. The raw material already exists. As we have seen, much work has already been undertaken and many alignments have already been drawn. To a degree, this book has been an effort in surfacing them – whether these be to pragmatism (e.g., Schön 1983; Dalsgaard 2014; Dixon 2020) or Wittgenstein's later philosophy (Krippendorff 2006),

or Heidegger (e.g., Dourish 1991) or any of the other pathways highlighted (e.g., Marx, Latour, Deluze, Foucault, postphenomenolgy) or, indeed, any other unmentioned reference points deemed worthy of inclusion.

A comparative philosophy for design (linked to studies in the philosophy of design) would help students, as well as established researchers and practitioners, make more informed choices with regard to the intellectual histories and traditions they are connecting with and the implications of such connections. Through such work, all would be able to see and, crucially, to understand why connecting to one perspective impacts upon the way in which one is able to logically approach what one does; what will matter and not will not; what will be considered right and what will be considered wrong; what type of claims that can be made both for the design process and its outcomes. Equally and importantly, such work would also allow students, researchers and practitioners to tell coherent stories of their discipline to those operating in other disciplines, with the philosophical references enabling a translation and transfer of key ideas and concepts.

On the face of it, such an enterprise would appear to be desirable. Whether or not it is or, indeed, whether or not it is fully realisable within the field is something which cannot be answered outright. It would have to be explored and tested, played with to see how far it might go. For now, it is a programme waiting to happen – one which holds the potential to yield real value across the discipline and beyond.

From here, we must take a further final step to consider how philosophy itself might benefit from a designerly perspective.

How Might Philosophy Benefit from a Designerly Perspective? Or, Towards a Designer-Philosopher

Beyond the framing of a justificatory epistemological narrative for design research involving practice, this book had a second key aim, muted and cautious though it was – to reflect on the extent to which philosophy itself might benefit from a designerly perspective as defined by design research involving practice. Having reached the end of the book, we may now ask: What can be said here? What is the reflection that can be offered?

There is an immediate hurdle to answering these questions. By any measure, we require a broader survey, a coordinated look at what philosophy requires of other disciplines in order to answer questions it is asking of itself. It cannot be restricted to just Dewey-Wittgenstein-Heidegger. It may be that a comparative philosophy *for* design would reveal what is required of design, if approached in this way. It may be that it will not.

Nonetheless, the baseline we have developed via Dewey-Wittgenstein-Heidegger does offer us a glimpse of what mattered in the early-to-mid twentieth century with regards to questions of knowledge, how it was to be understood and notionally produced. As has been explored through the entirety of this book, the outline they offer here points to the need for us to engage directly in processes which aim towards forms of transformation and require our contextual participation.

So, what might Dewey-Wittgenstein-Heidegger ask of design in this regard? The answer, I believe, can be drawn out from the revised agendas that each set out in relation to their respective 'turns', briefly noted in the Introduction. These turns can be seen as a setting out of renewed agendas for the individual philosophers themselves

but, equally, as the issuing of a plea for what the discipline of philosophy as a whole should be doing and why. Having covered highlights of their work through the course of this book, it will be worth, now, very briefly returning to consider each philosopher's 'turn' with a view to pinpointing the agenda they are seeking to map out.[12]

Dewey, as we saw, mirroring his own move from absolutism to experimentalism, was looking to recentre the field around experimentalism. Indeed, he went so far as to issue a famous call for a 'reconstruction' of philosophy (Dewey 1982/1920). On this reconstruction, philosophy would here aim to deal with the problems of men and not those of philosophers. We see further traces of this outlined in his introduction to *Experience and Nature* (Dewey 1981/1925) as he advocates for the development of a 'denotative' method in philosophy, whereby it would seek to investigate and test its ideas in experience (see Alexander 2013 for a recent exploration of this). From his perspective, philosophy needs to become more practical, more involved, truly experimental.

Similarly, Wittgenstein, as we have noted, was adamant that philosophers needed to move away from their imagined, language-bound problems and, instead, find ways of recognising them for what they are – nonsense. It would appear that within this he was concerned that philosophy was simply not practical enough.[13] As we noted in the discussion of language games (see Chapter 2), he believed that the discipline needed to work with the 'rough ground' of our lives as well as the abstract – to look as well as think in order that our ways of seeing might be changed.

Heidegger too felt that a redirection was necessary, though for him it was not so much about a practical turn as per Dewey and Wittgenstein. Rather, as we are by now aware, he was looking to get back to the *meaning* of being, asking what it is and what it means, tracing this concern through immediate experience and later through the poetic foundations of the everyday. We noted before that he imagined an inner 'turning' that might allow for an outer change in humanity's positioning towards being. Philosophy was to act as an aid to this process of inner turning but could not bring it about on its own (see Pattison 2000).

Reviewing the whole, we get traces of a collective call for a reimagining of what philosophy is supposed to consider and, more importantly, *do*.

Even though almost a century has passed since their key contributions were initially published, it would seem that what they argued for or at least what they pointed to has not been concretely realised. Certainly, Dewey's call for a reconstruction in philosophy, though considered, has not been effectively progressed (Stuhr 1993). Wittgenstein's notion of dissolving problems may be well known, but his proposed practice of looking-thinking as a means of responding and bringing about a change in our ways of seeing has not been properly explored within the discipline (Genova 1995). Equally, though Heidegger's work (both early and late) has obviously received much attention over the decades, there remains work to be done exploring how the vision of (and around) being he sketched out might continue to hold meaning today (Fried and Polt 2018).

This apparent failure to inspire reform is, on the face of it, perplexing. As will be clear by now, Wittgenstein and Heidegger are key figureheads within philosophy and have been for at least the last 50 years. Though Dewey's work was largely forgotten through the middle twentieth century (Bernstein 2010), there has been a slow but definite resurgence of interest over the last twenty years. If one were to attempt to put forward reasons as to why their proposals have not been properly picked up on, one

possible response is that what they pointed to diverges too markedly from existing norms; it was simply too much of a stretch. Aspects of what they offered could be explored and accommodated, yes, but not the whole.

This latter suggestion may be true. It may be that a full-scale reorganisation of philosophy along the lines proposed was not possible. Given that philosophy has moved on, it may no longer be possible or, indeed, necessary and desirable.

Either way – whether possible, necessary or desirable – if we connect back to the opening concern regarding what philosophy might stand to gain from a designerly perspective and place this next to the Dewey-Wittgenstein-Heidegger agenda, one might react negatively and argue that design has no role to play at all here. After all, perhaps Dewey-Wittgenstein-Heidegger would not want to ask anything of the field. Perhaps, for them, design would have no meaning, even if they still hoped for reform.

So as far as a response can be offered here, we would be wise to leave aside the question of what is or isn't possible and start instead with the question of the necessity and desirability of a reorganisation.

Here, we need not look too far for contemporary critiques of philosophy; some are very stark indeed in their criticism. For example, Arran Gare (2017) claims that the narrowness of contemporary analytic philosophy (and some continental philosophy) has crippled the discipline, preventing any consideration of the richness of life, with areas such as experience, ethics and aesthetics being out of bounds, and little effort being made to attempt to synthesise (i.e., combine) positions. On his view, this has given rise to a wider nihilism which is preventing the development of a positive, grand narrative that would allow humanity to work towards overcoming our looming existential environmental crisis.

Others are less damning but still despairing of the discipline's current trajectory and direction. Here, some talk exists of a crisis within analytic philosophy. Aaron Preston, for example, claims that analytic philosophy lacks a general agenda, and has reneged the formerly core philosophic responsibility to examine our 'fundamental assumptions' (2007). The evolution of continental philosophy too has been subject to attack with regard to its harbouring of certain negative stances such as those relating to, for example, nihilism (e.g., Diken 2009), anti-realism (i.e., whether the world exists independently of us) (e.g., Sebold 2014) and ethics (e.g., Armitage 2021).

In relation to Dewey-Wittgenstein-Heidegger's relevance here, the trio are often drawn upon as potential saviours within this debate (e.g., Kitcher 2011; Wallgren 2006; Fried and Polt 2018). Indeed, only a few decades ago, Hillary Putnam (1995) – an eminent, though now deceased philosopher – mobilised Dewey once again in a modern-day call to 'renew' philosophy against what he also perceived as a regrettable but unnecessary decline.

So, taking this into account, let us for a moment imagine that a reorganisation of philosophy, in some form, is desirable (even if not full-scale). Let us also take the view that, given the multiple crises we face – environmental, economic, political and beyond – it *is* necessary too, if only because no clear, obvious solutions have as yet been identified in relation to, say, climate change or rising income inequality or reactionary global populism. Equally, in doing so, let us also imagine that design has a role to play here. Even if only from the side lines.

What might this look like?

We already noted that the possibility of a coming together of design and philosophy has been considered by some. For example, previously it was noted that Sabrina

Hauser and colleagues (2018) argue in favour of 'doing philosophy through things' in the context of design research. Here, they envisage that by making things and placing them in real world contexts, it becomes possible to analyse human-technology relations from a postphenomenological perspective.

This is an exciting proposal, but it would seem that, set against the previously mentioned agendas, we have an opportunity to extend things a little further. I take the view that, as designer-researchers, engaging with philosophy we need not be limited to human-technology relations or, indeed, a postphenomenological perspective (if we so wish). Expanding the frame and looking beyond technology, we might, depending on the motivational context of a specific project, also reference ethical and political concerns or equally social, environmental or any number of other alternative subject matters which demand our attention. In doing so, we are able, and indeed, entitled, to draw on any number of philosophies so long as these are appropriate for design and offer perspectives which link the concern at hand (e.g., ethics).

In this regard, I would like to propose that there is the potential for a new figure to emerge within the field, the 'designer-philosopher'.

In terms of the *philosopher* designation, such an individual would be versed (if not well versed) in the general history and concerns of philosophy. Alongside this, they would, importantly, also hold a focus of their own, having clear grasp of a particular philosophy or particular philosophers' work.

With respect to the *designer* designation, their efforts would be grounded by a practical focus. They would be experimental in the Deweyan sense, seeking to bring about change and transformation in the real world. They would not be philosopher first. That would not be the point. Rather they would be capable of *doing* philosophy *through* design.

If they were not to act as philosophers, what would their broader purpose be?

As I see it, two potential lines of activity open up here. In terms of a first, it might be they would identify primarily as practitioners but hold an extraordinary concern for the meaning and impact of their work. In this, by applying a philosophical approach, they would be able to challenge their discipline and those who seek to mobilise design in particular ways by noting and articulating the dangers and consequences of a particular way of seeing. Such an ability would allow them to critically position projects and agendas within wider frameworks of meaning, referencing metanarratives which give fuller texture to what is at stake in, for example, technological, ethical, political, social, or environmental terms. Here, by asking challenging, critical questions of design from *within* design they would be better equipped to bring about positive disciplinary and local, project-based change.

In terms of a second line of activity, they might alternatively identify primarily as designer-researchers, seeking, in the main, to conduct design research but to do so in such a way as to allow for the drawing out of philosophic insight as a secondary by-product. Again, they would hold a concern (though perhaps not extraordinary) for the meaning and impact of their work. They too would note and articulate how given ways of seeing may harbour particular dangers or lead to certain consequences. They too would be able to position projects and agendas within wider frameworks of meaning. Distinctly however, based on the rigour of their work, they would also be able to yield viable, well-reasoned philosophic insights. As contributions, it is envisaged that these would be largely conceptual in the sense outlined by Höök and Löwgren (2012) in their strong concepts proposal. Here, they would be able to say

things about technology and human-technology relations (Hauser et al. 2018) but also multiple other domains, depending on the subject matter at hand. By operating in this way and, crucially, by yielding viable philosophic insights, they would be able to speak to deeper human concerns regarding what is and what matters, what we should be doing, how we should be living and why. Design, their design, would be the evidence against which such claims might be made – the reasoning would literally hold material form.

This may or may not sound compelling. This may or may not sound problematic.

Either way, we must stop there. Whether identifying as a designer or a designer-researcher, a designer-philosopher's precise methods cannot, at this point, be defined. To do so would be to run too far ahead and, in any case, such a definition would require a working out through trial and error, with dedicated focus and collaboration.

So far as anything can be said, a designer-philosopher would (whether consciously or unconsciously) give form to the agendas set out by Dewey-Wittgenstein-Heidegger – they would speak to philosophy but *not* focus on the problems of philosophers alone. Rather, as per Dewey-Wittgenstein-Heidegger, they would work with the everyday, i.e., the 'problems of men' (Dewey); they would not only 'think' (i.e., reason and imagine) but also 'look' to the rough ground, draw inspiration and test assumptions (Wittgenstein); and, further, not only would they seek to discover and bring about inner change, but also help us to connect with Being (Heidegger). In short, a designer-philosopher would, like the designer and the designer-researcher, engage in real-world work at the same time as draw on and even contribute to a wider intellectual programme.

All of this may be acceptable so far as it goes. Nonetheless it is acknowledged that some issues will likely be noted. Key, perhaps, is the idea of equipping an individual to hold this type of focus and engage in this type of work – in short, the matter of education. How could individuals acquire both the skills of designer as well as those of a philosopher? This would indeed present a challenge, however the reality is that there would be little divergence between the education of the notional 'designer-philosopher' and that of a designer-researcher. Both would require design ability, i.e., the capacity to work with stakeholders, in context, to bring about a desired change. Equally, both would require the ability to contextualise this design skillset within a separate, extra-disciplinary framework – in this case philosophy (in the designer-researcher's case, research, and the designer-philosophers', philosophy). In this, both must learn to conform (or at least cohere) with that extra-disciplinary framework's structures and processes such that they are able (when required) to take reference from them and possibly speak back, i.e., contribute.

Then of course, as was highlighted at the beginning of this, the process of knowledge production is technically linked to the epistemological tenants of philosophy, i.e., its definitions of what knowledge is and how it is to be produced. To move from this, towards a more philosophical outlook, would of course require that students have a firmer understanding of philosophy, but this will be achievable for those who wish to engage in philosophic questions and themes. Indeed, in such cases, highlighting the path that must be taken and noting what is required will likely be welcomed.

Beyond this, there is the obvious question of where contributions of a designer-philosopher would be positioned. Would they go to the field of philosophy proper, the field of design or something in between? The simple answer would be both. Maybe the philosophy of design might be permitted to expand beyond insights relating only

to design itself, but also by design. Such insights might be categorised as relating to a design-based consideration of technology, ethics, or politics and so on.

Can such a vision come about?

Reflecting on the history of philosophy, Stephen Gaukroger (2020) has noted that there is no one 'continuous substantive trans-historical philosophical enterprise'. Rather philosophy has always been changing, adjusting its enterprise depending on prevailing concerns and trends. Set against this changeability, it is possible to imagine a 'designer-philosopher' linking to philosophy, exploring how the 'intermediate knowledge' derived from designing might connect back to existing ideas, concepts and proposals, as well as possibly extend beyond them. The aim would be to bring about change in real terms but also in felt terms, in relation to what Wittgenstein called our 'world picture'.

This is of course ambitious. It may not be possible but it must be tested – the benefits in terms of what might be challenged, criticised and understood in relation to the multiple contemporary crises (e.g., environmental, economic, political) are profound.[14] More than anything, that is what Dewey-Wittgenstein-Heidegger call for – a testing, not just of knowledge or philosophy but of everything – go to the world and try it, attend and *see*. A good place to start, a good way to begin to attend and to see is by moving outwards from design research involving practice, working through its epistemological justificatory narrative and, from this, seeing if more can be said and, thereafter, if things can be changed – and not just changed for change's sake, but changed *for* the better.

Notes

1. As I hope will be clear from pronouncements made in Chapter 3, I am not here disavowing the possibility of fully generalisable knowledge arising from within design research involving practice. Rather I am highlighting the unlikelihood of generalisability when one is focusing on contextual issues.
2. It is almost impossible to 'look past' or move beyond the human with Dewey-Wittgenstein-Heidegger. Dewey and Heidegger certainly seek to think through and offer a glimpse of a beyond-the-human perspective, with their respective consideration of existence (see Chapter 1) and of Being in general (see Heidegger over Chapters 1, 2, 3). They are not however offering a 'flat ontology' (i.e., an understanding of being without hierarchical differentiation) in the way, say, Latour's actor network theory (2005a) would allow.
3. This point is worth noting for those who wish to draw links between classical pragmatism and a Marxian perspective.
4. While Bardzell et al. (2018) do attend to the work of the original Frankfurt School (i.e., the first generation of critical theory), they also look beyond it, offering up a broad historical survey, which includes, for example: Kierkegaard, Barthes, Hall, Eco, Said, Butler and Latour.
5. Deleuzian perspectives are well established in architecture, with Ballantyne's *Deleuze and Guattari for Architects* (2007) marking a key contribution.
6. Goehring focuses in particular on the concept of assemblage.
7. Ludwig Wittgenstein and Martin Heidegger are not commonly considered to fit within the process philosophy mould (Hartsborne 1983; Jacobson 1988).
8. Those who know Plato and Aristotle's work will be aware of clear divergences from process thought. For example, the latter focused on the concept of 'substance', i.e., material form, as the core of his metaphysics. However, on deeper inspection, both have nonetheless been seen to exhibit numerous process-based commitments too (Rescher 1996).
9. While it would be controversial to describe Gilles Deleuze (see previous) as a process philosopher (he famously eludes categorisation) he did draw inspiration from Whitehead, and

more broadly does share much with the commitments. Indeed some do look to categorise him as such (see in particular Robinson 2017).
10. There are a number of other aspects of Whitehead's metaphysics which would be considered controversial. Key among these is his presentation of God. For Whitehead, as with reality, God too is a process. As a process, God is in dialogue with the world. God holds awareness both of what is as well as all that might be, i.e., all possibility available to actual entities (Whitehead 1978/1927–28, p. 47). The point of this dialogue is to inform the world with 'possibilities', whereby God is 'the organ of novelty' (ibid, p. 67). A further unusual feature of Whitehead's philosophy worth noting is the concept of prehension, whereby all actual entities, human and nonhuman, are seen to hold, to varying degrees, the capacity to account for their environment and its meaning. Entities' prehensions of one another are the means by which they are drawn into relationships with one another in real terms. Whitehead refers to this latter state as a 'nexus' (ibid, pp. 19–20).
11. While all of the Studio's project work can be understood to implicitly fit within a philosophic framework, regular efforts are made to examine the relationship in explicit terms. For example, the 'Tilting Bowl' project was used to explore design's possible contribution to postphenomenological inquiry (Wakkary et al. 2018).
12. It important to note that Dewey-Wittgenstein-Heidegger were not the only philosophers to propose a new agenda for philosophy. However, to compile even a brief list of proposed but unrealized philosophic agendas would be beyond the scope of this book. Nonetheless we might here point to two additional, related examples. Classic pragmatism as a whole promised an agenda which would strike the balance between the long-divided schools of classic rationalism and empiricism (see the Introduction). It was to be a school which provided a method that would allow philosophers to focus on practical consequences, without regard for the merely theoretical (James 1975/1907). A second and complimentary example comes from Richard Rorty, who, after having risen to philosophy's highest ranks, proposed that the discipline abandon its historic concern for epistemology and instead focus on develop a hermeneutic outlook, drawing out the meaning of positions and claims from across all fields.
13. As was noted in the Introduction, Wittgenstein often threatened to abandon philosophy in favour of work that might be of more obvious benefit to society. On one occasion he even planned to emigrate to the Soviet Union so that he might contribute to the realisation of a better society (Monk 1991, p. 350).
14. It might well be asked what a design-philosophy coupling might enable in relation to environmental, economic or political problems.

References

Alexander, T., 2013. *The Human Eros: Eco-Ontology and the Aesthetics of Existence*. New York: Fordham University Press.
Antonio, R. J., and Kellner, D., 1992. 'Communication, modernity, and democracy in Habermas and Dewey'. *Symbolic Interaction*, 15(3), pp. 277–297.
Archer, B., 1979. 'Design as a discipline'. *Design Studies*, 1(1), pp. 17–20.
Armitage, D., 2021. *Philosophy's Violent Sacred: Heidegger and Nietzsche Through Mimetic Theory*. East Lansing, MI: Michigan State University Press.
Ballantyne, A., 2007. *Deleuze & Guattari for Architects*. Abingdon: Routledge.
Bardzell, J., Bardzell, S., and Blythe, M. A. (Eds.), 2018. *Critical Theory and Interaction Design*. Cambridge, MA: The MIT Press.
Bardzell, S., Bardzell, J., Forlizzi, J., Zimmerman, J., and Antanitis, J., 2012. 'Critical design and critical theory: The challenge of designing for provocation'. In *Proceedings of the Designing Interactive Systems Conference*, pp. 288–297. New York: ACM.
Bernstein, R., 2010. *The Pragmatic Turn*. London: Polity Press.
Berve, A., and Maaßen, H. (Eds.), 2017. *A. N. Whitehead's Thought Through a New Prism*. Newcastle upon Tyne: Cambridge Scholars Publishing.
Brassett, J., 2015. 'Poised and complex: The becoming each other of philsophy, design and innovation'. In B. Marenko and J. Brassett (Eds.), *Deleuze and Design*, pp. 31–57. Edinburgh: Edinburgh University Press.

Brassett, J., and O'Reilly, J., 2015. 'Styling the future: A philosophical approach to design and scenarios'. *Futures*, 74, pp. 37–48.

Boon, B., Baha, E., Singh, A., Wegener, F. E., Rozendaal, M. C., and Stappers, P. J., 2020. 'Grappling with diversity in research through design'. In S. Boess, S. Cheung, and S. Cain (Eds.), Synergy – DRS International Conference 2020, Vol. 5: Situations, pp. 139–151. London: The Design Research Society.

Büscher, M., and Cruickshank, L., 2009. 'Designing cultures? Post-disciplinary practices'. The 8th European Academy of Design Conference, The Robert Gordon University, Aberdeen, Scotland, 1–3 April.

Christensen, B. T., and Ball, L. J., 2019. 'Building a discipline: Indicators of expansion, integration and consolidation in design research across four decades'. *Design Studies*, 65, pp. 18–34.

Cobb, J. B., 2007. *A Christian Natural Theology: Based on the Thought of Alfred North Whitehead*, 2nd edition. London: Westminster John Knox Press.

Cooper, R., Dunn, N., Coulton, P., Walker, S., Rodgers, P., Cruikshank, L., Tsekleves, E., Hands, D., Whitham, R., Boyko, C. T., and Richards, D., 2018. 'Imagination Lancaster: Open-ended, anti-disciplinary, diverse'. *She Ji: The Journal of Design, Economics, and Innovation*, 4(4), pp. 307–341.

Cross, N., 1982. 'Designerly ways of knowing'. *Design Studies*, 3(4), pp. 221–227.

Dalsgaard, P., 2014. 'Pragmatism and design thinking'. *International Journal of Design*, 8(1), pp. 143–153.

Deleuze, G., and Guattari, F., 1994. *What Is Philosophy*. Translated by H. Tomlinson and G. Burchell. New York: Columbia University Press.

Deleuze, G., and Guattari, F., 2004 [1980]. *One Thousand Plateaus: Capitalism and Schizophrenia*. Translated by B. Massumi. London: Continuum.

Dewey, J., 1981 [1925]. *The Collected Works of John Dewey: The Later Works, 1925–1953, vol. 1, Experience and Nature*. Edited by J. A. Boydston. Carbondale, IL: Southern Illinois University Press.

Dewey, J., 1982 [1920]. *The Collected Works of John Dewey: The Middle Works, 1899–1924, vol. 12, Essays, Miscellany and Reconstruction in Philosophy*. Edited by J. A. Boydston. Carbondale, IL: Southern Illinois University Press.

Diken, B., 2009. *Nihilism*. Abingdon: Routledge.

Dixon, B., 2019. 'Experiments in experience: Towards an alignment of research through design and John Dewey's pragmatism'. *Design Issues*, 35(2), pp. 5–16.

Dixon, B., 2020. *Dewey and Design: A Pragmatist Perspective for Design Research*. Cham: Springer.

Dourish, P., 2001. *Where the Action Is*. Cambridge, MA: The MIT Press.

Fried, G., and Polt, R., 2018. *After Heidegger?* Lanham, MD: Rowman and Littlefield.

Gare, A., 2017. *The Philosophical Foundations of Ecological Civilisation: A Manifesto for the Future*. Abingdon: Routledge.

Gaukroger, S., 2020. *The Failures of Philosophy: A Historical Essay*. Princeton, NJ: Princeton University Press.

Genova, J., 1995. *Wittgenstein: A Way of Seeing*. Abingdon: Routledge.

Goehring, B., 2019. *Repurposing Deleuze and Design*. Unpublished Ph.D. Dissertation. Eugene, OR: University of Oregon.

Goricanec, J., 2009. *Towards Creating Sustaining Futures: A Philosophy of (Engineering) Practice for the 21st Century*. Unpublished Ph.D. Dissertation. Melbourne: RMIT University.

Hartsborne, C., 1983. *Insights and Oversights of Great Thinkers: An Evaluation of Western Philosophy*. Albany, NY: State University of New York Press.

Hauser, S., Oogjes, D., Wakkary, R., and Verbeek, P. P., 2018. 'An annotated portfolio on doing postphenomenology through research products'. In *Proceedings of the 2018 Designing Interactive Systems Conference*, pp. 459–471. New York: ACM.

Höök, K., and Löwgren, J., 2012. 'Strong concepts: Intermediate-level knowledge in interaction design research'. *ACM Transactions on Computer-Human Interaction (TOCHI)*, 19(3), pp. 1–18.

Horkheimer, M., 2002 [1972]. *Critical Theory: Selected Essays*. New York: Continuum.
Ito, J., 2016. 'Design and science'. *Journal of Design and Science*. [Online]. Available at: https://jods.mitpress.mit.edu/pub/designandscience/release/2 [Accessed: 28 December 2021].
Ito, J., 2017. 'The antidisciplinary approach: IRI medal address the antidisciplinary approach of the MIT media lab demonstrates how organizations might adapt to and take advantage of the evolving world of permissionless innovation'. *Research-Technology Management*, 60(6), pp. 22–28.
Jacobson, N. P., 1988. *The Heart of Buddhist Philosophy*. Carbondale, IL: Southern Illinois University Press.
James, W., 1975 [1907]. *The Collected Works of William James: Pragmatism: A New Name for an Old Way of Thinking*. Edited by F. H. Burkhardt, F. Bowers, and I. K. Skrupkelis. Cambridge, MA: Harvard University Press.
Jonas, W., 2015. 'A cybernetic model of design research: Towards a trans-domain of knowing'. In P. A. Rodgers and J. Yee (Eds.), *The Routledge Companion to Design Research*, pp. 23–37. Abingdon: Routledge.
Kitcher, P., 2011. 'Philosophy inside out'. *Metaphilosophy*, 42(3), pp. 248–260.
Krippendorff, K., 2006. *The Semantic Turn: A New Foundation for Design*. Boca Raton, FL: The CRC Press.
Langley, A., and Tsoukas, H. (Eds.), 2017. *The Sage Handbook of Process Organisation Studies*. London: Sage.
Light, A., 2018. 'Performing interaction design with Judith Butler'. In J. Bardzell, S. Bardzell, and M. A. Blythe (Eds.), *Critical Theory and Interaction Design*, pp. 429–445. Cambridge, MA: The MIT Press.
Marenko, B., and Brassett, J. (Eds.), 2015. *Deleuze and Design*. Edinburgh: Edinburgh University Press.
McComb, C., and Jablokow, K., 2022. 'A conceptual framework for multidisciplinary design research with example application to agent-based modeling'. *Design Studies*, 78, p. 101074.
Monk, R., 1991. *Wittgenstein: The Duty of Genius*. London: Vintage.
Odom, W., Wakkary, R., Bertran, I., Harkness, M., Hertz, G., Hol, J., Lin, H., Naus, B., Tan, P., and Verburg, P., 2018. 'Attending to slowness and temporality with olly and slow game: A design inquiry into supporting longer-term relations with everyday computational objects'. In *Proceedings of the 2018 CHI Conference on Human Factors in Computing Systems*, 77, pp. 1–13. New York: ACM.
Pattison, G. (Ed.), 2000. *Routledge Philosophy Guidebook to the Later Heidegger*. Abingdon: Routledge.
Preston, A., 2007. *Analytic Philosophy: The History of an Illusion*. London: Bloomsbury.
Putnam, H., 1995. *Renewing Philosophy*. Cambridge, MA: Harvard University Press.
Rescher, N., 1996. *Process Metaphysics: An Introduction to Process Philosophy*. Albany, NY: State University of New York Press.
Robinson, K., 2017. 'Gilles deleuze and process philosophy'. In A. Langley and H. Tsoukas (Eds.), *The Sage Handbook of Process Organisation Studies*, pp. 56–70. London: Sage.
Schön, D. A., 1983. *The Reflective Practitioner: How Professionals Think in Action*. New York: Basic Books.
Sebold, R., 2014. *Continental Anti-Realism: A Critique*. Lanham, MD: Rowman & Littlefield.
Stuhr, J. J. (Ed.), 1993. *Philosophy and the Reconstruction of Culture: Pragmatic Essays After Dewey*. Albany, NY: State University of New York Press.
Tarr, Z., 2011 [1972]. *The Frankfurt School: The Critical Theories of Max Horkheimer and Theodor Adorno*. London: Transaction.
Wakkary, R. L., 2020. 'Nomadic practices: A posthuman theory for knowing design'. *International Journal of Design*, 14(3), pp. 117–128.
Wakkary, R. L., 2021. *Things We Could Design: For More than Human-Centred Worlds*. Cambridge, MA: The MIT Press.

Wakkary, R. L., 2022. Teams call with Brian Dixon, 26 May.
Wakkary, R., Odom, W., Hauser, S., Hertz, G., and Lin, H., 2015. 'Material speculation: Actual artifacts for critical inquiry'. In *Proceedings of the Fifth Decennial Aarhus Conference on Critical Alternatives*, pp. 97–108. New York: ACM.
Wakkary, R., Oogjes, D., Lin, H. W., and Hauser, S., 2018. 'Philosophers living with the tilting bowl'. In *Proceedings of the 2018 CHI Conference on Human Factors in Computing Systems*, 94, pp. 1–12. New York: ACM.
Wallgren, T., 2006. *Transformative Philosophy*. Lanham, MD: Lexington Books.
Wegener, F., and Cash, P., 2020. 'The future of design process research? Exploring process theory and methodology'. In S. Boess, S. Cheung and S. Cain (Eds.), *Synergy – DRS International Conference 2020*, Vol. 5: Processes, pp. 1977–1992. London: The Design Research Society.
Whitehead, A. N., 1978 [1927–28]. *Process and Reality: An Essay in Cosmology*, corrected edition. Edited by D. R. Griffin and D. W. Sherburne. New York: The Free Press.
Zimmerman, J., and Forlizzi, J., 2008. 'The role of design artifacts in design theory construction'. *Artifact: Journal of Design Practice*, 2(1), pp. 41–45.

Index

Page numbers in *italics* indicate figures.

Abdulla, Danah 87n24
action research 96–97, 117n4
activity theory 43
actor network theory (ANT): architecture and 149n30; design discourse and 34, 143–144; Latour and 32, 41, 43, 60, 86n9, 143–145, 149n28; originators of 149n28; postphenomenology and 145; on relationships 86n9, 143–144; Science and Technology (STS) studies and 60, 149n29
Addams, Jane 79, 86n14
Advancements in the Philosophy of Design (Vermass and Vial) 33–34
Alessi 102
Alexander, Thomas 10n8, 119n25
analytic philosophy: criticism of 176; impact of Dewey on 30; language and 28; positivism and 34; pragmatist contributions to 29–30; radical philosophy challenges to 47n23; Wittgenstein and 6, 10n10, 30
ancient philosophy 23–25, 46n10, 47n17
annotated portfolios 20, 126–127, 147n7
Ansari, Ahmed 87n22
Anstey, P. R. 47n19
antidisciplinarity 172–173
Archer, Bruce 19
architecture: actor network theory and 149n30; Deleuzian perspectives and 179n5; design philosophy and 33; design research and 18; language in design process of 104, 116; Memphis design group and 42; participatory action research and 96; performative agenda in 116, 119n33; power and 40; social design and 17
Arendt, Hannah 33
Aristotle 22–24, 47n13, 100, 168, 179n8
Arts and Crafts movement 42, 48n42, 74

Arts and Humanities Research Council (AHRC) 9n1
assemblage 179n6
Augustine of Hippo, Saint 25, 100
Austin, J. L. 115–116

Bacon, Francis 26
Bacon, Roger 25
Bakhtin, Mikhail 86n10
Ballantyne, A. 179n5
Bang, A. L. 20, 57–58, 97
Bardzell, Jeffrey 165
Bardzell, Shaowen 165
Barthes, Roland 101–102, 117n7
Baudrillard, Jean 101, 117n8
Bauhaus movement 42
Beck, J. 127
Being and Time (Heidegger) 67, 69, 86n5, 118n20, 136
Bentham, Jeremy 27
Bergson, Henri 168–169
Berkley, George 26
Bernstein, Richard 7, 10n13
Binder, Thomas 97, 103
Björgvinsson, E. 10n7
Blythe, Mark 165
Boehnert, J. 84
Boon, B. 113
Botin, L. 146
Bowers, J. 126
Brandom, Robert 6–8, 10n13
Brandt, Eva 97, 103, 118n15
Brassett, J. 48n31, 167
Brave New Normal 106
Bremner, C. 16
Brereton, M. 95, 147n3
bridging concepts 126, 131–132
Bryman, Alan 128
Buchanan, Richard 33

Index

Buddhism: compassion and 111–112; design research and 75, 78, 111–112; Dewey and 80, 111; enlightenment and 119n27; on fixed reality 111; Heidegger and 80, 111, 158; history of 86n13; positioning and 75–76, 159; processing and 159; Zen Buddhism 87n18, 87n19
Butler, Judith 115–116, 119n30, 119n31, 165
Butter, R. 102

Callon, Michel 149n28
Campbell, J. 10n8
Candy, L. 46n8
Carnegie Mellon University 44, 81–82, 87n22
Cash, P. 169
Centre for Codesign (CODE) 103
Christianity 24–25, 46n12
claims: annotated portfolios and 126; artefacts/text and 125, 142; defining 124; design research and 124–127, 147n3; evaluation and 124–125, 127, 131, 135, 139–142; grounded 147n8; knowledge-claiming and 127; in natural and social sciences 127; objectivity and 128; reliability and 128; speculative 147n8; strong concepts and 126–127; truth of 128, 148n12; validity and 128; value-based 148n8
co-creative design: authentic 75; collective dreaming and 75; design tools and 103, 118n14; participatory design and 16–17; tools in 45, 103
communication: action and 37, 43–44, 93; design literacies and 130; design research involving practice and 97–99; Dewey on 43, 97–100; experience and 37, 43; inquiry and 100; language and 99–100, 104; participatory design and 104; pattern of inquiry and 113; processing and 44, 97, 156; semiotics and 100–102; signs and 101; symbolic interactionism and 85n3; truth and 136–137; visual 16, 32, 102
Communist Manifesto (Marx and Engels) 39
computer-aided design 19
Computer Human Interaction (CHI) 32
confirmability 129, 148n14
constructionist research 147n1
constructivism 61–63
continental philosophy 28–30, 36, 176
Cook, Siân 45, 106
Crary, A. 10n8
credibility 129
Critical Race Theory 29

critical theory: classical pragmatism and 165; continental philosophy and 28; design research involving practice and 8, 61, 165–166; development of 164–165; Foucault and 48n40, 60, 165; interaction design and 33, 165; Marxist perspectives and 43, 165; participation and 62–63; radical philosophy and 47n24; role of the researcher in 61; social research and 61; transformation and 164–166
Critical Theory and Interaction Design (Bardzell et al.) 165
Critique of Pure Reason, The (Kant) 26
Cross, Nigel 18–19, 94, 97
Cynicism 23–24

da Costa, N. 10n8
Dalsgaard, P. 126, 131
Darwin, Charles 27
Dasein concept 67–69, 72, 80, 108, 136
Davis, Meredith 63
Decolonising Design Group 83–85, 87n23
decolonising design movement: Designer's Critical Alphabet Cards and 83, 84; design practice and 82; design research and 56, 75; Dewey-Wittgenstein-Heidegger baseline and 78; ecoism and 85; emergence of 76–77; framework for allies in 84–85; non-Western thinking and 83; ontological goals and 83; philosophy and 44; political impact of design and 84; positioning and 75–77, 159; pragmatism and 78; processing and 159; sustainability and 83; transition design and 82, 87n22
Deely, J. N. 100
deep ecology 77
Deleuze, Gilles: critical theory and 165; design theory and 8, 33, 40, 167–168, 179n5; on empiricism 40–41; epistemology and 41, 166–168; Guattari and 40–41, 166–168; the ideal and 166–167; as metaphysician 40–41, 166; multiplicities and 166–168; nomadic concept and 167, 172; *One Thousand Plateaus* 167; on philosophy 166; philosophy of design and 48n31; process philosophy and 168–169, 179n9; relevance and 167; theory-practice relationship and 167
Deleuze and Design (Marenko and Brassett) 167
Deleuze and Guattari for Architects (Ballantyne) 179n5
democratic participation 32
dependability 129, 148n14
Derrida, Jacques 31, 101
Descartes, Rene 10n6, 25–26, 28

Index

design: actor network theory and 34, 143–144; alterdisciplinary terms and 16–17; collaborative problem-solving and 15–16; computer-aided 19; culturally-focused 17, 46n1; evolution of disciplines in 14–17; expertise in 19, 46n5; holistic experiences and 74, 86n10; human-centred 15, 112, 145–146; knowledge-claiming and 127; knowledge production process and 1, 46; non-commercial contexts and 16; performative instances of 119n35; pragmatism and 7; research questions in 63; scientific 18; semantic theory of 32, 104; socially-focused 17, 46n2; theory of knowledge and 3; unsustainability and 71–72, 81, 87n20; user-centred 15–16; womxn in 106

Designerly Ways of Knowing (Cross) 94
designer-philosopher 177–179, 180n14
Designer's Critical Alphabet Cards 83, 84
design for social innovation 17, 75
Design for the Pluriverse (Escobar) 87n22
Design for the Real World (Papanek) 16
design games 118n15
designing 24, 125, 130, 137
designing for provocation 165
Designing Integrated Systems (DIS) 32
Designing Quality in Interaction (DQI) 45, 138–139
design literacies 130–131
design methods movement 18–19, 62
Design PhD Jiscmail 83, 87n23
design philosophy *see* philosophy of design
design process: action in 138; co-creation and 16–17; design studies and 19; embodied aspect of 109; enframing and 71–72; epistemology of practice and 35; framing and 35; language and 104; methodology and 44, 93–95, 127; non-designers and 16, 103; outcomes of 20, 46n8, 174; participatory 17, 19, 32, 46n1; process philosophy and 169; research through design and 1; scientific design and 18; service design and 16; sustainability and 71–72

design research: aesthetic concerns and 138; analysis, projection and synthesis in 95, 117n2; antidisciplinarity and 172–173; Buddhism and 75, 78, 111–112; claims and 124–125, 147n3; constructionist 147n1; decision-making in 45; design hypothesis and 21; Dewey and 32, 36, 41, 47n29; disciplines and sub-disciplines in 18, 46n3; ecological and 75, 77; epistemology in 2–5, 10n5, 28, 38; ethical inquiry and 146–147; evidence and 124–125, 132, 147n3; experimentation and 21; feminism and 75, 77, 106, 108; generalisability and 129, 142, 162; Heidegger and 32, 36, 41; historical approaches to 18–22; language games and 104; Marx and 39–40; media and 95; methods for 2; outcomes of 20–21, 46n8; philosophy and 46, 138–139; potential value of 147n2; prescriptive methodologies in 18–19; process philosophy and 168–169; thinking-looking and 133, 136; true, ideal and the real in 117n2; unconcealment and 137; Wittgenstein and 32, 36, 41

design research for change 1–2, 9n1
Design Research for Change Symposium 10n1
design research involving practice: accountability to design audiences 130; artefacts as outcome of 10n4, 20, 46n8, 125–126, 130–131, 135–137, 141, 157; communication modes and 97–99, 124–125; contextual grounding and 44, 63, 73; critical theory and 8, 61, 165–166; designing for provocation 165; designing in 24, 125, 130, 137; development of 19; Dewey-Wittgenstein-Heidegger baseline and 44, 56, 131, 159, 160, 161–164; difference and diversity in 9, 22, 38, 43, 45, 155, 159, 161, 163; as embodied activity 95, 109; empiricism and 26; endpoints in 125; epistemological narrative and 1–5, 14, 38, 56, 97, 155, 159, 161–169, 173–174; evaluation criteria and 128–129, 132, 134–135, 139–143, 148n13; experience and 26, 73; extensibility and 129; framing and 114; generalisable knowledge and 2, 162, 179n1; grounded motivations and 57–58; human centring and 155, 163–164, 179n2; interdisciplinary research and 46, 165–166; language and 100, 115; language games and 104, 113, 157; Marxist perspectives and 74–75; methodology and 94–97; motivations in 20, 56–58, 73; objectivity in 1, 56, 58–60, 62, 128; participation and 38, 43, 45, 62–63, 155, 159, 161–162; participatory action research and 96; philosophical motivations and 57–58; philosophy and 14, 174–177; Platonic vision of the senses and 24; poetic thinking and 110, 113–114; positioning and 44, 56, 58, 63, 65, 67, 70; postphenomenology and 139; processing and 45, 94–95, 106, 109, 112–113, 115–117; process philosophy and 169; producing and 45, 124–125, 131–137, 139–143, 157; role of the researcher in 61–63; see-think relationships in 106;

Index 187

semiotics and 101–102; social research and 61–63; Thing theory and 70–71; transformation and 1–2, 14, 16, 38, 43, 45, 57, 62–63, 139, 155, 159, 161–162; uncertainty and 38, 43, 45, 155, 159, 161–162; unconcealment and 114

design research presentation: alternative forms of 133, 143; annotated portfolios and 20, 126–127, 147n7; artefacts as outcome in 20, 46n8, 125–126, 130–131, 141; artefacts/text and 125–126, 130, 132–133, 141–142, 147n5; bridging concepts and 126, 131; doctoral design submissions and 130, 147n6; evaluation criteria and 127–130, 132–135, 148n14; evidence-based 139; extensibility and 129; linguistic components and 125–126, 130; practice-based portfolios and 147n5; reliability and 128–129; strong concepts and 126–127; validity and 128–129; warranted assertability and 132–133

Design Research Society 83

Design Research Through Practice (Koskinen) 63

design science 18

design studies 19, 22, 83–84, 115

design theory: constructivist sensemaking and 35; Marxism and 39, 42–43, 158; participatory 41; pattern of inquiry and 98; philosophy and 2–3, 31–36, 170; practical 32; social design and 17; *see also* philosophy of design

design tools 45, 102–104, 118n14

Dewey, John: absolutism and 30; on art and experience 118n25; background of 36–37; Buddhism and 80, 111; communication and 97–100; critique of traditional epistemology 6; design research and 4–5, 10n7, 32, 47n29; empiricism and 47n20, 131; environmental ethics and 79–80; on experience and existence 44, 64–65, 72, 78–79; *Experience and Nature* 64, 85n5; experimentalism and 175; holistic experiences and 86n10; on language and meaning 103, 112; *Later Collected Works* 6; on logic 99; *Logic* 85n5, 131; naturalistic metaphysics and 69, 72; pattern of inquiry and 44, 93, 95, 98–100, 113–114, 117n5, 131–132, 145, 172; Peirce and 117n6; pragmatism and 3, 6–7, 10n10, 29–30, 79, 114, 165; problem-solving and 115; processing and 112; process philosophy and 11n18, 168; producing and 131–133; *Quest for Certainty, The* 99; reimagining of philosophy and 175–176; relation to Heidegger and Wittgenstein 6–8, 10n11, 36–37; revision of Western knowledge conceptions 37–39, 43, 45; turn from absolutism to experimentalism 30, 37; warranted assertability and 132–133, 140–141, 157

Dewey-Wittgenstein-Heidegger baseline: decoloniality and 78; design research involving practice and 44, 56, 131, 159, 160, 161–164; design theory and 32, 174–175; difference and diversity in 9, 22, 43; epistemology and 5, 8–9; existence and 44, 56, 64–70, 72–73; experience and 37–38, 43–44, 56, 63–70, 72–73; feminism and 79; important texts of 85n5; knowledge production and 22, 37–39; language/meaning and 63; philosophy and 5–7, 14, 30–32; positioning and 44, 56, 72–73, 155–156, 160, 161; processing and 93, 97–98, 106, 108, 111–115, 156–157, 160, 161; producing and 131–137, 139–143, 157–158, 160, 162; reimagining of philosophy and 175–179, 180n12; transformation and 5, 38–39, 43; uncertainty and 38, 43

Diamond, Cora 118n18

Dilnot, Clive 33

Dindler, C. 126, 131

Dixon, B. 10n7

Dixon, Catherine 58

Djajadiningrat, J. P. 149n23

Dorst, K. 46n5

Dourish, Paul 10n7, 71, 149n24

Dreyfus, H. L. 10n8

Duarte, A. M. B. 46n1, 46n2

Dudrick, D. 119n31

Durant, Will 22

dynamic reality 168–169

Eco, Umberto 101

ecological: annotated portfolios and 147n7; design research and 75, 77; Dewey-Wittgenstein-Heidegger baseline and 78–80; environmental ethics and 77, 79; Native American thought and 80; philosophy and 77; positioning and 75–76, 159; processing and 159; psychology and 35; sustainability and 70–71, 83; transition design movement and 56

ecosophy 78

Edmonds, E. 46n8

Ehn, Pelle 41, 43, 47n30, 104, 113, 118n16

empiricism: absolutism and 40; Deleuze and 40–41; experience and 26, 29; logical 47n26; rationalism and 105; root problem and 29; theory of knowledge and 3, 26; utilitarianism and 27

Engels, Frederick 39

188 *Index*

engineering design 18, 169
environmental ethics 77, 79–80
environmental sustainability 80–81
Epicureanism 23–24
epistemology: critical theory and 164–166; Deleuze-Guattari and 166–168; design research involving practice and 1–5, 14, 38, 56, 97, 159, 161–169, 173–174; Dewey critique of traditional 6; Dewey-Wittgenstein-Heidegger and 4–9, 14, 37–39, 43–44, 56; feminist 59–60, 77, 79; philosophy and 3, 22, 27; practical 147n3; practice-based design research and 1–4, 28, 38; social 60
Escobar, Arturo 80, 87n22
evaluation: alternative forms of 128–129; design outcomes and 124–125, 127–129, 148n13; doubting and 134–135; evidence-claims and 124–125, 127, 131, 135, 139–142; producing and 125; traceability and 130; warranted assertability and 132
Everyday Design Studio 45, 145–146, 170, *170, 171,* 180n11
evidence: annotated portfolios and 126–127; artefacts/text and 125, 142; defining 124; design research and 124–127, 132, 147n3; evaluation and 124–125, 127, 131, 135, 139–142; language games and 148n18; strong concepts and 126
existence: Dewey on experience and 44, 64–65, 72, 78–79; Dewey-Wittgenstein-Heidegger baseline and 44, 56, 64, 72–73; Heidegger on technological enframing of 48n36; Heidegger on thrownness of 68–69; poetic and 37; transformation and 38; Wittgenstein on 65–66
existentialism 28
experience: design research involving practice and 26; Dewey on existence and 44, 64–65, 72, 78–79; Dewey-Wittgenstein-Heidegger baseline and 37–38, 43–44, 56, 63–64, 72–73; empiricism and 29; Heidegger on 44, 69; knowledge production and 45; language and 37–38; philosophy and 31; product design and 31; Wittgenstein on 65–66
Experience and Nature (Dewey) 64, 85n5
extensibility 129

Fashion and Sustainability (Fletcher and Grose) 87n20
fashion design 14, 87n20
feminism: Butler critique of 119n30; design research and 75, 77, 106, 108; Dewey-Wittgenstein-Heidegger baseline and 79; epistemology and 59–60, 77, 79; objectivity and 79; positioning and 75–77, 159; pragmatism and 79; processing and 159; radical philosophy and 29, 47n23; scientific practices and 59–60
Fletcher, K. 87n20
Flores, Fernando 10n7, 71
Flusser, Vilém 34
Forlizzi, J. 20, 57–58
Foucault, Michel: Butler critique of 119n31; critical theory and 48n40, 60, 165; design theory and 8, 40; epistemology and 40; on knowledge as social outcome 60; performative and 116; philosophy and 40, 48n40; power-knowledge relations and 101, 115–116; social history and 40, 48n40
Frankfurt School 164–165
Frayling, Christopher 19–20, 46n6, 46n7, 58
Freud, Sigmund 28
Fry, Tony: on enframing 71; on Heidegger and design 10n7, 118n24; idea that design conceals 110, 114, 148n19; on sustainability 72, 80–81; transition design and 81, 87n22
Fuller, Buckminster 18

Galle, Per 33
Gare, Arran 176
Gaukroger, Stephen 179
Gaver, Bill 126, 131, 147n7
generalisability 1–2, 128–129, 148n10, 148n11
Genova, Judith 10n8, 67, 105
Gibson, James 138, 149n25
Gilmont, J. F. 47n18
Glasgow School of Art 20
Godin, Danny 130
Goehring, B. 167, 179n6
Goeminne, G. 146
Goesetti-Ferencei, Jennifer 118n23
Goethe University 164
Goricanec, J. 169
graphic design 14–15, 102, 117n12
Grayling, Antony 48n40
Greensted, R. P. 48n42
Gregory, Sydney 18
Grose, L. 87n20
Gross, M. D. 104, 113
Guattari, Felix: Deleuze and 40–41, 166–168; design theory and 167–168, 179n5; ecosophy and 78; epistemology and 166–168; the ideal and 166–167; multiplicities and 166–168; nomadic concept and 167, 172; *One Thousand Plateaus* 167; philosophy and 8, 48n31, 166; relevance and 167
Guba, E. 61, 129, 147n1, 148n14

Habermas, Jürgen 33, 165
Habraken, H. J. 104, 113
Halse, J. 103
Haraway, Donna 59
Hauser, Sabrina 146, 176–177
HCI *see* human computer interaction (HCI)
Hegel, Georg W. F. 27–28, 39, 47n22, 168
Heidegger, Hölderin, and the Subject of Poetic Language (Goesetti-Ferencei) 118n23
Heidegger, Martin: on art and truth 110, 118n25, 119n26; attunement/mood and 68; background of 36–37; on Being 67–69, 72, 136, 175; *Being and Time* 67, 69, 86n5, 118n20, 136; on being-in-the-world 7, 67–68, 71, 108, 138; Buddhism and 80, 87n18, 111, 158; care concept and 68–69, 72–73, 109; on communication and truth 136–137; Dasein concept 67–69, 72, 80, 108, 136; design research and 4–5, 10n7, 32; discovery process and 45, 109, 136; East Asian thought and 87n18; eco-phenomenology and 80; enframing concept and 71, 80, 141; environmental ethics and 80; existence and 64, 69; experience and 44, 69; feminist interpretations of 79; on forming interpretations 109, 118n22; hermeneutics and 145; on Hölderin 110, 118n23; language as house of being 108; meaning-making and 98, 112; Nazi party and 36, 48n33, 48n36; 'in-order-to' of things 109, 118n21; phenomenology and 6, 10n10, 30, 47n28, 70, 108, 114; on poetic thinking 45, 69, 72, 93, 108–110, 114–115; pragmatism and 3, 6, 8, 29–30; on preservation of work 148n20; processing and 108–109, 112; producing and 131, 137; *Question Concerning Technology, The* 86n5; reimagining of philosophy and 175; relation to Dewey and Wittgenstein 6–8, 10n11, 36–37; reorientation of theories 37, 48n36; revision of Western knowledge conceptions 37–39, 43, 45; on science 108; sustainability and 32, 70, 72, 80; on technological enframing 48n36, 71; on things and technology 70–72; Thing theory and 47n30, 70–71, 86n8; unconcealment and 114, 131, 136–137, 140–141; view of technology 32, 37, 48n36, 70–71; *see also* Dewey-Wittgenstein-Heidegger baseline
Helen Hamlyn Centre 21
Helix Centre 15–16
Heraclitus 23, 46n10, 168
History of Philosophy, The (Grayling) 48n40
Hölderin, Friedrich 110, 118n23

Höök, Kristina 126, 177
Horkheimer, Max 164
Houlgate, S. 47n22
human-centred design: Buddhist compassion and 112; empowerment and 112; Everyday Design Studio and 170, 180n11; Helix Centre and 15; posthuman perspectives and 146, 170; postphenomenology and 145–146, 170
human computer interaction (HCI): activity theory and 43; cognitive psychology and 149n21; critical theory and 165; evaluation criteria and 129; Heidegger on embodiment and technological use in 71; impact of Dewey on 64; interaction design and 15; IoT devices and 46; postphenomenology and 145–146; representation of artefacts in 126; use-embodiment themes in 71
Hume, David 26
Hummels, Caroline 139, 146, 149n27
Hush, Gordon 17
Husserl, Edmund 47n28, 70, 145

Ihde, Don 145–146, 149n33
ImaginationLancaster (Lancaster University) 21, 172
Imperial College London 15
industrial design 14, 102, 149n35
Ingold, Tim 34–35, 94
interaction design: cognitive psychology and 149n21; critical theory and 33, 165; design academization and 32; evolution of 14–15; HCI and 15; impact of Dewey on 64; Latourian theory and 32–33; performativity and 165
Interaction Frogger Framework 138
IoT devices 46
Irwin, Terry 81–82

James, M. 112
James, William 7, 10n10, 10n15, 11n18, 168
Jaspers, Karl 149n34
Jerryson, M. K. 119n27
Jonas, Wolfgang 95, 117n2

Kant, Immanuel 26, 28
Katoppo, M. L. 96
Kautzer, Chad 29, 47n24
knowledge production: acknowledgement and 133–134; action research and 96, 117n4; activities of 97–98; certainty and 37–38; design-based 40, 46; design research involving practice and 94–95; Dewey-Wittgenstein-Heidegger and 22, 37–39; doubting and 134; experience and 45; generalisability and 1–2, 10n2, 148n11;

ideas of certainty and 25–26; language/meaning and 63–64; meaning-making and 114; objectivity and 35, 44, 56, 58–59; philosophical epistemology and 177; positioning and 44, 94; processing and 94–95; research through design and 1–2; role of the researcher in 58–60; scientific involvement in 38, 59–60; social agreement and 114; social epistemology and 60; transformation and 1–2, 5, 21, 28; Western focus on surety in 99; Wittgenstein and 133–134

Koskinen, Ilpo 2, 17, 63, 97, 114, 130, 137, 141
Kossoff, Geodon 81
Krippendorff, Klaus 10n7, 32, 102, 104
Krogh, P. G. 97, 130
Kuhn, Thomas 59–61, 148n12

Lacan, Jacques 101
Lancaster University 21, 172
language: analytic philosophy and 28; communication and 99–100, 104; culture and 66; design process and 104; design research involving practice and 45, 100, 115; design tools and 103–104; experience and 37–38; Foucault and 40; Heidegger on house of being and 108; human-centred design and 15; inquiry and 100; performative 115–116; philosophy and 104–105; social agreement and 116; transformation and 100; Wittgenstein on meaning and 30, 44–45, 64, 66–67, 104, 114
language games: Brandt and 118n15; design research involving practice and 104, 113, 157; doing philosophy and 105; doubting and 134; evidence and 148n18; participatory design and 104, 118n16; problem-solving/dissolving 113; seeing of connections and 105–106, 118n18; Wittgenstein and 66, 104–106, 112, 118n15, 134–135, 148n18
Later Collected Works (Dewey) 6
Latour, Bruno: actor network theory and 32, 43, 60, 86n9, 143–145, 149n28, 149n29; design proposal and 144; design theory and 8, 32–33, 41; gathering notion and 70; Heidegger's Thing theory and 47n30, 70; participatory design and 32, 41; reflective stance and 41–42; technology and 149n29
Law, John 149n28
Lawson, B. R. 46n5, 119n34
Leibniz, Gottfried W. 168–169
Leopold, Aldo 80
Lepage, J. L. 47n17
Lévy, Peter 146

Lewin, Kurt 117n4
Lewis, C. I. 47n26
Life of Buddhism, The (Reynolds and Carbine) 86n13
Lincoln, Y. S. 61, 129, 147n1, 148n14
Lloyd, Peter 119n34, 119n35
Locke, John 26, 100
Logic (Dewey) 85n5, 131
logical empiricism 47n26
logical positivism 34, 117n9
Löwgren, Jonas 126, 177

MakeTools workshop 103, *103*
Maldonado, Tomás 101, 117n11
Manzini, Ezio 17, 75
Marenko, B. 48n31, 167
Margolin, V. 117n11
Marx, Karl: on alienation 74–75; on capitalism and industrial production 39, 74; *Communist Manifesto* 39; design theory and 8, 39–40; deterministic beliefs and 39; on dialectic and material reality 27–28; on historical passivity of philosophy 29; human creativity and 39; Marxist theory interpretations and 39, 48n41; radical philosophy and 29; transformation and 28, 39, 42
Marxism: activity theory and 43; critical theory and 43, 165; design and 42–43, 158; interpretations of 48n41; negative associations of 39; participatory design and 42–43; positioning on creativity and 73–75, 158; pragmatism and 179n3; product design and 42; radical philosophy and 29, 47n23
Matthews, B. 95, 147n3
McCarthy, J. 10n7, 86n10
McDonald, Hugh 79
McDonnell, Janet 119n34, 119n35
McKeon, Richard 33
McQuiston, Liz 106
Mead, George Herbert 85n3
Media Lab (MIT) 172
medieval philosophy 25, 47n14, 47n15
meditative thought 73, 86n7, 111
Memphis design group 42, 102
Merleau Ponty, Maurice 138
metaphysics 25, 47n15
methodology: action research and 96; actor network theory and 41; design process and 44, 93–95, 97, 127; design research involving practice and 94–97; link to sciences and the arts 94; participatory action research and 96–97; plurality and 172; processing and 44, 93–97, 156; research and 93
Mill, John Stewart 27

Mode 2 research 117n3
modern philosophy: Darwin's evolutionary theory and 27; Descartes and 25–26, 28; empiricism and 26; Hegel and 27–28; Kant and 26, 28; Marx and 27–28; rationalism and 25–26; technological advances and 26–27; utilitarianism and 27
Morris, Charles William 101, 117n9
Morris, William 42, 48n42, 74
Morrison, A. 147n6
Moudileno, L. 117n7
multiplicities 166–168
Murphy, Peter 95

Naess, Arne 77
natural sciences 2, 34, 59–60, 127
Nelson, H. G. 117n2
Newton, Isaac 136
Noel, Leslie-Anne 84
nomadic concept 167, 172
Nöth, W. 117n10

objectivity: design research involving practice and 1, 56, 58–59, 62, 128; existence and 73; experience and 73; feminist questioning of 79; knowledge production and 35, 44, 56, 58–59; reliability and 128; science and 59–60; social sciences and 61; traditional research and 124, 127–128; validity and 128
Olander, S. 46n2
Olly project (Everyday Design Studio) *170*, 171
Onafuwa, D. 84, 87n22
On Certainty (Wittgenstein) 133
One Thousand Plateaus (Deleuze and Guattari) 167
O'Reilly, J. 167
Overbeeke, Kees C. 138, 149n22, 149n24, 149n25, 149n27

Papanek, Victor 16–17
Parsons, Glenn 34
participatory action research (PAR) 96–97
participatory design (PD): co-creation and 16–17; collaborative problem-solving and 15, 42–43; communication and 104; language games and 104, 118n16; Latour and 32, 41; Marxist perspectives and 42–43; research through design (RtD) and 19; Scandinavian 17
pattern of inquiry: communication and 113; design research involving practice and 100, 113; design theory and 98; Dewey and 44, 93, 95, 98–100, 113–114, 172; logical theory and 99, 131; postphenomenology and 145; pragmatism and 114; settled 131–132

Pattison, George 48n36
Pedgley, O. 19
Peirce, Charles Sanders 7, 11n18, 101, 117n13, 168
performative utterances 116
performativity 115–117, 165
perspicuous representations 67, 104
PhD by Design conference 21
phenomenology: continental philosophy and 28; design research and 34; Goethean 81–82; Heidegger and 6, 10n10, 30, 47n28, 70, 108, 114; Husserl and 47n28, 70; *see also* postphenomenology
Philosophical Investigations (Wittgenstein) 66, 86n5, 135
philosophical pathways: Austin and 115–116; Buddhism and design 75–76, 78, 80, 111–112; Butler and 115–116; critical theory and transformation 164–166; decolonising design movement 75–79; Deleuze-Guattari and 41, 166–168; ecological and 75–80; feminism and 75–80; Foucault and 40, 115–116; Heidegger on things and technology 70–72; Latourian actor network theory and 143–144; mapping and 8–9, 154–155, 158–159, *160*; Marxist design influence and 42–43; Marxist positioning on creativity 73–75; postphenomenology and 144–147; process philosophy and 168–169; semiotics and 100–102
philosophy: abstract concepts and 47n27; analytic 6, 10n10, 28–30, 176; ancient 23–24, 46n10; contemporary 28; continental 28–30, 36, 176; critical theory and 8, 28, 47n24; defining 166; designerly perspective and 14, 174–177; design research and 46, 138–139; design theory and 2–3, 31–36, 170; design tools and 103, 118n14; Dewey-Wittgenstein-Heidegger and 5–7, 14, 30–32; dialectic and 27–28, 47n21; epistemology and 3, 22, 27; ethics and 77; existentialism and 28; experience and 31; grouping voices in 22–23; historical passivity and 29; history of Western 22–28; knowledge and 3, 37–38; language and 104–105; linguistic turn in 115; medieval 23, 25; metaphysics and 47n15; phenomenology and 6, 10n10, 28; pragmatism and 3, 6–7, 10n10; process 8, 11n18; radical 11n17, 28–30, 47n23, 47n24; reimagining of 175–179, 180n12; structuralism/poststructuralism and 28; *see also* modern philosophy; philosophy of design
Philosophy and Design (Vermass) 33
Philosophy and the Mirror of Nature (Rorty) 6

philosophy of design: comparative studies and 174; defining 33; designer-philosopher and 177–179; discourse on 33–34; experimentation and 171; Latour on 144; research through design and 10n5; theory at the edge of philosophy and 34–35; transformation and 144
Plato 22–24, 179n8
poetic thinking: artistic creation and unconcealment 110, 114–115, 119n29; Being and 119n29; design research involving practice and 110, 113–114; Heidegger on 45, 69, 72, 93, 108–110, 114–115; linking of Dasein with Being in 69, 72
Polanyi, Michael 34–35, 94
positioning: Buddhism and 75–76; contextual grounding and 44, 56; decolonising design movement and 75–77; defining 44; design research involving practice and 44, 56, 58, 63, 65, 67, 70, 94; Dewey-Wittgenstein-Heidegger baseline and 44, 56, 72–73, 155–156, *160*, 161; ecological and 75–76; experience and existence in 64–65, 156; feminism and 75–77; knowledge production process and 44, 94; Marxism and creativity 73–75; philosophical pathways and *160*
positivism 34, 60–63, 142
postphenomenology: actor network theory and 145; design discourse and 145–146, 180n11; design research involving practice and 139; HCI and 145–146; human-centred design and 145–146; human-technology relations and 144–146, 177; moral questioning and 146–147; product and service design 146
post-positivism 60–61, 164
poststructuralism 28
practical design theory 32
practice-based design research 125, 147n4
practice-led design 10n5, 125, 147n4; *see also* design research involving practice
pragmatism: American 7; classical 30, 47n26, 138, 165, 180n12; decoloniality and 78; design and 7; Dewey and 3, 6–7, 10n10, 29–30, 79, 114; Dewey-Wittgenstein-Heidegger and 10n13; feminism and 79; Heidegger and 3, 6, 8, 10n10, 29–30; James on 10n15; Marxism and 179n3; mixed methods approach in 62; pattern of inquiry and 114; social research and 61; Wittgenstein and 3, 6–8, 10n10, 30
Preston, Aaron 176
processing: communication and 44, 97, 156; defining 44; design research involving practice and 45, 94–95, 106, 109, 112–117; Dewey-Wittgenstein-Heidegger baseline and 93, 97–98, 106, 108–109, 111–115, 156–157, *160*, 161; embodied located activity and 112; knowledge production and 94–95; methodology and 44, 93–97, 156; researching and 93; see-think relationships in 106
process philosophy 8, 11n18, 168–169, 179n8
process theory agenda 169
Prochner, Isabel 130
producing: acknowledgement and 133; defining 44; design artefacts and 130–132, 135–136, 139, 141, 157–158; design research involving practice and 45, 124–125, 131–132, 157; Dewey-Wittgenstein-Heidegger baseline and 131–137, 139–143, 157–158, *160*, 162; doubting and 134–135, 140–142, 157; knowledge and belief in 131–132; personhood and 140; thinking-looking and 136; unconcealment and 136–137, 140–142; warranted assertability and 132–133, 140–141, 157, 162
product design: cognitive psychology and 149n21; design academization and 32; evolution of 14–15; experience and 31; Marxist perspectives and 42; postphenomenology and 145; semiotics and 102, 117n13; specialisation and 17
Products as Representations (Vihma) 117n13
product semantics 102
Pussy Galore typeface 106, *107*
Putnam, Hillary 176
Pythagoras 23, 46n10

Queer Theory 29
Quest for Certainty, The (Dewey) 99
Question Concerning Technology, The (Heidegger) 86n5

radical philosophy 28–30, 47n23, 47n24
Rapp, A. 146
rationalism 25–26, 29, 105
Read, R. J. 10n8
Redström, Johan 32, 95, 97
Reformation 25, 47n18
reliability 124, 127–129
Renaissance 25
research: applicability and 148n10; designerly endpoint in 131; evaluation and 128–130, 132; generalisability and 128–129, 148n10; objectivity and 124, 127–128; reliability and 124, 127–128; replicability and 148n9; validity and 124, 127–128; *see also* design research

Research Excellence Framework 48n32
research for design 19, 58
research into design 19
research through design (RtD): action research and 96; annotated portfolios and 126; biennial conference and 21; co-creative design and 75; common features of 1; computer-aided design and 19; design research and 21; effective solutions in 117n3; evaluation and 130; Frayling and 19–20, 46n7; generalisable knowledge and 1–2; genres in 113; methods for 2; relevance of work and 148n15; transdisciplinarity and 95; visual experimentation and 58
Rodgers, Paul 10n1, 16
Rorty, Richard 6–7, 180n12
Royal College of Art 15
Royal Danish Academy of Fine Arts 103
Russell, Bertrand 22–23, 28, 30, 168

Sanders, Elizabeth B. N. 16, 75, 103, 118n14
Saussure, Ferdinand de 28, 101
Scheman, Naomi 79
Schön, Donald A. 10n7, 32, 34–35, 94, 97, 117n1, 117n5
science: Aristotle and 24; design research and 18; empirical 3; feminist epistemology and 59–60; grounding ontology and 60; knowledge production and 38, 59–60; natural 2, 34, 59–60; objectivity in 59–60; post-positivism and 60; revolutions in 59; social theory and 59–60
Science and Technology (STS) studies 60, 149n29
Science Council (UK) 60
Sciences of the Artificial, The (Simon) 18, 94
Secomandi, F. 146
Seigfried, C. H. 79
semantic theory of design 32, 104
semiotics 100–102, 117n10, 117n13
service design 15–16
Shapin, S. 148n12
Simon, Herbert 18, 94
Simon Fraser University 45, 145, 170
Sleeper, R. W. 10n8
Sloterdijk, Peter 144, 149n32
Snelders, D. 146
social design 17, 84
social epistemology 60
social sciences: constructivism and 61–63; critical theory and 61–63; design research involving practice and 61–63; factual claims and 127; mixed methods movement in 61–62; participation and 62–63; participatory design and 17; positivism and 61; post-positivism and 61; pragmatism and 61; pre-paradigmatic 61; qualitative research and 61, 85n3, 128–129; role of the researcher in 60–62; symbolic interactionism and 85n3
social theory 59–60
Socrates 23–24
Socratic method 23, 47n21
Sottsass, Ettore 42
Stappers, P. J. 16, 103
Steffney, J. 87n19
Stienstra, Jelle 138
Stoicism 23–24, 100
Stolterman, E. 117n2, 127
Storni, C. 144, 149n31
strong concepts 126–127
structuralism 28
Structure of Scientific Revolutions, The (Kuhn) 59
Sudradjat, I. 96
sustainability: decolonising design and 83; design reform and 71–72, 80–81, 87n20; ecological and 70–71, 83; environmental 80–82; Heidegger and 32, 70, 72, 80; social innovation and 17, 75; transition design movement and 80–82
symbolic interactionism 85n3
Systematic Change group 149n27

technology: enframing and 48n36, 71; ethics and 57–58; Heidegger on 32, 37, 48n36, 70–71, 145; human relations with 144–146, 177–178; Latour and 149n29; Marxist perspectives and 42; mediation of perception by 145; participatory design and 17; postphenomenology and 144–146, 177; as present-to-hand 71; as ready-to-hand 71; slow 171; sustainability 146; wearable 146; *see also* human computer interaction (HCI)
Thales 23, 46n10
Things We Could Design (Wakkary) 146
Thing theory 47n30, 70–71, 86n8
Thomas Aquinas, Saint 25
Tirres, C. 78
Tonkinwise, Cameron 81, 87n21, 87n22, 147n4
Toulmin, Stephen 6
Tractatus Logico Philosophicus (Wittgenstein) 65–66, 86n5
transdisciplinarity 95, 117n3
transferability 129
transformation: critical theory and 164–166; design research involving practice and 1–2, 14, 16, 38, 43, 45, 62–63, 139, 155, 159, 161–162; Dewey-Wittgenstein-Heidegger baseline and 5, 38–39; existence and 38; knowledge production and 5, 21, 28; language and 100; Marx and 28, 39, 42;

participation and 38; participatory action research and 96; philosophy of design and 144
transformation design 16
transition design movement: Carnegie Mellon University and 81–82; contextual grounding and 44; decolonising discourse and 82, 87n22; ecological and 56; environmental sustainability and 80–82; phases of 81; reorganising of society and 81
Triggs, Teal 45, 106
TU Eindhoven 138–139, 146, 149n27

Ulm Institute of Design 101–102, 117n11
user-centred design 15–16
utilitarianism 27

Vaajakallio, Kirsikka 118n15
validity 124, 127–129
Vaughan, Laurene 130, 143, 147n6, 148n16
Verbeek, Peter-Paul 145–146, 149n35
Vermass, Pieter 33
Vihma, Susann 117n13
visual communication design 16, 106

Wakkary, Ron 145–146, 167, 170
Wallerstein, I. 48n41
warranted assertability 132–133, 140–141, 157
Wegener, F. 169
Weingarden, L. 42
What Things Do (Verbeek) 149n35
Where the Action Is (Dourish) 149n24
Whitehead, Alfred North 8, 168–169, 179n9, 180n10
William of Ockham 25, 47n16
Winograd, Terry 10n7, 71
Wittgenstein, Ludwig: analytic philosophy and 6, 10n10; architecture and 10n9; background of 36–37; on benefiting society 180n13; *On Certainty* 133; design research and 4–5, 10n7, 32; doubting and 134–135, 140–141, 157; on experience and existence 64–66; feminist interpretations of 79; on knowledge/acknowledgement 133–134; on language and meaning 44–45, 64, 66–67, 72, 93, 98, 104, 114; language games and 66, 104–106, 112, 118n15, 134–135, 148n18, 175; logic and 30; perspicuous representations and 67, 104; *Philosophical Investigations* 66, 86n5, 135; pragmatism and 3, 6, 8, 29–30; problem dissolving and 113, 115; processing and 106, 112; producing and 131, 133–136; reimagining of philosophy and 175; relation to Heidegger and Dewey 6–8, 10n11, 36–37; reorientation of theories 37, 48n35; revision of Western knowledge conceptions 37–39, 43, 45; rules concept 135, 157; seeing of connections and 105; thinking-looking and 133, 136; *Tractatus Logico Philosophicus* 65–66, 86n5; *see also* Dewey-Wittgenstein-Heidegger baseline
Women's Design + Research Unit (WD+RU) 106
womxn 106, 118n19
Wong, B. 112
Woolgar, Stephen 60
Wormald, P. 19
Wright, P. 10n7, 86n10
Wuppuluri, S. 10n8

Yaneva, A. 144, 149n30
Yardley, L. 148n14
Yee, Joyce 57–58
Young, Julian 69, 86n7

Zen Buddhism 87n18, 87n19
Zimmerman, J. 20, 57–58, 129–130, 142, 148n15